PIMLICO

751

GEORGE STUBBS AND THE WIDE CREATION

Robin Blake is a full-time writer whose publications include *Anthony van Dyck: A Life, 1599–1641* (1999) and *Essential Modern Art* (2001).

GEORGE STUBBS AND THE WIDE CREATION

Animals, People and Places
in the Life of George Stubbs, 1724–1806

ROBIN BLAKE

PIMLICO

Published by Pimlico 2006

2 4 6 8 10 9 7 5 3 1

Copyright © Robin Blake 2005

Robin Blake has asserted his right under the Copyright,
Designs and Patents Act 1988 to be identified as the author of this work

First published in Great Britain in 2005 by
Chatto & Windus

Pimlico edition 2006

Pimlico
Random House,
20 Vauxhall Bridge Road,
London SW1V 2SA

Random House Australia (Pty) Limited
20 Alfred Street, Milsons Point, Sydney,
New South Wales 2061, Australia

Random House New Zealand Limited
18 Poland Road, Glenfield
Auckland 10, New Zealand

Random House (Pty) Limited
Isle of Houghton, Corner of Boundary Road & Carse O'Gowrie,
Houghton, 2198,
South Africa

Random House UK Limited Reg. No. 954009

A CIP catalogue record for this book is available from the British Library

ISBN 9780712668613 (from Jan 2007)
ISBN 0712668616

Penguin Random House is committed to a sustainable future for
our business, our readers and our planet. This book is made from
Forest Stewardship Council® certified paper.

Printed and bound in Great Britain by Clays Ltd, St Ives plc

Contents

List of Illustrations

(Works are by George Stubbs, and in oil on canvas, unless otherwise indicated)

COLOUR PLATES

and a Hound, 1800 (Yale Center for British Art/Bridgeman Art Library).

BLACK AND WHITE PLATES

1. *Portrait of a Young Man*, William Caddick (Merseyside Museums/Bridgeman Art Library).

2. *Portrait of the Artist at his Easel*, Hamlet Winstanley (Merseyside Museums/Bridgeman Art Library).

3. *The Blackburne Family*, photograph of a lost painting by Hamlet Winstanley (British Library).

4. *Judge Richard Wilson*, Benjamin Wilson (Temple Newsam House/Bridgeman Art Library).

5–7. Three plates illustrating foetal presentations and obstetrical instruments, from John Burton's *An Essay Towards a Complete System of Midwifry, Theoretical and Practical, etc.*, 1751 (British Library).

8. *Foetus in Profile*, Jan van Riemsdyck from William Smellie's *A Sett of Anatomical Tables with Explanations . . . of the Practice of Midwifery*, 1754 (Wellcome Institute Library).

9. *Sir Henry and Lady Nelthorpe*, 1746 (Private Collection).

10. *Sir John Nelthorpe as a Boy*, 1755 (Private Collection/Bridgeman Art Library).

11. *Flayed Horse*, bronze (The Torrie Collection, © The University of Edinburgh).

12. Horse, partially dissected, anterior view, graphite on paper (Royal Academy of Arts).

13. Horse, partially dissected, anterior view, 8th Anatomical Table from Stubbs, George, *The Anatomy of the Horse*, 1766 (Private Collection).

14. *A Kill at Ashdown Park*, James Seymour, 1743 (Tate Britain).

15. *Three stallions with Simon Cobb*, 1762 (Private Collection/Bridgeman Art Library).

16. *Scrub with John Singleton up*, 1762 (Private Collection/Bridgeman Art Library).

17. *Jenison Shafto's Snap with Groom*, 1760 (Private Collection).

18. *Horse Attacked by a Lion*, 1762 (Yale Center for British Art/Bridgeman Art Library).

19. Jacobite Medal, Otto Hamerani, bronze, 1721 (© copyright Trustees of the British Museum).

20. *Lion Attacking a Horse*, Peter Scheemakers, Portland stone, 1742 (Rousham House/Bridgeman Art Library).

ILLUSTRATIONS IN THE TEXT

Chronology of the
Life and Times of George Stubbs

GS = George Stubbs; GTS = George Townley Stubbs; PoW = the
Prince of Wales; SoA = the Incorporated Society of Artists of Great
Britain; RA = the Royal Academy of Arts; b. = born; m. = married;
d. = died

1680–1714	1680: b. John Stubbs to Richard Stubbs, currier, Warrington, who moves his family to Liverpool	1688: Accession of William III following the Glorious Revolution
	1697: b. Mary daughter of John Patten, market gardener, Liverpool	
		1702: Accession of Queen Anne
	1710: John Patten d.	1714: Accession of George I and Hanoverian dynasty
1715–25	1717: Mary Patten m. Roger Laithwaite, Liverpool	1715: Defeat of Jacobite rebellion (the 'Fifteen')
	1723: Mary Laithwaite, widow, m. John Stubbs	
	1724: George Stubbs b. Dale Street, Liverpool, eldest of four. The family will move to a new house in Ormonde Street within a decade	1720: South Sea Bubble bursts
1726–39		1726: Jonathan Swift, *Gulliver's Travels*; James Thomson, *The Seasons* (to 1730)

1727: John Gay, *Fables*;
Thomas Gainsborough b.
1728: John Gay, *The Beggar's Opera*
1730: Josiah Wedgwood b.
1733:William Hogarth, *The Rake's Progress*; Alexander Pope, *Essay on Man*
1735: John Harrison's first chronometer

1740–51

1741: GS's lifetime companion Mary Spencer b. (?); John Stubbs d.; GS apprenticed briefly to Hamlet Winstanley at Knowsley Hall, but soon returns to Liverpool

1740: Samuel Richardson, *Pamela*

1742–4: GS works in currier's shop and teaches himself painting

1742: Henry Fielding, *Joseph Andrews*

1744–5: GS portrait painting in Wigan for Captain Blackburne, then in Leeds for the Wilson family

1745: Bonny Prince Charlie lands in Scotland (July); Thomas Holcroft b.; Jonathan Swift d.

1746–52: GS in York, now married; associates with Jacobites and Catholics around York Hospital; studies anatomy; paints *George Fothergill*; teaches drawing and perspective at Wakefield

1746: Jacobite rebellion, the 'Forty-Five', crushed at Culloden

1748: GS's son GTS b.

1748: First excavations at Pompeii
1749: Henry Fielding, *Tom Jones*: Gainsborough's *Mr and Mrs Andrews*

1750: GS's son Charles Edward b.

1750: Charles Watson-Wentworth succeeds as second

xii

Marquess of Rockingham
1751: Gray's 'Elegy Written in a
Country Churchyard'

1752–5 1752: GS at Hull; his
daughter Mary-Ann b.; John
Burton's *Essay on Midwifery*,
illustrated by GS, published
at York; paints for Nelthorpe
family of Barton-on-Humber
1754: GS in Rome at Easter,
but returns (possibly via
Morocco) by September
1755: GS in Liverpool 'at
his mother's house' where
he paints *James Stanley*;
his son John b. (May); Mary
Stubbs d.

1752: Jockey Club established
at Newmarket
1753: Hogarth's *Analysis of
Beauty*; Joseph Warton's
translation of Virgil's *Georgics*

1756–61 1756: GS goes to Horkstow,
Lincolnshire, with Mary
Spencer and under
patronage of the Nelthorpes,
where he dissects and draws
horses; paints *Sir John
Nelthorpe as a Boy*

1756: Outbreak of Seven
Years' War; Burke's *A
Philosophical Enquiry into . . .
the Sublime and Beautiful*;
William Blake b.
1758: John Dolland's
achromatic telescope; Robert
Adam, architect, and Richard
Wilson, landscape painter,
return from Italy

1759: GS's daughter
Mary-Ann d. Liverpool
age seven (September)
1759–60; GS, in London
with anatomical drawings,
attracts attention of
Rockingham and his circle;
spends time painting at
Wentworth Woodhouse,
Yorks (*Whistlejacket*),
Goodwood House, Sussex

1759: Laurence Sterne,
Tristram Shandy Parts I and II
published at York
1760: Accession of George III;
Josiah Wedgwood opens first
pottery works; public art
exhibition in London;
racehorse Gimcrack foaled

(*The Charlton Hunt* etc.),
Eaton Hall, Cheshire (*The Grosvenor Hunt*) and
Newmarket

1761: GS first exhibits at the Society for the Encouragement of Arts, Manufactures and Commerce

1761: Earl of Bute Secretary of State; Duke of Bridgewater's canal opened

1762–7

1762: GS delivers *Lion and Horse* and *Lion and Stag* paintings to Rockingham

1762: William Cobbett b.

1763: GS moves into a newly built house at 24 Somerset Street near Portman Square

1763: Bute's administration falls (April)

1764: Hogarth d.; Horace Walpole, *Castle of Otranto*

1765: GS paints Gimcrack and 'shooting' series; visits Southill to paint Lord Torrington's servants

1766: GS publishes *Anatomy of the Horse* (March)

1765: SoA incorporated under royal charter; Johnson's edition of Shakespeare; racehorse Eclipse foaled; sporting painter John Wootton d.; Lord Rockingham Prime Minister (July 1765–July 1766)

1767: Prints after GS by Benjamin Green published (to 1770)

1768–75

1768: GS Treasurer of SoA and vestryman of the parish of St Marylebone

1769–71: GS makes chemical experiments towards new enamel colours; William Woollett's prints after GS's 'shooting' series published

1770: GS draws the Duke of Richmond's first bull moose

1771: GS's first enamel

1768: RA founded by breakaway members of SoA; Joseph Wright of Derby, *Experiment on a Bird in the Air Pump*

1768–72: Sawrey Gilpin, paintings based on *Gulliver's Travels*

1771: James Cook and Joseph

painting exhibited at SoA, *A Lion Devouring a Horse*

Banks return from three-year voyage to the South Seas (June)

1772: GS President of SoA (one year)

1772: Weatherby's annual *Racing Calendar*
1773: Boston Tea Party protest
1774: Gainsborough moves from Bath to London

1775: GS first exhibits at RA; applies to Wedgwood for large-scale tablets suitable for enamel painting

1775: J. M. W. Turner b.; Edward Gibbon, *Decline and Fall of the Roman Empire*

1776–84

1776: American Declaration of Independence

1777: GS publishes his first single-issue print *A Lion Affrighted by a Horse*

1779: Joshua Reynolds, *Discourses*; Doncaster St Leger first run

1780: GS stays with Wedgwood at Etruria and meets Erasmus Darwin

1780: Gordon Riots; inaugural Derby run at Epsom

1783: First of GS's *Haymakers and Reapers* paintings

1783: John Hunter's Museum opens (later Royal College of Surgeons)

1784: GTS publishes satirical prints

1785–94

1785: GTS declared bankrupt

1785: PoW secretly m. Mrs Fitzherbert

1786: GTS engraves lampoons of PoW and Mrs Fitzherbert

1788: Gainsborough d.; seven-year impeachment of Warren Hastings begins; Gilbert White, *The Natural History of Selborne*
1789: French Revolution; Holcroft's translation of Lavater's *Physiognomy*

1790: GS begins work on PoW's Carlton House series;

1790: Thomas Bewick's *General History of*

Turf Review project launched

Quadrupeds
1791: The Escape scandal –
PoW leaves Newmarket;
Boswell, *Life of Johnson*;
Erasmus Darwin, *Botanic Garden*
1792: Reynolds dies; racehorse
Hambletonian foaled

1793: GS paints soldiers and
servants of PoW
1794: Turf Gallery opens in
Conduit Street; GTS styles
himself 'engraver to the PoW'

1793: Execution of Louis XVI
1794: William Blake, *Songs of Experience*; Erasmus Darwin, *Zoonomia or the Laws of Organic Life* (to 1796)

1795–9

1797: Ozias Humphry writes
biographical notes after
conversations with
GS; GS makes last enamel
paintings and begins work on
Comparative Anatomy
c. 1796: Turf Gallery fails;
GS helped by Isabella
Saltonstall

1795: Josiah Wedgwood d.;
Warren Hastings acquitted

1798: Malthus, *Essay on the Principles of Population*

1799: Match race between
Hambletonian and Diamond
(25 March)

1800–17

1800: *Hambletonian Rubbing Down*; GS sues
Vane-Tempest for his fee
1801: GS friendly with Earl
of Clarendon, whose
gamekeeper he paints
1803: GS's last exhibit at RA,
*A Newfoundland Dog,
owned by the Duke of York*
1804: GS publishes first
plates of his *Comparative Anatomy*, but the project
will remain unfinished
1806: GS d. 10 July at 24
Somerset Street, aged eighty-
one
1807: Sale of GS studio and

1802: Erasmus Darwin d.

1805: Battle of Trafalgar and
d. of Nelson; Wordsworth and
Coleridge, *Lyrical Ballads*

1807: British slave trade

library abolished
1808–09: Obituary of Stubbs
in the *Sporting Magazine* 1809: Charles Darwin b.
(July)

1811: Baptism of Mary
Spencer's adult son Richard
Spencer, who takes the name
Stubbs

1815: GTS d. aged sixty-eight; 1815: Napoleon defeated at
Richard Stubbs d. aged Waterloo.
thirty-four

1816: Mary Spencer d. aged
seventy-six

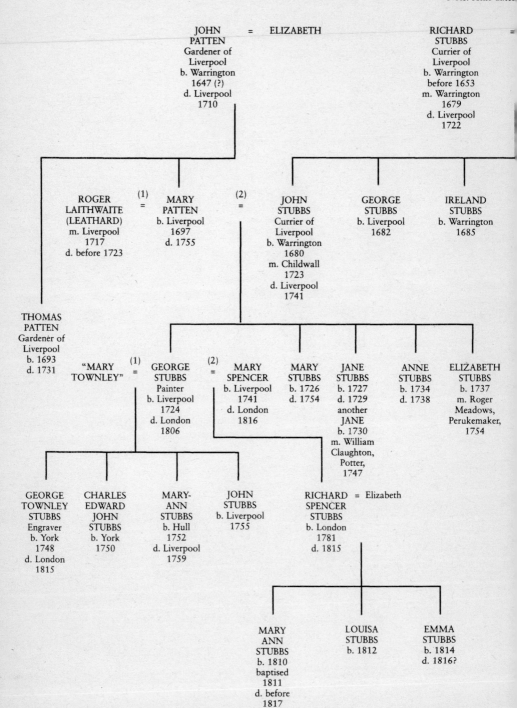

JOHN PATTEN = ELIZABETH = RICHARD STUBBS

JOHN PATTEN Gardener of Liverpool b. Warrington 1647 (?) d. Liverpool 1710

RICHARD STUBBS Currier of Liverpool b. Warrington before 1653 m. Warrington 1679 d. Liverpool 1722

ROGER LAITHWAITE (LEATHARD) m. Liverpool 1717 d. before 1723

(1) =

MARY PATTEN b. Liverpool 1697 d. 1755

(2) =

JOHN STUBBS Currier of Liverpool b. Warrington 1680 m. Childwall 1723 d. Liverpool 1741

GEORGE STUBBS b. Liverpool 1682

IRELAND STUBBS b. Warrington 1685

THOMAS PATTEN Gardener of Liverpool b. 1693 d. 1731

"MARY TOWNLEY"

(1) =

GEORGE STUBBS Painter b. Liverpool 1724 d. London 1806

(2) =

MARY SPENCER b. Liverpool 1741 d. London 1816

MARY STUBBS b. 1726 d. 1754

JANE STUBBS b. 1727 d. 1729 another **JANE** b. 1730 m. William Claughton, Potter, 1747

ANNE STUBBS b. 1734 d. 1738

ELIZABETH STUBBS b. 1737 m. Roger Meadows, Perukemaker, 1754

GEORGE TOWNLEY STUBBS Engraver b. York 1748 d. London 1815

CHARLES EDWARD JOHN STUBBS b. York 1750

MARY-ANN STUBBS b. Hull 1752 d. Liverpool 1759

JOHN STUBBS b. Liverpool 1755

RICHARD SPENCER STUBBS b. London 1781 d. 1815

= Elizabeth

MARY ANN STUBBS b. 1810 baptised 1811 d. before 1817

LOUISA STUBBS b. 1812

EMMA STUBBS b. 1814 d. 1816?

FAMILY IN LIVERPOOL & LONDON

are conjectural

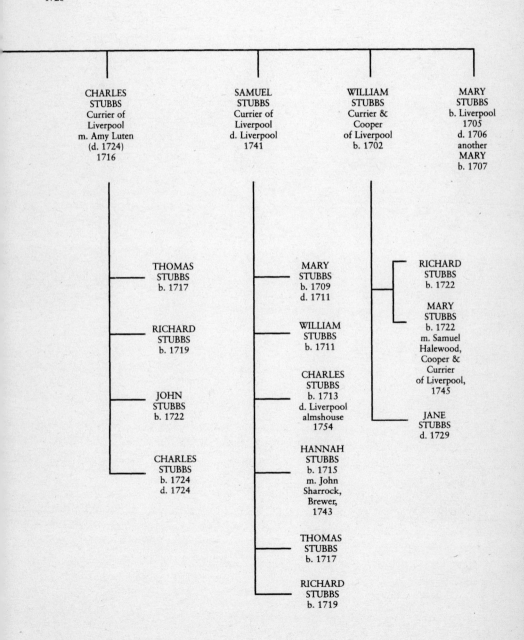

ELIZABETH
daughter of
GEORGE
RANSOM of
Warrington
b. 1762
d. Liverpool
1728

CHARLES
STUBBS
Currier of
Liverpool
m. Amy Luten
(d. 1724)
1716

SAMUEL
STUBBS
Currier of
Liverpool
d. Liverpool
1741

WILLIAM
STUBBS
Currier &
Cooper
of Liverpool
b. 1702

MARY
STUBBS
b. Liverpool
1705
d. 1706
another
MARY
b. 1707

THOMAS
STUBBS
b. 1717

RICHARD
STUBBS
b. 1719

JOHN
STUBBS
b. 1722

CHARLES
STUBBS
b. 1724
d. 1724

MARY
STUBBS
b. 1709
d. 1711

WILLIAM
STUBBS
b. 1711

CHARLES
STUBBS
b. 1713
d. Liverpool
almshouse
1754

HANNAH
STUBBS
b. 1715
m. John
Sharrock,
Brewer,
1743

THOMAS
STUBBS
b. 1717

RICHARD
STUBBS
b. 1719

RICHARD
STUBBS
b. 1722

MARY
STUBBS
b. 1722
m. Samuel
Halewood,
Cooper &
Currier
of Liverpool,
1745

JANE
STUBBS
d. 1729

In memory of my father

JOHN BERCHMANS BLAKE

1910–1999

Acknowledgements

I visited scores of galleries, libraries, archives and private homes in search of Stubbs, wrote hundreds of letters and e-mails, and had countless conversations about him. I am grateful to all those people who freely gave me help and advice.

Of professional archivists and curators, I received help from David Stoker and others at the City Library in Liverpool, as well as staff at the Walker Art Gallery (especially Audrey Hall), the Lancashire and Cheshire Record Offices, the Sheffield Archives, the Wigan History Shop (especially Christine Watts), Warrington Archivist Hilary Chambers, Marjorie Whaler of the Society for Lincolnshire History and Archaeology, Frank Salmon of the Brinsley Ford Archive (Paul Mellon Centre for the Study of British Art), Marijke Booth of Christie's Archive, Alison Brech and Christopher Webb of the Borthwick Institute and Sister Gregory Kirkus, archivist of the Bar Convent, York. I would also mention the Jockey Club, Val Loggie of the Erasmus Darwin Foundation, Tori Reeve, curator of Darwin's home Down House, Joan Appleton of Warrington, John Goodchild of Wakefield and H. F. Constantine, who was the first to look for Stubbs in the Rockingham papers at Sheffield. In America, the staff at the Yale Center for British Arts, Cathy Schenk, of the Keeneland Library, and Wendy Gottlieb of the Kimbell Art Museum, have also given assistance.

Historians and art historians who lent me their expertise over specific questions include David Alexander, Alex Kidson, John Ingamells, Margot Finn, Joanna Innes, R. F. Foster, Paul Langford, R. G. Wilson, Liza Picard, Andrew Loukes (Manchester City Galleries), Dom Alberic Stacpoole OSB (Ampleforth Abbey) and Abbot Geoffrey Scott, OSB (Douai Abbey).

For showing me works by Stubbs not in public collections I thank Lord Petre, Christopher and Lady Juliet Tadgell, and Alistair Macdonald-Buchanan.

Genealogists Jane Stubbs and Richard Fothergill, with their voluminous knowledge of the families to which they belong, have been

xxi

exceptionally helpful. I also benefited from information supplied by Hazel Lovatt, Gill Briscoe (Pontefract and District Family History Society) and Alan Laundon (of Horkstow) and also, consistently, by the professional and voluntary staff at the Genealogical Society, London.

Library work is at the heart of any biographical research, and staff at the London Library, British Library, Bodleian, Cambridge University Library, National Art Library, Natural History Museum Library, Sheffield University Library, Nottingham University Library, Wellcome Institute Library (especially Katja Robinson) and York Minster Library have all, at different times, gone out of their way to assist. The news that York Minster Library was threatened with closure, and its unique collections with dispersal, came at around the time I was working there. I am delighted that this threat has now been lifted.

Many others have offered references, books, advice and encouragement, including Andrew Blake, Tony Proctor, Janet Waugh, Chris and Christa Mee, Mark Roberts, Heather Mackay Roberts, Honor Sharman, Judith Flanders, Beth McKillop, Jane Merer and Helen McIntyre. Meanwhile Penelope Hoare, Poppy Hampson, Ilsa Yardley, and the staff at Chatto & Windus, have been unfailingly professional and supportive, as have my literary agents Gill Coleridge and Lucy Luck. Malcolm Warner of the Kimbell Art Museum, Fort Worth, came forward with a generous commission for three essays in the catalogue of his exhibition *Stubbs and the Horse* (Fort Worth, Baltimore and London 2004–5). Malcolm has also been a good friend and steady sounding board for ideas.

Above all I pay tribute to the scholar and writer Judy Egerton, author of the forthcoming *Catalogue Raisonné* of Stubbs. Without her friendship and her wise (often sceptical) counsel this book would have been an altogether poorer thing.

Finally, infinite thanks are owed to my family: Fanny, Matt, Nick and Spike.

Note on Text

Chapter epigraphs, unless otherwise attributed, are from Ozias Humphry's *Memoir of George Stubbs*. Parts of chapters 31–35 and 51–54 are adapted from passages in three essays by me in Warner, 2004.

Introduction

Drawings and paintings of animals – with or without their human associates – are among the most vigorous and interesting works in all British art. The genre was originally a seventeenth-century Netherlandish import, but by the time its supreme exponent, George Stubbs, was born in 1724, the form had taken root in England. It quickly became a national speciality, like the closely related fashion for paintings of country houses and estates. Such works were commissioned by sporting landowners, who were often prepared to pay handsome prices. In the generation before Stubbs, John Wootton, the London-based sporting painter, was regarded as the highest-paid artist in the country, though not a particularly creditable one: 'a cunning fellow, and has made great interest among the nobility but he is the dirtiest artist I ever saw'.[1]

Animal painters like Wootton were expected to provide portraits of racehorses, hunters and hounds, and from time to time to produce larger-scale sporting scenes set in a landscape. Later, specifically after 1760, and in large part through Stubbs's practice and influence, the scope widened to take in scientific and agricultural illustration, and conversation pieces of families posing with their animals. By this time British animal art had drifted far from its Netherlandish origins and was equally distinct from the work of contemporary *animaliers* in other European countries. It had, in fact, become a highly distinctive, very *visible* and truly national art.

In the hands of Stubbs this work reached an unequalled pitch of greatness, and it brought him huge success. The fee he could attract for a single commission was equivalent to tens of thousands of pounds in today's money, and his pictures graced the walls of neoclassical mansions in virtually every English county.

The fame he enjoyed in his lifetime surprised me as I began work on this biography. I knew Stubbs had been the cynosure of eighteenth-

century horse and dog painters, equally beloved by hard-riding landed sportsmen and rich ladies with their pampered spitzes and spaniels. But the art world in his time viewed animal painting as a low and degraded form. The contempt for Wootton, evident in the remark quoted above, was typical, and it was a prejudice that hardened as the Royal Academy of Arts, with its high-minded, class-conscious view of painting, gained ascendancy in the second half of the century.

Stubbs himself always disliked the Academy, and the sentiment was mutual. After his death, academic art erased him from its collective memory so thoroughly that, only two generations later, a rare Victorian admirer of his would write, 'the name of this eminent artist is familiar to few people at the present day. In some great mansion, the housekeeper will pronounce it and a visitor will catch that unknown monosyllable in the midst of her drawling roll, may glance with admiration at the big picture overhead, but will probably again forget.'[2] This amnesia was profound and long-lasting. For a hundred years and more none of the leading writers on British art, from John Ruskin to Herbert Read, ever mentioned George Stubbs.

His name has recovered all and more of the lustre it once enjoyed but, in the interval, the biographical earth has been left charred and almost barren. Except for one or two isolated documents in his hand, mostly brief and transactional, the documentary sources that a student of his life would hope to consult, the seeds of biography, have been almost entirely lost, consumed or destroyed. Of personal letters, journals, sketchbooks, studio accounts and appointment books, no trace of any kind has been discovered.

These gaps in the record might have been less gaping had the marginalisation of Stubbs not begun before his death. Just two published obituaries followed his funeral in 1806 – a few paragraphs in *The Gentleman's Magazine*, and a rather more substantial three-part appreciation carried by the specialist *Sporting Magazine*. None of the artist's family did anything to halt the slide in his posthumous reputation, let alone to establish a cult of his name. There is not even a memorial to him in the London church where he was a parishioner and vestryman, or in the graveyard where his bodily remains were laid.

Yet one remarkable, and in some ways remarkably detailed, source for Stubbs's life has survived. It is a manuscript memoir written, or rather scribbled, by his admirer, the younger artist Ozias Humphry, an obsessive accumulator of papers and documents about his own career in particular, and the London art scene in general. Without Humphry,

it is unlikely a biography at book length would be feasible at all.

The memoir consists of a manuscript notebook bound in half-calf. On its first (originally blank) page is pasted the obituary of Stubbs scissored from the pages of *The Gentleman's Magazine* in 1806. After some brief notes on the career of Francis Cotes, a minor eighteenth-century artist with no particular connection to Stubbs, another page is left blank before the Stubbs memoir begins.

> These particulars of the life of Mr Stubbs were given to the author of this Memoir by himself and committed from his own relation, – but are much too diffusive and unimportant for the public eye.
>
> Mr Stubbs's merits, however, are so great, his long continued diligence and perseverance, so uncommon, that the author was much amused in hearing the recital and committing it.[3]

These opening words affirm something important: the memoir is, in effect, an authorised life, containing the essence of what Stubbs himself considered to be the important facts of his career.

Humphry covered sixty-four right-hand pages in his own hand with a more or less continuous and chronological narrative. It is a hurriedly written screed, giving the impression of something like a dictation. When the continuous narrative comes to an end it is carefully dated below the last line 'February 3rd 1797', which means that the conversations on which it was based occurred in Stubbs's seventy-third year. On the left-hand pages of the notebook, later additions and glosses have been inserted, keyed to symbols marked in the continuous text. Some of these notes are in a different hand, that of Mary Spencer, who was George Stubbs's companion. She lived with him for half a century and was the mother of his natural child, Richard Spencer Stubbs. Mary did not add her observations until after Stubbs had died, doing so either at the request of Humphry himself, or of Humphry's illegitimate son William Upcott, who was probably the *Gentleman's Magazine* obituarist. As well as these scrappy additions, two fair-copy transcripts of the memoir have survived, made by Upcott, who in 1810 inherited his father's papers. In occasionally significant but not fundamental ways, they seek to 'improve' on the original in phrasing and choice of words, as if to prepare it for publication.[4]

The outstanding importance of this text is easily appreciated, but it is also in a number of ways a flawed and problematic source. There is no reason to doubt its general sincerity, or the overall accuracy of what it says. Many details can be checked against the *Sporting Magazine*

articles published in 1807 and 1808, the first two of which are signed 'T.N.' and the third, simply, 'N'. The obituarist has not been identified and, though he may have had access to the Humphry manuscript, he provides a fair amount of additional information, suggesting he had known Stubbs personally or at least, as he claims, had consulted relations and friends. A variety of other mostly fragmentary sources help to confirm and, with luck, to amplify the story: parish and estate records, dated pictures and prints, and odd references to Stubbs in the letters, journals and memoirs of his contemporaries.

These secondary authorities tend to confirm that the notebook charts the significant peaks of Stubbs's career with reasonable accuracy. The trouble is that it entirely ignores any troughs: the failures, the times of hardship, the personal crises. Indeed, Humphry tells us hardly anything about his subject's inner life. Mary Spencer's annotations are fractionally more revealing, but they are jottings, whose limitations are evident in this reverential synopsis of Stubbs's character:

> [He was] a rare example in the annals of his professional history: in his particular branch of art unequated; in his private life exemplary for honour, honesty, integrity and temperance, his genial beverage being water and his food simple, professed of a firm and manly spirit, met with a heart overflowing with the milk of human kindness, beloved by his friends, feared by his enemies and esteemed by all who knew him.[5]

Through Mary's eyes, this was a man of strict rectitude and thorough worth – a secular saint.

At times, Stubbs liked to portray himself in the same light. In 1781 he made a self-portrait at the age of fifty-seven for his friends the Thorold family, using the technique he perfected of enamel painting 'in large'. This shows him just past the peak of his artistic success and in ascetic, almost monk-like guise.

But, as my research into Stubbs unfolded, new perspectives opened up. I came across numbers of hidden or anomalous facts about his life and career, not all of them easy to square with the hagiographies of Humphry, Mary Spencer, Upcott and 'T.N.'. There were, for instance, a wife and children who had been comprehensively wiped from the record, and a whole circle of friends whose political subversiveness goes unmentioned. And instead of the unshakeable integrity of a 'firm and manly spirit' I found suggestions of apostasy or tergiversation on issues that might fairly be regarded as matters of principle. Most significantly of all, perhaps, I came to see the account Stubbs had given

to Humphry of his own aesthetic, the principles underlying his art, as misleading in ways that must have been deliberate.

In the absence of documents giving access to George Stubbs's mind, little of the psychological background to this is available for analysis. My aim in this book has therefore been to identify the external influences on him, the people, places, animals and ideas that he responded to in the course of a very long life. At times it is impossible to do more than sketch how his work and his life's experience cohere, and elsewhere a degree of guesswork is inevitable. 'Speculation' may be a word of scorn in art history's lexicon, but Stubbs is one of the greatest of British artists, who demands and deserves to have what light there is cast upon him, however shaded or refracted the proximate sources may be.

'Phaethon', mezzotint by Benjamin Green after George Stubbs, c. 1765–6.

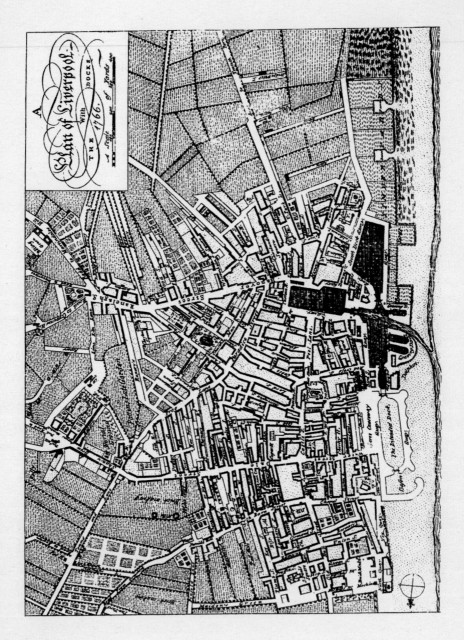

A Plan of Liverpool with the Docks, 1766. Note position of 'Patten's Late Garden'.

I

MINORITY

1724-44

CHAPTER I

Liverpool: a London in Miniature

The well-known Painter of Horses and other Animals, was born at Liverpool, in Lancashire, on 24 August 1724.

The house in which George Stubbs entered the world stood on Dale Street, which was the longest and most important thoroughfare in Liverpool, and formed the spine of its commercial life. The seaport had been slow to fulfil the expectations of its thirteenth-century founder King John. Clinging to the north shore of the Mersey estuary, clustered around a small creek, the Pool, it was isolated from the major trunk roads and had survived quietly on fishing and the coastal trade, and a certain amount of sleepy traffic to Ireland. But by the close of the seventeenth century the pulse of life was quickening. The old airborne scents of bladderwrack, herring, tar, hempen rope, wet canvas and sawn timbers now mingled at the dockside with more exotic smells – cinnamon and coffee, tea and tobacco leaf, wine, brandy, molasses, sperm oil, raw cotton. The triangular 'Guinea trade' – the exchange of shiny Lancashire ironwork for black African slaves, and those slaves for golden American sugar and tobacco – had begun to work its sinister alchemy. It would increase exponentially over the next century, and bring Liverpool undreamed-of wealth.

The port's much more successful rival had always been Chester, with its excellent road links to the Midlands and the South. But the balance of advantage had shifted as Chester's access to the ocean, the River Dee, became increasingly silted up. At the same time maritime warfare with the Dutch, Spanish or French had handed Liverpool an advantage over the great southern and eastern ports of the realm. Liverpool's western station meant that her ships enjoyed better odds in the game of survival against marauding men-of-war.

And Liverpool was modernising. A survey of the port around 1700 had outlined the problem. ''Tis bad riding afloat before the town by reason of the strong tides that run here; therefore ships that ride afloat, ride up the Slyne [the Pool] where there is less tide.' But, like the Dee, the Pool was becoming silted and this prompted the Corporation to take an enlightened and far-reaching decision. They engaged the

engineer Thomas Steers to form a harbour, a rectangular deep-water enclosure at the mouth of the Pool, surrounded by warehouses and with a sea gate giving on to the Mersey. Opened in 1715, Steers's construction was the country's first enclosed dock for civilian use outside London.[1]

Liverpool's main exports were Cheshire salt and cheese, and Lancashire coals and metal manufactures. A ruinous road network had always made it difficult for these to reach the dockside but, once the new dock was built, private investors made navigations of the River Weaver (as far as the salt towns of Nantwich and Winsford) and the Mersey (as far as Warrington and later Manchester), building locks and digging cuts to allow lighters and barges to penetrate deep inland.

The enclosed dock, and the navigations, were an extraordinary success and the town's clear commitment to modernisation attracted ever more trade, wealth and development. As early as 1696 the traveller Celia Fiennes had found Liverpool 'a very rich trading town, the houses of brick and stone built high and even . . . there are an abundance of persons you see very well dressed, and of good fashion, the streets are fair and long, it's London in miniature as ever I saw anything'. By the 1720s Daniel Defoe could warble ecstatically that 'there is no town in England, London excepted, that can equal Liverpool for the fineness of the streets and the Beauty of the Buildings; many of the houses are of Free Stone and compleatly finished; and all the rest (of the new part I mean) of Brick, as handsomely built as London itself'.[2]

But a medieval infrastructure was bending under the weight of the new, money-making superstructure. Migrants were being sucked in at a dizzying rate. In the century after the Civil War the population of Liverpool trebled and trebled again to reach 18,500 by the mid eighteenth century. The Vestry – the assembly which controlled parish affairs – struggled in these new circumstances to carry out their duties, of which by far the most onerous was the alleviation of poverty. The ley, a levy on householders to pay for poor relief, increased almost yearly. In 1681 the total collected for distribution was £40; four decades later it was £1000. In the same period the Poor Law overseers, appointed by the Vestry, increased from two to four, and then eight, by which time the days when individual grants could be listed in the minute book ('a wastcoat and drawers for Garner's lad, 1s.') were over. In 1732, after an experiment in privatisation – 'farming the poor' – had gone disastrously wrong, the newly fashionable (and, by the poor, greatly detested) alternative of a workhouse was built.[3]

4

One of the poor grants earlier approved by the Liverpool Vestry was in October 1694, 'for [the burial of] a child of Robert Stubbs, 3s.4d.' The deceased was a Liverpool-born six-year-old boy. His father Robert was a cobbler, otherwise styled cordwainer, who also apparently kept an inn. Robert's name first appears in the Liverpool records in 1683 when the Corporation paid 'on the King's Return from Holland, to Robt Stubbs for Ale – 12s.', which suggests that the innkeeper had friends in the city government. A year later, the register of St Nicholas church identified Robert's other occupation: '5th of June, baptised, Doraty, daughter of Robert Stubbs, shoemaker'. Despite his useful contacts in the Corporation (in 1692 he again supplied ale, this time worth 17s., 'for the Soldiers') the course of Robert Stubbs's life was clearly a bumpy one, but he continued to keep his Dale Street inn. It was no hole-in-the-wall taproom, but a respectable post house where Nicholas Blundell, diarist and Squire of Little Crosby, drank in 1708, and again in 1712, in the company of his lawyer and friend, John Plumbe, and 'Nicholson a writing master, Mr Taylor of Leverpoole the Watchmaker &c.'. Two years later, when Robert Stubbs died, the parish register gave him the rank of Postmaster. So the former recipient of Poor Relief had ended his life a man of some account in the town.[4]

Liverpool from the Bowling Green, Michael Angelo Rooker, watercolour, 1769 (detail). This view shows the city at about the time of the plan on p. xxviii, which marks the position of the Bowling Green.

5

CHAPTER 2

The Skin Trade

A considerable currier and Leather dresser.

The Stubbs family was to proliferate in Liverpool in the first half of the eighteenth century, but its immediate origins were twenty miles to the east in the town of Warrington, which stood on the border with Cheshire and at the lowest practicable crossing point over the River Mersey. Here, in the reign of Elizabeth I, Henry and Joyce Stubbs had established a currying business – the production of refined leather – on Bridge Street.[1] Their descendants became Warrington's chief curriers with, like Robert Stubbs later in Liverpool, a useful sideline in innkeeping and brewing.[2]

Young Robert seems to have joined a Stubbs migration from Warrington to Liverpool for, at about the same time as he appeared in the rapidly growing seaport, another leather worker, 'Richard Stubbs, currier', also arrived. This hopeful young man had married Elizabeth Ransom at Warrington in 1679, and a year or so later the couple travelled with their baby son, John, westward along the rutted mule track which passed for the Warrington-to-Liverpool road. Richard was probably Robert's elder brother; he was certainly the grandfather of George Stubbs the painter.[3]

Leaving Warrington either because of friction with his Bridge Street relations – the 'Ireland' Stubbses – or in a drive to diversify the currying business, Liverpool now became his home, although he and Elizabeth did not sever all connections with Warrington (at least one of his children, Ireland, was baptised there in May 1685). The family's first known address is Castle Street, at the very centre of town and close to a crumbling old Norman keep. Here Richard and Elizabeth raised a family so large that, by the time their final child was born, in 1707, their progeny were spread out across more than a quarter of a century. The sons, or those who survived childhood, all became curriers.[4]

There are no surviving Stubbs wills from which to judge the success of the enterprise in this period, but it seems to have been no better than modest. By 1708 Richard and Elizabeth had moved to Dale Street where they crammed into a rented four- or five-room house. Rated to

6

pay a ley of just 1s.4d, the value of the property was at the bottom of the scale for householders in Dale Street.[5] Richard Stubbs, as a merchant in an important trade, would have been expected to serve as an alderman, or take some other Corporation or parish post. He never did so, even though holding office would have opened many lucrative business opportunities. The underlying reason may have been political. In the early part of 1696, when the government was expecting a landing by armies in support of the ousted Stuart king, James II, 500 Liverpool citizens joined together to form an association affirming their absolute loyalty to the Dutchman, William III of Orange. Richard Stubbs (unlike Robert the shoemaker) refrained from signing, a strong signal that he was a nonjuror, whose Jacobite sympathies prevented him from swearing loyal oaths to anyone other than King James. Nonjuring was a stance men took on principle, often against their own economic interests, for it automatically disqualified them from almost all public offices.[6]

George Stubbs the painter has sometimes been described as having grown up, as the son of a currier, surrounded by flayed animal corpses, and that this stirred his interest in animal anatomy.[7] This is based on a misconception. Currying was not tanning, and did not involve the slaughter and skinning of animals. Instead, the currier bought his hides already tanned. The town tannery occupied a 'brown-field' site north of Dale Street and east of Cheapside, near which stood two windmills, a pot works and the town ducking stool. The tanned hides were marketed by the tanners at the Leather Hall, Liverpool's leather exchange which, since the formerly royal castle had passed to the Corporation in 1718, had been housed on Derby Square, in the cellar below the castle's great tower. Here local leather was sold alongside specialist imports straight from the quays – shagreen, morocco or cordovan. A high proportion of the customers were shoemakers, glovers, saddlers and curriers.[8]

Leather was a ubiquitous material and one of the great industries of Europe. It has been calculated that in England, in 1770, leather 'contributed over 23 per cent of total value added in industry, only a little less than the 30 per cent contributed by wool'. For the entire century and beyond, it was the durable material of choice for the manufacture of bags, boxes, book covers, buckets, bottles, breeches, buttons, boots and belts; also for shoes, gloves, aprons, hoods, caps, jerkins, chaps, stays, laces, purses, upholstery, harness, whips, saddles, straps, collars, the suspension of carriages and the surface of writing tables.[9]

The currier's niche in this market was specialised, but secure. He produced dressed or luxury leather, that is, sheets of thin, smooth, pliable material, grained, tooled and coloured as necessary, for making the softest gloves and finest court shoes, covering the smartest carriages and surfacing the most beautiful desks. These sheets were created by a process analogous to planing wood. The tanned hide, having been thoroughly soaked in water and scoured, was shaved down, using a distinctively designed currier's knife, to the degree of thinness and delicacy needed. This was the central, repetitive activity of the currier's shop, a highly skilled manual task that required sure hands, exquisitely sharp tools and plenty of mental concentration. The shaved leather pieces were then treated with oils and fats such as dubbin and tallow, to give them strength and pliability, and finished in different ways.

An account of the premises of a typical currier in the Victorian era – a period in which the currying process had hardly changed in 200 years – gives some idea of what the Stubbses' Dale Street premises were like. At street level was the scouring house, with its soaking tubs and scouring slabs. On the floor above was the currying shop itself, a large, light and airy room, in the centre of which were set the 'beams', the flat working surfaces standing on four legs like angled butcher-blocks. On these the hides were laid to be shaved by the currier wielding his knife. Around the walls 'a series of tables, the plane surfaces of which are made from mahogany or marble, are firmly fixed to the floor, near the windows, so that the workmen may have the full benefit of the light. At a short distance from each table, and behind the workman, is a wooden trestle, across which the currier throws each piece of leather after he has worked it on the table in any of the dressing operations.' These operations included rounding, setting, finishing, stoning, starching, graining, waxing, top-sizing and embossing. In the courtyard at the back of the shop, under awnings, were racks for drying the leather.[10]

The currier's office, entered from the street, was a busy space with customers coming and going during the day. The majority were craftsmen such as shoemakers, glovers, bookbinders and saddlers, but the currier also dealt directly with end consumers, in an era when luxury items were generally made to order from materials often picked out by the customers themselves. One of the town's leading lawyers, John Plumbe, kept a pocket diary in which he recorded one such transaction, which surely refers to the Stubbs shop.

> To: Mr Pain to pay the curriour for dressing a hide that Jo: Woods made my book & shoes of, 2s–0d.[11]

In the early 1720s the business, still headed by Richard, appears to have employed his sons John, William, Charles and Samuel. In time Richard's grandsons, too, were apprenticed to the firm and one of those was George, the future painter.[12]

When Richard Stubbs died, in May 1722, he was over seventy, and had run the shop in Liverpool for four decades.[13] Now John, at the age of forty-two, was in charge. He was still unmarried but, within eighteen months of his father's death, he decided to take a wife, marrying Mary Laithwaite at the parish church of Childwall, three miles from Liverpool, on the morning of 10 November 1723. A degree of mystery has previously surrounded the bride, as she is not found in the obvious Liverpool family, that of William Laithwaite, watch-case maker of Chapel Street, Union Street and eventually Edmund Street, round the corner from the Stubbs home.[14] Searches for a possible Mary among William's ménage – in addition to his four children the watch-case maker seems to have been joined in Liverpool by several more Laithwaites from the Lancashire hinterland – remained for a long time disappointing. It is not until the 1723 Marriage Licence of John Stubbs and Mary Laithwaite is taken into account that the problem is solved. This, unlike the marriage register, describes 'Mary Lathway', in the Latin, as 'vidiam', widow. Stubbs's mother was therefore a Laithwaite only by marriage.[15]

But if Mary's maiden name was not Laithwaite, what was it? The marriage licence clearly describes her as being 'of Leverpoole' and the Liverpool parish registers provide a single candidate: Mary Patten who, on 26 November 1717, had married Roger Leatherd at St Nicholas church, Liverpool. Mary was at this date twenty, having been baptised on 23 June 1697.[16] The Pattens were another family from Warrington and in their upper echelons a far more important one than the Stubbses. They were copper smelters with works at Bank Quay, and had extensive salt interests in the Cheshire 'Wiches'. In Liverpool they were prosperous merchants, exporting their Cheshire salt and Warrington manufactures, while importing tobacco, sugar and other goods from the Guinea Trade, using their own 'flats' or barges along the river navigations, or else carts and packhorse trains, to move their merchandise along the inland trade routes. Handling the Liverpool end of their business was Hugh Patten, born in Warrington in 1675 but living now in a house in Old Hall Street. Assessed for the Liverpool Poor Rate at 11s.6d, his home was a substantial property.[17]

Mary, however, can only have been a very poor relation of Hugh. The precise origins of her father, John Patten, are unknown but by the 1700s he was of Dale Street, a neighbour of the Stubbses.[18] He was a market gardener who worked two closes (land enclosed from the old town fields, which had originally been common) on a portion of Frostlake Fields which bordered Frog Lane. This land, rented from the Corporation, amounted to two acres and two roods (two and a half acres) and had a good situation near one of Liverpool's main fresh-water sources, the Fall Well. John Patten's Dale Street dwelling-house, like Richard Stubbs's, was not large, with five rooms in total, and he rented a warehouse nearby, also of no great size. Following his death, in February 1710, an inventory was drawn up of his house's contents, showing the total value of his movable property to have been a little over £15.[19]

The inventory eloquently evokes the modesty of John Patten's circumstances. The most valuable items were his 'too milke Cowes, £4-0-0'. The collection of movable goods – sturdy cottage furniture, ironwork, pewter and brass, a clock and looking-glass, feather beds and other bedclothes, rugs and curtains, creamware and earthenware – amounted to £12.1s.10d. Almost as much, £10, was owed to the deceased 'in debts sperate and desperate', which suggests a generous or gullible nature. His 'wearing apparel' was valued at one pound, and there was hardly anything else:

Item, in odd implimentes, trash and trumpery . . . 1s.3d.

Mary, born in 1697, was the third child and second daughter of John Patten and his wife Elizabeth. Roger Laithwaite whom she married as her first husband, seven years after her father's death, is harder to place than his bride, for his marriage at the church of St Nicholas is his only appearance in the Liverpool parish records. There were no children of the marriage and Roger was dead by 1723, since his widow became Mrs John Stubbs in that year at the age of twenty-eight. His death is not recorded, and it was quite possibly at sea.

From public records the historian can piece together the family's names, their births, marriages and deaths, the state of their finances and other details, but these are only skeletal remains, from which the flesh has been stripped. The truth is that very little of substance is known about either of Stubbs's parents. The one extended source, the Humphry manuscript, which might have captured their personalities for later generations, is almost silent on the subject of Mary. It is a little

more informative about Stubbs's father, the master currier, who appears as a man held in universal respect and affection. The word used to describe him is 'considerable' and yet, in the light of his complete absence from Corporation records, it cannot be said that John Stubbs made any greater mark on the Liverpool of his day than his father had in his. The sense is that John was driven not by worldly ambition and the pursuit of wealth, but by the prime virtues of hard work and integrity, setting no more store by 'trash and trumpery' than his late father-in-law John Patten. In this respect his painter son grew up to be very like him.

A currier shaving a hide.

CHAPTER 3
Honest John

His father was a man of so much candour moderation and integrity
that he was known amongst his neighbours and friends by the
enviable appellation of 'Honest John Stubbs'.

George Stubbs was born in August 1724, a time of storming weather.
We know from Squire Blundell's *Great Diurnall* that throughout that
summer the country around Liverpool had suffered an almost daily
battering from high winds, torrential rain, thunder and lightning. The
hay was sodden, the corn was pitifully thin and difficult to harvest,
apples were stripped unripe from the trees. Wagons hauled by teams of
carthorses overturned, dumping their loads in the mud and breaking
the draught animals' legs. And just as horses and produce were
destroyed on land, so ships were lost at sea. Men of Liverpool drowned,
cargoes went down and prices went up. At the end of the following
year, which was even wetter, Blundell wrote 'the Rodes being so very
bad in Summer people could not get home their provisions of coles, so
were forced to fetch them on Hors-Backs . . . and a Hors load of coles
was sold at Leverpoole for half a crown which formerly might have
been bought there for seven pence'. On the more positive side, the
increased moisture resulted in a fine harvest in August 1724 of Squire
Blundell's juiciest ever plums.[1]

Blundell's estate was nine miles from Liverpool and his rides into
town, which the diary chronicles once or twice a week, in all seasons
and any weather, demonstrate the way in which urban Liverpool was
interrelated not only with the sea on one side but with the surrounding
countryside on the other. Blundell himself was beguiled by ships and
cargoes. He often visited the port, viewing Steers's dock while it was
under construction, being entertained on board ship, buying casks of
'whit port'. But this interest in the docks and ships was a by-product of
his business in the town itself. He visited shops and offices, and
socialised with professional men and tradespeople in the pubs and
coffee houses, including Robert Stubbs's place in Dale Street.

For all this, Blundell's main economic preoccupations were not with
the sea, or the town, but with marling his land, modernising his

windmill, tending his plum trees and keeping on good terms with his tenants. The countryside can afford, in this way, to be more introspective or self-sufficient than the town. The whole point of an eighteenth-century town was that it was like a cell nucleus, drawing to itself nutrients (food, finance, people) from the cytoplasm of the lands and waters around it. Nicholas Blundell probably put more into the town of Liverpool than he got out of it.

So Liverpool people, though increasingly urbanised, did not live apart from the countryside, any more than from the sea. They were not like nineteenth-century East End Londoners, famed for not knowing the nature of bacon, milk and wool. Their town houses had yard plots at the rear where chickens, geese, pigeons and pigs were raised among the cabbage patches and bean rows. As population density increased in the course of the eighteenth century, pressure for more living space ate into these cultivated yards. But to a child growing up in Liverpool in the 1720s and 1730s, plants and animals of every kind were always close at hand.

In 1734 Mary Stubbs was expecting her fourth child, Anne, having already given birth to daughters Mary and Jane. Meanwhile, as the Stubbs family increased, so did Liverpool's general population, and its wealth. The expansion was good for business and John Stubbs's trade was now flourishing to the extent that he moved into larger premises among the new developments that were rising on the northern perimeter of the city – Edmund, Ormond, Bicksteth, Lumber and George Streets. Branching to the east off Old Hall Street, and built on open fields, these streets were very much 'made in Liverpool'. Their bricks were fired from local clay dug on the spot. The slate roofs and sandstone lintels, window heads, door cases and parapets were quarried locally. The window glass was made at Poole's glassworks at the corner of Argyle and Paradise Streets, and the sash cords obtained from the Ropeyard between Dale Street and Frog Lane. Other materials may have come from further afield: iron nails from Wigan, copper hinges from Warrington, timber and slate from north Wales. The area was watered by wooden pipes bored from the trunks of beech trees and sunk two or three feet under the ground.[2]

John took out a lease on two adjoining houses at the east end of Ormond Street, on the corner of Lumber Street. The premises were both for dwelling and business, and would be rated in 1743 at the high value of £9. They were flanked on the west side by an arched gateway and passage leading into a rear courtyard, which was later known as

Chapel Yard, having been chosen in 1746 as the site of Liverpool's second (and initially secret) 'Romish' chapel after the first, round the corner in Edmund Street, had been destroyed by rioters. The earliest account of the second chapel stresses that the residents of the houses protecting the yard were either definitely Catholic, or sympathetic to the old religion – an indication, it would seem, of the same orientation that had caused Richard Stubbs in 1696 to refuse to join the Loyal Association.[3]

In this district George Stubbs grew up and began his education. But what kind of education was it? He confided nothing to Ozias Humphry about his schooling, preferring to make out that, scorning instruction, he had learned all by himself 'from nature'. Even in terms of his education as an artist this is questionable: of Stubbs's general education it will not do at all. All the evidence is that John Stubbs prized above everything a life of hard work and integrity and that he knew the foundations of such a life were best laid by the strongest available teaching. So, after learning his letters and numbers at home, George is likely to have been sent first to a local dame school, then to a more serious academic establishment, which could have taught him until he was about fourteen. There is little surviving information about such schools in Liverpool. The Free Grammar School, later known as the Bluecoats Hospital, was a charity school with places for just sixty of the poorest children in Liverpool. As the Stubbs family was not a charity case, they would have followed other tradespeople and merchants in patronising small privately-run academies, which taught, as a core curriculum, the most important skills (with a view to the commercial future) of writing and arithmetic. Beyond that, the academic work would follow the bent of the schoolmaster himself.

An interesting possibility is that Stubbs attended school at Kirkdale, which was two or three miles outside Liverpool and within easy daily reach from his home. Here was a mathematical and commercial academy run by the Glasgow University graduate John Holt (1704–72). Holt had been a dissenting minister at Kendal and was a remarkable educator, despite numerous eccentricities. The date of the Kirkdale school's foundation is unknown, but the master is described as having been 'long employed' in it by the 1750s, when he was invited to take up a post at the Warrington Academy. His new job was prestigious and came as a result of recommendations from merchants in Liverpool and Manchester whose offspring had passed through his hands at Kirkdale. These mentioned his 'great abilities [and] very

amiable character' in addition to his considerable experience as a teacher.

With men like Joseph Priestley on the staff, the Warrington Academy was one of a new breed of dissenters' universities, where academic standards were high. Holt could not have been employed there without being a progressive intellectual of distinction. The Academy's scientific instruments were donated by him from his own personal laboratory, to be used by Priestley in some of his seminal electrical experiments. Holt was a strict rationalist, who insisted on absolute precision in the use of language. Apart from mathematics, he also taught logic, metaphysics, natural philosophy (covered now by the word science) and history. Although a stickler for accuracy in experiment and argument, he seems to have been too mild-mannered to be an effective disciplinarian. But given a gifted, perceptive and committed pupil he was well able to transmit the fundamental attitudes of the Enlightenment: independence of thought; the spirit of enquiry; respect for close observation and experiment from nature; a grasp of logic, precision and proportion; rejection of ideas that could not be supported by reason; taking nothing for granted. These were all important aspects of George Stubbs's mature mind, but it is simply not known where he acquired them.[4]

The house occupied by the Stubbs family from c. 1735–1750, painted in 1844. The view is down Ormond Street from Lumber (Lombard) Street. The next-door building is the partly-demolished currier's shop, with its arched gateway into Chapel Yard.

CHAPTER 4
Drawing Up

He began his little studies in Anatomy.

Looking back from the perspective of old age, Stubbs would stress that his powers of observation derived from an early passion for drawing, which he claimed had already attracted adult attention when he was only five. As his skill as a draughtsman developed, he naturally looked around for other children sharing the same interest, and was lucky enough to find two in his immediate neighbourhood: William Caddick and Richard Wright. Both these older boys grew up to be professional artists. William Caddick was 'William son of William Chadock, shoemaker, born 9 April 1719', his father's profession placing the family firmly in the same social and professional orbit as John Stubbs. A shoemaker would also have been among the currier's prime customers. Caddick, in the course of a long life, became Liverpool's premier resident portrait painter, a business continued by his sons William and Richard, until the latter ceased to practise in the 1820s. William Caddick was a competent if dull portraitist, who delivered what his bourgeois clients required: uncomplicated, inanimate images suggestive of solidity, sobriety and reliability.[1]

Richard Wright became a very different artist from either Caddick or Stubbs – the only one of the three to take up the challenge of Liverpool's compelling and ever-present subject, the sea. Born about 1721, he was the son of a bookbinder with premises 'off Old Hall Street', meaning that his father was another of John Stubbs's customers. Wright was later to spend some time at sea, possibly as a sailor, and he undoubtedly went to the Isle of Man for a period. He also painted on shipboard. The title of the first picture he exhibited in London in 1762 was *A View of the Storm when the Queen was on her passage to England, painted from a sketch drawn on board the Fubbes yacht*.[2]

It is not recorded what sort of subjects the three boy artists sketched in Liverpool, apart from the significant fact that young Stubbs had a fascination for drawing up anatomical specimens. In his talks with Ozias Humphry, the elderly Stubbs made a point of emphasising that

16

this subject absorbed him from a very young age, and he even provided the name of the man who introduced him to it.

> It is said that soon after his father removed into Ormond Street, when he was scarcely eight years old he began his little studies in anatomy, that he had Bones and prepared subjects dissected and lent to him by Doctor Holt a benevolent neighbour, who wished to amuse and promote his improvement.[3]

It is tempting to identify this 'Doctor Holt' with John Holt of Kirkdale, who might easily have been locally styled 'Doctor'. But this is dubious. John Holt may have been benevolent, but he was no neighbour of the Stubbses, and in any case there is a better candidate in Dr Ralph Holt of nearby Red Cross Street.[4]

Ralph Holt was a surgeon, a man midwife and a highly colourful figure in his own right, as a news story from a couple of decades later confirms.

> Last week was sent from hence under a proper guard and committed to Lancaster, (the second time) the noted Tom Radcliffe, the Pipe-maker and Bruiser. He was committed to Lancaster August 12 last, for preventing three of the King's officers of excise from doing their duty, whom he knocked down and abused. He broke jail at Lancaster soon after his first commitment and was retaken by some of the officers of excise, and Dr Holt, armed, after a scuffle in which Radcliffe was desperately wounded.[5]

Holt's combative character is also illustrated by the style in which he defended the professional conduct of his apprentice John Wareing, who was accused in 1766 of bungling the delivery of a child, resulting in the newborn's death. As Wareing's master, Holt took the criticism as a personal insult and forced the baby's stricken father into publishing a grovelling apology in the local paper, *Williamson's Advertiser*. There was clearly another side to Holt's benevolence, but the story also reveals the man's strong commitment to a pupil.[6]

Anatomy was then an advanced taste and Stubbs's fascination with it might be compared with a boy of today absorbed in the study of astrophysics or the genome. The peculiarity must have intrigued adults and we are told that John Stubbs, for one, was charmed by his son's scientific interests, as well as his draughtsmanship. On the other hand, like any convention-hugging parent, he did not regard drawing and painting, however cleverly done, as the basis for a sound career. When Stubbs told his father he intended to be a professional artist,

his father jestingly told him that he would advise him to learn the fiddle, and by joining a stroling [sic] company of players or puppet show men, he might paint their scenes and with his instrument perhaps get bread, and cheese, so low were the Arts at that time in England, in the general estimation.[7]

John Stubbs's view of painting as nothing but a mountebank activity was quite conventional. Many artists were itinerant 'limners', hawking their talents like tinkers from town to town. Such a painter is described in Oliver Goldsmith's *The Vicar of Wakefield* (a novel drenched in neurosis about genteel poverty) as 'a limner who travelled the country, and took likenesses for fifteen shillings a head'.[8] And at a time when, as the Liverpool print seller, interior decorator and antiquarian Matthew Gregson would remember, 'a print of 2s. value could not find a purchaser in Liverpool nor was there a painting worth three pounds', this cannot have looked to a caring parent like a profitable line of work.[9]

So John's point of view carried weight. Although the early eighteenth century was a time of peace and rampant economic growth, there is a strong vein of financial insecurity running through the entire culture, but the lower middle class were especially nervous. Experiences such as the investment fiasco of the South Sea Bubble in the 1720s had left them deeply prejudiced against all forms of moneymaking other than well-founded trade in solid goods. To have no merchandise but pictures, no wealth but colours and no skill but mimicry, was seen as courting a rootless and hand-to-mouth existence, likely to end in a man begging for poor relief or, worse, imprisoned for debt.[10]

The growing eighteenth-century habit of novel-reading provided many cautionary examples. Financial anxiety, with the interlinked theme of sexual virtue threatened by depravity, underlay many novels in the first age of English fiction, with plots of comfortable fortunes gradually eaten away through foolishness, profligacy or greed, lost at the turn of a card, or picked clean by artful thieves and conmen. The overt subject of *The Vicar of Wakefield* is the debt trap, the process by which a single foolish decision can pitch a respectable family into the vortex of bankruptcy, poverty and abjection. This intimation of the hovering spectre of poverty was the collective fear, the master neurosis, of the entire 'middling sort' of English people. It was present in the streets they walked, in the air they breathed, and, even in boom-town Liverpool, it was running out of control.

So, rather than let his son prepare for a rootless profession, with

hardly any apparent market, John Stubbs insisted that George follow him into the currier's shop. There is a tradition that 'being of rather a delicate constitution' he did not learn the manual side of the trade, being employed instead with bookkeeping. Since physical delicacy is the last quality ascribable to the adult George Stubbs, this reads like the early nineteenth century pushing him into the mould of a prototype romantic artist: aetiolated, sensitive and cerebral. Yet Stubbs's schooling had undoubtedly made him literate, numerate and able to write with a fluent hand. At some point he also learned to keep accurate double-entry accounts. So it is quite likely that, having acquired the rudiments of the trade's manual skills, he was later assigned to the currier's writing desk.[11]

It is easy to see how this task must have infuriated someone as ambitious, original and single-minded as George Stubbs and, though he bowed to his father's will, he continued to badger John to let him become an artist. John for his part obdurately opposed the idea 'by every means in his power'.

But in 1741 John Stubbs fell gravely ill. Knowing that the time of his influence over events had almost run its course, he suddenly changed his mind about George's artistic ambitions, and gave them his qualified consent. The proviso he made was characteristic.

> He recommended him to enquire for some eminent character in the Arts to instruct him, being willing to allow him any expence that was in his power to afford, as he had always been of the opinion that to excel in the profession was difficult & required every aid; & that with less than excellence a competent income was hardly to be hoped for . . .[12]

George, knowing that his parent was dying, assured John that he would find such a master.

A deathbed undertaking to a loved and loving parent is a serious matter but George, as we shall see, would fail to keep his promise in full. There is no sense of any retrospective guilt about this, and good reason to believe Stubbs felt none at the time. He made a point of describing his young self as a passionately loved child, one 'who being an only son was fondly caressed and greatly entrusted for his years'. This is illustrated by a laborious anecdote of how, as a young boy, he once met

> several of his father's workmen at the half-mile house near Liverpool, enjoying themselves at a holiday [race] meeting; they tempted him by little

19

and little, tho' a child, to sip so often from various glasses, that he became enlivened, and told them, that in addition to what they had already taken, they might go on with more liquor, as he would be answerable to the amount of half a guinea, which they accordingly availed themselves of. When his father was informed of the circumstance, without enquiring minutely into the particulars of this festivity, he went to the house and asked if his son had discharged the reckoning. They said he had, but had he entirely? For if he had not, he himself would pay and from that moment never mentioned a word of it to his Son.[13]

Always hard-working, sober and well-balanced as an adult, George presents himself here – at the very outset of the account given to Humphry – as a Prodigal Son. The tale is overtly intended to speak particularly of John Stubbs's love for George, yet it also resonates in a way that illuminates the character of the whole family.

As a reworking of the New Testament parable of the Prodigal Son Stubbs's anecdote carries a clear message of dissipation and sin followed by forgiveness and redemption which, in religious terms, is a distinctly Catholic one. The problem of Stubbs and religion will come up again in this narrative but, beyond the fact that his parents had married and baptised their children in the established church, nothing is known for certain of any religious influences in his childhood and youth. The family were almost certainly not practising papists, yet earlier hints of a nonjuring tradition, and of papist sympathies in the family, speak of sentiments that might have amounted to crypto-Catholicism. This reminiscence by Stubbs of himself in the Prodigal's role points strikingly in the same direction.[14]

On 16 August 1741 John Stubbs died. It was a few days before his son's seventeenth birthday and George, while mourning the loss, now saw the future opening at last in front of him. Confident of his own talent, and emboldened by parental permission, he embarked on the only career he had ever wanted to follow.[15]

CHAPTER 5

Winstanley of Warrington

Our young Artist therefore . . . sought and found an Instructor in
compliance with his Father's advice.

Knowing that uncles and cousins were plentifully available to keep the
currying business going, and with his mother's support, the would-be
artist immediately set about looking for a master according to his
father's wishes. Settling on Hamlet Winstanley, a painter and etcher
who was one of the few artists of repute in south-west Lancashire, he
made an obvious, though not a very happy, choice.

Born in 1694, Hamlet was the son of William Winstanley, a
tradesman of Warrington. But the Shakespearean christening of his
eldest son reveals the father's mind, which took a cultivated view of the
arts. Hamlet had been educated at the Boteler Free Grammar School,
run by a highly rated educator, Samuel Shaw, Rector of Warrington.
Meanwhile another local clergyman, John Finch, had taken an interest
in young Hamlet's precocious skill at drawing. Finch, Rector of
Warrington's wealthy adjoining parish of Winwick, was an aristocratic
priest whose brother was Earl of Nottingham. With his own collection
of oil paintings (including some by Sir Godfrey Kneller, the nation's
premier portrait painter), and widespread contacts among landowners
and the wealthier middle class, Finch was in an excellent position to
help the young artist.

In 1718, when Hamlet was twenty-four, Finch arranged for him to
become a pupil-assistant at the London workshop of the 'arrogant,
methodical and efficient' Kneller. In his three years' service, the young
Lancastrian grew so fond of his master that, when Kneller died in 1723,
Winstanley is said to have received letters of condolence. Residence in
London also enabled him to forge useful connections in the
metropolitan art world, and he attended the popular life class at the
nearby Great Queen Street academy of art, which had been founded by
Kneller and others in 1711.[1]

After three years he returned to Warrington, a practised exponent of
Kneller's style, and was immediately considered good enough to attract
commissions. His big chance came with the invitation to make family

portraits for thirty-one-year-old Sir Edward Stanley, a wealthy baronet who lived at Preston and was heir to his cousin, the childless tenth Earl of Derby.[2] Winstanley did half-length portraits of Sir Edward and Lady Stanley, and also painted a large family piece of the couple with their eight children.

A further boost to the artist's career came when Sir Edward recommended him to his cousin the tenth Earl. This nobleman was an old soldier who twenty years earlier had inherited the title and estates from his brother. The Earls of Derby occupied a position of towering importance in the north-west of England; being the hereditary proconsuls of Lancashire, their enormous wealth made them the supreme patrons of the region. As the leaders of Lancashire society it was incumbent on them to cut a dash and the Earl had for some years been modernising his principal house, Knowsley Hall, near Ormskirk, including the building of a new Palladian wing and a classical colonnade. Now, at just the time that Winstanley breezed back from his Knellerian finishing school, the Earl had decided that his newly renovated hall should be graced by an important, and very expensive, art collection.[3]

The foundation of this was to be old master works, either bought in London, or directly imported from abroad. The accent was on the Italians of the sixteenth and seventeenth centuries, although the Flemish, Dutch and French schools were by no means ignored. Canvases by fashionable contemporary Italian painters such as Giovanni Paolo Pannini were also acquired, as was classical marble statuary, and new family portraits and up-to-date topographical views of the Derby lands were commissioned as well. Finally, copies were ordered of 'capital' works from rival English and foreign collections, while the best pictures already in the collection were themselves replicated for distribution to relatives and friends. Among the many involved in this ferment of artistic activity, Winstanley quickly became Lord Derby's principal copyist and landscape painter at Knowsley and, in time, his chief picture-buying agent.[4]

In the summer of 1723 Lord Derby offered to finance Winstanley on a trip to Italy, where he would sharpen his artistic taste and buy or copy paintings for the art collection. He set off, carrying in his luggage a bolt of the best black English broadcloth as a present for 'a certain cardinal at Rome . . . with a prospect to introduce Mr Winstanley into what favours he had occasion for, to view all the principle paintings, statues and curiositys in Rome and to copy some curious pictures (that could

not be purchased for money) that Lord Derby had a desire of'.[5]

Winstanley's journey, on which he was accompanied by his brother, was an outstanding success. The young men looked everywhere, viewed everything, sketched what they liked best and made purchases for Knowsley. Winstanley also busied himself making replicas in oils for his patron. He copied, for example, 'a fine Aurora by Guido', a ceiling fresco over which he took a good deal of trouble for several months.[6] He also took on an enormous (almost ten-foot-long) canvas after another ceiling, the *Triumph of Bacchus over Ariadne* by Annibale Caracci in the Farnese Palace.

Winstanley's work for Lord Derby continued in the same vein after his return. He frequently bid for works in the London salerooms, sometimes as the Earl's agent, sometimes speculatively putting up his own cash. The latter seems to have been the case with his star buy for Knowsley Hall, Rembrandt's *Belshazzar's Feast*. Meanwhile he had continued to turn out replicas to order, going for example in 1727 to Chatsworth to copy the Duke of Devonshire's *Manlius Curius Dentatus* by Ciro Ferri.[7] He also carried out landscapes in the style of Tillemans and, most significantly of all, made etchings of nineteen of the collection's capital works. These were published as a book, *The Knowsley Gallery,* in April 1730, under a long-winded and obsequious Latin dedication from Winstanley to the Earl. This volume is one of the first in a soon to be very popular genre of large-format books illustrating country house collections, and its bold, fluent etching shows off Winstanley the artist to great advantage. Although the edition was of only a hundred copies, it must have greatly boosted his name locally.

The posthumous reputation of Winstanley has suffered from the sneers of William Hogarth, George Vertue and Horace Walpole. Vertue's biographical notes on English artists convey the impression that the Warrington man was an indifferent and lazy portraitist, painting only the faces of his sitters, which he then cut out and posted to a specialist drapery painter in London, the Dutchman Joseph Van Aken, who had an almost Van Dyckian sensitivity to the fall of light on rich fabrics. Van Aken is said to have pasted Winstanley's 'masks' on to a stretched canvas before completing the rest of the figure and the background composition. The finished work was then sent back to the face painter who, in return for Van Aken's fee, was allowed to claim the whole portrait as his own. Vertue, a printmaker who, like Winstanley, had attended Great Queen Street's life class, remarks in mock admiration that the procedure was 'quite new and

extraordinary'. The truth is that it was common for artists to call in specialists. John Wootton, an acknowledged master of horse painting and landscape, had been working with many top painters including Kneller and Hogarth, while Van Aken's services were used by all the senior London portraitists, including Joseph Highmore, Allan Ramsay and Reynolds's master Thomas Hudson. In fact his contribution to the art of his time was so great that painting in the 1730s and 1740s has been described as the Age of Van Aken.[8]

Winstanley's production of portrait 'masks', and the postal collaboration with Van Aken, unnatural though it seems in today's terms, was partly a consequence of geography and the poor state of roads. It was expensive, tedious and risky to send large canvases to London either by land carrier or sea packet, while a face-sized oval of canvas could conveniently, quickly and safely be sent by mail coach. But, just as importantly, the whole procedure could be justified by a well-known Knellerian principle absorbed by Winstanley at Great Queen Street. It is mentioned in a letter from Alexander Pope to his friend Lady Mary Wortley Montagu, which concerns the portrait of her in Turkish headdress that Pope himself had commissioned from Kneller. Pope writes that the painter

> thinks it absolutely necessary to draw the face first, which he said can never be set right on the figure if the Drapery & Posture be finishd before. To give you as little trouble as possible he proposes to draw your face with Crayons, and finish it up at your own house in a morning; from whence he will transfer it to canvas so that you need not go to sit at his house. This I must observe is a manner in which they [the artists] seldom draw any but Crowned Heads; and I observe it with a secret pride and pleasure.

Pope's last sentence was intended to flatter Lady Mary: the procedure was certainly more common than he says it was.[9]

That Winstanley's portrait style is a debased or mechanical form of Kneller's is easily seen. Kneller himself could be, when he extended himself, a most subtle face painter. But his workshop operated on an almost industrial scale, producing great numbers of portraits to off-the-shelf designs – straight-backed figures half turned to left or right, their heads looking back with a pallid regard for the viewer. As David Piper has pointed out, this was as much a matter of consumer demand as of an overflowing order book: the Augustan temper was culturally static and reliant on rules for all social occasions. According to Pope in *The Dunciad*, this was the apotheosis of dullness. Satires by him and his

friend Swift repeatedly attacked the numbing cultural conformity of the times.

In this respect Winstanley was no rebel, nor could he afford to be. He soon seems to have abandoned engraving and confined himself to portraiture in the Knellerian style, except when Lord Derby required landscapes and replicas. His faces are highly uniform and static. Framed by the hair or wig, their features are stolid and expressionless, done always in such a way as to emphasise the oval, an effect reinforced by a fondness for a painted oval surround. Yet Winstanley was regarded as being at least the equal in competence to the better provincial portraitists active in the 1720s and 1730s – including the expatriate Frenchman Jacques Parmentier who, in Yorkshire, enjoyed a comparable reputation to that of Winstanley in Lancashire. Both artists found patronage within the network of northern gentry, men bound together by common regional economic interests and webs of marital alliances, who lived at such a distance from London that their ideas about art lagged a comfortable generation behind the London fancy. Parmentier captured the likenesses of Yorkshire dignitaries such as Marmaduke Fothergill, Ralph Thoresby and the Sykes family, just as Winstanley painted the upper echelons of south Lancashire society. Some of the latter would become important contacts for the young George Stubbs.[10]

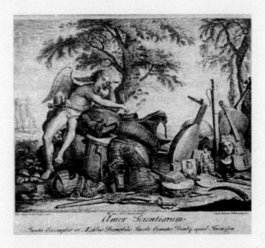

Amor Scientiarum, Hamlet Winstanley's etching of the 'Van Dyck' painting at Knowsley Hall which Stubbs hoped to copy.

25

CHAPTER 6
Knowsley

*He proposed to engage young Stubbs to copy all the pictures of
that Collection.*

In a lively, youthful self-portrait painted for Lord Derby, Winstanley
shows himself as a genial turban-capped fellow, confidently brand-
ishing his palette and brush in front of a large canvas, while rocking
back on his stool and tilting his head to look behind him, as if
welcoming a visitor to his studio. A second self-portrait, a bust-length
miniature datable to around 1750, allows us to glimpse him at about
fifty, only a little older than he was when Stubbs knew him, jowlier
than before, and with high-coloured cheeks. His eyes are shrewder but
retain their kindly look. This impression of benevolence contrasts
markedly with the character Stubbs would later give him. It seems there
was much bad temper in their relationship, and a most stubborn refusal
by both to bend to the other's will.[1]

Stubbs had been given the specific task of helping his master copy the
works at Knowsley Hall, after Winstanley set him a test of making

> a study of a picture which he himself had painted from one of the
> Collection of the Earl of Derby at Knowsley Hall in Lancashire which
> satisfied the preceptor so much that he proposed to engage young Stubbs
> to copy all the pictures of that Collection and to work for him
> continually; and as an encouragement, beside affording him instruction,
> proposed to allow him, tho' not 16 [sic] years of age, at a rate of a shilling
> a day for pocket money.[2]

Did Stubbs sign on, in a formal sense, as Winstanley's apprentice? The
ancient system of apprenticeship was enforced by town guilds, to
produce future generations of craftsmen under strictly controlled
conditions. When a boy was taken on he signed indentures binding him
to the master and his family paid over a premium which, in the case of
'higher' trades such as goldsmithing or watchmaking, could be a
substantial sum, even as much as £300. Under such indentures
Winstanley, as Stubbs's master, would have become legally responsible
for the young man's board, lodging, training and welfare over a
specified number of years, at least three and no more than seven.

When Humphry declares that Winstanley 'proposed to engage young Stubbs to copy all the pictures of that Collection and to work for him continually', the reader's first thought is that this was not an apprenticeship at all, and that Stubbs had simply been offered a job. This would have been possible because, with his studio established on an important nobleman's estate, Winstanley was under no obligation to conform to guild regulations, either in Warrington or Liverpool. On the other hand, though Stubbs may have had a high opinion of his own drawing skills, he knew little about painting, and nothing at all about old masters – those at Knowsley must have been the first he had ever seen.

In fact, what we know of the Knowsley arrangement points strongly to a formal apprenticeship rather than a journeyman engagement. Most important is the mention of 'instruction' for, although apprentices had to work, and to work hard, they were unquestionably there principally to learn all the craft mysteries that their master could teach them: this was fundamental to the system. Almost as indicative is the term 'pocket money'. The apprentice, unlike the journeyman, could expect no wages: training, with board and lodging, was all he got in return for his labour though, if he was lucky, he would receive small amounts of spending money. In Stubbs's case, a shilling a day must be judged an exceptionally generous handout, but Winstanley was no fool. He had had apprentices at Knowsley before – the Liverpool artist Henry Pickering for one – and his experience had told him Stubbs, once trained, would be a particularly valuable and useful prospect, worth tempting with a juicy sweetener. Years later, Stubbs's own distant but clear recollection of the arrangement was that Winstanley had offered him unusually liberal terms which, as well as this pocket money, included the run of Knowsley and the privilege of making studies of any pictures he chose.[3]

Meanwhile the tenth Earl of Derby, who began the collection, had been succeeded by his heir, Winstanley's original patron Edward Stanley of Preston. Most of the other artists involved at Knowsley had moved on – Tillemans was dead, Wootton was working as a sporting and animal painter, Arthur Devis had become a London-based specialist in conversation pieces and Henry Pickering was in Italy. Only Winstanley remained ensconced, now it seems with plenary authority to decide which of the Derby paintings were to be copied and by whom.

It was on this very question that the quarrel with his new pupil turned. If Humphry is to be believed,

our young artist desired for his first Essay that he might copy the celebrated Cupid by Vandyke in a state of adolescence; considering what course he should undertake surrounded by emblems of several professions, such as the symbols of Music, Painting, Architecture, War &c &c which were all painted by Snyders with his utmost ability.

To this choice Mr Winstanly objected, as it was a picture he determined to study himself.[4]

The theme of this composition, a youth mulling over his choice of career, would have been not inappropriate under the circumstances. But, as Winstanley must have pointed out with some asperity, Stubbs's technique cannot just yet have been equal to Van Dyck's.

Swallowing his pride, the student changed tack. Something from a highly fashionable, near-contemporary Italian artist, 'a Composition of the Ruins of Rome by Giovanni Paolo Pannini', had caught his attention. Knowsley, in fact, had two Panninis on this theme. One, which was to be found in Lady Derby's dressing room, showed the remains of a semicircular building in which a group of homeless men are engaged in building a fire, watched by the centrally placed figure of a white horse. The second, a larger, more complex canvas in 'Madame J. Stanley's drawing room', showed the Justinian general Belisarius, old, blind and destitute, begging for bread among ruins, with a dog by his side. Either of these paintings might have provided stimulus to Stubbs's imagination: the first with its dramatic role for a white horse, the second representing a possible, if impertinent, riposte to Winstanley, with its message that, however great, those in authority can so easily slip into senescence and beggary.[5]

Whichever Pannini it was that Stubbs picked out, the master again said no and Stubbs was outraged. 'Our youth told [Winstanley] then he might copy *all* if he would, for as he found he could not depend upon his word, or his engagement, he would have nothing further to do with him.'

With that, he packed his bags and returned to Ormond Street. He had germinated what would become a lifelong prejudice against any unthinking reliance on the word, and the example, of other men.

CHAPTER 7

Self Help

From this period, without seeking assistance from anyone, he proceeded unassisted to make all his studies after nature, intending by everything he did to qualify himself for painting Rural, Pastoral and familiar subjects in History as well as portraiture. — In the course of study he continued, till he was near twenty years of age at the expence of his Mother.

The story of the teenage Stubbs walking out on Hamlet Winstanley, and turning his back on the treasures of Knowsley, is told with relish in the Humphry memoir. Stubbs wanted posterity to believe that he had never needed a teacher and would certainly not take orders from a dunce like Winstanley. But was this strictly true? A reader of the Humphry manuscript might easily suppose Stubbs's formal pupillage to have been over in no time: a couple of days or even a single afternoon. But, after the Van Dyck had been placed out of bounds, Stubbs is found 'pausing and considering the refusal', a process which surely took rather longer than he implied to Ozias Humphry. And if this is so, Stubbs must have absorbed much more from Winstanley, and from his residence at Knowsley, than he later wanted us to believe.

Stubborn, prickly and liable to nurse a grudge though he may have been, Stubbs was not impetuous, and he knew he had much to learn about art and the history of art. Liverpool had no public gallery in which an aspiring artist could study great works, and no public library in which he could read about or see prints of them. The town's first secular library, the Lyceum, had not yet developed from its origins in literary gatherings at the Merchants' coffee house, the noted Subscription Library was not founded until 1758 and the first attempts at a Liverpool society for the promotion and study of visual art began only in 1769. It is, of course, likely that Stubbs had access to books owned by friends such as his anatomical patron Dr Ralph Holt. But judging by the legacies mentioned in Holt's will, his library of mostly medical texts was small enough to be contained in a single bookcase. Even the aggregate of books owned by the literate merchants and professional men in Liverpool, supposing Stubbs could have had access

to them all, must have amounted to a lesser resource than the large and eclectic library at Knowsley Hall, with its rare and expensive prints, and illustrated volumes.[1]

Knowsley's books alone would have offered an enquiring youth rare opportunities for study, especially, in Stubbs's case, the scientific volumes and the collection of fine prints. But it was the sculpture and paintings that were decisive for, as Stubbs told Humphry, 'this being the only collection of pictures in that neighbourhood it became of course a most desirable object to Mr Stubbs to study there'. Some of the high-quality works at Knowsley have already been mentioned, but here also were history paintings by Titian, Tintoretto, Veronese, Giulio Romano, Salvatore Rosa, Caravaggio and Nicolas Poussin. There were hunting scenes by Rubens, Snyders and Hondius, horses by van Bloemen and Wootton, sporting landscapes by Tillemans, genre pieces by Hondecoeter and Campidoglio, a sea piece by van de Velde. The large collection of classical sculpture included a fine copy of the statue of Hercules in Rome's Farnese Palace.[2] The student artist would have needed a minimum of weeks, if not months, to take all this in. At the same time he would have had the opportunity to meet Winstanley's south Lancashire clients, some of whom were destined to play an important role in the direction of his career.

Nevertheless there is no reason to doubt the broad outline of the proposition that Stubbs returned prematurely to Liverpool and that he was a largely self-taught painter. The question is: how did he do it? Of painting's many mysteries, the two most obscure and closely guarded were of the chemistry of paints and the mathematics of perspective. A young person would find it hard to learn either of these without professional help. Artists' paints were not yet mass-produced and it was part of an apprentice's duty to mix them daily according to the master's own recipes. As little as a century earlier paint chemistry had been kept as dark as the alembroths of Paracelsus. Indeed, people often confused artists and alchemists, as had been the case with Van Dyck in England in the 1630s. Stubbs himself developed a close scientific interest in pigments and their media, applying his habit of restless enquiry to such questions as the fading of colours over time and the merits of quick- versus slow-drying preparations and was to make laborious experiments with oils, wax and other materials throughout his life. Stubbs also gained an academic grasp of perspective before he was twenty-five, a deeper and subtler one than Winstanley ever developed.

Given the kind of persistence Stubbs certainly possessed, his knowledge of paint and its composition could have been learned in Liverpool itself. His friend Richard Wright, now over twenty-one, had in the meantime trained as a decorative painter of houses and ships (and perhaps as a sign-painter too) and was therefore in a position to pass on pigment-related information to Stubbs. Another source of advanced knowledge was Caddick, and there is a tradition that Stubbs continued to study with the older man at this time. Now twenty-three, Caddick married the daughter of a Burslem potter and it is quite likely that his own education in paint chemistry came from initial training as a ceramics painter.[3]

Ceramics were an important product of Liverpool. Its potteries dated back to 1710, when workers from London's chief potting district, Southwark, arrived to set up a pot works under one Richard Holt. Initially they made Delftware, or tin-glazed earthenware, but by the mid century the industry had grown to a considerable size and sophistication, which included the manufacture of porcelain. Richard Chaffers's pottery on Shaw's Brow led the way, with Liverpool's distinctive blue-and-white ware being a popular export to the Americas. These pot works supported a community of decorative artists who formed the town's most concentrated pool of creative work in paint and surely a magnet to avid young men like Caddick, Wright and Stubbs.[4]

The intellectual discipline of perspective would, on the other hand, have been of no interest to the pot decorators, and of little more consequence to Wright's colleagues. However, mathematics teachers were not scarce in a town where would-be mariners needed to learn the mysteries of navigation and the sextant, and our three young artists could have found a perspective teacher among these. John Holt of Kirkdale, for instance, was a first-rate mathematician and very interested in the mathematics of proportion. Within five years, Stubbs was himself teaching perspective in Wakefield, and it is difficult to see how he managed this unless he himself had received formal training in the subject.[5]

Two of Humphry's claims about Stubbs's artistic training, subsidiary to the overriding claim that he was entirely self-educated, must be highlighted at this stage. The first is that the young man's ambitions as a painter were general: he wanted to learn all the branches of the painter's trade, not just one of them. This is important because he later felt an uncomfortable tension between the specialism of horse painting,

which had made him famous, and the much wider range of projects and techniques – portraiture, narrative art, enamel work, anatomy, landscape, printmaking, publishing – which he espoused throughout his career, though with rather less certain or solid acclaim. The second message, one that is hammered home repeatedly in Humphry, is that Stubbs made 'all his studies after nature'.

From this we are supposed to understand that the Winstanley experience had turned him for ever against the examination and copying of pre-existing works of art. The question of the role of nature in Stubbs's art, and what he meant by nature, is not a straightforward one, and will recur in these pages. For now it is enough to notice the strongly anti-classical, anti-academic, anti-artificial twist he chose to give to his early creative life when looking back on it. With what degree of accuracy he did so will remain, for now, uncertain.

II

OBSCURITY

1744-58

Orford Hall, the seat of John Blackburne, photographed in the 19th century.

CHAPTER 8

Captain Blackburne

He soon after removed to Wigan.

In 1744, at the age of twenty, Stubbs left Liverpool and travelled to Wigan, which lies only about thirty miles away to the north-east. Straddling the main trunk road which still connects Lancashire to the Midlands and London, this ancient borough was very different from the cheerfully expansionist, ferociously mercantile and Whiggishly optimistic seaport in which Stubbs had grown up.

> It was governed by the strictest of old Toryism and Red-tapeism . . . The gates were closed in the face of all able-bodied strangers both able and willing to work, and who themselves might have fostered new trades or given their remunerative energies to the staple ones. At every court leet dozens of such persons were fined ('amerced') for daring to try to settle in the ancient and loyal borough and ordered to go at once, unless they could produce excellent credentials as to their fitness to work and ability to maintain themselves in every likely emergency.[1]

Liverpool, busy port that it was, could hardly have afforded to behave as defensively as this, but the mentality was typical of many inland towns. The possibility that incomers were good for both commerce and culture was not considered, while the overriding obsession was with paupers, vagabonds and masterless men. If admitted to residence, these would surely breed more of their kind who, under the Poor Laws, had then to be supported on the rates. In England today, the same fears can govern attitudes to immigrants and asylum seekers. In the eighteenth century pregnant women who lacked residence rights were chased out of town with cudgels as soon as their labour contractions came on.

Amercement was in full force at the time Stubbs went to Wigan. Surviving court leet records from 1742 show that dozens were fined in that year, usually the considerable sum of thirty-nine shillings. Stubbs, when he came into the town, was himself a masterless man, but he found a protector there capable of keeping civic disapproval at bay.

> He fortunately became acquainted with Captain Blackbourne with whom he boarded and lodged, and who attached himself to him with particular

affection from a resemblance he happened to have to a Son whom he had just lost, & who treated him in every respect as if he had been his own child.

The Captain had lost a son and Stubbs a father. Both were comforted.[2]

Humphry gives no further particulars of Captain Blackburne, but he must have belonged to one of Lancashire's more prosperous gentry tribes, the descendents of William Blackburne, landowner of Thistleton to the north-west of Preston. The Blackburnes' land was productive and well managed, and they enlarged their estates by marriage and land purchase. Drifting south, some of them also went into business. At Warrington and Liverpool the most vigorous branch of the family set up as traders, salt refiners, coal merchants, shipowners and river navigators.

In the 1740s, the head of this branch was the long-lived John Blackburne of Orford Hall, north of Warrington, who had been born in 1690 and would live to be ninety-six. He was on the face of it a classic eighteenth-century country squire, enjoying the almost hereditary office of chief magistrate for Warrington and with an elegant mansion in twenty acres of parkland. But he was far from the Squire Booby stereotype as we know it from Hogarth and Henry Fielding. Conjuring the parliamentary Country Party, sitting in opposition to Prime Minister Walpole, Macauley memorably wrote of 'rows of ponderous foxhunters, fat with Staffordshire or Devonshire ale, men who drank to the King over the water and believed that all the fundholders were Jews, men whose religion consisted in hating the Dissenters and whose political researches had led them to fear like [Fielding's] Squire Western that their land might be sent over to Hanover to be put in the sinking-fund'. John Blackburne was not at all like this.[3]

He was certainly no diehard Tory, but a Whig; not a hater of dissenters, but a supporter of the Warrington Academy when it was founded in 1756; and not at all ponderous, but an energetic forward-thinking capitalist, with especially developed interests in the salt industry, one of the key exportable raw materials of the north-west. Produced in the Cheshire 'Wiches', salt had since Roman times been extracted from briny ground water, but was now also being mined as rock salt. The Blackburnes, led by John, had become very important players in the local salt monopoly, with their own mine at Northwich, Cheshire, and two salt works, one of which was in Liverpool, close by the Dock.[4]

Blackburne's web of family connections was essential to the way he did business and the most significant of these was with that other important Warrington family, the Pattens. His much older half-sister, Margaret, had married Thomas Patten, the copper smelter of Patten Lane, and their son, also Thomas, was born in 1690, the same year as Jonathan Blackburne's second wife Ann gave birth to John. Uncle and nephew were therefore children together, and would remain lifelong friends and business partners. The most spectacular commercial success of their alliance came when the two men worked with other Liverpool and Cheshire interests to make the River Weaver navigable from Winsford, in the heart of the Cheshire salt fields, to the Mersey estuary at Runcorn. This was one of the first manifestations of what became the canal craze. It involved a good deal of skilful political work to get the necessary Act of Parliament passed, even before the engineering of locks and cuts could begin. At a cost of £15,000, the navigation opened in 1732, after which barges replaced the old system of packhorses in the transport of Wigan coal into Cheshire, where it was needed for the evaporation and refining process, and of the salt itself back – ready refined or in bulk-transit for the salt house – to Liverpool's quays.[5]

There was, however, much more to John Blackburne than a pioneer navigator and salt merchant. He was a passionate scientific gardener and his hothouse at Orford 'glazed like the windows of a cottage with leaded squares', and designed to grow rare and exotic plants, was one of the wonders of Lancashire. Its owner corresponded and exchanged plants with all the leading naturalists, including Linnaeus himself, and there were 2500 species in his garden meticulously catalogued on the Linnaean system, by generic, specific and common names.[6] Appropriately for a Lancastrian, Blackburne was the first to cultivate a crop of cotton on English soil, in just enough quantity to make a muslin dress for his daughter. He also grew the second successful crop of pineapples (*Bromelia Ananas*) to be seen in England.

There is no clinching evidence, but it is highly likely that John of Orford was Stubbs's Captain Blackburne. He took an interest in art and was a prominent client of Hamlet Winstanley in 1741, just when Stubbs was working with the Knowsley copyist. That year, Winstanley completed a large family portrait of the Blackburnes with their eight children – a memorial piece rather than a realistic one, since Mrs Blackburne and her youngest son James, who were both represented, had recently died. Two years later Winstanley produced a solo portrait of John Blackburne that is revealing of the man, not as a squire-turned-

37

businessman, but as just the kind of intellectual naturalist – his hand resting on a volume by the celebrated Swedish naturalist Carl Linnaeus – who would have aroused Stubbs's enthusiasm. The portrait emphasises that Blackburne's interest in Linnaeus was not merely theoretical for, in the background, we see Orford Hall's heated greenhouse belching fumes from its smokestack. It is thought that the portrait originally showed the subject proudly balancing one of his own pineapples on his hand which, for some reason, was later painted out.[7]

It is obvious that the nineteen-year-old Stubbs, with his head full of the seeds of enlightened enquiry in art and science, would have found John Blackburne an appealing figure. It is true that Humphry specifies a residence in Wigan, without mentioning Warrington. But the towns are only ten miles apart, most of John Blackburne's lands lay between them – at Winwick and Newton-in-Makerfield – and he is quite likely to have owned real estate in Wigan itself. John Blackburne had also lost his son, James, who is represented in the Winstanley group portrait as a babe in his mother's arms. According to the nineteenth-century antiquarian, historian and sometime Mayor of Warrington William Beamont, John Blackburne had even received a military commission in the same year in which Stubbs lodged with his own Captain.

> In 1743, on March 19 and 21 respectively, the Earl of Derby gave Mr Blackburne a commission of Captain in his (the Earl's) own regiment, and appointed him Deputy Lieutenant, and in the same year Mr Blackburne was appointed High Sheriff of Lancashire.[8]

There is one more argument, to my mind a compelling one, to identify 'Captain Blackbourne' with John Blackburne of Orford. It is that he provides a link in the chain of biographical events clearly laid out in the Stubbs memoir. When Stubbs moved away from Lancashire, and out of the orbit of the Captain, he entered the circle of a Mr Wilson in Leeds, but this was no random move. John Blackburne's sister was married to a Leeds lawyer named Richard Wilson, and he, or a member of his family, was Stubbs's new employer. It seems, then, that, in 1744 or 1745, Blackburne dispatched Stubbs to Leeds to paint portraits for his brother-in-law.

CHAPTER 9

The Tyrant of Leeds

From Wigan he removed to Leeds & practised Portrait Painting only. — At this town he received great kindness & favor from Mr Wilson.

Stubbs went to the West Riding of Yorkshire in search of opportunities that the inland Lancashire towns could not provide. He had good reason to do so, for Leeds was more prosperous than either Wigan or Warrington. Superficially a modern, mostly brick-built town, it was ruled by a tightly knit group of families all engaged in the serious business of wealth creation. Although the town was steadily rising, it was not yet of national importance. This was to the advantage of the ruling merchant families, the Ibbetsons, Denisons, Dixons, Cooksons, Lodges and seven or eight others, including the Wilsons. Keeping a firm grip on the council, the magistracy and the civic infrastructure, they created a Leeds that was half a city-state, whose oligarchical arrangements would have done credit to an outlying Greek *polis* of the pre-Hellenistic period. Leeds is an extreme example of Tom Paine's acid description of the eighteenth-century English charter town, a political and legal insularity, whose citizen's 'rights are circumscribed to the town and, in some cases, to the parish of his birth; and all other parts, though in his native land, are to him as a foreign country'.[1]

The unquestioned rule of the leading merchant families was possible because Leeds returned no members to Parliament and in consequence received little attention from the county magnates. Had Leeds been a constituency borough, one or other of the Yorkshire 'boroughmongers' – most likely Lord Irwin, but perhaps the Marquess of Rockingham – would undoubtedly have acquired a portfolio of property there, in order to corner the parliamentary vote.[2] He would also have asserted his power by nominating the town's magistrates and other officers, some of whom might be outsiders. A famous example is Lord Lonsdale's elevation of James Boswell to be Recorder of Carlisle in 1788. Fearing to offend the touchy and arrogant Lonsdale, and hoping to be promoted in time to be one of Lonsdale's tame MPs, Boswell accepted the distant and (to him) small-time job, in a town he had no

connection with and didn't much fancy. His entry into the Recordership was less than triumphal, but very revealing of his attitude to these new responsibilities: riding through the city gates he was so drunk that he fell off his horse. Leeds was proud to be free of such farcical appointments.[3]

The town lived by trade, specifically in woollen and worsted cloth. The Aire bridge had for centuries been the site for the twice-weekly, early-morning cloth market, where the rural clothiers, mostly cottage workers, brought their bolts of narrow- and broadcloth to sell to the merchants. Since the end of the previous century commerce had become so great that the market was forced to move, first to Briggate, the wide main street, and then into a variety of covered halls built for the purpose. There was no hullabaloo, no crying of prices, in the market: the business was conducted in whispers, and so briskly that it amazed visitors. With a connoisseur's eye, the London merchant's son Daniel Defoe describes how the buyers chose from the bolts of cloth laid out on trestles by the clothiers:

> Some of them have their foreign Letters of Orders, with Patterns seal'd on them, in Rows, in their Hands; and with those they match Colours, holding them to the Cloths as they think they agree to . . . [then] they reach over to the Clothier and whisper, and in the fewest Words imaginable the Price is stated; one asks, the other bids; and 'tis agree, or not agree, in a Moment . . .
>
> Thus you will see Ten or Twenty thousand Pounds value in Cloth, and sometimes much more, bought and sold in little more than an hour.[4]

The first of the Wilsons to make a fortune from cloth was Major Wilson, who had claims to be one of the earliest Englishmen with considerable business in the Baltic. He specialised in the Russia trade and became known to Peter the Great as 'my English Jack'. Major (it was his name, not a title of rank) was a man of culture and a patron of the arts, who lived in the Leeds Manor House on Mill Hill. Born in 1674, he reputedly survived to be 110 and was known for his great height and prodigious beard. Wilson's family was of similarly exaggerated proportions. He fathered fourteen children, only the youngest of whom rose to any prominence – the talented Benjamin Wilson, who became an artist-scientist three years older than Stubbs, and who would soon gain sufficient national repute to become both Royal Academician and Fellow of the Royal Society.

Is it possible that Major Wilson was the 'Mr Wilson' to whom Stubbs was sent by John Blackburne? Still a mere seventy years old when

Stubbs came to Leeds, the cultivated Major would certainly be a leading suspect among the Wilsons of Leeds, were it not for three factors: he had no personal connection with the Lancashire Blackburnes, he already enjoyed the use of a portrait painter in his own youngest son Benjamin and, most significant of all, he had for fifteen years past been living in near poverty. In the early 1720s his ship had been lost at sea and, as his grandson put it, 'property of my grandfather's to a great amount was lost, and this first caused the misfortunes of the family'.[5] By the 1740s Major Wilson was no longer a man who could afford to indulge in art patronage.

The misfortune to Major had been a stroke of luck for his cousin, the lawyer Richard Wilson. John Blackburne's brother-in-law bought the Manor House and its lands from his distressed relative and lived there in style for the rest of his life. Richard was the eldest son of Thomas Wilson, who was Major's first cousin, and himself a successful merchant. Inheriting Thomas's fortune at the age of only sixteen, Richard read for the Bar and set up barrister's chambers in his home town, where eventually he was elected Recorder for life in 1729, holding the job for thirty-three years before bequeathing it to his eldest son and junior partner, also Richard.

As Recorder of Leeds Richard Wilson cut a very different figure from that of James Boswell in Carlisle. The Recorder was the Corporation's supreme legal officer, as well as the town's chief magistrate, and was in a position to wield, if he chose, tremendous local power. No one in Leeds was shrewder or more ruthless in making money, peddling influence and putting down opposition than Lawyer Wilson, who always acted in the interests of himself and his fellow oligarchs which, as they all agreed, were identical to the interests of the town as a whole.

Their governance did not shrink from atrocity, as was seen during occasional outbreaks of protest against them. By 1753 the first turnpike roads linking Leeds with neighbouring towns such as Halifax, Bradford, Selby, Tadcaster and Harrogate were introduced. They were private enterprises, allowed by Act of Parliament to improve the rutted, boulder-strewn quagmires that were the existing roads, and then to charge a toll for their use. The project was intended to increase profits overall by speeding the wheels of commerce in and out of Leeds, but the tolls were also expected to produce good dividends for their investors, who were naturally the Leeds oligarchs themselves. The wider population hated these tolls and, when a toll strike was organised, the Corporation arrested ten strike leaders, bringing them before the bench of magistrates for judgement. But, as Lawyer Wilson and his colleagues assembled for

the trial, a crowd of protesters surrounded the courthouse, crying shame and digging up cobblestones to hurl at the windows. Besieged and showered by broken glass, the Recorder advised the Mayor that he might lawfully call out a detachment of dragoons, which fired on the crowd, and left ten dead and twenty-four wounded, both demonstrators and onlookers. For months an armed guard was posted at the door of Richard Wilson's house, as well as that of the Mayor.[6]

The Recorder's moral conduct towards his fellow citizens sank at times to the level of operatic villainy. A caustic depiction of him in this mode appeared in a forty-eight-page satirical booklet published in 1751 under the name Pendavid Bitterzwigg. This publication, which 'may be had of S. Howgate, Bookseller at Leeds and Jo: Lord at Wakefield', consisted of a mock Horatian epistle in rhyming couplets, a fable in rhyme, a sub-Shakespearean speech in blank verse and a cod 'Last Will and Testament of Pendavid Bitterzwigg'. As an appendix to these a second pamphlet containing *A Pastoral Poem by Pendavid Bitterzwigg, Jun. Esq.*, written in imitation of the satirical epistles of Alexander Pope, came out in 1765. It was probably composed at the same time as the other material, but is significantly more libellous and could perhaps not be printed until after the old Recorder's death in 1761. Taken together, the four poems of Bitterzwigg (whose real name was John Berkenhout) amount to an angry indictment of the Recorder's conduct and character.[7]

Bitterzwigg's real name was John Berkenhout. His father, a Dutch immigrant also called John, had established one of the wealthier Leeds merchant houses, but seems to have fallen out with the other oligarchs when his election to the Corporation was objected to and annulled by legal proceedings, behind which one suspects the manipulations of the Recorder. A decade later the offence remained unpurged, for a row erupted between the families over another important financial interest of the oligarchs, the Aire–Calder Navigation. This highly successful and profitable canalisation of the waterways between Leeds and Hull had carried Yorkshire wool to the eastern seaboard since 1700. During the 1740s the Navigation had been under the de facto management of the Leeds Recorder.[8] When, in 1750, its three lucrative toll-farming leases were up for renewal the younger Berkenhout was promised Wilson's support in getting one of them for himself. He agreed to stay away from the meeting called in a Wakefield tavern to finalise the matter, confident that Wilson would arrange his appointment. By the end of the day, Berkenhout knew his foolishness. Not only had he been excluded, but the third lease had itself been abolished. Now, the spoils

of the toll farming would be split not three ways, but two, with one of the shares going to a new lessee, Thomas Wilson, none other than the Recorder's second son.

In the Bitterzwigg poems, Wilson's duplicity at the Wakefield meeting is spelled out both in literal and allegorical terms. But the verses level many more general accusations against him. Wilson, says Berkenhout, ruled the town like a tyrant, while hiding his true nature under a cloak of hypocrisy:

> He seem'd a friend to every one,
> And yet, in truth, was but his own;
> Would pick their pockets with a grace
> And, smiling, stare them in the face:
> Nay, what is more, he often would
> Persuade 'em 'twas for their own good.

Berkenhout accuses Wilson of all manner of corruption and wickedness as when, 'full famous for the detention of title deeds', he abuses his legal privileges 'well knowing, that so long as such valuable papers remain in his custody, the parties to whom they belong will not dare, for their own safety, oppose him in whatever schemes he shall think it proper to execute'. Meanwhile the Recorder grows gluttonously fat while banning the townspeople's own innocent pleasures, such as dancing, plays and archery. Wilson surrounds himself with sycophants and, worse even than his peculations, he is a serial lecher. From Berkenhout's jaundiced point of view, the future for the town under the regime of this man, whom he calls 'Ryco', was bleak indeed:

> Inflated by his past Success,
> He'll know no limits, but suppress
> Your very Senses; soon your Food
> Without his Licence won't be good.
> No Shepherd touch the Nuptial Bed
> Till RYCO seize the Maidenhead
> Of every Bride, unless redeem'd
> By Gifts, as every Swain's esteem'd
> T'abound in Wealth.

In fact, it was the Wilsons whose wealth abounded, while Berkenhout quit Leeds to try his luck in London and on the Continent. Nevertheless the fact that he continued his vendetta against the Wilson family up to at least 1765 shows how deep the cut had been.[9]

Yorkshire Art

... who gave him considerable employment in painting of himself,
his family and friends.

John Berkenhout's flaying of Richard Wilson is curiously at odds with
Stubbs's evident respect, even affection, for his own Mr Wilson of
Leeds when he met him five years earlier. Perhaps Stubbs, the outsider,
never became familiar enough with Leeds politics to see through the
Recorder's veneer of bonhomie. Perhaps he was too busy or naïve. Or
perhaps the individual who offered him such 'great kindness and
favour' was not in fact the Recorder himself but one of his sons, most
likely his eldest son Richard. He was certainly a man of refinement,
whose plans for the development of the Parks area of Leeds, drawn up
after he inherited the estate in 1766, were elegantly residential –
Georgian streets and squares carefully laid out in modern style.[1]

He had been exposed to the arts from an early age. Major Wilson
had had the Leeds Manor House, where old Richard Wilson's children
grew up, extensively decorated by Jacques Parmentier, over a number
of years prior to the Frenchman's departure from Yorkshire in 1721,
after a residence of twenty years.[2] Parmentier had been part of a
Yorkshire mini-renaissance in the arts. In York he joined a group of
artists and fine art enthusiasts known as the York Virtuosi, who
included Francis Place, a painter of York, Henry Gyles, the glass
painter, and William Lodge, a painter and engraver whose family were
members of the Leeds merchant oligarchy. A key figure in the group
was the Leeds-born merchant-antiquary Ralph Thoresby, a relative of
the Wilsons and taste maker to the more intellectual Leeds citizens.
Gyles introduced Parmentier to Thoresby in 1703, and it is likely that
Major Wilson gave the first of his series of commissions to the
Frenchman on Thoresby's recommendation. The Wilson murals and
ceilings at Mill Hill – said to be his most extensive solo work – were on
biblical themes. Although he made murals for other Leeds merchants,
the market for grand decorative schemes in the West Riding was limited
and jobbing portrait commissions kept him going. At Hull in gratitude
for £800 worth of portraits commissioned in the town, he gave a Last

Supper altarpiece to Holy Trinity church, a work thought by Ellis Waterhouse in the twentieth century to be 'deplorable'.[3]

When Stubbs saw the decorative scheme of the Manor House, it must still have seemed remarkably opulent, even though the general taste was running against narrative ceilings and other rococo embellishments. By the time of Stubbs's visit, only one Leeds painter of note had emerged, but it is significant that he, too, was a member of the Wilson family. This was the Recorder's cousin and Major Wilson's son Benjamin, who was at that time building a considerable reputation. As a result of his father's impoverishment, Wilson trained with Thomas Hudson while working as a humble clerk in London and receiving no support or relief at all from his wealthier Leeds relations. He luckily made an early impression, getting to know William Hogarth and working for periods of the 1740s in Dublin. He was also active sporadically in the West Riding, even after he became a celebrity portrait painter in the metropolis in the 1750s.

Benjamin Wilson represented a new kind of artist, quite distinct from the Parmentiers and Winstanleys who had previously worked in the English provinces. As a painter, he was not a bad technician and the portrait of his cousin Lawyer Wilson shows a degree of psychological penetration which explains in part why this painter, who is hardly remembered today, should have achieved his temporary eminence in the Georgian art world. In Wilson's canvas the lawyer looks easily arrogant and foxy enough to fill the role ascribed to him by Pendavid Bitterzwigg. But it was not so much Benjamin Wilson's painting as his wider artistic and intellectual interests that marked him out as a member of the coming generation. He was a more than competent etcher and turned out fake Rembrandt prints good enough to fool a self-appointed expert such as Wilson's former master Thomas Hudson. Wilson was also a fair caricaturist and was quite willing to place this skill at the political service of the Yorkshire magnate Lord Rockingham in the mid 1760s. Most significantly of all, Wilson was an enthusiastic scientific experimenter. In 1746, when Stubbs was in Leeds, Wilson published the first of his papers on electricity, *An Essay Towards the Explanation of the Phaenomenon of Electricity, deduced from the aether of Sir Isaac Newton*. On the strength of this and other papers he was elected a Fellow of the Royal Society in 1751, when he was still only thirty. Wilson threw himself into a debate with Benjamin Franklin over the design of the lightning conductor. In a controversy that drew in the King and involved the fire defences of the Royal

Ordnance at Woolwich and a large-scale experimental trial at London's Pantheon, the two Benjamins took opposing positions as to the correct shape of the conductor's tip: Franklin maintaining it should be pointed while Wilson espoused a large round knob. In his later career, much of Wilson's painting was theatrical scenery. He attached himself to George II's oldest surviving son, the Duke of York, for whom he would manage a private theatre and exhibit remarkably toadying tendencies.

It seems highly improbable that Stubbs, working for the Wilsons and with his strong interest in science, did not know Benjamin Wilson in Leeds, although there is no documented connection between the two. The new breed of artist-scientist represented by Wilson was one to which Stubbs himself instinctively belonged. He may already have considered himself in this role while looking over this older contemporary's canvases in Leeds and listening to his chatter about the aether of Sir Isaac. Was it then that he realised his own far greater subtlety of understanding and technical ability equipped him, much more fully than Wilson, to unite the skill of the artist to the boundless curiosity of the natural philosopher?

We have few accurate time flags that can be pinned on the map of Stubbs's movements around the north, but there is one in a manuscript diary written by a young Liverpudlian artist called William Clarke in 1746. He was, like Stubbs, a friend of William Caddick and his journal records, in brief form, the events of a trip from Liverpool to London by himself and Caddick in the autumn of that year. In the capital, the young artists make contact with another mutual friend, the genial Richard Wright, who had by this time settled in London. Among various pieces of business mentioned by Clarke – 'Sold Camera scura to French for £1-1-0', 'Finished Mrs Hoddins's picture', 'Mr Caddock alter'd Mrs Snows picture, dined with Mrs Fletcher, Recd. Letter o' Wright, drunk Tea at Mr Snows' – there is the following entry against the date 6 October:

> Memd. To direct to Mr Geo: Stubs to be left with Mr Richd. Tireman Glover in Coney Street York.[4]

Whatever it was that William Clarke had to send to Stubbs he does not trouble to say, but the memorandum indicates that by now Stubbs had left Leeds and was living in York. However, judging from what Humphry says, the move must have been some months earlier, possibly

towards the end of 1745. What, then, was the significance of his connection with Mr Tireman?

It is possible Richard Tireman had rented Stubbs a room, or provided him with a poste restante. But the York City records open up another possibility when they tell us he was 'Richard Tireman, felmonger and glover, son of William Tireman, currier', he had recently risen to the freemanship of the City.[5] Tireman's glove workshop would have been closely linked to his father's currying premises, both established businesses at the centre of town. The inference is obvious: Stubbs, unable for the time being to make ends meet, had taken a job as one of Tireman's assistants.

Humphry's memoir explicitly states that in York Stubbs was 'always maintaining himself by his profession', clearly meaning painting and drawing. But setbacks and frustrations played no part in Stubbs's private mythology and, in his recital to Humphry, he insisted on his career as a smooth upward progress towards recognition and success. In reality, at this stage, he was far from successful. Only two of his commissioned portraits from before 1754 – one definitely done in York – can be seen today, while a third (of Alice Atkinson) is known about but lost. Even assuming a heavy attrition rate of provincial canvases, this hardly suggests a flourishing practice. Humphry tells us that when Stubbs went to York a number of commissions were already awaiting him there. But what if these were cancelled, or the finished portraits were rejected and unpaid for? Understandably reluctant to make a humiliating prodigal's return to his mother, Stubbs may have felt he had no choice, after a few months of struggle, but to take alternative work. And the only thing he was fully qualified to do was shaving hides.

One explanation for Stubbs's disappointing debut in York would be the stiff competition from a resident York painter, and a distinguished one, Philippe Mercier. This artist, of French Huguenot origin, had come to the city six years earlier at the age of fifty. An artist of high quality, Mercier had previously been in favour as a courtier to the discerning Frederick, Prince of Wales. At York his pictures – Watteau-like fancy pieces, or acceptably 'English' portraits with a lick of French sophistication – enabled him to live at a prestigious address in Minster Yard, making him a neighbour of the powerful Dr Jaques Sterne, the Archdeacon of Cleveland and Precentor of York Minster. There is no proven contact between Stubbs and Mercier, but some sort of meeting is quite likely and, indeed, especially intriguing. In the 1720s the

Frenchman had created some of the earliest English conversation pieces, themed (usually family) portrait groups, which became a genre of some importance in English art, not least to Stubbs himself. Something or other had prompted him to begin French lessons in York: perhaps it was an encounter with, even a desire to emulate, the refined Mercier?[6]

CHAPTER 11
York and War

He went now to execute some commissions at York . . .

Stubbs's move from Leeds to York appears a quite natural progression. With its population of about 15,000, this was the capital of the north, and one of Europe's great old cities. In terms of social class, Liverpool, Wigan, Warrington and Leeds were common towns, full of self-improving merchants whose wealth, though great and growing, was tainted by their origins in trade. York, on the other hand, was a 'noble city', of ancient lineage and proven pedigree.

Like all existing cities, it was dwarfed in size and prosperity by London. In modishness it lagged a distance behind Bath. But in a period obsessed with the antique, when every other gentleman and most of the clergy were part-time antiquaries, the prestige of Georgian York was sanctioned by history. Its walls were Roman and its archbishop had been the nation's second-ranking cleric since Anglo-Saxon times. From his palace at Bishopsthorpe and his medieval cathedral, the awe-inspiring St Peter's Minster, he ruled a vast spiritual and temporal domain assisted by a complex bureaucracy of deans, sub-deans, precentors, archdeacons, deacons and prebendaries. Standing at the confluence of the Great North Road and the River Ouse, which was navigable to the Humber estuary and the sea, York had been for centuries a hub of trade and communication. It was up the Ouse that the Vikings had rowed to make the city their most substantial urban settlement, and the navigable river subsequently enabled York to become an inland port and international trading post.

It was a place of many markets, at which tons of fresh produce were sold daily from barrows, while herds of horned cattle were driven through the streets to the fortnightly sales. For centuries, magnified markets in the form of the York Fairs had flourished. At each of the calendrical junctures of the year – Palm Sunday, Whitsun, old St Peter's Day, St Luke's, Old Lammas, All Souls', Martinmas, Candlemas – these fairs held sway, often for several days at a time. Their mixture of serious commerce and general inebriation helped to make the city a magnetic social centre, as well as a commercial one. All the nobility of

the north, and the richer gentry, kept York town houses, which they used as bases for doing business, educating their children, consulting professional advisers and attending the Assembly Rooms and the theatre. Other less decorous attractions included the celebrated race meetings and the city and county elections, when 'treating', feasting and revelry were significantly more in evidence than political debate.

The Assembly Rooms had been designed by the Yorkshire architect-peer Richard Boyle, third Earl of Burlington, along impeccably up-to-date Augustan lines. Brilliantly lit by thirteen Venetian chandeliers supporting 234 candles between them, it was a basilica-shaped building with two rows of forty-four Corinthian pillars. According to the elderly Sarah Churchill, Duchess of Marlborough, these were a great hindrance to social intercourse, being 'as close as nine-pins. Nobody with a hoop petticoat can pass through them.'[1] Nevertheless the Rooms were essential to York's fashionable society, as were the city's summer races on the Knavesmire, an open stretch of ground outside the city walls. Racing served many social purposes, not least as a celebration of northerners' great pride in their horses and horsemen, which they thought superior to any product of Newmarket or Epsom.

These elements, along with the Palladian Mansion House, the hospital founded in 1740 and a number of fine sash-windowed town houses in Micklegate, supplied York's clean modern face. But the overall townscape was cluttered and maze-like, lined with tile-roofed, timber-framed, out-of-kilter houses of plaster and wattle, their upper floors jutting dourly over the street. A score of medieval churches crammed within the walls and the great five-arch span across the Ouse was an inhabited bridge in the medieval style. This mixture of old and new was an alluring one.

Mercier's dominance over York portraiture blocked Stubbs's access to the influential circles around Archbishop Herring and Precentor Sterne. But another factor made the end of 1745 a particularly unpropitious moment for a young, unproved artist to find work at York. Now, suddenly, as everyone feared, the Jacobite rebels were heading for Yorkshire.

The Jacobite rebellion of 1745 is today remembered as a crazy adventure with little chance of success, but it was impossible to take such a view at the time, particularly in the north of England.[2] The previous summer Charles Edward Stuart, the Catholic Young Pretender and grandson of King James II of England (and VII of

Scotland), had stepped ashore on the western island of Eriskay with just seven followers. A determined and charismatic young man, he was intent on regaining the crowns of Scotland and England for his father James Edward, the Old Pretender, whose claims had been supplanted in 1688 by William III and then, in 1715, by the House of Hanover. As the clans, many of them Catholic, rallied to provide the kernel of an army, he finessed his way past the Hanoverian defence force under General Cope, and marched unopposed to Edinburgh where, on 17 September 1745, he proclaimed his father King of Scotland. Four days later Cope's army caught up with him, only to be smashed by the Highlanders in open battle at Prestonpans. To the consternation of metropolitan Englishmen in their coffee houses, the Pretender had won in Scotland and was suddenly poised for a deep thrust across the border. With him would come, as almost everyone believed, thousands of bloodthirsty, plunder-happy savages.

The rebel army, of some 5000 effective fighters, might have entered England on the eastern side, marching through Northumberland towards York, and then on to the wealthy valley towns of the Aire and Calder. But a government army under General Wade was at Newcastle, and the western road into England looked a safer bet. This took the rebels through Penrith and across the bleakness of Shap Fell, a daunting obstacle for men on foot in winter, even without military opposition. But the Highlanders were hardy and Shap was crossed on 21 and 22 November. They then proceeded south without check to Kendal, Lancaster and Preston.

A degree of anti-Hanoverian sentiment was common throughout the northern counties, as in other regions distant from London. This held especially true of York. The Jacobite Duke of Perth had recently visited the city in secret to gauge the Pretender's support, and found profound divisions there.[3] On the one hand many of the city's leading citizens were Tory and hankered nostalgically for the Stuarts and Divine Right. On the other stood the pro-Establishment Whig church, headed by the able Archbishop Herring and, more flamboyantly, by Herring's political hatchet man Jaques Sterne, whose nephew was Laurence Sterne. The future novelist was at that time vicar of nearby Sutton-in-the-Forest, and assisted his uncle with pamphlets and polemics lampooning the York Jacobites.[4]

Now, with danger imminent, Herring rallied the local Whigs through fighting sermons, while a Loyal Association (of which Lawyer Wilson was a member) came together under Lord Irwin, the

Lord-Lieutenant of the East Riding. Of the York Jacobites only one, as we shall see, rashly decided to act. The others were more careful, meeting secretly in each other's homes and debating what best to do if Bonnie Prince Charlie came their way. There seemed every prospect that he would. In Lancashire two troops of local levies, Lord Derby's militia and a regiment raised in Liverpool especially to fight the Jacobites (the 'Liverpool Blues'), had 'melted away with amazing rapidity once the prospect of a real fight loomed'.[5] Urged on by Herring, York had formed its own 'Blues'. They were useful for lookout duty and breaking down the doors of suspected papists, but in face of the enemy's ferocious reputation, this motley crew of adolescent gentry, apprentice boys and layabouts – a mere 275 of them it seems – can hardly have been expected to perform better than their Lancashire counterparts.[6] The Corporation certainly did not think they would. The Lord Mayor had already written to the Lord-Lieutenant of the West Riding, Lord Malton (later the first Marquess of Rockingham), that York 'is not tenable against even a small force'.[7]

As the rebels reached Manchester there still seemed every prospect they would descend on south Yorkshire, with all its wealth and potential booty. Around Whiggish Hull an ambitious defence scheme was devised to flood the countryside and form a vast moat to deter attackers. In Leeds, Richard Wilson was quaking. He wrote to the Lord-Lieutenant, 'it is generally believed that the rebels intend to miss General Wade and to march on Leeds.' These fears were misplaced. The clansmen advanced instead to Derby where, on 5 December, a fierce argument split the Prince's war council. He himself wanted to press on to London, while his senior officers, disappointed by the lack of English recruits, were for turning back by the way they had come. They won the argument and disconsolately the Highlanders began to hike back up the Manchester road.[8]

For some days yet there was uncertainty about their true direction. In London there was general alarm, and a run on the banks. The normally urbane Horace Walpole trembled:

> Nobody but has some fear for themselves, for their money, for their friends in the army . . . I still fear the rebels beyond my reason.[9]

As Stubbs arrived at York, a similar panic had seized the population. The Corporation plate, and other valuables, were loaded on to carts and removed to safety outside the Bars. Wives and children were likewise sent to the country. Ann Worsley, a gentlewoman in

Hovingham, had already written in a letter that 'Poor nanny cried about the rebels in Scotland, and advised us seriously to turn Papist before they got into Yorkshire' and later that 'Ye road is perfectly crowded' with refugees. Now, on 15 December, she took shelter at the Earl of Carlisle's seat, Castle Howard, where a crowd of timorous York citizens huddled for safety.

> Mr Aisalbie [an MP] is hear drove from York with the Panick that seiz'd all people upon hearing the Rebels were in full March for Leeds, a great many trade's people are hear as an Asylum.[10]

In York itself, taking his cue from London, where Romish priests had already been identified and rounded up, the fire-breathing Precentor Jaques Sterne used his authority as a magistrate-cleric to order the city gates closed on 7 December, and the houses of known Catholics to be raided by the 'Blues' in search of warhorses and arms. Little of use to a rebel was found, but according to Archbishop Herring,

> the manner of searching put the Town in great Terror, and has raised a Ferment in the Corporation, who complain that their own Gates were taken from them by Force.[11]

At the same time new realities of war had been brought home to the citizens of York by the arrival of rebel prisoners on foot, exhausted, sick, chain-ganged men and women, most of them unlucky stragglers or ambushed outriders of the Prince's army. They were locked up in York Castle, where they soon started dying of gaol fever.[12] The unusual number of prisoners – eventually 250 of them – and their close confinement in dungeons designed for half as many created a stench difficult to get rid of, as Thomas Herring noted in disgust: 'When the wind sets fair, I can almost fancy that I can smell them, as they do hogs at a distillery.'[13]

No wonder, in the middle of this ferment, Stubbs was struggling to find work. 'Savage' Catholic invaders were threatening to lay the kingdom by its Hanoverian ears and drive a broadsword through its heretic heart. At such a time the thrifty Englishman's cash was for laying up under the floorboards, or burying in a strongbox in the garden. It was certainly not to be spent on portraits by a young, unknown artist from Lancashire, however sincere and talented.

CHAPTER 12

Family, Religion and Politics

Here he became acquainted with Mr Charles Atkinson, a surgeon.

By the time Stubbs was settled at York with Richard Tireman in October 1746, the emergency was over. Then, in May or June 1747, came a new development: he conceived a child. The birth is recorded in the parish register of St Helen's, Stonegate, at the date 26 February 1748:

Baptised, George son of George Stubbs, liminer.[1]

The register omits the mother's name and, while that is nothing unusual, its lack has meant that her identity is a mystery. No marriage registration, no reference to such a marriage, or sexual relationship of any kind at this stage in Stubbs's life has ever turned up. It is not even hinted at in Humphry, strongly suggesting that there was something painful, unfortunate or disreputable about it, which later prompted Stubbs to excise the woman from the record.

There seems little doubt it was a lasting relationship, a true marriage, even if it lacked an official clergyman's sanction. Further children were born, a second son at York in 1750, a daughter, Mary-Ann, at Kingston-upon-Hull in 1752, and a third son, John, at Liverpool in 1755, by which time the family had been together for at least eight years. The only clue to the wife's identity lies in the middle name later used by George Stubbs junior, to distinguish himself from his father. He called himself George Townley Stubbs, a clear indication of his mother's surname. There was in Liverpool a tobacconist called George Townley, who lived in John Street. The eldest of his three daughters, Mary, was born in 1731, making her just sixteen at the time of George Townley Stubbs's conception.[2]

This is as far as the records take us. Townley was a common name in the north-west, and is found also in Yorkshire and elsewhere. However, the most prominent Lancashire Towneleys (the spelling was variable) were a widespread gentry family, with a strong tradition of Catholicism and Jacobitism. Colonel Francis Towneley had marched with the rebels at the head of his Manchester Regiment, the only

significant English contribution to the Pretender's army. He was executed as a traitor. There are strong circumstantial hints that Stubbs's Miss Townley may have had similar connections.

These hints arise from the known circles in which Stubbs moved in York, and they were quite distinct from those of the Huguenot Philippe Mercier, or of the Whig Precentor Sterne. In total, only seven of Stubbs's friends or close contacts in York can be named with certainty. Six of these (the exception being Richard Tireman) were papists or nonjurors, and sympathetic to the Jacobites. One was Dr Charles Atkinson, resident surgeon at the York Hospital and the York-born son of a well-to-do Catholic grocer.[3] He befriended Stubbs and later employed him. Another was the Tory physician Dr Francis Drake, a colleague of Atkinson at the hospital and a cultivated man with widespread contacts. He was a Fellow of the Royal Society and, as a committed Freemason for two decades, had been one of the leaders of the York Grand Lodge, a very important centre of Georgian Freemasonry.[4] Like many of the more intellectual Tories, Drake was also an antiquary whose great tome *Eboracum*, published in 1736, became a famous early history of York. Drake held that 'a Gentleman without some knowledge of the Arts and Sciences is like a fine Shell of a House without suitable Finishing, or Furniture'.[5] He certainly supported Stubbs's work, commissioning, for example, a portrait of Alice Atkinson (probably a relation of Charles Atkinson), who is said to have lived to the age of 110. Stubbs kept a small preparatory sketch for 'the large Picture which Mr Stubbs painted for Dr Drake of York' in his studio until his death.[6]

The third known friend of Stubbs in York was the Tory activist and physician Dr John Burton (of whom more will be said in due course) and a fourth was George Fothergill, a retired draper who lived quietly in Micklegate. The York Fothergills were nonjurors and some of them were Catholics, as were George himself and his presumed relation Dr John Fothergill, another of the hospital's medical staff. Draper Fothergill, a bachelor, was painted by Stubbs in an affectionate portrait which is the sole surviving painting certainly done by Stubbs in York. It is inscribed 'G: Fothergill aet 57', which may indicate a birthday portrait, a thought that is underlined by the meaningful way in which the sitter brandishes his pocket watch. Fothergill's fifty-seventh birthday fell on 25 June 1746.[7]

The final member of this group was the mother of Stubbs's children. Encouraged by the undoubted fact that her only daughter was

christened Mary, let her for the sake of argument be called Mary Stubbs née Townley. Did she also harbour Jacobite sympathies? She seems to be telling us so, two years after the birth of George Townley Stubbs, with the combination of names under which her second son was baptised. The entry, again in the parish of St Helen's Stonegate, reads:

> 1750. Baptised: Charles Edward John Stubbs, son of George Stubbs, liminer, 19 July.[8]

Four years after the failure of the Forty-Five, there was still a lively tradition of sentimental Jacobitism in England: oak leaves, Jacobite medals set into watch cases, toasts to 'the King over the water', engraved wine goblets, loving cups. At the (unofficially tolerated) Bar Convent, outside York's Micklegate Bar, medals touched by the Stuarts in Rome were used secretly by the nuns to simulate the royal healing 'touch' on the city's poor. In 1750, in this tradition of continued covert homage to the Stuart dynasty, to give a child the forenames of the Young Pretender himself clearly marks parents who were, one or both of them, in some sense Jacobites.[9]

But was Stubbs's wife also a Catholic? If she came from the Towneleys of Burnley, or their relations at Dutton, near Preston, she certainly had strong Catholic connections. She does not correspond to any female mentioned in the extensive pedigrees of these families that I have consulted, but if she was illegitimate she would not have been recorded there. Even were 'Mary' the Protestant-born daughter of George Townley, the Liverpool tobacconist, she could have been a nonjuring Jacobite who converted to Catholicism.[10] In the present state of knowledge, little more than this can be said about Mrs Stubbs.

My questions and suggestions about Stubbs's religion and politics in the 1740s rest on two assumptions: first, that Stubbs had inherited nonjuring sympathies in Liverpool and/or had married or joined up with a woman from a similar background; and second, that in a time when Jacobite and anti-Jacobite activity peaked in England, as it would never peak again, Stubbs was close to York's Catholic community – a very intimate one, probably numbering only about 330 adults.[11]

But it was not, I think, principally religion, politics or painting that first brought Stubbs into contact with the group of Drake, Atkinson and Burton. I believe the principal factor in this coming together was science or, as it was then called, natural philosophy, and it is to this that my attention now turns.

York County Hospital, 1745.

CHAPTER 13

Vile Renown

. . . & here he began a regular course of anatomical study . . .

In most cultures a line, however fuzzy, can be drawn between the reactionary and the progressive. But in a few they can merge or cross over, and this was a particular feature of Georgian England. John Wesley created a new religion by combining social radicalism with a fundamentalist interpretation of the Bible. Similarly the most radical innovation in the arts of the period, rightly called the novel, numbered among its progenitors Jonathan Swift, an extreme pessimist and reactionary, and Samuel Richardson, an authoritarian moralist. In George Stubbs's York the same effect was apparent. He arrived to find that the city's diehard antiquaries and clock-rewinding Jacobites were also the most progressive scientists, who gathered around the very modern and liberal institution of the new County Hospital.[1]

York's Publick Hospital for the Diseased Poor of the County was founded in 1740, the work of a few visionary and energetic individuals, all of them Tories. It formed part of a 'hospital movement' that had been gaining momentum across the country since the foundation of the Westminster Hospital by philanthropists in 1720. London had built four more new hospitals since then, while others had appeared in Edinburgh in 1729, Bristol in 1735 and Winchester the following year. York's new hospital therefore placed it close to the vanguard of medical progress.

By the time of Stubbs's arrival, it was firmly established in a new building, with a pair of staff surgeons and two physicians, men backed by an up-to-date European medical training, in contrast to the empirics, mountebanks and quacks who had dominated York's medical scene only a generation earlier. On its first floor were two wards, a male and a female, holding sixteen in-patients each, and a bathroom, used for therapeutic sweat baths rather than washing. On the floor above were the surgical theatre, two smaller wards and the room of the all-powerful matron. Below were the porter's lodge, the doctors' common room, a bakehouse and a brewhouse. The last two were not merely, or even primarily, for providing food and drink, but

to ensure a ready supply of bread-and-ale poultices.[2]

Groaning in its paupers' wards were men and women with hands and fingers cut off, broken limbs, fishbones stuck in the throat, dog bites, boils, fistulas, the bloody flux, abscesses in various parts, hysterical complaints and other more or less inadequately diagnosed ailments. The hospital's published outcomes for in- and out-patients in the year 1744–5 reveal an optimistic rate of cure:

Total admitted last year	482
Of whom have been cured	324
Relieved	25
Discharg'd as incurable	12
Discharg'd for Irregularity	2
Discharg'd as improper Objects	2
Discharg'd at their own Request	10
Discharg'd for non-Attendance	7
Died	13
Remaining under cure	87[3]

Though it must sometimes have done good for its patients, the hospital movement's historical significance does not come from how well it treated disease, but from the way it promoted medical study. The hospital was a rolling exhibition of pathology, the beds were test beds in which illnesses could be compared and contrasted, and diagnoses and (sometimes) treatments developed, in a convenient, concentrated and controlled environment. Stocked with both live and (a few) dead subjects, the hospital provided a momentous, if still primitive, new way of doing medical education and research. The downside was that, largely unknown to the doctors, hospitals also promoted disease by concentrating pathogens and spreading them from bed to bed, as they still sometimes do. The extremely low death rate published by the trustees of the York Hospital in 1745 was a matter of public relations. Patients likely to die were not admitted at all, and in-patients in the same condition were quickly discharged to do their dying at home. No one wanted to disturb the illusion that the wonderful new hospital was a place of cure.[4]

Stubbs's tale of his six or seven years in York, as he related it to Humphry, is almost entirely about his anatomical experiments at or around this place. His interest in such studies centred for the first time on the human figure, and Stubbs soon became known throughout the city for these activities, to the extent that a letter written later by Sir

Thomas Frankland to Sir Joseph Banks remembers the 'vile renown' he earned in York as a result of them.[5]

Humphry says that it was Dr Charles Atkinson 'who procured him the first subject for dissection'. Atkinson's son (and successor as surgeon at the York County Hospital) was to write many years afterwards that his father had been a man of 'the highest energies' and that he had particularly befriended 'Stubbs the famous horse-painter'.

> When I went accidentally to see [Stubbs's] gallery of paintings in London, he also acquainted me, that my father had first initiated him, and taught him the anatomy of the horse, and had made several dissections for him. He acknowledged this fact to me with gratitude; and on that account treated me with particular attention.[6]

Stubbs's pursuit of anatomy does not signify he was becoming less interested in art. He well knew and approved of the fact that, on the Continent, anatomy and drawing were old bedfellows. This was not, however, true in England, where student artists traditionally approached the body apprehensively, and from outside. Life drawing came after many months of studying 'ideal' antique nude statues and casts, and only then could one move on to life drawing and the wobbly imperfections of the flesh itself. But at the Académie Royale in Paris, and similar schools in Italy, young artists were trained also to look inside the body, by either carrying out or (more commonly) watching dissections, whereby they proclaimed themselves heirs to the tradition of Leonardo, Michelangelo and Raphael. With English art education lagging so conspicuously behind this example – anatomical demonstrations for artists began haltingly only in the 1760s – it is striking that Stubbs, on his own course of self-education, was constrained to tackle anatomy even before he had been to Italy to study classical perfection, and that he did it so very seriously. His whole instinct as an artist, even at this early stage, compelled him to discover the radical structures underlying life's surface.

The relationship between art and science was a two-way street. The medical anatomist needed the artist to record the results of his work, before they dissolved in mess and putrefaction, but he also wanted the cultural validation which art could give. A glance at anatomical illustration between 1600 and 1800 shows how artists helped to make anatomy cultured and respectable. They arranged skeletons and flayed corpses in 'artistic' poses, decorated the images with emblematic detail, and provided them with high-minded backgrounds (see p. 176).

Stubbs's anatomical mentor Charles Atkinson, whose exact birth date is uncertain, was still a young man, probably between twenty-five and thirty. Only recently appointed to the hospital (he is not among the medical staff listed at its inauguration) he took Stubbs under his wing, recognising in him a youth perfectly suited to the work of an anatomical artist. It was a task that made exceptional demands, as Stubbs's predecessor in this field Leonardo da Vinci himself had once emphasised:

> And though you have a love of such things, you will perhaps be impeded by your stomach . . . [or] the fear of living through the night hours in the company of quartered or flayed corpses fearful to behold. And if this does not impede you, perhaps you will lack the good draughtsmanship which appertains to such a representation, and even if you have skill in drawing it may not be accompanied by a knowledge of perspective; . . . you might lack the methods of geometrical demonstration and the methods of calculating the forces and strength of the muscles.[7]

For early anatomists delving into flesh was analogous to exploring the globe. They, too, were voyagers, hacking through the inner jungle of the Corpus Humanae in search of the biological Eldorado of the soul, the golden element of life.[8] Leonardo had written of 'the geography of the heart' but he had been an anatomist far ahead of his time, not merely representing the explored body, but revealing the method of dissection, and then the process by which the biological systems so revealed could be understood. His achievement was to combine realism (that is, the simulation of three-dimensional space on paper) with necessary schematic simplifications, all with the overriding purpose of understanding. Stubbs answered well to all that Leonardo saw as necessary in the anatomical illustrator. He developed into, and in the 1740s must already have been to some extent, a superb anatomical draughtsman with a strong grasp of structural mechanics, perspective and geometry. Nor can one doubt Stubbs's stomach for the gruesome task.

By the eighteenth century most anatomists were of the Leonardian persuasion. For them it was enough to understand the different and interlocking mechanical systems by which life organised itself: skin, bones, blood vessels, nerve networks, alimentary tracts, intestines, lymphatic systems, organs. But they were still trying to answer the problem of life by studying death. It is the presence of this paradox that distinguishes anatomy from autopsy, which seeks the causes of death, not the mechanisms of life.

If these were the scientific motives of the Georgian anatomists and surgeons, they were widely unappreciated or disbelieved. William Blake's savage indictment of 'Jack Tearguts' is a vision of dreadful night:

> He understands Anatomy better than any of the Ancients. He'll plunge his knife up to the hilt in a single drive, and thrust his fist in, and all in the space of a Quarter of an hour. He does not mind their crying, though they cry ever so. He'll swear at them and keep them down with his fist, & tell them that he'll scrape their bones if they don't lay still & be quiet. What the devil should the people in the hospital that have it done for nothing make such a piece of work for?[9]

Hatred of surgeons arose partly because, in an age without anaesthesia, their violent and agonising assaults on the body seemed to bring so little benefit. More negatively, surgical activity, whether on the living or the dead, was morally linked to sexual depravity. Some anatomical illustration was frankly sexualised and it is hard not to think that the Catholic Church's long-standing hang-up about dissection was in part a matter of sexual disgust.

But the analogy between surgery and sexual violation was not the hardest obstacle faced by anatomists. The biblical doctrine of the resurrection of the body promised that, on the Last Day, all corpses would rise fully restored from their graves and walk again: 'And I will lay sinews upon you and will bring flesh upon you, and cover you with skin and put breath in you, and ye shall live; and ye shall know that I am the Lord.'[10]

This general resurrection was almost universally accepted by the mass of people, and this meant there were severe legal restrictions on what could be done to a dead body. Huge cultural importance was attached to the 'decent Christian burial', by which the intact body was interred in consecrated ground. So spectral was the prospect of incomplete burial in the popular mind that, for centuries, the worst judicial penalty reserved for traitors was to be publicly hanged, drawn and quartered, a fate that almost everyone believed to be more terrifying than death alone. But now, in the increasingly punitive eighteenth century, the principle of judicial butchery found both extension and refinement: it was extended to acts of murder in general, and refined so that the criminal's body was opened not by the hangman but the anatomist, as likely as not under the eye of an anatomical artist, with his graphite pencil and sheets of Whatmore paper at the ready. Georgian murderers were thus increasingly condemned to be hanged and quartered – and then drawn.

The *perceived continuity* between executioner and anatomist must have been uncomfortably pointed up at York – not least to Stubbs's own group of friends – when the twenty-two Jacobite rebels met their deaths on the Knavesmire. After the hangings, their hearts were cut out, shown to the crowd and burned in a brazier, after which the heads were severed and held up for the crowd to cheer. But 'drawing' or disembowelment no longer took place and the severance of the limbs – the quartering – was performed only symbolically, with the hangman's cleaver lightly scoring the flesh.[11] So the mutilation and separation of body parts performed by the anatomist had, by this time, begun to exceed anything done by the hangman. When violent demonstrations attended Tyburn executions, these were not protests against capital punishment as such, but against the medical dissection of the remains that was likely to follow.

CHAPTER 14

In the Schoolroom

Mr Stubs, it seems, has been a drawing master amongst other things at Heath's Academy, though he followed that profession for a short time.[1]

Most corpses in anatomy labs were not those of executed criminals. They were, as the public to its horror gradually became aware, the bodies of perfectly law-abiding people, which the anatomists bought illegally from the night-time entrepreneurs known, with grim irony, as Resurrection Men. Largely preying on paupers' graves (because the rich were buried deeper), the grave robber was a familiar face in dissecting rooms, passing and repassing with his grisly, sack-bundled merchandise.

The resurrection trade was both deeply unpopular and greatly feared – some mourners took to setting man-traps around the graves of their loved ones – but it was growing at a startling rate. Legitimate dissections at the few old-established medical schools, and at the Barber-Surgeons' Hall in London, had always been infrequent and were largely theatrical demonstrations. Now, as a new investigative type of doctoring became the fashion, the dissection of the human body in private anatomy schools was all the rage. Atkinson appears to have organised such a school in York, with Stubbs initially as one of its pupils, then as a teacher.

If the mortality figures published in the *Courant* are accurate, opportunities for post-mortem examinations in the hospital itself were limited. There can be little doubt, therefore, that when we learn of Stubbs 'procuring' anatomical subjects, this must mean from grave robbers. Atkinson, though a Catholic, does not seem to have worried about the morality of this, any more than about the practice of dissection itself. Stubbs's conscience was equally untroubled, as is related by his obituarist in the *Sporting Magazine*:

> To dissect the body human was also his diligent pursuit insomuch as (as I have heard a relative of his declare), to procure subjects for his improvement, Mr Stubbs has, an hundred times, run into such adventures as might subject anyone with less honourable motives to the greatest severities of the law.[2]

Stubbs was not training for a medical career, and so remained free to concentrate his attention solely on anatomy. His 'vile renown' indicates he was regarded as a local specialist who, quite soon, 'was prevailed upon to give anatomical lectures privately to the pupils of the Hospital'.[3]

It is the first glimpse we have of Stubbs in this new role of teacher. Later, in London, he undoubtedly took pupils, among the first of whom was his eldest son. But by that date he was exercising his right to sign apprentices or trainees, the prerogative of every busy studio-based painter. These helped with the routine work of preparing canvases, mixing pigments and keeping the place clean, while learning by instruction and example the rudiments of their master's trade. But Stubbs's anatomical demonstrations in York were for groups of fee-paying students, a very different matter.

Young artists, waiting to be overtaken by success, commonly lived by teaching privately or in schools, as they still do today. Stubbs may have found this preferable to working shifts in Tireman's shop, since he now took on a second teaching job. This was not in anatomy and it was not in York. Hearing that the Heath Academy, a boarding school for boys founded in 1740 in the village of Heath near Wakefield, needed a drawing master, he applied for the job and was appointed.

By this date Stubbs's patron Dr John Burton was a resident of York, but he had previously lived and practised medicine at Heath. He still owned property there and, since he must have known all about the Academy, it was probably Burton who introduced Stubbs to its headmaster, Joseph Randall.

Randall was a man of progressive views, likely to have been impressed rather than bothered by Stubbs's 'vile renown' as an anatomist in York. Buying a large house in Heath from a successful shoemaker, he had chosen the 'salubrious' village as an ideal place for his school, which had capacity for 130 boarding pupils and another forty day-boys. In 1745 Randall advertised his 'Terms for Instructing Young Gentlemen at the Academy for the Counter . . . for the Compting House . . . for a Stewardship . . . for an Attorney's Clerk . . . for the Navy . . . for the Army . . . for a Gentleman' with tuition fees ranging between 3 and 5 guineas, and an additional 10 guineas charged for boarding.[4] Three years later Randall wrote a detailed article on the school – later expanded into a book – and this gives an idea of the scale of Randall's ambition.

This little Village is much taken Notice of for its healthful Air, genteel Buildings, and the delightful Eminence of its situation, and for being happily retired from Temptations. In the Schools of this Academy, which is a spacious modern structure, Ten Masters are employ'd in forming Youth for the Different Scenes of Life . . . Those now in the Academy are of different ages, from man's Estate to seven Years of Age; and of all Ranks from the Nobleman to the Tradesman . . . They consist of Natives of this County, and most of the Counties North of London, and of that city; Scotland; Ireland, and several Foreign Parts. And in order to furnish the Minds of Youth with proper Ideas, the pupils have the Liberty of attending Discourses in the Evening, upon the most interesting Subjects; and are encourag'd freely to speak their Thoughts that they may be assisted in their Conceptions and Expressions. In these meetings the Works of GOD, most visible in the creation, and their general uses to mankind, are pointed out; to excite the Wonder and Gratitude of Youth . . . [5]

All this erudition was dispensed in a building previously known as 'Cobbler's Hall'.

Stubbs had come here as 'a drawing master among other things' as he later told Josiah Wedgwood. The nature of those 'other things' was not revealed, but the young artist evidently played a fuller part in the life at Heath than might be supposed had he been only a part-time art teacher. Randall's courses were drawn up along vocational and class lines. All pupils learned writing, English grammar and arithmetic, and could choose between the classical languages and English history. Lessons in French and drawing were also common to all but thereafter study was tailored to the pupils' ages and the needs of different careers. More advanced mathematics and philosophy were thought essential for the army and navy, and useful for gentlemen aiming at the university, though not for those with lowlier destinies. Clerks and stewards might have to content themselves with bookkeeping and 'the use of the Terrestrial Globe and Maps', while prospective merchants studied the mysteries of 'bookkeeping in the Italian style in three Ballances', legal clerks learned 'the Law Hands', and estate stewards did 'Hydrostaticks, particularly adapted to conveying water to Gentlemen's seats', a curricular item that speaks, it may be, of a personal enthusiasm of Randall's. On the other hand, Randall was not doctrinaire about his curriculum: 'If those design'd for Business show genius for the Classics they should be allowed to study them . . . Let the Genius of Youth be what it will.' He also sympathised with the pain of the unsuitable pupil 'tormented many years with Latin to which he has not been equal', and

these pupils were offered the less taxing and more entertaining alternative of studying history.

Existence at the academy was not entirely dour and studious. As well as drawing with Mr Stubbs, the pupils (usually at extra cost) were taught science in the form of 'Experimental Philosophy', 'dancing by Mr Greaves of Wakefield' and fencing. They could also enjoy swimming in the nearby river and take 'agreeable walks and manly diversions'. Randall himself was primarily a geographer and topographer, very interested in the science of agriculture and land management, and a man of considerable energy. Where possible, he was the author of his students' textbooks, including the compendium volume *A System of Geography and Introduction to Mathematicks,* and 'my new French grammar, now in the press', both published in 1745. Randall seems to have been more humane than the general run of schoolmasters. In his *York Courier* manifesto, he deprecates 'that ungenteel Custom of Whipping, which ought to be warded off, and never made Use of, till the unhappy Youth makes it absolutely necessary to prevent greater Evils to himself, his Friends and to Mankind'.

Randall was the kind of headmaster who attracted teachers of the highest quality and Stubbs must have found the staff common room a stimulating environment. In the particular case of George Gargrave, the mathematics master, the Academy enjoyed the services of a very remarkable intellect indeed. Gargrave was a Yorkshireman from Leyburn in the Dales and was 'generally considered one of the best practical astronomers in the north of England' who was also 'a very skilled musician and a very superior penman'. His erudition, based on mathematical insight and telescopic observation, resulted in a series of treatises on Venus and the moon, but Gargrave was a highly successful schoolmaster, too, eventually founding his own academies in Liverpool and Leeds. These did so well that he retired to his native Dales a wealthy man.[6]

Later, recalling his time there to Josiah Wedgwood, Stubbs pinpointed Heath as the place where he first fully worked out his ideas on the fundamentals of art.

> He began by teaching perspective to his pupils, which he believes to be just as rational a method in drawing as learning the letters first is [in] acquiring the art of reading, & he would have the learner to copy nature & not drawings.[7]

This procedure was highly irregular. The student draughtsman conven-

tionally progressed from making laborious copies of 'ideal' prints and drawings (rather as Winstanley had tried to start Stubbs as a copyist), then to sketching casts of body parts and whole figures (usually classical sculptures) before at last graduating to life drawing. For professionals, the highly technical and difficult science of linear perspective was learned still later; in the case of schoolboys it is unlikely to have been broached at all.[8]

Stubbs's reversal of these priorities indicates that he had been studying Leonardo da Vinci's *Treatise on Painting*, a book which may have been his teaching primer at Heath. The treatise, first published in English in 1721, shows from its opening words the exact correspondence between Leonardo's and Stubbs's principles: 'Whoever would apply himself to Painting,' writes Leonardo, 'must in the first place learn Perspective', and he goes on to argue within a few pages that the artist's business is 'not to Represent the works of Men, but those of Nature, who at the same time is so abundant in her Productions that 'tis ridiculous to have Recourse to her Servants who have nothing but what they borrow'd from her'.[9] Leonardo's ideas were not then particularly influential in Britain – the book's next English edition did not appear for more than a century – but it looks as if he was a model of great significance for Stubbs, not just reinforcing his prejudices in favour of perspective and against second-hand working, but providing a robust conceptual framework for the Englishman's whole artistic outlook. More immediately, however, Leonardo offered the strongest possible validation of Stubbs's growing ambitions in anatomy.[10]

1. Stubbs's enamel self-portrait, 1781, the year of his election (later annulled) to the Royal Academy. It was probably painted for his Lincolnshire friend, the lawyer Richard Thorold.

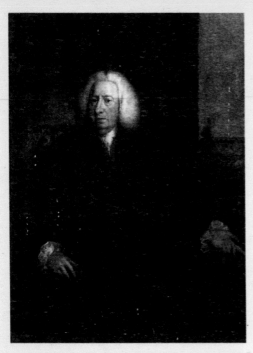

2. John Blackburne of Orford Hall in 1743, by Hamlet Winstanley. Note the heated glasshouse in the background.

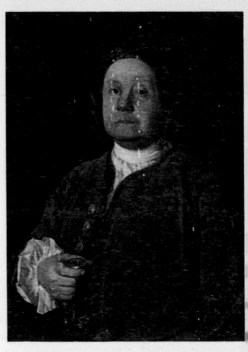

3. The Catholic draper George Fothergill of York. Possibly commissioned for his 57th birthday, 1746.

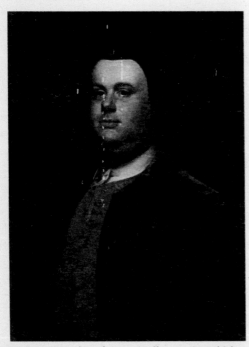

4. James Stanley of Cross Hall, near Ormskirk, Lancashire, in 1755.

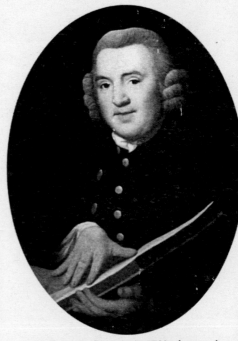

5. Dr Erasmus Darwin in 1783, the year he published his first book, *A System of Vegetables*, translated from Carl Linnaeus.

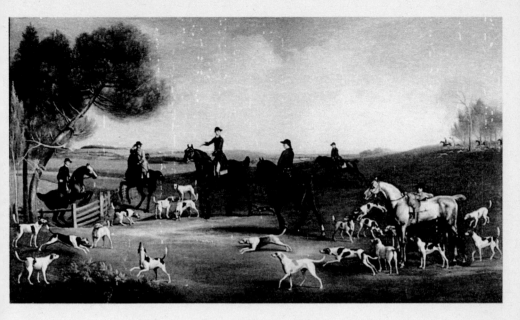

6. *The Charlton Hunt*, 1759.
The Duke of Richmond is the tall, centrally-placed rider.

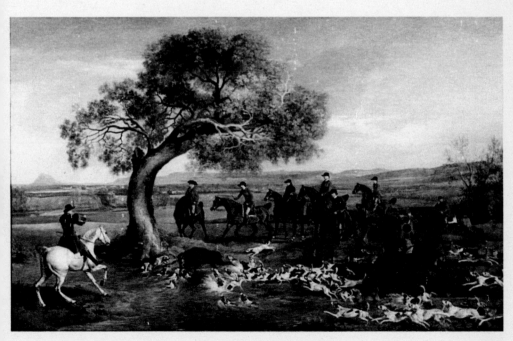

7. *The Grosvenor Hunt*, c.1762.
Richard Grosvenor is the stocky rider looking down on the stag.

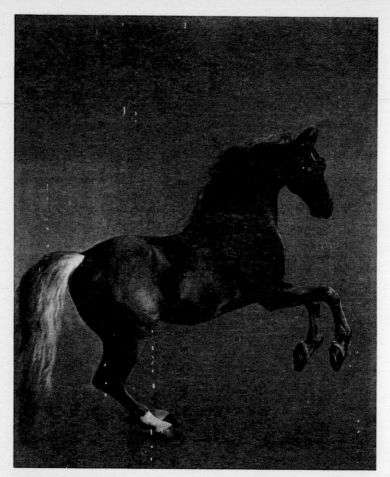

8. Lord Rockingham's Whistlejacket, at life-size, 1762. The significant space between the horse's head and the top of the canvas supports the idea that he was intended to carry a rider.

9. Gimcrack on Newmarket Heath, 1765.
In the background Gimcrack trounces three opponents, while the foreground shows the same horse 'rubbing down' afterwards. The jockey wears Lord Bolingbroke's colours.

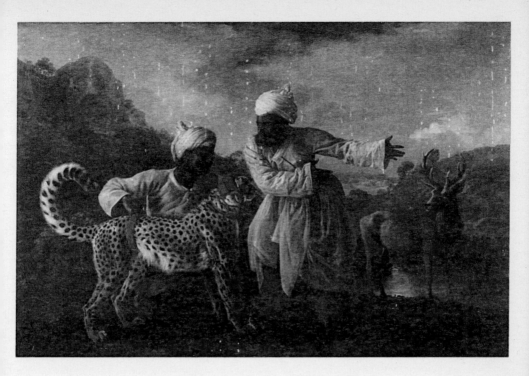

10. A cheetah and its Indian handlers, 1765.
The imaginary landscape contributes to the mythological atmosphere of this painting.

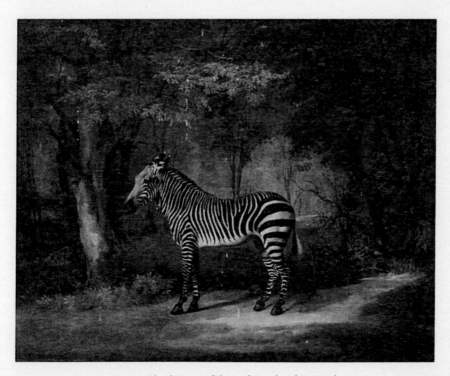

11. Queen Charlotte's celebrated South African zebra,
painted in 1763.

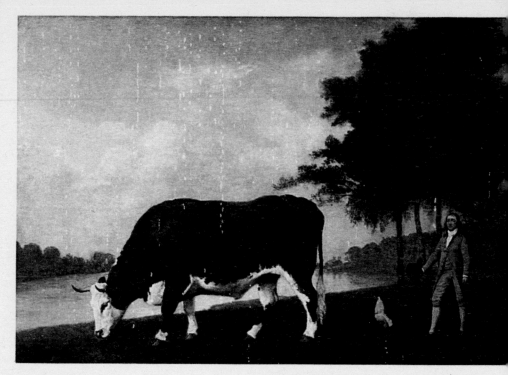

12. John Gibbon in 1790 with his fighting cock and the Lincolnshire Ox – a triple display of masculinity in the setting of St James's Park, London.

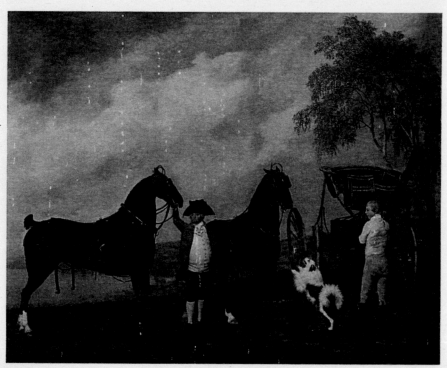

13. Samuel Thomas, the Prince of Wales's state coachman, with the royal phaeton, its team and a tiger-boy. This vehicle is the eighteenth-century equivalent of a high-performance sports car.

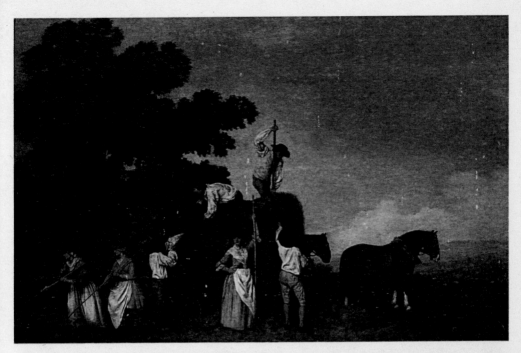

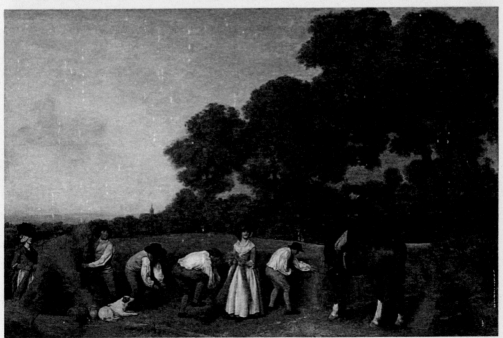

14 & 15. *Haymakers* (*top*) and *Reapers*, 1785.
The paintings were saved for the nation after a high-profile public campaign and appeal in 1977.

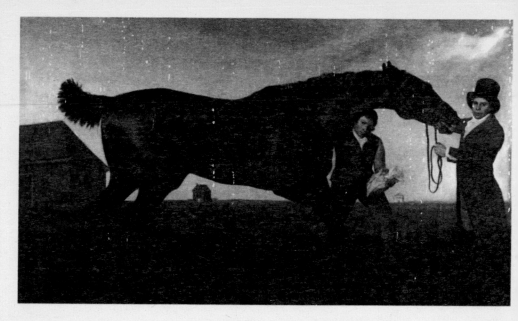

16. Sir Harry Vane-Tempest's Hambletonian in 1799, rubbing down after his victory in one of the greatest match-races ever run.

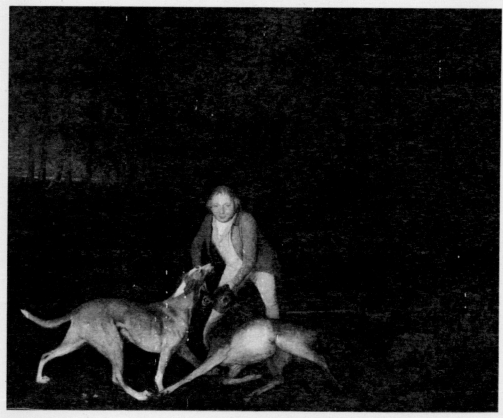

17. Freeman, the Earl of Clarendon's gamekeeper, at twilight, with a dying doe and a hound. Painted in 1800.

CHAPTER 15

Burton the Jacobite

Dr Burton, Physician and Man Midwife, applied to him . . .

While Stubbs found in Dr Charles Atkinson a committed anatomical patron, he also owed much to the physician and obstetrician John Burton. Until after their two older sons were born, the Stubbses' main home continued to be the parish of St Helen's Stonegate and, in his comparatively short time with Joseph Randall, the artist may have divided his time between here and Wakefield. Since we know Dr Burton was close to Stubbs at the end of the 1740s, it is likely that, as the family increased to three, and then four, the great man midwife himself attended these births.

During the same period Stubbs was aiming to better himself on various fronts. He took lessons in French and fencing, and he, or his wife, may have also learned dancing, for there was an incident that evidently earned him some notoriety: 'Here [at York] he had the rencontre with Mr Wynne the Dancing Master.'[1]

Dancing masters were stock Aunt Sallies for the comedians of the age. Foppish, fussy and generally regarded as serial philanderers, their skills were nevertheless in demand from all who wanted to acquire grace and decorum.[2] A 1738 advertisement in the *Leeds Mercury* shows that Robert Winn gave dancing lessons at his own premises in Wakefield's Westgate, as well as borrowing rooms from 'Mr Hoole the pewtherer' in Leeds, where it is possible Stubbs first ran into him.[3] But Humphry's use of the French term 'rencontre' indicates some altercation or fight, even a duel, between Stubbs and Winn in York. What on earth could this have been about?

In such cases a 'domestic' incident always looks likely and Stubbs may have discovered, or imagined, that Winn had made a pass at his wife. But the fact that the dancing master was a Wakefield man opens another possibility. The baronet Sir Rowland Winn of Nostell Priory, near Wakefield, was a prominent figure among the Yorkshire Whigs. In 1733–4 he had almost bankrupted himself in a failed attempt to be elected as a Whig to one of Yorkshire's parliamentary seats. It had been a famously bruising contest, and the most violent campaigner against

69

Winn was none other than the arch-Tory Dr Burton himself, at that time living and practising medicine at Heath. If there was some (illegitimate?) relationship between Robert Winn and Sir Rowland, the face-off between the dancing master and Stubbs may have been a question of politics and of Stubbs's close association with Dr Burton. But it seems unlikely we shall ever know for sure.[4]

Burton is a fascinating figure, with the distinction of having inspired two eighteenth-century English geniuses: not only George Stubbs but the York novelist Laurence Sterne. The son of a rich London merchant who had retired to Heath, Burton got a rounded medical education at Cambridge, Leyden and Rheims Universities before returning to Yorkshire to practise as a physician.[5] In 1735, at the age of twenty-five, he moved his practice from Wakefield to York and took the leading role in establishing the York County Hospital, a great coup in civic politics for his party. Burton became resident physician at the hospital, but he also had a large and popular practice in the town and surrounding countryside. He treated the illnesses of rich and poor alike, usually without charge to the poorest. The strong personal following he built up in this way enabled Burton the politician to exercise direct influence over numbers of votes at election time.

Burton's private tastes were antiquarian – he was particularly fond of the medieval monasteries of Yorkshire – and his attachment to the House of Stuart was sentimental as well as principled. But those principles were fierce: aggressively discontented with the Hanoverians and suspicious of London, he upheld ancient English liberties which, so he felt, had been sapped by years of corrupt centralising rule by German kings and the Whig Sir Robert Walpole. Burton's voice was one of the loudest of the city's traditionalists, as contemptuous of 'modernising' Whiggery, as of the political tricks of the local Whig enforcers around the Archbishop. His life and his writings reveal a forceful, proud and at time boastful individual, who could also be dangerously rash.

It was rashness that possessed Burton as soon as Bonnie Prince Charlie crossed into England by the western road, making him the only one of York's Jacobites stupid or brave enough to cast caution aside. After consulting the Recorder Thomas Place (himself a silent sympathiser with the Pretender's cause) Burton obtained safe passage out of the city, saying he had business in the market town of Settle, in the extreme north-west of the Yorkshire Dales. As he rode through

Micklegate Bar early on Saturday, 23 November, attended by one servant, the rebel army was on the road from Kendal to Lancaster. In driving rain and across rough Pennine country, Burton's was an arduous ride whose ostensible purposes – to collect rents and pay the bills of two farms his wife owned in Ribblesdale – were real enough. But they also sent him in precisely the right direction to intercept Bonnie Prince Charlie.

Burton travelled fifty miles that day. At Settle he consulted with his land agent and slept the night, before moving on to Hornby. Here he could have had no conceivable estate business, but he had heard that a detachment of rebels was staying at Hornby Castle. Stopping at Mr Johnson's inn, Burton sent up a letter addressed to the Duke of Perth, whom he had met in York during the Duke's recent reconnaissance trip. Shortly afterwards two Highlanders appeared at the inn, finding Burton in the barber's chair being shaved. According to the doctor's own exculpatory account, printed four years later, they arrested him and took him for interrogation to Lancaster, where the main body of rebels had now arrived. Burton's accusers in York would later come nearer to the truth when they alleged he had deliberately engineered the arrest. Precisely what passed at Lancaster Castle, in interviews with the Duke of Perth, Lord George Murray and (no doubt to Burton's intense gratification) the Pretender himself will never be known for certain. But a fugitive fragment is preserved in a letter from Archbishop Herring to his friend Lord Hardwick, the Lord Chancellor, written a week later. Herring, having spoken with Burton in his prison cell, relates the physician's own verbatim account of the briefest of exchanges with Charles Edward.

PRETENDER: Who are you, Sir?
DR BURTON: Dr Burton, a Physician at York an't please your Highness.
P: What brought you here?
B: Some affairs in the neighbourhood.
P: How stand our Friends affected at York?
B: Please your Highness they are very unanimous there.
P: Where is Wade and his Army?
B: I believe, Sir, his motions will depend on those of your Royal Highness.
P: Where is Ligonier?
B: I certainly don't know, Sir, but by our last accounts he is in Cheshire.
 Exit Dr Burton.[6]

The phrase 'they are very unanimous' stands as a nicely diplomatic answer, though I wonder if the doctor (who when talking with Herring

was trying to save his own skin) would admit to addressing the Prince as 'Your Royal Highness'.

The 'prisoner' spent the night of Sunday, 24 November in Lancaster, though he was not actually in confinement and passed freely among the Jacobites thronging the town. He was allowed to leave next day, without even being required to surrender his horses, though they were 'a Brace of Geldings of great value', according to Herring. Returning through his estates, where he completed his business, Burton arrived back in York the following Wednesday to find his cover had been thoroughly blown. His activities had become the talk of the Dales and the Settle postmaster, a Quaker named Burbank, had been quick to write to the authorities in York with particulars. The Whigs in the city were convinced that Burton had treacherously briefed the Pretender on the state of York's defences and he was arrested and committed to York Castle a few days later. Now with a charge of treason hanging over him, he knew that, if convicted, he faced a dreadful death.

Burton had run an extraordinary risk. Why? Perhaps, as some said, he had taken a gift of money to Lancaster from the Prince's York supporters. Perhaps he genuinely wished to brief the Prince. Or his journey might merely have been the impulse of a besotted fan, prepared to gamble all to be taken into his idol's presence. He would have had grounds to hope that friends like Thomas Place would not persecute him afterwards. But Precentor Sterne, who already hated Burton with a passion, was another matter. As the Archbishop's political strongman in York, Jaques Sterne had first run up against John Burton during Rowland Winn's campaign in 1734. They locked horns again in another hard-fought York election in 1741 and, now that Burton had set himself up for a thumping fall, Jaques Sterne – a magistrate as well as a powerful church official (and Laurence Sterne's uncle) – was the very man to give him the trip.

But the servant who had accompanied Burton to Lancaster refused to testify against his master and Sterne needed more solid evidence. This came when a fellow prisoner, James Nesbitt, informed Sterne that he had witnessed Burton, during his confinement in York Castle, drinking a toast to the success of the rebellion. A second *prisoner*, Richard Murth, was later found to corroborate Nesbitt's story. But while Sterne was still assembling a case against Burton to present at the coming assize, the suspect was whisked out of his jurisdiction. On 12 March Burton was ordered to London, in the custody of a Court Messenger named William Dick, to be questioned by higher-ranking

men than Sterne. Hobbling from an attack of gout, Burton refused to mount a horse and was conveyed to the capital by coach. Before leaving he had resigned his post at the hospital, a most reluctant action which pained him quite as sharply as the gout.

Burton spent the next twelve months in London, confined successively in William Dick's house (where he succumbed to the charms of a fellow prisoner, the Jacobite pin-up Flora Macdonald) and in the Tower (spending the time copying '416 charters, patents and escheat rolls'). At the Cockpit in Whitehall he suffered a five-hour examination by Andrew Stone, secretary to Secretary of State the Duke of Newcastle, at which, stoutly maintaining his innocence of treason, Burton insisted he had been brought to the Pretender against his will.

Meanwhile Burton's livelihood had dried up and there were moves in York to make him bankrupt: one tale had it that he owed £5000. Mrs Burton failed to pay the rent on their large house in Blake Street and was turned out by Burton's landlords, the City Corporation. The lease was advertised in the *York Courant* on 8 April 1746: 'The Dwelling-House of Dr Burton, being a large commodious House, in compleat Repair; with Coach-house, Stabling, two Gardens, and other Conveniences'. To compound this embarrassment, 'the Furniture and his Library of Books [are] to be immediately disposed of' which, in the case of the library, was a grievous loss for a man like Burton. Yet there is no record of an actual bankruptcy. Perhaps this was because most of his largest creditors were the very Whigs who wished to bring him down, and his ruin would mean they would never get their money back.[7]

As Burton's discomfort increased his enemies in York rejoiced, with Jaques Sterne orchestrating the huzzas. Sterne also kept control of the police work in the case. He sent investigators across the Pennines in search of witnesses to Burton's activities during the rebellion and amassed bundles of damaging circumstantial evidence. One of his emissaries, a fellow magistrate and lawyer of York, Dr Mark Braithwaite, wrote gloatingly in May 1746 to Sir Rowland Winn that 'I have been at Lancaster with Mr Masterman examining the Rebels there . . . if you come to York at the meeting [i.e. York races, held during the assizes] I think that the Dr. may chance to swing'.[8]

But swing, in the end, he did not. Despite the strong case against him, London thought Burton small fry compared with Lord Lovat and Colonel Francis Towneley, both of whom went to the gallows as traitors. After Culloden, Burton benefited from a slowly developing

desire for amnesty. The process took almost another year, but on 25 March 1747 he was quietly released to go home to his wife, his medical practice, and his circle of friends in York. Of this group, the Stubbs family were by now established members.

William Hogarth's illustration of a scene from *Tristram Shandy*. The somnolent figure in the chair is Dr Slop.

CHAPTER 16

Dr Slop

... to make designs for a book of Midwifery he was about to publish ...

Burton returned bristling with determination to vindicate himself. A hostile letter to the *York Journal or Protestant Courant* described him at this point as

> an angry Adept of the [Medical] Faculty equally famous for his skill in Poetry and Politics, Medicines and Oeconomics. We hear the said M.D. as soon as he is delivered out of the Hands of his bloodthirsty Enemies, designs to read lectures in these several sciences for the Benefit of the Publick *and Himself.*[1]

This anonymous correspondent was almost certainly Laurence Sterne, put up to the job by his uncle.

Perhaps the first of these lectures, if Burton ever gave them, were more like coffee house rants about how he had been persecuted, rehearsals for the book he was already writing entitled *British Liberty Endanger'd.*[2] In the guise of a political apologia, the book is a vigorous attack on Precentor Sterne, and his devious motives and methods. In print by the end of 1749, it is rather an impressive polemic, despite Burton's tendency to lapse into sarcastic cavilling. As a defence of his own actions during the Forty-Five it is less persuasive, and Burton is silent about his dealings with the Jacobites in Lancaster on the crucial dates of 24 and 25 November 1745, presumably because anything he did say would only condemn him.

The second thrust of Burton's rehabilitation was medical rather than political and to that end he wrote another book. The subject was obstetrics, which was still a bitterly contentious subject. Childbirth had been until recently, and by convention and common consent, the exclusive preserve of female midwives using their traditional but 'unscientific' skills. For scientific doctors (always, of course, male) to get involved (as they were now doing in increasing numbers) was to threaten to overturn a natural order: reason and the intellectual life were male, and childbirth was female. Mixing the two might lead to

many unknown and unwelcome consequences. But there was another factor, too. By making bold to touch a woman's private parts, the male doctor threatened the husband's monopoly over his wife's body. It was therefore as lechers and, worse, as gender traitors that many men regarded the likes of Burton.

But this was also a period in which physicians were beginning to make distinctions between consultants in various fields. Two of the earliest specialists to emerge from the swamp of medical ignorance were man midwives and mad-doctors. This was partly because their territories were easier to mark out than most, but it was significant, too, that the two specialisms posed key Enlightenment problems at their starkest: the appearance of life, the disappearance of reason. There was irresistible pressure therefore for the natural philosopher to enquire into them, so that men like Burton found it impossible to stand aside and leave the management of birth to women alone. Having worked as a man midwife for a decade or more, he now decided to distil his obstetrical knowledge into a treatise which, as he promised, would be not only theoretical but practical, for it would 'save lives . . . and avoid many Dangers'. In seeking an illustrator for this world-changing work, he looked to his young friend George Stubbs.[3]

Like so many earnest treatises of its day, the title of the book, which was issued in 1751, doubled as a publisher's blurb:

An Essay Towards a Complete New System of MIDWIFRY, Theoretical and Practical; Together with the Descriptions, Causes and Methods of Removing the Disorders peculiar to Pregnant and Lying-In WOMEN and New-Born INFANTS Interspersed with Several NEW IMPROVEMENTS; Whereby WOMEN may be Delivered in the dangerous Cases, with more Ease, Safety and Expedition, than by any other method heretofore practised: Part of which has been laid before the ROYAL SOCIETY at London, and the MEDICAL SOCIETY at Edinburgh; after having been perused by Many of the most Eminent of their Profession both in *Great Britain* and *Ireland* by whom they were greatly approved of.

All Drawn Up and Illustrated with several Curious Observations and Eighteen COPPER PLATES.

In FOUR PARTS by John Burton M.D.

> *– Si quid novisti rectius istis*
> *Candidus imperti; si non, bis utere mecum.*
> HORACE.[4]

The book's four divisions deal in turn with: the anatomy and aetiology of normal pregnancy and birth; disorders of pregnancy and their

treatment; 'preternatural labours' and the practitioner's use of instruments, including Burton's own design for obstetrical forceps ('more safe than others'); and finally the causes and prevention of abortion, with notes on the disorders of the newborn and of nursing mothers. This is a good enough framework and Burton uses it competently to summarise the obstetrical knowledge of his day.

But he cared passionately about his reputation and the blithe, take-it-or-leave-it modesty indicated by that Horace epigraph on the title-page (Burton was a devout Horatian) is not reflected in the book. True, it shows him to be quite capable in stretches, of using an acceptably clinical tone. But then he lapses into boasting and violent outbursts against his enemies, who ranged from traditional and ignorant practitioners to jealous rivals. This darker side of the text is broached early, in a Preface so truculent that at times it froths over into paranoia.

> For those people, who like Birds of the Night scream in the Dark, when none can see them; and like cowardly Enemies, unseen, shoot their invenomed Darts at me, in secret Whispers, or anonymous Papers, such Creatures may spit their Malignant Choler, till it consume Themselves, before I shall regard them in the least.[5]

Burton's underlying anxiety was aggravated by the knowledge that several rival obstetricians in London were about to publish their own books, in particular the distinguished London-based Scotsman William Smellie. Beating Smellie to the post – beating London – was another way in which Burton could restore his self-confidence, so badly shaken by months of imprisonment in the shadow of the gallows.[6]

If successful, it would put him in the forefront of the war of words over midwifery. Many books and pamphlets denouncing the employment of men in birthing rooms had been, and would be, written. The great weapon of resistance to such attacks was Reason, and the great enemy of that was Superstition. So, despite his Toryism, Burton lined up alongside those like the militant Deist John Toland, a renegade son of Irish Catholics, who saw the birthing room as uniquely polluted by that grand shibboleth.

> We no sooner see the light but the grand Cheat begins to delude us from every Quarter. The very Midwife hands us into the world with Superstitious Ceremonies and the good women assisting at the Labour have a thousand spells to avert the Misfortune or to produce the Happiness of the infant.[7]

Burton's obstetrical attack on traditional midwives also ranged him

against the more ambivalent figure of Laurence Sterne, whose fascination with the obstetrical battleground led him to place it at the heart of his flamboyant novel *The Life and Opinions of Tristram Shandy*. Published in parts between 1760 and 1768, this is not, despite its title, a book of Tristram's life, but very largely of the events surrounding his birth, which Sterne recounts at inordinate, super-digressionary length. In doing so, he introduces the pompous, complacent, mercilessly lampooned man midwife Dr Slop, an overt fictionalisation of Burton.

Laurence Sterne was the middle-ranking vicar of a country parish not far from York, and had supported his uncle's politics in the 1740s by writing satirical, even scabrous, attacks on the local Tories in the Yorkshire press. Very prominent among these was, naturally, Dr Burton. But, if to ridicule the Tory physician was a reflex for Laurence Sterne, Dr Slop is more than a lampoon. We have seen in Burton and his friends how political traditionalists could also be progressive scientists. Laurence Sterne, despite being an Enlightenment Whig, exemplified the opposite tendency. He disliked Burton's science as much as his politics, and he used his novel to prick what he saw as the man's pomposity and self-delusion.

> Imagine to yourself a little, squat, uncourtly figure of a Doctor *Slop*, of about four feet and a half perpendicular height, with a breadth of back, and a sesquipedality of belly, which might have done honour to a sergeant in the Horse-Guards.[8]

The extent to which this traduces its model can be seen from a description of the real Dr Burton, gathered by one of Precentor Sterne's investigators during 1745–6. In his statement, Cuthbert Davis of Lancaster 'says that on Sunday Evening Novr 24th he saw a tall Well sett Gentlemn in a light Colored Coat in Boots with a Whip under his Arm . . . who he says was called Dr Burton of York'.[9] The phrase 'Well sett' might indicate the size of the doctor's belly, but Davis certainly did not see a dwarf four and a half feet tall.

Tristram Shandy's next distortion is of ideology rather than physique: Slop, unlike Burton, is an admitted Roman Catholic. He thus professes reason in medicine while embracing unexamined tradition in the wider sphere, a pattern of thought which, as we have seen, was typical of Burton's real circle of friends. In the novel Catholicism – the extremity of unreason – is painful to Walter Shandy, but the rational possibilities of Slop's medical theories and supposed expertise are

78

finally decisive in bringing the two men together in a comic alliance against Mrs Shandy and the village midwife.

Walter Shandy's reading of Slop's (i.e. Burton's) book provides the imaginative cement for this alliance. Following Descartes, he locates the seat of the human soul at a specific spot in the brain, 'in or near the cerebellum – or rather some-where about the *medulla oblongata*'.[10] A passage in Slop's 'five-shillings book' had convinced Walter that a conventional head-first birth thus placed the soul in danger of being crushed during its passage through the birth canal, and he hoped Slop's patent forceps would enable his wife to deliver by podalic version – that is, with the baby emerging feet first – or at least to have a speedy delivery, with minimal damage done. The outcome is, of course, the reverse: after a prolonged labour, the baby is born with his nose clumsily crunched in the jaws of the man midwife's forceps.

CHAPTER 17

Dame Nature

The execution of the plates failed in some degree.

In agreeing to engrave Burton's eighteen copper plates, Stubbs was again taking part in the debate about art and nature, but now from a different angle. In effect it was a battle over the meaning of 'nature' itself: was this merely another word for common sense tradition, or was it the substratum of truth which could only be properly understood by rigorous observation, experiment and thought? One of the great themes of *Tristram Shandy* is the whimsicality of human thought, its contradictions and the ease with which reason slips into unreason, and it is not surprising that Sterne trusts his own beliefs so little that he squirrels them away under layers of irony. But in the midwife debate his preference for his old-fashioned female practitioner comes through. He praises her in terms highly pertinent to the debate about nature as an

> upright, motherly, notable, good old body of a midwife, who [got her reputation] with the help of a little plain good sense, and some years of full employment in her business, in which she had all along trusted little to her own efforts, and a great deal to those of dame nature.[1]

In his own book the 'real' Slop insisted on the contrary view of nature. For him the task of the man midwife was to replace this inauthentic and complacent idea of the natural – 'Dame Nature' – with an explicitly Enlightenment view of the case.

> As Nature discloses herself in an obscure manner, we must strictly observe her Operations, by which we shall see the Facts; and then a very thorough knowledge of Philosophy and Anatomy will enable us by such Guides, to penetrate into her Secret Principles; so that these may be said to support or assist each other, as two Lights which ought to unite to dissipate the seeming Obscurity of Nature.[2]

The opposition implied here, between tradition (second-hand knowledge) and the direct observation of nature (the 'light' of anatomy), ran exactly parallel to the artistic questions that Stubbs had been thinking about at Heath.[3]

Stubbs was twenty-three when he met John Burton in 1747 and, on what I think is the only possible interpretation of Humphry, he received the commission for the *Essay*'s obstetrical figures shortly afterwards.[4] Stubbs's youth and inexperience – indeed, his own sense of being 'insufficient' to the task – weighed heavily on him but he nevertheless resolved to 'make himself thoroughly a master of the human figure, & of that part of it in particular which concerned Midwifry'.[5] This, of course, meant in the first place working by observation from nature, that is, from fresh dissections. But the supply of bodies was in this case even more restricted than usual. There would, for example, be no question of using the corpse of an executed criminal, since no pregnant woman was likely to be hanged, even in those punitive times. But a solution eventually presented itself.

> Fourteen or sixteen miles from York, a female subject who had died in childbed was found singularly favorable for the purpose of these studies & brought to York by Stubbs's pupils, where it was concealed in a Garrett, and all necessary dissections made.[6]

This was skulduggery indeed.

Stubbs did not only dissect and draw, he made anatomical paintings in oils, an apparently unprecedented thing to do.[7] My guess is that they were made as visual aids, either to obstetrical lectures given by John Burton or even (since they remained in the artist's possession) to Stubbs's own anatomical lectures.

Given his year or more of dissection and drawing under Charles Atkinson, these parts of the commission were well within Stubbs's compass. However, he told Burton that he was not competent to engrave the plates himself and recommended the use of a professional engraver. Burton may have been mindful of expense, or found it difficult to find a local printmaker willing to take on this sensitive task. Furthermore he was in a hurry. He dismissed Stubbs's reservations, 'insisting upon it, from what he had seen, that he [Stubbs] could not fail in whatever he *undertook*'.[8] Stubbs therefore set about learning how to etch.

It was a quaintly make-do process. Stubbs asks the advice of 'a House painter at Leeds . . . that engraved now and then', who

> had no other instruction to give, than to cover a halfpenny with an etching varnish and smoked it, and afterwards with a common sewing needle stuck in a skewer he shewed him how etching was to be done.[9]

By trial and error Stubbs learned how to handle the etching varnish and needle, until he was able to begin work on Burton's eighteen plates,

which he etched and then, in places, worked over with an engraver's burin, borrowed from a clockmaker. There is a brief passage in the book's preface concerning these plates. Burton may have heard that William Smellie's book, whose publication in 1752 was to lag a satisfactory year behind his own, was not going to include figures.[10] Burton was scornful of the omission.

> Some inconsiderate People look upon Copper-Plates in this Case, to be useless; but judicious Persons must be sensible, that in describing Objects not to be seen, the Reader will have a better idea of them from a true Representation upon a Plate, than only from a bare description, as is evident in all branches of Philosophy.[11]

Smellie – like Burton, rushing into print – chose not to be delayed by the preparation of plates. He was to remedy the deficiency two years later by publishing a magnificent, folio-sized *Set of Anatomical Tables, with explanations, and an abridgment, of the practice of midwifery, with a view to illustrate a treatise on that subject* (1754). In the meantime he laid himself open to Burton's charge of being an 'inconsiderate' person.[12]

Stubbs's pictures fall into several groups. The majority – seven of the eighteen plates – feature pairs of cutaway views inside the womb, demonstrating presentations of the foetus at or close to full term. These include the 'normal' head-down position, podalic version (feet-first presentation) and a variety of problematic breach or transverse presentations. Another group of images, on a single plate, illustrate the development of the embryo in fourteen stages from conception to full term. Two plates give frontal and lateral views of the bones of the pelvis (looking oddly like a male rather than a female one), another two show the placenta and a third pair are cutaway images of empty wombs, one before the conception and the other after the birth. The last plate is non-anatomical, showing the parts and assembly of a variety of obstetrical instruments.

It is easy to understand why etching, rather than woodcut or engraving, was the preferred method of printmaking. Firstly, when time presses, the rapidity of etching gave it a considerable advantage over other techniques.[13] By the same token, etching should have been the easiest of all printmaking techniques to learn, if not to master completely, though on Stubbs's own account he struggled with it at first, being slow to grasp that he must heat the plate in order to get a smooth layer of the wax-based etching varnish on to it. Some artists

rubbed the wax on to the surface of the warmed plate through a screen of silk and then, removing the silk, smoothed it with a leather-covered roller. But Stubbs merely warmed the plate after applying the wax, 'till the plate was sufficiently hot to melt the wax, which he kept warming till it ran off'.[14]

Once a very smooth, thin layer of wax was achieved, etching was not much different from drawing on a sheet of paper. The etching needle or other pointed tool (J. M. W. Turner was to use the sharpened tine of a table fork) was used like a pen. Lines drawn in the varnish, which had been smoked to darken it, exposed a line on the surface of the plate. When the plate was then dipped in a liquid mordant – based on nitric or hydrochloric acid – the drawn lines were 'bitten' into the plate, while the varnish remained unaffected. For the novice etcher, the pitfalls lay in the difficulty of seeing his work clearly as he went along, and in dipping the plates correctly. The temperature of the acid, and the length of time a plate was immersed, were crucial. Mistakes, if not too drastic, could be put right by the direct use of a dry-point scratching needle or, in the case of heavier correction, of an engraver's burin. Stubbs's beginner's work required the latter and, once again, he applied to a friend for help: 'Many of [the plates] were too small to be finished without an engraver, which was equally new to him. These gravers he borrowed off a clock maker.'[15]

As a result of Stubbs's inexperience the technique of these etchings is unsophisticated. Stubbs thought them 'imperfect', though much of the work is quite serviceable and, in the case of the full-term foetuses, striking. These pictures have a certain pathos, as most show foetal presentations from which a live birth could not be expected – neither by the kind of medical intervention then available, nor by trusting in nature. Sixteen different problematic foetal positions are shown. If all were drawn from a single dissection, as we are told they were, we must imagine Stubbs working on the dissected body with Burton alongside him, arranging and rearranging the unborn for Stubbs to copy. In one case, a leg kicks out of the womb and in another an arm seems to grope vainly for entry into the larger world. We see also the highly dangerous case of the umbilicus preceding the foetus into the birth canal, and of the baby's head stuck in the canal while the position of the shoulders prevents further egress.

The work was rough and ready and, to Stubbs at least, over schematic. Most of the wombs are shown as perfect egg shapes, an image driven more by convention than truth. Of the two tables

showing twin foetuses – placentas in table 7, the twins themselves in table 13 – the latter shows the foetuses wedged uncomfortably together in the confined space, their lifelong interdependency fully prefigured. And the demonstration of an obstetrician's assistance, in a case of podalic version, has an almost surreal effect. Here an alien, adult hand reaches into the womb to grasp the baby's ankles in order to pull it by main force into the world: an obstetrical Deus ex machina not to be resisted.

The atmosphere of these images is enhanced by our knowledge of Stubbs's life at the time. He was working on them during, or shortly after, his wife's second pregnancy, which resulted in the birth of Charles Edward Stubbs. That occurred in July 1750 and it is quite likely that the boy was ushered into independent life by Dr Slop himself.

An Essay Towards a Complete New System of Midwifry was published in 1751. It was received unfavourably, particularly by the influential *Monthly Review*. The problem may have been a combination of Burton's provinciality, his Jacobite notoriety and his uncompromising stance vis-à-vis his rivals. Later medical historians have been kinder to Burton, pointing out his more than adequate grasp of the subject as understood in his day. The book was thought good enough on the Continent to merit a French edition in 1771, complete with newly engraved copies of Stubbs's plates. In this, the only other edition of the book, Burton was puffed as one of England's most famous doctors: '*qui jouit de la plus grande celebrité parmi ses compatriots, et dont les ouvrages lui ont acquis une gloire justement meritée*'.[16] How Burton would have relished these words, although it is unlikely he ever saw them, for he was to die on 19 January of the year in which they were published.

Burton's obstetrical ideas have faded into the obscurity of medical antiquarianism, but one aspect of his book has continued to attract comment. This is his pride in the tools of his trade, the instruments that are represented, in all their mechanical complexity, by Stubbs's last three tables. In *Tristram Shandy*, Sterne focuses attention on these instruments by having Dr Slop arrive at the scene of Tristram's *birth* without them. 'Truce! – truce, good Dr. *Slop*! – stay thy obstetric hand,' Sterne apostrophises,

> Thou hast come forth unarm'd; – thou hast left thy *tire-tête*, – thy new-invented *forceps*, – thy *crotchet*, – thy *squirt*, and all thy instruments of salvation and deliverance behind thee. – By heaven! at this moment they

are hanging up in a green bays bag, betwixt thy two pistols, at thy bed's head![17]

The prose in this passage capers in delight at its command of irony. In the eyes of a woman in labour, these were instruments not of deliverance at all, but of dread.

The most terrifying – seen on Stubbs's table 17, figures 6–9 – are the various foetal extractors, the crotchets, double hooks, and *tire-tête* – whose grim purpose was to catch a dead foetus and drag it from the womb. Burton's *tire-tête* incorporated a mechanism designed to crash through the foetal skull and, with several twists of a toggle-shaped handle, to open spokes like an umbrella, thereby gaining purchase for extraction. In some cases the head was torn from the body during this procedure.

On table 18 we see a more hopeful tool, the famous forceps, which were made to Burton's own design and of which he was at this time inordinately proud. These forceps are quite different in structure from the scissor action of conventional forceps and far more complicated. Their jaws, which have been likened to a lobster claw, opened and shut (like the extractor) by means of a screw mechanism running inside the shaft and a toggle handle. While Burton thought his forceps would be a breakthrough in medical technology, historians have been dismissive of the 'whimsical contrivance', finding it bulky, fiddly to work, and with jaws too short and insufficiently curved. These defects alone might not have dashed Burton's hopes, but even he soon realised that his design incorporated a fatal flaw. The forceps did not give the operator any sense of the force he was exerting as he closed the points round the foetal head: it had no 'feel' to it. Laurence Sterne appears to have understood this perfectly. The crushing of the bridge of baby Tristram's nose is directly attributable to the defect.[18]

Burton's obstetrical 'crutch', not mentioned by Sterne, is shown in action by Stubbs in table 16, figure 11. It was used to push the foetus back into the womb in a case where an arm has preceded the head in parturition. Like the forceps, the crutch was a relatively benign device. With the arm protruding there was no chance of a successful birth, and the only other recourse was amputation.

Finally, the *squirt* referred to by Sterne is not seen on Stubbs's plates, being not an obstetrical instrument at all, but a religious one. It was used in Catholic countries to perform a baptism *in utero,* at times when the foetus was thought to be close to death so that it could be taken

quite literally as a means of 'salvation' if not 'deliverance'. Slop, as a Catholic, might be expected as a matter of course to carry one in his green-baize bag and perhaps, for the benefit of his Catholic patients, the Anglican Burton did the same. But clearly such an object had no place in a scientific treatise.

The public failure of Burton's book stood in contrast to that of Smellie's *Treatise* which, gallingly for Burton, was greeted with acclaim in 1752. Incensed, Burton sat down to write a venomous 233-page exposure of his rival's errors, a *Letter to Smellie*, which he published a year later. Laurence Sterne pored over this book in such delight that it became, with the *Essay*, the novelist's prime source for the obstetrical comedy of *Tristram Shandy*. The second book has, however, useful remarks on a variety of matters: the importance of clean instruments (impossible in the case of Smellie's leather-wrapped forceps), the muscle structure of the uterus (played down by Smellie) and the physiology of sex (Burton denies Smellie's hints about the vaginal orgasm and correctly stresses the importance of the clitoris in his account of 'Pleasure in the Female').

The single plate accompanying *A Letter to Smellie* is unacknowledged, but it is not Stubbs's work. His authorship of the *Essay*'s copperplates, also deliberately unsigned, is not in doubt, however, since Humphry's attribution was later confirmed independently by James Atkinson.[19] Why did Stubbs seek anonymity? He claimed to have been so dissatisfied with the quality of his etchings that 'he therefore wished not to affix his name to them'. This shows a considerable capacity for self-criticism in a young artist, whose pride at getting into print might be expected to override any reservations. But I wonder, too, if by now Stubbs felt that his friendship with Burton would soon become more of a hindrance than a help and, by keeping his name off the title-page, he avoided creating a hostage to fortune.

CHAPTER 18

Hull

From thence he removed to Hull.

We are told that, after finishing John Burton's illustrations (presumably in 1750) Stubbs stayed at York for 'two or three years. From thence he removed to Hull always practising Portrait Painting and dissection. – Here he remained about two years longer.' In reality he had at most two more years in York and was a little less than two years in Hull. What took him there?

Some forty miles from York, on the north shore of the long barrier of the Humber estuary, Hull was a town very like Liverpool, a Whiggish place busy with shipping and commerce. It was the principal outlet not only for cargoes conveyed down the River Ouse, but also for the woollen goods of the West Riding which were barged to its quays along the Aire–Calder Navigation. Hull grew steadily throughout the eighteenth century. Even in the 1720s Defoe found it 'exceedingly close-built, and should a Fire ever be its Fate, it might suffer deeply on that Account; 'tis extraordinary populous, even to an inconvenience, having really no room to extend itself by Buildings. There are but two Churches, but one of them is very large, and there are two or three very large [Nonconformist] Meeting Houses, and a Market stored with an infinite plenty of all sorts of Provision.' The population in 1750 was about 12,000, comparable to that of Leeds.

Very little is known about Stubbs's patrons in the town. A solid link with his York associates presents itself in the elephantine shape of William Constable, whose ancestral home stood only six miles from Hull at Burton Constable in Holderness, and who knew John Burton through the latter's antiquarian studies. As he tells us in the preface to his history of the Yorkshire monasteries, *Monasticon Eboracense*, Burton went frequently to Constable's vast Elizabethan pile, with its enormous collections, to 'peruse above 50 vols. of [Constable's] MSS, in folio, out of his elegant library, chiefly collected by his late worthy father [Cuthbert] who spared no expense to procure anything to illustrate any branch of the history of Yorkshire'.[1]

The Constable family were famous in the region for their Catholicism,

and their fashionable learning. Cuthbert Constable had, like Dr Burton, studied medicine abroad. He was also an antiquary, bibliophile and experimental scientist of some repute, as was his son William, a former student at the University of Paris. On the basis of his father's already distinguished collections, William Constable built up a famous museum of art, antiquities, artefacts and natural objects, which attracted hundreds of curious visitors to the house. Much of the Burton Constable collection was antique and originated in Italy, which its owner visited three times.

William Constable's scientific interests embraced astronomy, botany, chemistry, electricity, mechanics and pneumatics. He possessed all the latest instruments from microscope to telescope and laid on scientific demonstrations in his Long Gallery, which he called his Philosophical Room. William was in every sense a large figure, who grew so corpulent in later life that his legs would not support him. When he died in 1791, at the age of seventy, he had worn out six wheelchairs. His half-brother was Marmaduke Tunstall, the zoologist and ornithologist, who specialised in collecting live birds and animals.[2]

Stubbs is not known to have actually worked for William Constable. But, furnished with John Burton's introduction, he surely visited the house, if only as a tourist in search of scientific titillation. But setting himself up in the Whig city of Hull, Stubbs was beginning to look in an entirely new direction from York and its Jacobites and Catholics. Hull's prospect across the wide Humber estuary drew his eye towards the rural scene of north Lincolnshire, where he was soon tending a new and fruitful vine of patronage and friendship. Among these was probably Thomas Carter, a Lincolnshire man who had followed his father William into the parliamentary seat for Hull. He lived at Redbourne Hall, a few miles to the south-west of Brigg, the Lincolnshire market town in which his relations the Nelthorpes held great sway.

It was serious hunting country. In 1713 north Lincolnshire hound packs bred by the Vyner, Tyrrwhitt and Pelham families were combined to form the Brocklesby Hunt, which became one of the most advanced packs in the country, its hound lines of primary importance for the development of the foxhound breed in England. Both Charles Pelham of Brocklesby Hall and his friend the Rev. Thomas Vyner (whose family lived not far away at Eathorpe) would later commission paintings by Stubbs of fox-hunting, their consuming passion. Another large Lincolnshire landowner was the High Sheriff, Peregrine Bertie, third Duke of Ancaster, whose estates centred on the village of Grimsthorpe.

Ancaster was Master of the Horse at court but he was more of a horse racer than a fox-hunting man and would commission a notable pair of horse portraits from Stubbs early in his career as a horse painter.[3]

But it was the Nelthorpes of Barton-on-Humber and Brigg in the extreme north of Lincolnshire, the part of the county closest to Hull, who became Stubbs's earliest and most particular friends there. A series of portraits, commissioned over many years, testifies to this family's regard for him. He had known them some years before his arrival in Hull, having painted, in 1746, a double portrait of Sir Henry Nelthorpe, fifth baronet, and his wife Elizabeth, in oils on a wooden support. No date is inscribed on his rarely seen panel but as Sir Henry died on 28 June 1746, it must belong to Stubbs's first months in York. We can narrow this down even more, to May or June, the months in which lily of the valley, a stem of which is held between Elizabeth Nelthorpe's fingers, comes into flower. This dating means that the Nelthorpe picture pre-dates, conceivably by only a few weeks, the portrait of George Fothergill. The draper's birthday on 25 July was the first date after which he could be described as 'aet. 57'.[4]

Sir Henry may have been close to death, but in the picture there is no sign that he knew it. He is in florid good health and would do very well for one of Henry Fielding's ebullient country squires: round-bellied, solidly at ease in his surroundings and with humorous, clever (almost roguish) eyes. Wearing a full-bottomed wig and sumptuous brown velvet suit, he holds a slim morocco-bound book closed round his thumb to keep the place. For an artist so young the liveliness of this portrait is a considerable achievement, as well as a significantly modern one. In the old Kneller tradition seriousness, even severity, was the rule for face painting. But now artists like Mercier, Francis Highmore and, especially, William Hogarth had begun to loosen the convention. It was still almost unknown for sitters to be seen broadly smiling (Hogarth's *Shrimp Girl* is a rare example) but in appropriate cases there was an increasing tendency for eyes to twinkle, or lips to twitch, in a suggestion of humour.

The figure of Elizabeth Nelthorpe also seeks to accent character. To be sure, she is a model of refinement. The silk of her expensive gown shimmers in acceptably Van Dyckian style – did Stubbs learn to do this by studying Mercier's technique at York? – and the face too is strong, with a high, clear forehead and fine eyes. Yet Stubbs does not flatter the lady. This is not a beautiful face, but a good, plain one, with a thin mouth and pronounced double chin. The sense of tension in the mouth is borne out by her rigid body, and the way in which she holds the stem

of lily of the valley to savour its strong fragrance. It seems a forced gesture, the appearance of a cushion under her elbow showing she was required to hold it for long stretches. It might of course have been Stubbs's intention all along to characterise Lady Nelthorpe in this way, if he perceived that her enjoyment of life was not equal to her husband's. Or it might be that her compressed mouth was trying to suggest the opposite – another hinted smile, a stab at the life behind the mask. If so, the attempt was botched. Stubbs, at this stage, was a more proficient portrayer of the male than the female figure.[5]

Artists could gain privileged access to wealthy families either as portrait painters or as drawing masters. Stubbs had met the Nelthorpes in the former capacity, but I wonder if he did not become reacquainted with them, from his base at Hull, in the latter. At all events, if any painting was done for Lady Nelthorpe over the nine years following Sir Henry's death, none survives. The next is a full-length portrait of the sixth baronet, Sir John, as a boy painted in 1756, by which date much had changed in Stubbs's life. But Humphry states that Lady Nelthorpe had given him numerous earlier commissions, apparently during the time he was living at Hull.

Wrestling once again with Humphry's ambiguities, I read him to mean that these commissions were not immediately carried out and that Stubbs kept them on the slate until he was ready to fulfil them. If this is true, it would indicate either that Stubbs had been very busy in Hull (a possibility not supported by evidence of surviving paintings) or that he believed himself not yet equal to the tasks Elizabeth Nelthorpe had set him and would return to these only when he was. Deferment of the work, and forfeiture of immediate payment, would show considerable commitment to the Nelthorpes on Stubbs's part, especially at a time when he had to meet the expense of a growing family. This had increased by one member on 8 February 1752, when his daughter Mary-Ann was baptised at Holy Trinity church, Hull, in front of Parmentier's deplorable altarpiece of The Last Supper.

In fact, Stubbs seems to have been for the first time financially secure during and after his stay in Hull.[6] He is unlikely to have saved much money from painting, currying for Richard Tireman or schoolteaching, and his family business in Liverpool was never opulent. Yet Stubbs now laid plans to undertake two projects, both of which could be described as speculative and expensive investments in his future. The first of these was to be a trip to Italy, a country that had long been, and would long remain, of consuming interest to ambitious young artists in England.

CHAPTER 19

Grand Tour

*After two months' passage he arrived and landed at Leghorn &
shortly afterwards reached Rome.*

Not all young Georgian artists had the chance to go to Italy. Of men
working the northern circuit in Stubbs's time, Benjamin Wilson went to
Dublin instead. The Cumbrian George Romney's colourful mentor, the
accomplished wandering portraitist Christopher Steele (1733–68),
whose movements included residence in the city of York in the mid
1750s, had favoured France, where he studied with the master Carle
Van Loo. James Cranke (1709–81), an older Cumberland artist also
involved in Romney's education, does not seem ever to have left
England, and Stubbs's friends William Caddick of Liverpool and
Richard Wright (by now) of London were two more stay-at-homes.
Romney himself did see Rome – where he was accompanied by Ozias
Humphry – but this was not until 1774, when he was already famous.[1]

But there were other painters, within the same professional and
geographical space as Stubbs, who made Italy an essential part of their
early development. Two, the Cheshire and Lancashire artist Edward
Penny (1714–91) and the Liverpudlian Henry Pickering (who was
active 1740–90 with significant periods in York) both brought back
their Italian tales to the north of England. They had followed increasing
numbers of young Englishmen (*milordi*) who travelled to Italy with
their tutors (*ciceroni*). These eager young noblemen often also carried
with them the commission of their fathers to buy sculpture and
pictures, and the artists were themselves sometimes also involved in this
trade, to the considerable enrichment of some.[2]

The admiration and adoption of Italian, then Graeco-Roman, forms
and attitudes had long been at the apex of taste. Now at last it was
percolating downwards, trickling like a finial fountain into provincial
art and architecture, literature and decoration. The York Assembly
Rooms of 1727 had been a forerunner. Now, and over the next half-
century, virtually all north-country landowners remodelled their halls,
gardens, stables and shooting lodges to accommodate the fashion. It

became *de rigueur* to have a sculpture gallery, furnished with antique marbles, or copies in marble, bronze and plaster of the most talked-about discoveries of Roman (later Greek) excavation: emperor busts and marmoreal nudes, gladiators in action and rearing centaurs, manly gods and erotic goddesses. Shelves, mantelpieces and cabinets displayed antique seals, medallions, intaglios, bronzes, coins and everyday objects such as cups, clasps and combs. In painting, the accent was on the Italian Raphaelite tradition which, though 'modern', had grown out of the nutritious classical earth. Picture galleries were restocked by such means as we have seen at Knowsley. Everywhere gawky old family portraits were rehung to make space for mythological battles and hunts, Venetian portraits, scenes of ruined temples and Italianate landscapes. With demand rising and a dwindling supply of good, reasonably priced Italian paintings, a market for landscapes, subject paintings and even 'histories' by native British artists was showing signs of life. It was, however, generally argued that no painter could do much in this line without first spending significant time in Rome.

It is easy to imagine George Stubbs, no classical scholar, regaled with these views from all sides by Horace-reading amateurs in Yorkshire and Lincolnshire, eager to beard him about his ambitions in art. 'Go to Rome, young man' would be the cry. Judging by the urn and column in the Scawby double portrait, the Nelthorpes, rich but very rural, subscribed to the classical fashion. If Stubbs taught drawing to the junior Nelthorpes, even to Lady Nelthorpe herself, he may have found himself stubbornly arguing the position he had adopted at the Heath School, the Leonardo position that working directly from nature was better than copying antique models. Ozias Humphry, himself a great enthusiast of Italy after his visit with Romney, would not entirely have agreed with the ideas he ascribes to Stubbs, when explaining the reasoning behind Stubbs's Italian trip: 'Let it not escape notice that Stubbs's motive for going thither was to convince himself that nature was & is always superior to art, whether Greek or Roman.'[3] Lady Nelthorpe's possible role in all this is not mentioned. But as long as the source of Stubbs's travelling fund remains a puzzle, she is his most likely backer.[4]

On Humphry's evidence, the Stubbs family must have left Yorkshire and Lincolnshire some time during the latter part of 1753 to return to Liverpool. Here Stubbs settled his wife and children, probably with his mother, and made his preparations to sail for the usual Italian entry port, Leghorn. The pioneering Liverpool–Leghorn packet ship did not

begin its regular service until 1772, but Stubbs would have found no difficulty taking passage on a merchantman. It was a voyage of a couple of months. British arrivals in Leghorn usually stayed at the hotel kept by Charles Hadfield, a Catholic Englishman whose daughter Maria grew up to marry Stubbs's later friend in London, Richard Cosway. A Liverpool arrival might also be expected to call at the offices of Fortunatus Wright, the celebrated Liverpudlian shipowner and resident of Leghorn. In peacetime Wright was a shipping agent, acting for British art dealers and collectors consigning their purchases to England.[5] In wartime (i.e. during most of the 1740s) he was the swashbuckling commander of the privateers *St George* and *Fame*, and had had an enormous price placed on his head by the king of France.

But Stubbs did not linger either at Leghorn or elsewhere. Instead he proceeded briskly to Rome.

The English in Rome flocked together. Their quarter was around the Piazza di Spagna, where a close-knit group of artists, dealers and dilettanti met in the English Coffee House to form a welcoming committee for British tourists blowing into town. In 1752 the artists among them had felt homogenous enough to combine, under the patronage of the Irishman Lord Charlemont, into a British Academy with more than a dozen members, including Joshua Reynolds who was in Rome between 1750 and 1752. In 1754 the Academy still existed, but it was already declining and would be wound up later that year. Some of its members were men of considerable talent. Others were little more than Grand Tour parasites, acting as *ciceroni* to the sites, fixers for visits to the private collections and agents in the purchase of artworks and souvenirs. Humphry provides a list of six Britons 'found' by Stubbs in Rome: 'Sir Wm Chambers, Jenkins, Brettingham, Wilson, Hamilton, Verpoil &c &c'.[6]

The most committed and original artist among these was Richard Wilson (1714–82), who spent six or seven years in Italy, most of that time in Rome. Arriving as a portrait painter, he departed as the virtual founder of the British school of landscape painting. Wilson was described as 'a man full of information and anecdote, and no less full of satire. He had deep feeling for the importance of his art and of his own importance as a professor of it. Humour him but upon this point and he would be most agreeable.'[7] Wilson was an admirer of Claude Lorrain and aspired to be the 'English Claude'. During the Grand Tour of Lord Bolingbroke, which seems to have ended just before Stubbs's

arrival, Wilson and the Viscount went together on sketching expeditions to Tivoli. Five years after just missing Stubbs in Rome, Bolingbroke was to become one of his most important London patrons.

The other men named were all close in age to Stubbs himself. Gavin Hamilton, the Scottish gentleman-artist, became a permanent expatriate in Rome and gained eminence there as a history painter and connoisseur. He had trained as an artist under the Roman painter Agostino Masucci and developed into a cool, correct classicist who completed a long series of scenes from the *Iliad*. He was also a dealer and excavator of antique sites. In 1754 he may have been engaged in the important business of negotiating to buy Titian's *Venus with a Lute Player*, for the collection of Thomas Coke, Earl of Leicester, at Holkham Hall.[8]

William Chambers was to become a leading neoclassical architect in England and, as drawing master to the Prince of Wales (later King George III) and a 'courtier, wheeler-dealer and hard-nosed politician' of much energy, was a key player in the founding of the Royal Academy of Arts.[9] He went on to design Somerset House in the Strand, ensuring that the Academy had the most magnificent apartments in it. When Stubbs first met him he had been in Italy since 1750 and was to stay another year. He was a forceful, interesting personality, the son of an English merchant trading from Sweden. In his teens he shipped to India and China as a cadet officer of the Swedish East India Company, and had studied Chinese architecture and garden design in Canton. Once established back in England, he helped initiate the rage for chinoiserie that gripped fashionable London society and designed that craze's most visible monument, the Kew Pagoda of 1762. He is unlikely to have been a particular friend to Stubbs: too Hanoverian and too elitist.

Thomas Jenkins, a former pupil of Thomas Hudson in London, had actually been born in Rome. His knowledge of the terrain, the language and the personalities of the Eternal City, together with a sharp business sense, eventually enabled him to become the most prosperous of Rome's English artistic residents. Although he produced some portraits for the visiting *milordi*, this soon gave way to other activities. He provided lucrative banking services to English visitors and got a reputation as a spy for the British government, reporting back on his fellow expatriates and passing tourists, especially any Jacobites.[10]

Matthew Brettingham (1725–1803) was son of the Earl of Leicester's architectural works manager at the still unfinished Holkham Hall in Norfolk. This is one of the great Palladian buildings of England

and Brettingham the younger provided his father with marbles to be sold on (at a profit) to Lord Leicester. Many paintings were also sent, including two of the seven Claudes in Holkham's Landscape Room, which Brettingham sent from Rome in 1752. He also made plaster casts of what were considered the best statues, particularly for Charles Lennox, third Duke of Richmond, whom he met in Rome in 1755. These casts formed part of the celebrated Richmond Gallery, a sort of Open University for London's art students, which was very successfully launched in 1758.[11]

Finally, Simon Vierpyl (c. 1725–1810) was a London-born sculptor who had studied under a well-known master, Peter Scheemakers. He went to Rome with Brettingham and established himself in the Palazzo Zuccari close to the Spanish Steps, sharing rooms at various times with Joshua Reynolds and his fellow sculptors Joseph Wilton and Francis Harwood. Now he was rooming with Thomas Patch. Vierpyl was a hard grafter who put in many long hours 'winter and summer . . . in the chilling Capitoline Museum', working on his replicas. In 1749 he had met Lord Malton and copied an *Apollo* and a *Clapping Faun* for the young tourist, to be installed at his father's great Yorkshire house, Wentworth Woodhouse, near Sheffield. By the time they were finished, Malton had inherited the house and, within a few years, as the second Marquess of Rockingham, he became one of Stubbs's most important patrons.

Of contacts possibly covered by Humphry's et ceteras, Vierpyl's house-mate Thomas Patch cut a distinctive figure. Seven years earlier, when only twenty-two, he had abandoned his medical studies in England and walked to Rome to be an artist. He lived in Italy for the rest of his life, despite making himself unwelcome in Rome after the first eight years. The following note appears against his name among the list kept by Richard Hayward of Rome's British community:

> Banish'd Rome by order of the Inquisition in twenty-four hours for Crime well known to the Holy Office, 'tis said to have proceed'd from some Confession his poor boy Girolamo made at his Death for ye ease of his conscience. Christmas 1755.[12]

The offence appears to have been sodomy, but Patch survived the disgrace. He fled to Florence and made a good living producing landscapes and comic caricatures of touring *milordi*, copying famous works, and dealing in minor antiquities. In Zoffany's *The Tribuna of the Uffizi*, painted in 1772, Patch appears among the English

expatriates and tourists, drooling over the Medici collections. He is the dapper figure discoursing to the British envoy Sir Horace Mann, his great friend, on Titian's *Venus of Urbino*, a painting considered the absolute height of sophisticated eroticism.[13]

It was with these men, then, that Stubbs mixed in Rome. And he engaged in a dialogue with them about their purpose in being there, which developed into a debate, and then a dispute, whose terms went to the very heart of how an artist should seek inspiration. The others insisted their model, their ideal, was in the antiques that surrounded them. Stubbs could not have disagreed more.

CHAPTER 20

Nature and Art

Nature was and is always superior to art, whether Greek or Roman.

Stubbs's famous utterance about art and nature is quoted by almost everyone who has written on him. But what exactly did he mean? 'Nature' might be understood as a short form of Natural Philosophy – experiments in what is now simply called science. If this is what Stubbs was referring to, his proposition becomes the precursor of discussions that were still grumbling away in Britain 200 years later: the art-and-science debate, the clash of 'the two cultures'. But if such an interpretation is accepted, it would be perverse for Stubbs of all people to be thrusting art beneath the heel of science. Almost all his working life – until, that is, he began work on his *Comparative Anatomy* – science was done ostensibly in the service of his art. In reality, at the deepest level, I do not think that Stubbs differentiated between a work of art and the discoveries of science. The two, for him, were indivisible.

This distinctly unified sensibility marks him out as an Enlightenment man and when such individuals spoke of nature in its most general sense they were referring to nothing less than the rationale of life itself. In the post-Newtonian mentality nature was a power discoverable by reason because it was itself the quintessence of reason. It was the doctrine set out by Dr Burton in his book: that reason, not faith, best enabled one to understand life and its meaning. Not only did this lead on to the enlightened man's scrupulous examination of nature, as faith had once led to the exegesis of scripture, it was the basis of every worthwhile, every *good*, human activity.

The Enlightenment found sermons in stones, tongues in trees and 'good in everything'[1] and, once you have posited 'good in everything', religious scruples fall away and vast new areas of enquiry come into view. Nothing was, in principle, off limits to the Enlightenment, for every human interest was governed by, and lit by, the power of nature. The study of planets and stars, rocks and fossils, animal and bird life, plants both wild and cultivated, disease and death were all essential parts of the Enlightenment project. To this list could be added, without

embarrassment, religion, philosophy, psychology, literature and art, because each of these reflected, and reflected *on*, nature. To proclaim the greatness of nature was therefore to blow a clarion call for the Enlightenment as a totality of thought and feeling.

Nature in this wide sense not only took obvious precedence over art, it was a quite different kind of thing, so that to place the two together as equivalences was to make a category mistake, a conceptual blunder. I have no doubt that Stubbs would have accepted the Enlightenment view of nature as an overarching principle. But he was also capable of viewing nature in its more limited sense of man, animals, plants and rocks which were the raw material, as he saw it, of true art.

But he found his fellow artists in Rome mining their art from a different seam. It is significant, in his proposition about the superiority of nature over art, that Stubbs qualifies the term 'art' with the phrase 'whether Greek or Roman'. In Italy 'Greek or Roman' antiquities were everywhere but the ability to study their variety had become much enhanced in recent years. This came not only from the prime 'private' collections at the Villa Medici, and the Palazzi Farnese, Borghese, Mattei and Ludovisi, always high on the list of attractions for tourists, but from the establishment by Pope Clement III of Rome's first public museum of antique art on the Capitol. A further hefty boost to this enthusiasm had occurred with the initial excavations of the two 'subterraneous cities' Herculaneum and Pompeii, buried ever since the eruption of Vesuvius in AD 79.

Artist-visitors infested the Roman collections, as they did the public open-air sites of the Forum and elsewhere. They stood with easel and drawing board, indefatigably sketching and copying classical marbles and Renaissance paintings. Virtually all artists in Rome, whether professional or amateur, did this, following a practice deeply rooted in local academic tradition. Art training in Italy, increasingly codified under the Accademia di S. Luca, was based on the search for the ideal, something both natural and at the same time better (more beautiful or more exemplary) than any individual bit of nature. Notions about the ideal were derived from pre-Enlightenment beliefs about fallen nature and a prelapsarian Golden Age of uncorrupted form and ideal beauty. The Renaissance had identified this perfection with the classical age.[2]

It was in pursuit of the same ideal that English *milordi* wanted to view and to collect such items: to educate their sensibility and be able to show knowledge of what is beautiful. In their tourist-friendly book *An Account of the Statues, Bas-Reliefs, Drawings, and Pictures in Italy,*

France etc. with Remarks – a work Stubbs may well have had to hand
– the two Jonathan Richardsons had explained why as long ago as
1722:

> Few People see the Beauties of Things . . . 'Tis not easy to Paint well, but
> easier than to See well; that is an art that is learned by conversing with the
> Best Masters, and the Best Authors; but even all this is not sufficient
> without Genius and Application, at least to carry a Man any considerable
> length.[3]

Devotedly 'conversing with' the past masters was what these students
and tourists were up to, the British as much as visitors from other
nations. But, as they seemed little interested in nature, their fervour left
Stubbs unmoved.

> It does not appear that whilst he resided in Rome he ever copied one
> picture or even designed one subject for an Historical Composition; nor
> did he make one drawing or model from an antique either in Bas-relief or
> single figure; and so much had he devoted himself to observe and to
> imitate particular objects in nature that whenever he accompanied the
> students in Rome to view the Palaces of the Vatican, Borghese, Colonna
> &c &c to consider the pictures, he differed always in opinion from his
> companions, and if it was ever put to the vote found himself alone on one
> side and all his friendly associates on the other.[4]

Stubbs's colleagues remained 'friendly', so his refusal to follow
convention evidently caused no rancour. Perhaps it was because he
argued his case so well and, though the convention was strong, he had
logic on his side. After all, the genius of the antique artists themselves
did not come from the gods, but from their own responsive study of
nature. The mathematics of perspective, symmetry and proportion are
not improvements on natural forms, but discoveries about those forms.
So, while nature cannot be improved by art, the study of nature is the
only way in which art can improve, or be improved.

Stubbs's zeal in following nature, and his refusal at Rome to copy
from broken antique busts and mangled monuments, does not mean he
was either temperamentally or ideologically anti-classical. In his work
he demonstrates the reverse again and again. He recognised in the
antique almost all his own impulses in representation and design, and
to look at his work is to sense the presence of an instinctive classicist.
The habitual frieze-like patterns, the cool planar rhythms and
mathematical proportions of his mature paintings enhance their
measured Horatian atmosphere. How can this be reconciled with the

artist's disdain for the antiques that he found in Italy? The essential point is that Stubbs regarded himself not as the slave of classical art, but as its equal. He wanted to do what he considered the old artists themselves had done: to draw out the essential orderliness, the *classicism*, that the enlightened mind could discover in nature. He was thinking like a philosopher.[5]

Palazzo Muti, Rome, in the 1750s, the gloomy home of the exiled Stuart dynasty.

In Excelsis

He accompanied the Students in Rome to view the Palaces of the
Vatican.

For an unknown reason, Stubbs does not appear in Hayward's register
of comings and goings in Rome and we cannot date his arrival with any
certainty. If he was there by early March 1754, he would have
witnessed the Shrove Tuesday carnival which tourists found irresistibly
fascinating, with its masks and costumes, parades and balls, sex and
intrigue. One highlight of the festivities was the riderless horse race
along the Corso. A year or two earlier James Russel had written home
with a description of it.

> Towards the evening the coaches and machines are ranged on each side
> of the Corso, in order to make room for the race of five or six barbary
> horses; which, being let loose at the Porto del populo, run from one end
> of this long street to the other. Instead of jockeys mounted on them the
> poor beasts have balls stuck with small iron spikes tied to their tails;
> which, at every stretch, wound them on their sides or behind and push
> them on through the hideous cries of the multitude. The prize for the
> horse that wins is a piece of cloth of gold.[1]

It was a contest which members of the English Jockey Club, such as
Lord Bolingbroke (on his Grand Tour in 1753) must have thought
barbarous, though this would not have stopped them betting on it.

Stubbs had certainly arrived in time for the other important
attraction in the Roman calendar, the celebration of Easter. In 1754 the
feast fell on 14 April, when he is recorded in the *Stati delle anime* (an
official annual register of 'the state of souls') as being resident in a
house on the Piazza di Spagna.[2]

Every Easter Rome staged an orgy of Catholic ceremonial, which
English visitors found simultaneously seductive and repulsive. Even the
most Protestant-minded tourists hurried to St Peter's to be shocked by
the exposition of the relics of the Passion – tokens of flagrant
superstition such as St Veronica's handkerchief and a spar of the True
Cross. They crowded, too, into the piazza to witness the Pope ritually
cursing all heretics (including, thrillingly, themselves) and then blessing

the faithful, *urbi et orbi*. And they vied for tickets to the Sistine Chapel Choir's annual performance of Allegri's ecstatic *Miserere*. The music of this nine-part setting of the fifty-first psalm was so colossally secret and so complicated that no public copy was made until Mozart (as the story goes) gleefully produced a pirate version after memorising the performance he heard in 1770.

Stubbs had been closely aligned with Catholicism until very recently. At about this time two other rather different Enlightenment men, Edward Gibbon (in 1753) and James Boswell (in 1760) both went through youthful Catholic phases, before realising by process of reverse epiphany that they were not religious men at heart. If such an insight came also to Stubbs, affronted by the religious excesses of Rome and with all the implications such a change of heart would carry of trauma, regret and struggle, the bitter, even shameful, aftertaste of apostasy might help to explain his later denigration of the whole Roman experience. Sadly, nothing – no letter home, no Grand Tour journal – has been found which might confirm or deny the hypothesis.

It is equally impossible to be sure if Stubbs had up to this point been in any sense a committed Jacobite, despite his personal links to upholders of the cause over the previous ten years. In the Rome of the 1750s, the presence of the court of James Edward Stuart – 'King James III of England' – was an irresistible draw for British tourists. English diarists and correspondents commented on contacts with the gloomy, increasingly pathetic Old Pretender, or on sightings of him and his retinue at balls and at Mass, rather as a modern tourist in Africa reports on sightings of wildebeest and giraffes. Regal appearances of a kind were kept up at the Palazzo Muti, the Pretender's home on Piazza della Pilotta. But with Bonnie Prince Charlie adrift in Europe – he had not been in Rome since before the Forty-Five and would, in fact, never see his father again – there was little glamour here. The Stuarts were poor, completely dependent on the goodwill of the Pope, and without a policy to better their lot, or press their claim on the English throne. James Edward's obviously woebegone state depressed the visiting Jacobite as much as it buoyed up the Hanoverian.

Stubbs cannot have failed to appreciate the Pretender's hopeless prospects. At the same time the little-England Catholicism he had come across in York, a pared-down, make-do faith with its back against the political wall, made a bad fit with papal triumphalism *in excelsis* at St Peter's. Stubbs's appreciation of the extravagance of the Vatican, and of the simultaneous dowdiness of life in the Palazzo Muti, stood on the

cusp of his removal from his old Catholic and Jacobite friends. Any connection between these matters is, as things stand, an unprovable inference, but not a fantastic one.

Stubbs's visit to Italy, the only foreign journey he made, was brief. He was back in Liverpool by August 1754 for, in May of the following year, the Liverpool parish registers record the birth of another child.

His Mother's House

He removed to his native place.

A long section of the *Sporting Magazine*'s obituary of Stubbs, from the pen of the unidentified T.N., tells of a detour he made en route from Italy, which is not mentioned in Humphry. According to this story, which is elaborated with much atmospheric detail, he had met a cultivated African who invited him to break his journey to England by visiting his father's castle at Ceuta in Morocco. Stubbs agreed and, during an evening walk along the castle walls, he looked out across the desert and saw a desert lion stalking and bringing down a wild horse. This scene 'was a grand study for our artist', which came to haunt his imagination, and resulted in some of his most powerful and dramatic paintings and engravings.

There is no other source to corroborate this dramatic story. But is it true? As the inspiration for Stubbs's celebrated later obsession with the horse and the lion fight, a more solid source exists in the form of a life-size antique sculpture, the *Lion Attacking a Horse*, which was prominently displayed at a 'must-see' Roman site on the Grand Tour itinerary, the courtyard of the Palazzo dei Conservatori.[1] This marble group was already well known in England, having been favourably mentioned in guidebooks such as that of the Richardsons. Stephen Weston, the author of a new guide written after Stubbs became famous, took it for granted there was a connection between him and the Capitoline marble group:

> In the court to the right of the Capitol Square, on entering from the steps, near the colossal heads of Domitian and Commodus, are some very fine remains of a lion devouring a horse, great favourite of Michael Angelo, and from which an ingenious countryman of our own has made frequent studies with uncommon success.[2]

An asterisked note at the foot of the page identifies the ingenious one as Stubbs.

This marble group was in any case well known in London. It had long ago been copied for sale as a bronze statuette by the studio of the

early seventeenth-century Florentine sculptor Giambologna, and became a desirable *objet de vertu*, brought back by several Grand Tourists to adorn their London mantelpieces.[3] Adamo Ghisi's highly collectible sixteenth-century print of the incident (possibly derived from a work by Giulio Romano as well as the Capitoline group) might also have been seen in several private libraries.[4] Finally, there was a grand full-scale copy of the marble in Portland stone in the landscaped gardens of Rousham House, Oxfordshire, dated 1742. This had been made by Peter Scheemakers at about the time he was master of Stubbs's acquaintance in Rome, Simon Vierpyl.[5]

So, if we do not need the Ceuta anecdote to account for Stubbs's lion-and-horse obsession, can we say whether he went to north Africa at all? The fact that Humphry makes no mention of a Moroccan visit is striking. If Stubbs had told the story, his friend would certainly have found it too exciting to keep to himself. It would be equally incredible for Stubbs to choose *not* to tell it. The broad thread running through his account of the Italian journey is that of nature's power to inspire art, and there could hardly be a better supporting illustration of it, or a more perfect rebuke to the complacent classical face of Roman tourism, than this sublime experience. Having seen that contest in the flesh in Morocco, as well as in the marble in Rome, Stubbs could have spoken with emphasis on the comparative superiority of the former over the latter. But he did not.

The Italian adventure, whether or not it included a Moroccan excursion, ended in London, where Stubbs came ashore on his first visit to the capital. He stayed a week, with business unknown, before returning to Liverpool and his mother's house, where he rejoined his wife.

He must have been there towards the middle of August, for now a fourth child was conceived. The following May, the register of St Nicholas records:

> 1755: John, son of George Stubbs, currier, of Plumb Street, born 12 May, baptised, 23 May.[6]

Young John Stubbs will not trouble these pages again, nor will his mother, whose giving birth on 12 May was her last known act. But this baptism provides two pieces of information that advance a little our knowledge of Stubbs himself. First, it provides a new address for him in Liverpool, the house in Plumb Street. A block or two from the old

premises, Plumb Street was still under construction in 1755. The Poor Rate Returns for 1756 list the Stubbs house as a substantial property, with a rateable value of £8.8s.od, almost as high as the combined value of the Stubbs home and workshop in Ormond Street. Stubbs's ownership of this new house is part of his 'puzzling prosperity' at this time.[7]

Second, the parish record uses the word 'currier' beside Stubbs's name, as opposed to the usual 'limner'. He had, it seems, reverted to his old trade yet again. But why? Humphry gives the following sequence of events:

> He removed to his native place and his Mother's House, where pictures in abundance were proposed to him, which he went on constantly executing, occasionally dissecting and considering his anatomical subjects. –
> In about eighteen months, his mother died; – after which, he remained another year & half at his home, settling and arranging his mother's affairs.[8]

Stubbs may have come back from Italy to find his mother sickening and the business in disarray. He might even have cut his trip short, having heard she was ill.[9] This seems the most likely explanation for his final reappearance in Liverpool as a currier: that, in the shadow of his mother's illness and death, he was forced to take the shop in hand in order to sell it as a going concern.

Of the 'pictures in abundance' that he found time to paint during the busy year of 1755, just one has come down to us. It was completed at Christmas and is inscribed on the back 'James Stanley/ An: Aetat 33. Christ. 1755/ Geo: Stubbs pinxit'.[10] The sitter was the third surviving son of Thomas Stanley, a former High Sheriff of Lancashire. James was born near Clitheroe, in central Lancashire, but grew up on an estate further south, at Cross Hall, close to Ormskirk and about sixteen miles to the north of Liverpool. The Cross Hall estate was leased by his father from their distant relative James Stanley, tenth Earl of Derby, whose ancestral lands at Lathom adjoined it. Stubbs's James Stanley was only eleven at the time of his father's death, when Cross Hall passed to James's unmarried elder brother Charles. Under the childless tenth Earl's will, Charles inherited the freehold of Cross Hall three years later, enjoying possession for another eighteen years before dying without issue in 1754. Thus the next oldest brother, the Rev. Thomas Stanley, inherited the house and lands just before Stubbs painted James's portrait. But Thomas was Rector of Winwick, a successor to John Finch who had once helped launch the career of Hamlet

Winstanley. Thomas may therefore have allowed his younger brother to move into Cross Hall in his stead, in which case the portrait was probably to celebrate James's taking up residence, with his wife Ann, in that fine old red-brick mansion, 'on an elevated and most delightful site, commanding the best views of the surrounding scenery, which is most pleasant and varied'.[11]

Bulge-bellied beneath a scarlet waistcoat resplendent with embroidered golden braid and polished buttons, James appears good-natured and contented, despite his goitrous jowls. That almost-smile, seen previously on Sir Henry Nelthorpe, hovers around his lips. His nose is most carefully modelled and gives a nice three-dimensionality to the image. The eyes, too, are finely painted, though with a bovine dullness that offers James up as a solid and dependable but not very bright recruit to the squirearchy.

It is interesting to find Stubbs's Lancashire patronage network still operating at this point. The relations between the Cross Hall Stanleys and the Earls of Derby (James Stanley was second cousin to the eleventh Earl, Hamlet Winstanley's patron in the 1740s) were cordial. This is shown not only by the inheritance of Cross Hall, but by the appointment of James's clergyman brother Thomas to the Rectorship of Winwick, the village between Wigan and Warrington whose benefice was in Lord Derby's gift. Thomas's and James's older sister Mary was married to John Lowe, the curate of Winwick, and James, with both a brother and sister living there, is likely to have been a frequent visitor. He may even have lived with his sister after their mother's death in 1738, when he was still only sixteen. Furthermore, Winwick was the family church of the Blackburnes of Orford and the location of their family vault. Given the way in which the social lives of rural gentry families worked, the Stanleys of Winwick Rectory and the Blackburnes of Orford would have frequently visited each other's houses and known each other well.

But human portraiture was not all that occupied Stubbs. At some time during his two years in Plumb Street he made his first significant animal portrait.

> He painted at this residence his own Grey mare, which was thought to have succeeded greatly, so that when Mr Parsons, a picture dealer from London saw it, he said that he was sure the author of that picture if he came to Town would make his fortune in that line of art.[12]

London was beckoning. But first there had to be a thorough investigation of this new artistic theme.

CHAPTER 23

Inside the Horse

He resolved to carry on and complete what he had long since determined upon . . .

In the man's world of the eighteenth century, the horse was the essential masculine adjunct, in business even more than in sport. The ox and donkey were its only serious rivals for powering draught and land transport, but these had none of the horse's speed and versatility, and none of its magnificence. In Norse times it had been worshipped as part of the cult of Odin. Its monumental image – etched in chalk thousands of years ago into English downland – had been a symbol of all the power and beauty that could be imagined.

The horse still carried prestige, especially in war, sport and ceremonial, but familiarity had tarnished its glitter. Now it was a thing to be worked, as like as not to be flogged, starved, overcrowded and exploited. In the fourth book of Jonathan Swift's *Gulliver's Travels*, Lemuel Gulliver had astonished the race of ultra-rational horses, the Houyhnhnms, with his account of the condition of horses in England. If young, fit and healthy they were generally prized and cared for, he told them. But the older and more decrepit they became, the less horses were valued and the worse they were treated.[1] As economic activity doubled and redoubled, the lives of such horses had deteriorated since Swift's time. England was not a 'paradise for women' but it could certainly be 'a hell for horses'.

The Enlightenment, however, gave hope of better times. It had long been agreed that domestication was of benefit to animals, especially those most closely associated with man's supremacy.[2] But now the great rallying cry was improvement and it was realised that selective breeding could produce stock better adapted to the purposes of man. This concentration on improvement in husbandry had a side effect, however, for now the animal began to be seen as an *individual*, with a glimmer of sentience, a flicker of kinship with humanity. At the same time progress in human dissection was uncovering comparative anatomy – the animal in man. And as the spheres of the human and the animal drew closer, something like a cult of sympathy arose.

Improvement was not merely a kindness to animals, it was actually achieved by being kind.

This coming together of man and animal was particularly marked in the case of the horse, of all beasts the most versatile and willing extension of human activity. To sit on a horse was as easy as to put on your boots, and it accepted to be sat on as naturally as your head received its hat. So here was a sense of mutually beneficial partnership, however unequal. Usefulness gratified the horse as much as the master, and to run at speed was the delight of both.[3]

When his *Anatomy of the Horse* was eventually published in 1766, Stubbs would write in his 'Address to the Reader', 'when I first resolved to apply myself to the present work, I was flattered with the idea that it might prove particularly useful . . .'[4] The word flattery carries here no overtones of insincerity, but only of encouragement, and it was the energetic Charles Atkinson who was Stubbs's main encourager, as his son recorded.[5]

It is generally accepted that Stubbs began *human* anatomy in York, but not that he dissected horses there. However, Charles Atkinson's claim to be the first to get him started on equine anatomy is supported by a detail from *The Gentleman's Magazine*'s obituary of Stubbs. The writer tells an anecdote to demonstrate the artist's preternatural strength.

> Such was his muscular strength, that he has more than once carried a dead horse on his back up two flights of a narrow staircase to the dissecting room on the attic floor.[6]

This hard-to-access anatomy room looks like the same 'garret' at York where the pregnant woman's body had been brought for dissection by the York students in the late 1740s.

If Stubbs first looked inside a horse at York, it was also while living there that he and his scientific friends discussed the idea of a complete study of the subject.[7] A glance at the existing literature would have showed them that the knowledge of equine anatomy had hardly progressed for 150 years. The Bolognese Carlo Ruini's *Dell'Anatomia e dell'infirmita del Cavallo*, published in 1598, was the work of a genuine anatomist and the book in its time had been easily the most advanced published analysis of the physical structures of a horse or, for that matter, of any animal.[8] Ruini's sixty-four anatomical wood engravings proved so useful that they continued to be consulted across

Europe until the mid eighteenth century. Meanwhile all the standard veterinary texts in English, from Andrew Snape's expensive *Anatomy of an Horse* (1683) to William Burdon's cheap *The Gentleman's Pocket-Farrier* (1730), had been based not on new investigations, but on Ruini's wood engravings re-engraved, complete with his anatomical mistakes and often (as in Snape's case) unacknowledged.

The scheme evolved by Atkinson and Stubbs was to go back to the actual body of the horse, and by accurate dissection and drawing to correct the Italian and all his plagiarists. Stubbs's 'Address to the Reader' in the published volume identified his expected market with some precision as

> those of my own profession; and those to whose care and skill the horse is usually entrusted, whenever medicine or surgery becomes necessary to him; I thought it might be a desirable addition to what is usually collected for the study of comparative anatomy, and by no means unacceptable to those gentlemen who delight in horses, and who either breed or keep any considerable number of them.[9]

The work was, therefore, ostensibly intended equally for artists, veterinarians, zoologists, horse breeders and sportsmen, a constituency wide and varied enough to allow hopes of general applause and a financial return. But in fact, the scope of Stubbs's work inclines it sharply towards 'my own profession' and to horse connoisseurs. Horse-doctors and scientists would be only half satisfied by it while the needs of artists are met more or less fully.

Artists were generally drawn to anatomy because it revealed the substrata determining outward appearances. A striking and prominent instance of this interest was the bronze statuette of the Flayed Horse at the Villa Mattei in Rome. By an unknown sculptor, but of relatively recent date, it was a horse 90 centimetres high on a plain rectangular plinth, advancing in a 'managed' attitude. Despite Stubbs's repeated claim that he made no drawings in Rome except from nature, it is hard to believe he did not study the Mattei horse in some detail.[10]

The Mattei horse has no skin. Its surface is a display of muscles, ligaments, nerves and blood vessels, based not on original *dissections* but on three of Ruini's plates.[11] Artists who made use of it were therefore consulting the old Italian at second hand. But the Mattei horse was always regarded as being not just an exceptionally beautiful piece, but an important teaching model. Bronze copies and plaster casts had been produced since the early 1740s, and were soon familiar

objects in the art schools of Europe. The director of the French Academy in Rome, who acquired a plaster version to send to Paris in 1748, went so far as to call it *un morceau nécessaire pour dessiner parfaitement le cheval*.[12]

Misguidedly, then, many artists used the Mattei horse as a short cut to anatomical knowledge. One who had studied it recently was the French sculptor Édme Bouchardon (1698–1762) by whom the Louvre has sixty drawings on horse anatomy, none deriving from direct dissection, all copied from Ruini, but several through the medium of a plaster cast of the Mattei horse. The contents of Bouchardon's never published treatise, on which he worked in the late 1740s, bore significant similarities to the *Anatomy* of Stubbs. He concentrates on the skeleton and the upper stratum of muscles, ignoring forty-four of Ruini's original illustrations showing details such as the brain, genitalia, viscera and inner organs, all of which would have been of vital information for horse-doctors, but were incidental to artists.[13] Stubbs, too, would interest himself only in structure. He, too, would ignore the organs. This shows that, despite his pitch for veterinary business, the fundamental purpose and imaginative heart of the work was artistic, not therapeutic. Yet a vast gulf yawns, too, between Stubbs and Bouchardon, and it is above all in the combined quality of their curiosity and imagination that they differ. As Jacob Bronowski wrote, 'all imagination begins by analysing nature.'[14] And Stubbs's commitment to direct anatomical work as opposed to Bouchardon's copying was driven by an imaginative curiosity unparalleled in an artist since the death of Leonardo himself.

Mary Spencer

*. . . with no other companion or assistance than his female relation
and friend Miss Spencer . . .*

Before embarking on this work a number of practical problems had to
be addressed. Stubbs would be working with very large decaying
corpses and he needed space and no close neighbours, as well as an
adequate supply of subjects and, ideally, an assistant with a strong
stomach and strong arms. Most important of all he required capital, or
a patron to pay his bills.

Financial support for the scheme had once been promised by his old
York associates, but this had not been forthcoming.[1] By 1756,
however, Stubbs could to some extent finance himself, after receiving
the proceeds from the sale of the currier's business, or at least
borrowing against its assets. He also had a new patron in Lady
Nelthorpe, who already expected him back in Lincolnshire to complete
his portrait commissions. The Nelthorpe acres were agricultural, and
Lincolnshire in general was sparsely populated and not much visited. A
few decades later John Byng passed through Barton-on-Humber,
Elizabeth Nelthorpe's home, and found little to recommend the town.
'Most glad to part from Barton, which is a nasty, gloomy place,' he
wrote. Nor was nearby Brigg much more exciting. 'We enquired at
Brigg, (as we do everywhere) for any place to be seen, and always get
the same answer, "that they don't know of nothing".'[2] If some obscure,
removed spot in this rural backwater could be identified, it might
provide the ideal location for the planned great work.

The spot was found in the village – in reality little more than a hamlet
– of Horkstow, a few miles north of Brigg and about the same distance
from Barton-on-Humber. Stubbs took a farmhouse on the edge of the
village, leased in all probability (and perhaps free of rent) from
Elizabeth Nelthorpe. The accommodation may have included an ice
house, a highly desirable feature in view of the work Stubbs planned to
do, and must have had a suitable ground-floor space for arranging the
anatomical subjects.[3] Having found adequate accommodation, he now
turned his attention to the question of an assistant.

*

Stubbs's relationship with the woman I have called Mary Townley was over. There are so many possibilities to explain the separation of husband and wife – death and infidelity are merely the most obvious – that speculation is futile. What can be said is that, when Stubbs's daughter Mary-Ann died in Liverpool in 1759, at the age of seven, only George Townley Stubbs visibly remains of the household that Stubbs had set up in or around Stonegate, in York, at the end of the 1740s.[4]

The children's father would not in any case have wanted his family with him at Horkstow in 1756, where his task required long and intense concentration, working against time and the relentless decay of the carcasses. It would not be a comfortable or healthy billet for children and it would be understandable for him to have left his progeny in Liverpool, if not in the care of his wife, then perhaps with his sisters, Jane, Elizabeth or Anne.

However, even if separation was originally a temporary expedient, it soon became something else, for Stubbs had now found a new female companion who went with him to Horkstow and would stay for the rest of his life. The arrival of Mary Spencer is a crucial waymark along the road George Stubbs was now taking.

The information we have about her identity is partial, but very interesting. Having described her (in his main text) as Stubbs's 'female friend and relation' and (in the fair copy corrected by Mary Spencer herself) as his 'niece, who was born near him at Liverpool', Ozias Humphry scribbles a marginal note about her father, whose sensational demise occurred while Mary was still in the womb:

> Mrs Spencer was the posthumous child of Capt. Spencer of the Guinea Trade who was slain by an Insurrection in his ship and by his own privileged slave in particular; who beat his Master's brains out with an Iron Bolt, as he was stooping down to examine the Fetters which had been filed thro' to effect a Mutiny; after which he instantly jumped overboard and was shot dead by the harpoon of the ship.[5]

It is probable that the slaver who died so dramatically is Richard Spencer 'of Chapelyard, sailor', later 'of Ormonde Street', who appears in the Liverpool church registers as father to Eleanor, born 1736, and Mary, born 29 January 1741. After this, Richard vanishes from all known records,[6] but if he was Mary Spencer's father it means she went to Horkstow at the age of fifteen.[7]

It is quite possible for her to have been Stubbs's niece, in the familial sense of a sibling's daughter. Nineteenth-century writers usually

affirmed that this was the relationship, while finding nothing wrong in her keeping house innocently for her uncle. The more sexually aware twentieth century posited the reverse case. The idea of a housekeeper-niece was taken as pure euphemism, the cover for an unmarried sexual cohabitation. It may, however, be that she was both Stubbs's familial niece *and* his mistress.

The genealogical picture is inconclusive. Stubbs had no brother, but had four sisters, of whom the eldest, Mary, was fifteen at the time Mary Spencer was conceived.[8] But if George Stubbs's Horkstow companion really was born out of wedlock to his sister and, forty years later, as seems to be the case, she herself gave birth to Stubbs's fourth son Richard Spencer Stubbs, we are rather suddenly faced with the troublesome matter of incest. As is clear from the career of Lord Byron, this was no less taboo in the eighteenth century than it is today and, whether we suppose sexual relations began at Horkstow, when Mary was little more than a child, or much later in London, when she was middle-aged, or at some point in between, incest remains an uncomfortable possibility.

But that is all it is. Just to sketch the most obvious variant, suppose Mary Spencer, instead of being Stubbs's sister's child, was niece to one of his brothers-in-law – William Claughton, the potter who married Stubbs's next sister Jane, or Roger Meadows, a peruke maker recently married to Elizabeth, his youngest sibling. The illegitimate child would quite naturally have been thought of as a 'niece' of George Stubbs also, though with no trace of consanguinity. In this case Stubbs as a rational biologist would have found nothing wrong in sleeping with her, although it is true that the public, if they knew, would not have approved. Stubbs was heavily discreet in his later handling of Richard Spencer, not even acknowledging him as his son, as if the boy did indeed represent something to be ashamed of.[9]

Whether she was the illegitimate child of Stubbs's sister or not, the young Mary had expressed rapt interest in her uncle's scientific work in Plumb Street, showing 'particular pleasure in observing from time to time the experiments he made'. Perhaps she was genuinely an enthusiast for natural philosophy. If not, she had so much interest *in* Stubbs himself that she worked hard to simulate a passion for his work. Either way, she created an affinity strong enough to persuade Stubbs that she was suitable for life in the lonely Lincolnshire farmhouse as his friend and only 'companion or assistance'.[10]

CHAPTER 25

Scalpel and Pencil

He proceeded to dissect.

At Horkstow, Stubbs arranged his dissecting room and assembled the instruments and chemicals he would need. A dead horse is not easy to manoeuvre and he devised and set up special tackle to help him grapple the equine corpse into a working position and hold it there.

> A Bar of Iron was then suspended from the ceiling of the room by a Teagle to which Iron Hooks of various sizes & lengths were fixed. – Under this bar a plank was swung about 18 inches wide for the horses feet to rest upon and the animal was suspended to the Iron Bar by the above mentioned Hooks which were fastened into the opposite off side of the Horse to that which was intended to be designed; by passing the Hooks thro' the Ribs & fastening them under the Back bone and by these means the Horse was fixed in the attitude which these points represent & continued hanging in the posture six or seven lengths or as long as they were fit for use . . .[1]

The subjects were brought to him alive and, as we are told without a trace of sentiment, bled to death by the jugular vein. The blood vessels were then injected with liquefied tallow, or wax, which hardened so that 'the Blood vessels and nerves retained their form'. This was the process used by Leonardo and perfected by the Dutch anatomist and professor at Leyden University, Jan Swammerdam (1637–80), who used wax and dye injections to make blood vessels easier to trace and record. Stubbs must have learned these difficult and laborious techniques in the second-floor garret in York.

Using the hooks, block and 'teagle' that was already set up, he lifted the horse into position and arranged its hooves on the supporting plank to simulate standing or walking. Then he

> began by dissecting and designing the muscles of the abdomen proceeding thro' five different layers of muscles till he came to the peritoneum & the pleura, through which appeared the lungs and intestines – afterwards the Bowels were taken out and cast away – then he proceeded to dissect the Head by first stripping off the skin, & after having cleaned and prepared the muscles &c. for the drawing he made careful design of them,

& wrote the explanations which usually employed him a whole day. – He then took off another lay' of muscles which he prepared, designed and described in the same manner as is represented in the work. – and so he proceeded till he came to the skeleton.[2]

Forty-one of Stubbs's Horkstow drawings survive in the Royal Academy of Arts library. They were bequeathed to it in a bundle by Charles Landseer, a long-serving Keeper of the Royal Academy schools and keen anatomist, who got them from his younger brother, the painter Edwin Landseer. Landseer's bundle included twenty-three working drawings, made as the dissection progressed, and eighteen finished studies ready for the engraver.

Three angles of view are shown in these drawings: lateral (the figure viewed standing, from the side), anterior (walking forward) and posterior (walking away). The working drawings were done in black chalk and red-brown ink on strong laid Whatman paper, with a slightly rough surface typical of its time.[3] They were not quite exact records of Stubbs's individual anatomical subjects. He necessarily used a number of cadavers in the course of dissection, and as they varied in size and shape, he needed to standardise the results. So three master skeletons were drawn, one for each of the viewpoints, and then either lightly traced or 'pounced' on to the sheets. Using this template, Stubbs overdrew what his scalpel uncovered, carefully adjusting the proportions as necessary.[4]

The eighteen finished studies from which the plates in the book were to be engraved are on flimsier sheets of paper.[5] Although these are derived from the working drawings, the latter are markedly different in both the anterior and posterior views. The anterior view is from a wider angle, closer to a three-quarter view, than in the finished studies, while the anterior working drawings adopt a higher viewpoint than the finished ones. It must be that Stubbs was working in a relatively cramped space, and was particularly short of room at the head and tail of his subject. He had all the width he wanted, but would have liked a room several feet longer.[6]

Stubbs's earlier anatomical work was relatively sporadic, carried out as opportunities arose. Now he was engaged in a systematic study, a long journey into the body of the horse, meticulously planned and recorded every step of the way. As a former Professor of Drawing at the Royal College of Art has put it:

The subtle surety of the pencil allows one to follow the process, from muscles unpeeled from the surface, expressed with rich volume, to the inner musculature, sinews and tendons, to the cathedral vault of the spine as it marches from skull to pelvis, and finally to the majestic living bone underneath.[7]

Stubbs's metaphorical journey was taking him down to the underlying structures of reality, structures which determined the nature and effect of his mature work. The process was unique in his time. It is axiomatic that Stubbs was the supreme representer of rural eighteenth-century England, a genius of the mid-Georgian conversation piece and a meticulous painter of animals. But, in painting, greatness does not emerge from subject matter, from *quantity*. Really progressive achievements are made in technique, design and colour, bound together by understanding of form, weight and volume, which is not a quantity but a quality. Leonardo's *Treatise on Painting* descants, rather awkwardly, on this when writing about figural equilibrium:

> A figure standing firm on its Feet makes an Equilibrium of all its members around the Central Line, on which it is sustained. A Figure therefore, thus steady, and thus balanced, stretching one of its arms out from the Body, must at the same time shift so much of its weight to the opposite side, as is equal to that of the extended arm. . . . A Man will never be able to lift a Burthen till he lays a weight of his own greater than the Load he would lift in opposition thereto.[8]

Leonardo returns so often to the relationships between tension and stasis, movement and equilibrium, balance and counterbalance, that he clearly sees them as cardinal compositional principles. Stubbs would have agreed. For him the only way to organise mass in a painted composition was by understanding the underlying structural realities, and the forces thereby placed in tension. An article Basil Taylor wrote in 1976 brilliantly articulates this insight as the soul of Stubbs's greatness:

> How few English painters have regarded design as a matter of disposing of weight and force through the control of mass, as the balance and counter-balance of thrusts and lines of force, as a matter of dynamics This *is* the method which Stubbs employed and obviously understood.[9]

Stubbs's anatomy, like Leonardo's, was the starting point and continual reference point of this understanding. That is why it is of such prime importance to any understanding of the artist.

A Lincolnshire Van Dyck

Mr Stubbs went . . . to execute commissions which he had long
received even before he went to Rome from Lady Nelthorpe.

The period Stubbs and Mary Spencer passed at Horkstow was rather
less than two years, between 1756 and 1758, but it almost certainly
included both winters. Stubbs would have spent these continuously
dissecting, to take advantage of the cold weather, which kept his
subjects workable for the longest possible time. So it is likely to have
been during the intervening summer of 1757 that Stubbs went to
Barton to paint the boy-baronet, Sir John Nelthorpe, then nine or ten
years old. This portrait is especially interesting because it is the only one
Stubbs conceived in imitation of Anthony Van Dyck. The Flemish
master had been court portraitist to the Stuart dynasty more than a
century earlier, but his dazzling example was now being revived as a
model for the smartest portrait painters in England.

The dull Knellerite tradition had already given way to playful French
rococo ideas, imported by the likes of Mercier and Van Loo. But
attempts to launch a native English portrait style had also been made
by the ever-combative, and xenophobic, William Hogarth. In 1740 he
had portrayed a genial, enthroned commoner, the merchant-
philanthropist Thomas Coram, as an early John Bull prototype. In the
1750s he produced his *A Market Wench* (known these days as *The
Shrimp Girl*) with her shocking toothy smile, and also a painting of the
founder of English classical architecture, Inigo Jones. All three of these
were attempts to foster a portrait style to suit the national character
and defeat the influence of the hated French, and two of them are linked
to the resurgent example of Van Dyck's English portraits. Hogarth's
Coram is like a reworking of a widely distributed Van Dyck royal
portrait, the seated King Charles I in *The Great Peece*, while his *Inigo
Jones* is a direct copy of Van Dyck's portrait of the architect and stage
designer. Hogarth openly boasted that he was as good a painter as Van
Dyck, reinforcing the claim by putting Van Dyck's image on the sign
that swung over the door of his Leicester Fields studio.

However, in the 1750s other Van Dyck patterns were attracting a

rising generation of artists, eager to eclipse Hogarth. These were the aristocratic 'cavalier' portraits, whose subjects posed in sumptuous fabrics against rugged outdoor backgrounds – patterns that were already being imitated in London by Reynolds and would later be adopted by Gainsborough.[1] In the long run, such patterns held little appeal for George Stubbs, any more than for the anti-elitist Hogarth. Nevertheless, at this point we find Stubbs, for the only time in his career, trying for the same effect.

Sir John Nelthorpe as a Boy is hardly a match for Gainsborough's Van Dyckian *The Blue Boy*, but the origin of its composition is very clear. Each element here is a favourite motif from Van Dyck's English period. The rocky bluff against which the boy stands serves various purposes: to frame and protect the person portrayed; to offer the contrast of stone with living flesh and rich fabrics; and as a reminder of rock-like qualities in the human character.[2]

The patch of open landscape in the top left-hand corner of the canvas similarly follows Van Dyck's practice. The feature enlivens the background and opens up a window from the world of the portrait into the world of nature, the domain of human action. The leaning tree and the presence of the dog show equally strong Van Dyckism, while Nelthorpe stands with left hand resting loosely on his hip, the crook of his elbow balanced by a bent right leg and his right hand extended to show affection for and authority over the submissive creature. It was a pose Stubbs would have seen in many Van Dyck prototypes.

This Italian greyhound, or perhaps whippet, has the distinction of being the earliest surviving animal known to have been painted by Stubbs, and his mastery of physical realism can already be seen in the detail of the front paws and the head, as well as in the animal's overall posture, elegantly curving round the boy's right side. Van Dyck himself had been a fluent painter of dogs, using them to great effect in many portraits to show the subordinate animal world acknowledging human wisdom and strength, sympathy and command. But the dog in *Sir John Nelthorpe as a Boy* is also the most naturalistic and 'Stubbsean' element in the painting, foreshadowing what was soon to become the painter's stock-in-trade of animal portraiture.

This canvas is all that is left of the numerous Nelthorpe commissions, which supposedly took Stubbs back to Lincolnshire in 1756. We don't know what happened to the others, but Stubbs was to return to the county in later life, and paint more pictures for Sir John and his friends. The family links between his Lincolnshire customers demonstrate

again, but even more strongly, how Stubbs worked through family networks in the English counties. Sir John's wife Charlotte was a Carter, the great-niece of Thomas Carter, the Hull MP who was also Robert Vyner's father-in-law, grandfather of Charles Anderson-Pelham, later Lord Yarborough, and uncle to the Rev. Robert Carter-Thelwell, who married Sir John Nelthorpe's sister. All these relatives commissioned paintings by Stubbs over the next two decades.

But, for now, he turned away from Lincolnshire and, determined to have his anatomical sketches printed and published, he looked towards London. If ever he was going to make his name as a painter, now was the time, and London was the place.

III
CELEBRITY
1758–86

CHAPTER 27

Wonderful Immensity

He took measures for bringing all his studies to London.

Stubbs was now thirty-four. For fifteen years he had applied himself to self-education in drawing, painting and scientific method. He had gained favour with wealthy patrons and taken instruction where he found it, not only in art and anatomy but in fencing, French and dancing. He rejected what he could not use but made fast progress on many fronts. If fame had so far eluded him, he could plausibly account for this. Perhaps the early liaison with his children's mother had been a hindrance, or his association with Jacobites and Catholics. Perhaps his own necessary self-certainty (or pig-headedness) had made him enemies as well as friends. Perhaps he had simply not been ready. Well, now he was.

At the end of the reign of the old king, George II, who was to die in 1760, London had more than 600,000 inhabitants. James Boswell, another seeker after metropolitan fame, was right in regarding it as 'the great field of genius and exertion, where talents of every kind have the fullest scope and the highest encouragement'.[1] As the hub of all that was busy, current and fashionable, the city constituted an almighty hubbub of opinion and argument, wagers and duels, cant and rant. This was its distinction, as Dr Johnson believed. 'It is not in the showy evolutions of buildings,' he told Boswell in 1763, 'but in the multiplicity of human habitations which are crowded together, that the wonderful immensity of London consists.'[2] It is the *crowding together* that impressed him, for this made the city seethe with human inter-actions, the like of which had never been known before. Londoners were always out and about, on pleasure or business (which for many were the same thing), and their continual shuttling and social ricochet wove a vast daily internet of news and debate from Mile End Green to Tyburn Turnpike.

It is not surprising that Samuel Johnson loved the interactive aspect of London above all else. If the Great Cham of Literature stood for anything, it was the value of reading and the charm of conversation,

and the city was a ferment of both.[3] Scandal and gossip were ubiquitous, but London also abounded with scientific clubs and literary discourse to the extent that, as Johnson was to claim, 'there is more learning and science within the circumference of ten miles from where we now sit, than in all the rest of the kingdom'. This he thought represented the true 'happiness of London'.[4]

London was not merely the Mecca of enlightened learning, it was the capital of Taste. That word was one of the greatest importance, not because it was a cultural yardstick, but because circumstances had made it a vital instrument of political control. England's old ruling elite enjoyed greater wealth than ever, yet for them this age was one of anxiety. Previous assumptions about inherited power, based on the ownership of land, were being undermined by the rise of the new mercantile money, which seemed likely to overwhelm the old landowners in a tidal wave of middling-sort values and attitudes. Taste was seized on as an ideal flood barrier. Its key elements were a classical education, the ability to take part in aesthetic and philosophic discourse, and the possession of a grand Palladian or neoclassical house, with a library and a top-notch art collection inside. You could have all the money you liked but, if you had no taste, you were still a nobody.

The leaders of taste were the leaders of the country, and vice versa. Outside Parliament, the nation's political club, they operated through numerous other clubs in this clubbable society, groupings where aesthetic matters came especially to the fore – the Society for the Encouragement of Arts, Manufactures and Commerce, the Society of Antiquaries, the Society of Dilettanti. Those aspiring to political power or any kind of social status were always anxious to join these groups, and the judicious manipulation of their membership kept out the threatening tsunami of mercantile thinking.

If the middling sort was defined on one side by its exclusion from the world of taste, it was shaped on the other by the poor and disenfranchised – the mob. For them the struggle to survive was intense and unremitting. In 1763 a prospective purchaser, visiting a supposedly empty house in Stonecutter Street, found on the first floor the bodies of three young women. They were the remains of basket-carriers in the Fleet Market who, overtaken by sickness and unable to work, had starved silently to death. On the floor above he came upon two more squatters, barely alive. There was no adequate safety net for such cases. Here, as in Liverpool, poor relief was in the hands of the parishes, but it was reserved for those legally settled within the parish boundaries. In

a city swelled by constant immigration, and by thousands of unregistered births, there were many homeless who had to fend for themselves.

Suicide, riot, violence, vice, crime and callousness were parts of life. In the Bridewell house of correction, the flogging of prostitutes was public entertainment and at Bedlam the insane were gawped at like zoo animals. In the absence of an official police force (the idea was thought to smack too much of foreign absolutism) the filthy coop of Newgate Gaol was kept full by a corrupt system of bounty-hunting and self-appointed thief takers.[5] The gaol was generally awash with gin, which was the cheapest way to oblivion ('drunk for a penny, dead drunk for tuppence'). Criminal justice in general was arbitrary and bore down with massive disproportion on the poor. There were over 200 capital offences on the statute book but lesser punishments could be equally fatal: offenders committed to the pillory were regularly stoned to death by the mob.

Sporadic mob action was always an important factor in public life, but it was not normally aimed against inequality or perceived social injustice. The mob was largely conservative, acting on its prejudices against 'innovators and interlopers' who threatened or abused what were perceived as ancient English liberties.[6] Daniel Chater, who informed against a group of unemployed weavers-turned-smugglers, was seized by the mob and hung by his arms from a beam halfway down a dry well. When found to be still alive two days later he was thrown to the bottom and pelted with rocks until he died.[7] On the other hand, when justice finally caught up with Mrs Brownrigg, a parish midwife who had beaten and starved her foundling apprentices to death for years, the mob turned out in force to see her hang. As the cart rattled the condemned woman and her coffin towards Tyburn, the noose already looped round her neck, the mob danced behind yelling to the accompanying clergyman to pray for her eternal damnation. When she was finally strung up and tipped off the ladder, the cheer could be heard at Charing Cross.

The insolvency laws were savage. London in 1759 had 20,000 prisoners whose only crime was that they could not pay their way. If they could find the means they lived with a bailiff in a so-called sponging house, where lawyers and creditors, and not least the bailiffs themselves, bled them completely dry. Then they were consigned to debtors' prison, the Fleet or the Marshalsea, where food was not provided (or not without charge) and the inmates, if they had no friends

to help them, were reduced to reaching their hands out through the barred unglazed windows, in hope of bread or pennies from the street.

And yet society and economic life continued, and prosperity for the majority increased. That rising curve of comfort tickled the consciences of some, and the first effective philanthropists such as Jonah Hanway and Captain Thomas Coram appeared to beat a (still fairly muffled) drum against poverty and exploitation. But the temper of the times was against being told what to do: there was no *duty* of charity such as the Victorians felt. Rather, sympathy and conscience working case by case was what enabled altruism to come through when it did. That note of individual action, of self-mastery, which was seen as the only counterbalance to the evil of the mob, resounds through the age. Again Dr Johnson is its voice.

> Nothing can be great which is not right. Nothing which Reason condemns can be suitable to the Dignity of the human Mind. To permit ourselves to be driven by external Motives from the Way which our own Heart approves, to give Way to any Thing but Conviction, to suffer the Opinion of others to overrule our Choice, or overpower our Resolves, is to submit tamely to the lowest and most ignominious Slavery, and to Resign the Right of directing our own Lives.[8]

This desire to direct his own life was what brought Stubbs to London in 1758, and it is the spring of all his subsequent actions.

CHAPTER 28

Ridicule and Applause

He made application to many of the engravers . . . but when his designs were shewn to them they rather excited ridicule than applause.

Since his prime object was to publish the anatomical treatise, Stubbs tramped around London in search of engravers and publishers. One of the first he approached was Arthur Pond, a man of many parts – artist, art dealer, collector, engraver and publisher. But Pond was on the verge of retirement and showed no interest, although the mention of him gives us a date by which Stubbs must have arrived in the capital, for Pond died suddenly in September 1758.[1] Stubbs's next stop was Charles Grignion, one of the foremost scientific engravers in England. To his consternation, this fashionable artist laughed at his efforts, and matters were not improved when Stubbs found other engravers taking the same attitude.[2]

With all his hopes invested in this project, it is easy to imagine Stubbs's umbrage. Grignion's laughter particularly hurt. As recently as 1749 he had worked on the English edition of the Dutch anatomist Bernhard Siegfried Albinus's paradigmatic *Tabulae Sceleti et Musculorum Corporis Humani*.[3] In modern eyes (and quite possibly in Stubbs's) it is the Albinus that looks ridiculous now, the flayed forms and skeletons placed by the anatomical artist Wandelaar in declaratory poses before ideal landscapes, and with a supporting cast of menagerie animals. Such embellishments were thought the height of continental sophistication, while Stubbs's untrammelled images, exemplary scientific illustrations as they now look, seemed naïve by comparison.[4]

With typical stubbornness, Stubbs resolved to engrave and publish the book himself, financing it with the help of an ambitious 5 guinea subscription for each printed set. Apart from meeting his costs, this 'he considered as one of the best methods of making himself known'. It was nevertheless a brave decision. Stubbs, of course, had already made the plates for Burton's book, but he had been disappointed in the results. If his etching should now fail to match the brilliance of the finished Horkstow drawings, the entire project would be jeopardised.

Stubbs began on the plates at once, but progress was agonisingly slow. Working in his spare time, in the early light of the morning, or by evening lamplight, he produced plates to the required specification at a rate of just three per year, so that the full set of eighteen were not finished until 1765. This long drawn-out genesis is not entirely explained by the need to proceed carefully, although Stubbs undoubtedly felt the quality of his midwifery plates had been compromised by Burton's need for speed. The other reason for Stubbs's slow progress now was that his days, and his daylight, had to be spent earning a living.

For the first time in his life, this did not prove too difficult. Almost as soon as he arrived in London, Stubbs found himself gathering commissions at, for him, an unprecedented rate. It seems that one of the first of his customers was Joshua Reynolds, who asked Stubbs for a horse painting, 'a War Horse, which he executed'. Reynolds apparently wanted the horse as a model for an equestrian portrait for which he himself had been commissioned by Lord Ligonier. Having fulfilled that commission by 1760, Reynolds returned Stubbs's 'war horse [which] remained in his possession, – and was at length disposed of at the general sale of his works after his decease'.[5]

That Reynolds was the first to take up the cause of Stubbs is not unlikely. The elder by a single year, he was at that time building rapidly on a two-year Italian trip (1750–2) to advance his career as England's foremost painter, but it must have been in Italy that Stubbs first heard of him. Reynolds had left Rome two years before Stubbs got there, but he was a great friend of Vierpyl, with whom he lodged in Palazzo Zuccari, while he also knew Patch, Brettingham and William Chambers. With such mutual connections, Reynolds could have first met Stubbs during the stopover the latter made in London on his return from Rome in 1754.

Reynolds had little book-learning as a boy and, as he himself put it, his mind was being formed at this time by his friendship with Dr Johnson, an education that would soon enable him to write and lecture on art and take a lead in discussions about the artist's place in society. Reynolds was a confident painter but even here he knew his limitations, particularly in Stubbs's specialities of linear perspective and anatomy. Having received a commission for an equestrian portrait, Reynolds might well have seen the *Anatomy of the Horse* drawings, noted their extraordinary quality and asked Stubbs to paint a 'managed horse' for

him to copy. Having done so, he no longer needed the model and is said to have exchanged it for one of Stubbs's rare mythological paintings, *Phaeton and the Horses of the Sun*.[6]

As to the 'managed horse' itself, examples could be studied from life at the riding school built by that enthusiast of equitation, the tenth Earl of Pembroke, near his house in Whitehall and run by the suave Italian Domenico Angelo. In 1759 Angelo moved into a house on Leicester Fields, now Leicester Square. He was the supreme riding master to the Quality, including the heir to the throne, soon to be George III, and his brother the Duke of York. He taught far more than how not to fall off a horse. The Angelo course in equitation involved study and long practice in dressage,

> the art of training a horse to walk, amble, trot, gallop or take various positions in answer to slight touches of the knee the spur or the whip, some veterinary skill, and a complete acquaintance with anything connected with equine care and management.[7]

Stubbs's studies in horse anatomy would have interested Angelo deeply, even had the Italian not already been interested in art. He was, in fact, a particular friend of Reynolds, whose Great Newport Street premises were very close to Leicester Fields. This area had long been London's 'artists' quarter'. The St Martin's Lane academy, founded by Kneller and later taken over by Hogarth, was round the corner, as were many artists' studios. On Leicester Fields itself, Hogarth lived two doors from Angelo and, in 1760, Reynolds moved into a grand house and studio right opposite, where he painted Mrs Angelo's portrait. According to the name-dropping *Memoirs* of Angelo's son Henry, Stubbs too began to frequent the Angelo riding school soon after coming to London.

If he went there originally to make studies for Reynolds's managed horse, he soon became a friend of the Angelo family – also painting Mrs Angelo's portrait, staying to dine, and meeting the other fashionable men and women who frequented the place:

> All the celebrated horse painters of the last, and some of the veterans of the present age, were constant visitors at our table, or at the *manège* which my father erected in the space between Carlisle House and Wardour Street. It was left to the late Mr Stubbs to raise the reputation of this department of painting to that high state of excellence which it had formerly attained in the old Flemish and Dutch schools; and I shall never cease to remember that it was to the friendship of the elder Angelo that this most distinguished early member of the British School principally

owed the patronage which he obtained. Some of his earliest and best studies were made by his faithful pencil from my father's stud, who had, indeed, some magnificent horses.[8]

Domenico Angelo was adventurous, amusing, good-looking, cultured and, soon, very rich, being reputed to earn £4000 a year by the 1760s. As well as Reynolds, he counted David Garrick and the composer Johann Christian Bach among his friends. He was also an acquaintance of Dr Johnson and had been the lover of the star actress Peg Woffington. Apart from being, as the King himself thought, 'the most elegant rider in England', Angelo was a superb swordsman. In a sensational bout fought with foils at the Thatched House Tavern, at the bottom of St James's Street, he defeated Dr Keyes, the top Irish fencer.[9] He went on to establish a fencing academy alongside his Soho Square riding school, and to write the influential textbook *École des Armes*, published in 1763. When the Earl of Pembroke raised a regiment of cavalry, the 15th Light Dragoons, to serve in the European war, it was Angelo who trained the raw recruits to handle their horses and weapons.

During the last years of George II's drab reign, Angelo cut a dash by playing host to fashionable rakes like Sir Francis Dashwood, John Wilkes and John Horne Tooke. His establishment became a magnet for the rich noblemen, the rising generation of the old Whig landowning families, who all came of age during the 1750s: Richard Grosvenor, Viscounts Torrington and Bolingbroke, the Dukes of Richmond, Portland and Grafton, John Spencer of Althorp (soon to be the first Earl) and above them all the Marquess of Rockingham. These were as much in love with art and science as they were with horses, blood sports, gambling and political intrigue. By birth, inheritance and inclination they aspired to the leading role in national life, in which, at this stage, Rockingham was their acknowledged leader, to the extent that they were generally known as the 'Rockinghams'.[10] All of them had the qualifications to be leaders of taste – the classical education, the Grand Tour, the landscaped and 'improved' estates and neoclassical mansions. Almost all also had strings of racehorses and stud farms.

These men had massive resources. In a time of extreme income differentials a vicar like James Woodforde of Norfolk was delighted to get £400 a year, and this was indeed an immense amount compared, for example, with a servant's annual wage of £5. Rockingham and his friends inhabited a different universe from this. Grosvenor enjoyed at

least £20,000 a year, Spencer £30,000, Richmond £35,000 and the Marquess £40,000. The richest of the lot was William Cavendish, fifth Duke of Devonshire, who came into an inheritance at the age of sixteen worth £60,000 per annum. Such almost incomprehensible wealth made them princelings over their country estates, and they regarded conspicuous expenditure and a careless attitude to money as absolutely mandatory. The level of their gambling beggars belief today, almost as much as it beggared some of them at the time.[11]

There was a self-destructive streak running through the psycho-pathology of the whole nation, a mania for excitement and risk that expressed itself not only in war but in fox-hunting, horse racing, cockfighting and cards. The notoriously reckless gambling of the aristocrats of the age is nowhere better exemplified than in Hogarth's fascinating late print (it was published in 1759), *The Cockpit*. Here the Lord Albemarle Bertie, the blind second son of the Duke of Ancaster, is seen laying bets on a main of cocks being fought out in front of him, surrounded by a frenzied crowd. The irony of the composition, a parody of Leonardo's *The Last Supper* in which Bertie takes the place of Christ, is daring in itself, but it is mitigated by the pathos of a man assailed on all sides by cheats and thieves, betting on a contest which he cannot see and cannot win.

All the Rockinghams gambled. Even the Marquess himself, who was not known as a serious plunger, is said to have scooped £5000 betting on his colt Bay Malton to beat the celebrated Gimcrack at Newmarket in October 1765 – both animals being later painted by Stubbs. He also enjoyed novelty bets, as when he wagered £500 on a match race between a gaggle of geese and a flock of turkeys, to be driven over the distance between Norwich and London.

But the Rockinghams threw themselves with equal energy into cultural and intellectual pursuits, nursing England through the transition from the more rigid intellectual paradigms of the Augustan age to the double revolutions of industrialisation and romanticism. While acknowledging the complexity of the terms 'Augustan', 'industrial' and 'romantic', it can be said that, in intellectual terms, the clouds of perplexity and pessimism that had hung over Swift and Pope now became higher, and fluffier, as the century progressed, with many patches of blue sky in between. Culture and thought, no less than industry and society, breathed what was felt to be emancipated air. The lower orders, as ever, saw things more murkily but, looking down from the heights of the stratified social landscape, a young man of wealth and

education enjoyed his view in a clear light.[12] This also is the light that plays across the many sporting pictures Stubbs painted for this, his latest and most important patronage network.

Domenico Angelo's Fencing Academy, Soho, by Rowlandson, 1791. Angelo stands to the right with swords.

CHAPTER 29

Goodwood

> The first [commission] of considerable importance he received was
> from the Duke of Richmond.

The first of the Rockinghams to respond to Stubbs's anatomical work
with a commission was the soldier, scientist, fox-hunter and politician
Charles Lennox, third Duke of Richmond. It was an ambitious scheme
for three paintings depicting outdoor life at Richmond's country estate
at Goodwood in Sussex.

Stubbs developed a lifelong habit of doing pictures in series, and of
uniform size, which were designed to be hung and appreciated together
as one work. This has been touched on by scholars in relation to several
individual series by Stubbs, but it is important to see it more widely, as
a characteristic way he had of working.[1] There is plenty of tradition
behind the idea of linked pictures, from triptych altarpieces to large
narrative or thematic tapestries.[2] In eighteenth-century England
Hogarth is the painter most readily associated with serial narrative art.
His paintings and prints unfold moral arguments through a succession
of (usually four) scenes taken at significant moments in a story.
Stubbs's series are, however, not primarily narrative in intention. To
use an anachronistic word they are documentaries, which combine to
present a conspectus of a place or an activity, usually on the estate of a
particular patron. The Goodwood series was the first of these.

Born in 1735, Richmond came into his estates on the death of his father
when he was fifteen. At the time Stubbs met him, he had just opened at
his London home, Richmond House, his gallery of casts after antique
statues for the benefit of any artist in London wanting to study Roman
and Greek sculpture. Prizes were given to the best work done here. But
beside his interest in the arts, Richmond had a degree in science (strictly
speaking natural philosophy) from the University of Leyden. During his
long Grand Tour of 1752–6, on which his *cicerone* was Abraham
Trembley, a pioneer of marine biology, the young Duke had been
deeply impressed by a meeting at Berne with Albrecht von Haller, the
botanist, anatomist and poet.

Charles Lennox, then, was a patron in the mould of John Blackburne, except that he was immeasurably richer. The interests of his father, the second Duke, had also been divided between art, the antique and natural philosophy, with a particular focus on plants and animals. On the menagerie at Goodwood, with its big cats, bears, raccoons, chimpanzee and armadillo, a modern historian of the Lennox family has written:

> capturing and cataloguing the beasts of the wild brought them out from disordered nature into the ambit of human rationality. By virtue of being studied, animals became almost human, and they certainly became beloved. When a lioness from the menagerie died, Richmond built her a magnificent tomb in the Goodwood grounds where she reposes in marble among the trees.[3]

Stubbs took the greatest care over the Goodwood commissions, taking nine months to produce three large matching canvases, one a soft, sweeping landscape with the Duke's racehorses exercising, the second a sprightly view of the foxhounds and followers of Richmond's Charlton Hunt casting for a scent, and finally a shooting scene, with two sportsmen attended by loaders and grooms. The paintings are all of the same height, but *The Charlton Hunt* is considerably wider than the racehorses and the shooting piece, so that the natural way to hang them would be with the hunt between the other two. The reason for the centrality of the hunting piece is not only that the chase was Richmond's favourite sport, but that this picture alone contains his portrait, a tall, upright and very youthful figure astride a magnificent bay hunter commanding the centre of the composition.

Apart from Sir John Nelthorpe's whippet, the dogs in these three paintings are the earliest Stubbs is known to have painted and his first working dogs. The Charlton foxhounds were regarded as having the best pedigrees in the country, so admired that the second Duke had been asked to send two of his stud dogs to Brocklesby more than a decade earlier to contribute to the improvement of that already highly rated pack.[4] During his months at Goodwood Stubbs took time to develop a connoisseur's eye for the breed. Twenty individual hounds are seen in the fore- and middle ground, each in a different movement, as if to illustrate a treatise, and yet each undoubtedly an identifiable portrait. A single graphite sketch survives of one of these hounds, as do two paintings in oils on paper, one being the same hound as that in the drawing.[5] It looks very much as if Stubbs's studies involved careful

drawings and paintings of each of the hounds, presumably at least twenty of them, in preparation for his composite painting.

Almost thirty years later he executed a set of fine soft-ground etchings, one a replica of the existing drawing, the others of four hounds in poses identical to particular individuals in *The Charlton Hunt* painting[6]. The prints suggest that the kennel drawings had acquired a definitive quality in the artist's mind, though the idea of publishing them in 1788 may have been prompted by the Duke's completion in the previous year of magnificent new centrally heated kennels at Goodwood, designed by James Wyatt in the Palladian style and built at a cost of £6000.[7] As Abraham Trembley wrote of his pupil, 'he loves dogs prodigiously.'[8]

The Duke's old tutor had added, coyly, that 'he loves also the human race and the feminine face', so it is not surprising that Richmond wanted Stubbs to take trouble over these figures also. *The Charlton Hunt* includes a portrait of Lord George Lennox, the Duke's brother, while *The Duke's Racehorses at Exercise* are watched by his duchess and his sister-in-law, Lady Louisa Lennox, George's wife. In the shooting picture, the shooters are a brother-in-law, the beefy politician Henry Fox, later Lord Holland and father of Charles James Fox, and a soldier-uncle, the Earl of Albemarle.

Stubbs told Humphry that he took Albemarle's portrait under incongruous circumstances, 'whilst he was at Breakfast, the day before he embarked upon the ever memorable and successful expedition to the Havannah'.[9] This evokes an image of Stubbs's time at Goodwood House, haunting the halls and salons in order to take likenesses of the family members as they came and went. Stubbs frequented the servants' hall in the same way, for the grooms, hunt servants and keepers in all three pictures are scrupulously and robustly portrayed. They no doubt included members of the Budd and Pickerell families, whose names recur in the Goodwood register of servants. A figure he particularly noted is the liveried black page, his ear adorned with a gold earring, sitting on a tree stump while he holds Lord Albermarle's elegant Arab colt and restrains a pet dog from spoiling the work of the five pointers who quarter the ground ahead of the guns. This young man's unfocused stare perfectly captures the boredom and disengagement of a servant attending, but not involved in, his master's sporting pleasures.[10]

The dismounted horses in each of the episodes are especially well drawn. In *The Duke's Racehorses at Exercise* the eye is taken by the

leggy filly stretching her neck fretfully as no less than four grooms rub her down with straw. The same role is filled in the shooting piece by Albemarle's Arab with its four white socks and distinctive *Portuguesa* saddle, and in the hunting scene Stubbs took special care, too, over the grey whose girths are being adjusted by Christopher Budd, the Duke's Huntsman.[11]

At the same time, important compositional features of these paintings undermine Stubbs's boast that his only model was nature. There are evident similarities between *The Duke's Racehorses at Exercise* and John Wootton's *The 2nd Lord Portmore Watching Racehorses at Exercise*, painted in 1735. Wootton, still alive in London when Stubbs came there, had been a pupil of Tillemans before building a considerable practice as a sporting artist. Stubbs's painting agrees with Wootton's in the action portrayed and in the overall conception, as well as in the number and direction of racers being sweated, and the relative position of the spectators. A difference is that Stubbs moves the watchers significantly into the centre to make room for the rubbing down detail on the right, while Wootton allows for an idle poor man and his dog squatting in the foreground – a detail which can be read as social comment, though not on the side of the peasant.[12]

Similarly, several elements of *The Charlton Hunt* are reminiscent of a work by James Seymour, *A Kill at Ashdown Park,* painted in 1743 for Lord Craven.[13] As a man and an artist, Seymour was in every way a contrast to Wootton and Stubbs. Unreliable and dissolute, he was essentially a highly gifted amateur, technically clumsy but a good colourist and full of real enthusiasm for country sport, of which he had plenty of direct experience. Stubbs's painting is organised along very similar lines to Seymour's. In both cases the left side of the canvas is blocked with a tree. In front of the tree both artists show a barrier being leaped in identical style by the mount of a hunt member, towards the mêlée of hounds and horses at the centre. On the upper right, Stubbs also follows Seymour in opening a vista of downland, across which further sport is glimpsed in progress. Seymour's main compositional idea, then, of strong movement from the crowded left, and more distant, faster impulsion from the more open right, towards a vortex of hunt activity at the centre, is basically the same as Stubbs's.

It is worth pointing to these similarities not to minimise Stubbs's originality, but to highlight it. No artist works in a vacuum and Stubbs is bound to have borne in mind existing paintings and engravings when he designed his own compositions. But he asserted his difference, too,

in ways that are of critical importance to any assessment of his work. In both his hunt and his racehorses, Stubbs forswears extraneous details (the scruffy peasant and his dog in Wootton's foreground, the shepherd and his flock in Seymour's background) and adopts a far more rigorous approach to the alignment and relationship of the figures in his pictured space. By using what has been characterised as 'false attachment'[14] he links these figures together in serpentine curves that look like novel adaptations of Hogarth's aesthetic desideratum, the line of beauty. Compared with Wootton's ruler-straight linearity and Seymour's monotonous figuration, Stubbs's most notable quality is his attention to the rhythm of the design. This would continue to be his care throughout the remaining five decades of his professional life and in almost everything he did. It was his professional hallmark.

CHAPTER 30

The Grosvenor Hunt

On leaving Goodwood he went to Eaton Hall, in Cheshire, the seat of Lord Grosvenor.

Born in 1731, Richard Grosvenor inherited his estates at the age of twenty-four, becoming Baron Grosvenor in 1761 and an earl twenty-three years later. Enormously rich by virtue of his Cheshire estates, and the ownership of most of what is now Mayfair and Belgravia, his personality was far less intellectually and morally balanced than Richmond's. Though his family had old northern Tory roots, Grosvenor idolised William Pitt and was for the most part a follower of 'the great commoner' in Parliament (he served as member for Chester from 1754 to 1761 and in the Lords thereafter). But he was regarded as something of a political liability and was never invited to sit at the top table of power, not even being admitted to his dearest ambition, the lord-lieutenancy of Cheshire. Much of the reason can be traced back to his chaotic private life and finances.

In 1764 he married Henrietta Vernon, a granddaughter of Thomas Wentworth, Earl of Strafford, and a relative of Rockingham. The marriage was a disaster. Grosvenor gave his wife 'no small grounds for alienation', but, when she allowed herself to be seduced by none other than the young Duke of Cumberland, brother of King George III, Grosvenor was incensed beyond reason. The 'Cheshire Cornuto', as the satirists mercilessly hooted, repudiated his wife, settled on her what, in his terms, was an ungenerous £1200 a year and embarked on a revenge mission against his cuckolder. He sued the Duke for criminal conversation with Lady Grosvenor and in a sensational case won £10,000 in damages, despite all the efforts of the Lord Chief Justice, Lord Mansfield, to save the honour of the family of George III.

Grosvenor's income was astronomical, but his expenditure was even higher, most of it going on his grand enthusiasms: gambling, sex, horses and pictures. He was unusual in his preference for modern British painters. These naturally included the best portraitists – Gainsborough, who had painted Henrietta in the early happier days of the marriage, and Reynolds. But Grosvenor's interest in the artists of

138

England extended to history paintings by Benjamin West, landscapes by Richard Wilson and sporting pictures by Sawrey Gilpin. In 1770 he gave the King further pain by outbidding him for West's piece of tragic triumphalism, *The Death of General Wolfe*, which startlingly treated a modern event as the moral and aesthetic equivalent of a mythological or classical one.

Grosvenor was not always so progressive. In 1759 he had been furious at failing to get his hands on *The Lady's Last Stake*, a new painting by Hogarth on a theme that agreeably combined sex and gambling. With his blood up, Grosvenor announced he would buy Hogarth's next oil painting, on any subject, and at any asking price. But when the work appeared, Grosvenor was horrified to find the fashionable world laughing at it. In 1758 Hogarth, outspoken English patriot that he was, had been angered by the £400 obtained for an Italian old master painting, *Sigismunda Weeping over the Heart of Guiscardo*, then thought to be by Correggio. He swore that an Englishman could paint the same subject (taken from *The Decameron*) and get the same price. It was a bet that, in view of Grosvenor's offer, he thought he could not lose. But his finished *Sigismunda*, with her bloodied fingers, and (according to Horace Walpole's scoff) the look of a scorned and vengeful whore, was thought vulgar, a transgression against taste. Grosvenor refused to accept the picture and the ageing Hogarth, who felt he had emptied himself physically and emotionally into the canvas, was very nearly killed by the rejection.

Grosvenor would prove much more loyal to George Stubbs, whom he must have met at about the time that he rejected Hogarth's *Sigismunda*. *The Grosvenor Hunt* became the first and largest (it measured 8 feet wide) of a significant body of Stubbs's work that entered Grosvenor's collection over the next two decades, before the peer's finances were ruined completely. Most of these paintings were of mares and stallions at the peer's two stud farms, one at Eaton Hall and the other at Oxcroft, near Newmarket. There was an elegant, unnamed Arabian stallion,[1] 'his celebrated Horse Bandy',[2] the thoroughbred stud horses Gimcrack, Polyanthus, Mambrino and Sweetbriar, and the first of Stubbs's serenely languorous essays on the theme of *Mares and Foals in a Wooded Landscape*.[3]

However, *The Grosvenor Hunt* was something else – 'the greatest of English hunting pictures'.[4] The scene is a tributary stream of the River Dee, which runs through the 11,000-acre estate ruled by Grosvenor in

the style of a princeling. In the distance is Beeston Castle, once a royal stronghold. A note inserted by Mary Spencer in Humphry says the painting is a 'very large Hunting Piece, in which the portraits of Lord Grosvenor (on honest John), his brother Mr G, Sir Roger Mostyn, Mr Bell Lloyd & appropriate Servants, together with a view of the Country from the Saloon of Eaton Hall. Every object in this Picture was a Portrait.' (The name of the Duke's mount is piquant: a reminder of Stubbs's father.)

Wild stag and buck hunting, the oldest organised field sport in Britain, had been in decline as the animals' forest habitats were cleared for agriculture or timber. But although the stag was being increasingly supplanted by the fox, its hunting was still an activity of the court and a favourite sport of George II. The stags he hunted were not wild, but bred in the Windsor deer park and carted during the hunting season – which stretched from Holyrood Day (25 September) to Easter Monday – to the field at Richmond or Hounslow. The animals were released half a mile from the hunt and pursued by horse and hound for an hour or more. At the culmination of the chase, the lives of these pampered corn-fed beasts could be spared or not, Colosseum style, by the decision of His Majesty, or of the huntsman. If it was to die, the method of dispatch was laid down in obsessive detail. It was a day of ceremonial as well as sport.

The Grosvenor Hunt, too, has formal elements in addition to its furious hunting action and the mix is important. A glance at this monumental piece – it is half as large again as *The Charlton Hunt* – shows its continuity with what Stubbs had already achieved for Richmond, yet it makes an astonishing leap forward in technique and maturity. Of all eighteenth- and nineteenth-century hunting pieces, it is hard to think of one that is more charged with energy. The huntsmen and hounds come at their prey from the right in a splashing, murderous thrust. The stag is down and floundering in the river. The terror in his eye is palpable. The frenzy of the hounds and the exploding water are brilliantly realised, an effect whose virtuosity Basil Taylor demonstrated by printing a detail of a Stubbs watersplash alongside a high-speed photograph of the real thing.[5] It is this camera-shutter observation that has led to Stubbs's reputation as above all a dispassionate realist.

But of course Stubbs is not a camera and there is something else which tilts this canvas into quite another dimension from the merely photographic. Distinctly framed by the river bank and overhanging oak

tree, Richmond and his party look calmly down from their horses on the violent, bestial events enacted below. In their airy detachment they appear like gods in a mythological painting or masque, viewing a scene they have ordained – as, in a sense, they have. Stubbs emphasises the hunt servant on the left of the composition, mounted on a muscular but apparently awestruck grey hunter, who celebrates the kill by blowing the 'mort'. He reminds me of another servant in an otherwise rather different hunting scene, the Louvre's *Pardo Venus* by Titian, who also stands on the extreme left of the scene and gives news of Jove's presence with a trumpet blast. In Stubbs's great painting, Grosvenor and his companions, like Jove, are Olympian presences on the hunting field.[6]

This was not done particularly to gratify their vanity (though it must have more than adequately done so) but as a political statement. The social system operating in Britain was one of inequality and injustice more extreme and arbitrary than at any other time in modern history. This inequality was underwritten by the landed nobility's sense that it was a class standing apart even, if necessary, from the court and the King, and that it was charged with the historic task of guarding the land, the fabric of the nation. In *The Grosvenor Hunt* Stubbs's portrayal of the central group of noble riders – the patron, his brother and their friends – is carefully designed to embody that idea and that role.

It is highly significant that the subject of the painting is sport. Since the Great Revolution of 1688, Whigs had tended to regard rural sports as the philistine activity of the rubicund, ale-guzzling, beef-eating Tory squires of Sir Roger de Coverley legend. As Lord Chesterfield wrote languidly to his son in France,

> I suppose you have hunted at Compiègne. The hunting there, I am told, is a fine sight. The French manner of hunting is gentlemanlike; ours is only for bumpkins and boobies.[7]

The stereotype of Squire Booby at his sport emphatically denied him any possible taste or sensibility, as a 1755 article in the London periodical *The Connoisseur* put it:

> His hall must be adorned with Stags' Heads instead of Busts and Statues; and in the Room of Family Pictures you will see Prints of the most famous Stallions and Racehorses . . . To this absurd Practice of cultivating only one Set of Ideas, and shutting oneself out from Intercourse with the rest of the World is owing that Narrowness of Mind which has . . . made Roughness and Brutality the Characteristics of the mere Country Gentleman in Politics and Religion.[8]

If there was one thing fashionable Whigs avoided, it was 'cultivating only one set of ideas'. Meanwhile, under successive recent administrations Squire Booby and his kind went into decline. The real problem was that their estates were too small and they were unable or unwilling, by the adoption of modern land management, to squeeze enough profit from it to meet the increasing rate of Land Tax. As a result they quickly found their lands being ingested by larger and more efficient neighbouring landowners, usually the nobility. These big-scale proprietors – Rockingham, Richmond and Grosvenor included – did not consider themselves bumpkins and boobies, but they could not deny loving their estates and their horse sports. They needed, then, to update the public image of hunting and racing in order not to conflict with their superior pretensions in politics and taste. What better way than to reinvent sporting art on the grand, quasi-historical scale?

That such a project was thinkable shows how much art had changed during the Georgian era. When Sir James Thornhill, Hogarth's father-in-law, painted a mural on *The Landing of George I* for the Upper Hall of the Greenwich Hospital, his biggest problem was to circumvent 'objections that will arise from the plain representation of the King's landing as it was in fact and in the modern way and dress'. In order not to show the King in the clothes he actually wore, the relative meanness of the ship he arrived in and the scruffiness of the crowd that welcomed him, the entire scene was translated into mythological terms, with the King represented in antique costume coming as a god from the sea.[9] Two generations later, the classicisation of modern history made such euphemism unnecessary by bringing in the possibility of modern-dress mythology, as in West's *General Wolfe*.

It might be asked did Stubbs, by giving them this classical *gravitas* and heroic status, endorse the self-image of men like Grosvenor? Did he even share their love of blood sports? These are good questions, but the wrong ones to ask at this stage, when Stubbs's private views mattered less than his professional priorities and developing aesthetic. The work for the Young Whigs paid well. Even more important, it was the kind of work Stubbs wanted to do: big-scale canvases on big themes, for clients receptive to his ideas about design.

For Stubbs, painting was an intellectual challenge more than an emotional one. A modern art historian writes:

> At the heart of Stubbs's art there is something cold and unflinching, a relentless compulsion to describe reality unmitigated by any need on the

artist's part to muddy the images with his own subjective comments or emotions: in short, a deeply classical attitude towards painting.[10]

Stubbs's use of classicism shaped his vision of truth. When looking at *The Grosvenor Hunt* any feelings he may have had about the social system, and even about hunting, are a side-issue compared with this. The painting's technical accomplishment, and the assured way in which this meets the demands both of neoclassical taste and scientific detachment, are the keys to its brilliance.

CHAPTER 31

Rockingham

> Mr Stubbs painted for the Marquis of Rockingham two portraits
> of horses the size of life; one of them was called Whistlejacket.

Stubbs's career now swept forward in a surge of creativity, the most intense of his painting life. He could no longer afford to spend months as Lord Grosvenor's guest, as he had at Goodwood, and must have made studies of people, hounds, horses and the landscape features 'of the Country from the Saloon of Eaton Hall', before returning to finish the work in London. And here he found another patron bidding strongly for his services.

Charles Watson-Wentworth, second Marquess of Rockingham, was close to the beau ideal of Enlightenment aristocracy. During the first half of George III's uncommonly long reign, he was a genuinely formidable figure in the coffee rooms of power and, on two occasions, was himself able briefly to swarm to the top of the greasy pole of government.

Yet he was an unflashy character, who epitomised the steady man: loyal, principled, intelligent and with good taste. He was born in 1730 with expectations of great wealth and much land, and these came to him early, at the age of twenty, when he inherited his title and extensive estates, primarily in the West Riding of Yorkshire, but also in Nottinghamshire and Ireland. His father, a close friend of the power-broking Duke of Newcastle, had received the prestigious hereditary title of Marquess of Rockingham only in 1746, four years before his death. He and his son both profited greatly from the extraordinary economic and industrial expansion of Yorkshire, which was enriching many commoners and professional men like Recorder Wilson of Leeds, but benefited the great county landowners even more. Much of the young Marquess's huge annual income was invested in improvements to his houses, farms, navigations, roads, coal mines, studs and art collections. In the course of a lifetime, he laid out around £80,000 alone on Wentworth Woodhouse, his vast pile near Sheffield, which, as a result, still boasts the longest façade of any private home in England.[1] Like his friends, Rockingham was interested in theoretical science,

which overlapped quite naturally with patronage of the arts and made his group especially partial to artist-scientists. When the Marquess himself (hardly out of his adolescence) was elected a precocious Fellow of the Royal Society we find him taking a special interest in the speculations of a more humble Fellow, Benjamin Wilson, the painter whose family Stubbs had known in Leeds during the 1740s. Rockingham employed Wilson as a family portraitist at Wentworth Woodhouse and went on to support his experiments to determine the correct shape for the tip of a lightning conductor.[2]

But it was technology, the fruit of science, that allowed knowledge to become visible and profitable. Rockingham financed, and was closely involved with, controlled experiments in fertilisers, land drainage, ploughing and hoeing machinery (some of which he designed himself), tile and brick making and ceramics. With parts of the 16,000-acre Wentworth estate sitting on large deposits, he made pioneering enquiries into the properties of coal, apparently working with the leading metallurgist and chemist John Roebuck FRS.[3] The muck-loving farmer and journalist Arthur Young travelled 20,000 tireless miles in pursuit of agronomical enlightenment. In his *Tour Through the North* (1771) he was so impressed by Rockingham's farms that he devoted seventy-two pages to hymning their virtues.

> I never saw the advantages of a great fortune applied so nobly to the improvement of a country . . . The general management of grassland and manures, among numerous other articles, are at Wentworth carried to the utmost perfection.[4]

The perfection of nature is an impossible objective in today's age of relativity, but it seemed a perfectly achievable one to the men of the Enlightenment. That is why they spent so much time and money on landscape gardening, the canalisation of rivers, tree husbandry, fat-stock breeding and horticulture. But perhaps nowhere was the idea of perfection more energetically and expensively pursued than by the young Whigs in their activities on the turf.

The thoroughbred horse, as still seen in the regulated racing of today, is in essence the product of Stubbs's lifetime. The first Arab, Turk and Barb (North African) stallions, and a smaller number of Barb mares, had been imported in some quantity during the previous century and interbred selectively with indigenous 'hobby' or Galloway horses, which were already involved in the unstructured racing of that time. The imports were prized for their speed and grace, while local blood

provided a hardier genetic mix. The result, by the 1730s, was a hybrid raised to the status of a distinct breed. The English thoroughbred had been the extraordinary outcome of a nationwide scientific experiment, with scores of studs and stables around the country acting together over decades. Until the founding of the Jockey Club in 1751, there had been no body, no research committee or funding council, to plan, finance and control this remarkable experiment. The only control, the one test bed, had been the racecourse test. As Charles Darwin put it,

> our English racehorses differ slightly from the horses of every other breed; but they do not owe their difference and superiority to descent from any single pair, but to continued care in selecting and training many individuals during many generations.[5]

'Difference and superiority': recording the development of those two sovereign elements in the thoroughbred – in its pedigree, physical measurements and racing results – was always an important part of the enterprise. But the horse had two additional qualities by which its creators esteemed it, and these could not be set down in tables, lists and figures. The first was, precisely, that the creature *was* theirs, brought into being by their own vision and effort. The second was the animal's extraordinary beauty. This did not come from an ethereal aesthetic, nor from any utilitarian charm. It was the beauty of precision, of justness and proportion, and of athletic power. To set these qualities down, one needed not a stud-book, nor a statistician, but an artist, and one of a very particular kind.

The beginning of Stubbs's association with Rockingham is traceable in the Wentworth Woodhouse account books.[6] The first payment made to the painter was for several pieces of work in mid 1762, after Stubbs had stayed for a considerable time there. His receipt reads:

> August ye 15th 1762. Recd of the Most Hnble ye Marquis of Rockingham, the sum of one hundred and ninty four pounds five shillings in full for a picture of five brood mares and two foles one picture of three stallions and one figure on Horseback and a picture of five dogs, and another of one Dog with one single Horse. R. Geo. Stubbs.

Four of these five paintings are identifiable, the exception being 'one Dog with one single Horse'. The 'figure on Horseback' is *Scrub with John Singleton up*, probably the earliest single portrait of a racehorse that Stubbs painted.[7] Scrub had retired from the track in 1761 after a not especially distinguished career. The jockey, Rockingham's

principal race rider for many years, said drily 'that Lord Rockingham had mounted him on many a *good* horse, and many *bad* one, but now he had mounted him upon a Scrubb forever'.[8] It is a ruefully affectionate remark. Scrub was something of a favourite, which is why the end of his racing days was commemorated in paint. He was later painted again by Stubbs, this time life-size,[9] and, after his career at stud the old horse was Rockingham's retirement gift to his jockey.

The 'picture of five dogs' shows three dogs and two bitches, foxhounds from the Wentworth pack, standing against upland country, profiled and in a row. Two hounds face inwards from the left and the other three do the same from the right, giving this otherwise highly schematic, rhythmical composition a faint theatrical element, a hint of confrontation. In size this picture exactly corresponds to *Scrub*, but the other two slightly larger canvases form a more obvious pair. The 'five brood mares and two foles' are matched with 'a picture of three stallions', one of the latter being the chestnut Whistlejacket and two unidentified bays. Like the hounds, the horses stand in frieze arrangements. The stallions are in strict profile regularly spaced and (again like the hounds) in identical poses, while the mares and foals form a more complex and interactive pattern, turning this way or that, one lowering her head to pick at the ground, others seeking eye contact, the foals at foot contentedly suckling.

In the painting of the three stallions, Stubbs avoids monotony by inserting a liveried human figure between Whistlejacket's chest and the rear end of the middle horse. He is Rockingham's stud groom, Simon Cobb, who embraces Whistlejacket most tenderly, but also protectively. Cobb, we see, is not a sentimentalist. His serious features indicate a man aware of his responsibility for horseflesh whose value would be put at risk by confrontations between high-spirited stallions. Alongside that vision of potentially destructive male rivalry, *Mares and Foals* represents harmony and peace but, again, it is an unsentimental vision: rhythmical and closely observed.

Of the two patterns, it was 'mares and foals' that Stubbs's patrons seized on, and at least another dozen variations on the theme were painted, over the next decade, for the young Whig circle.[10] The difference is that in all the derivations there is a landscape background, which generally presents the familiar Stubbs mix of grass, trees, distant water, sky and cloud. In complete contrast, the three Rockingham stallions, and the mares and foals, have no figural background, just monochrome space, with vestigial shadows underfoot to make it clear

the animals stand on a solid surface. Context-free, and with nothing to distract the eye between and around the horses' forms, all concentration is on the animals themselves.

The idea behind the renunciation of background in these paintings came to Stubbs accidentally, while working on what is now his most famous painting, and one of the most popular and recognisable in all British art. This is his portrait of Whistlejacket magnificently alone. At life size, and awesome in his power, the horse is free to express himself without human control, rearing against a background of infinite and empty honey-coloured space. Yet, surprisingly in what appears a supremely integrated work of art, this was not the original conception.

The story given in Humphry is that Rockingham already owned a painting by David Morier of King George II astride a managed horse and after the accession of George III he wanted to pair it with one of Whistlejacket,

> upon which it was intended that his present majesty should have been represented by the best portrait painter, and the Landscape back ground by the best artist in that branch of painting; hoping by an union of talents to possess a picture of the highest excellence.[11]

Some commentators have doubted the story, understandably in view of the complete artistic integrity of the work in its present state. *Whistlejacket* strongly projects the horse as a free being, and the thought of a saddle, reins and rider, let alone one so stodgy as 'Farmer George', is hard to swallow.[12] However, such a scheme is confirmed by two independent sources. Horace Walpole, after a visit to Wentworth in August 1772, wrote in his diary that he had seen 'many pictures of horses by Stubbs, well done. One large as life, no ground done; it was to have had a figure of George 3d.'[13] Half a century later the American man of letters, George Ticknor, wrote that he, too, was told the story when he visited Wentworth in 1835.[14] Another supporting factor is that the *Whistlejacket* canvas, and that of the Morier equestrian portrait of George II, are of equal dimensions.[15]

Walpole says Rockingham abandoned the scheme for political reasons and Ticknor attributed it to 'his being offended at the king'. Humphry has a variant but not contradictory cause for the change of plan: Rockingham, he says, was so beguiled by Stubbs's work as it was that he

> resolved to have another horse painted for the purpose of introducing the King. His Lordship therefore ordered Mr S to begin a fresh picture and

fixed upon Scrubb . . . which was immediately executed as it now appears at Wentworth House.[16]

It is a plausible explanation, in view of the two other stud scenes minus background that Stubbs painted for Rockingham in the same year. Both Stubbs and his patron could see that any background or rider was superfluous: the horse himself was astonishing, with a majesty that could only be diminished by the addition of His Majesty.

CHAPTER 32

Political Paint

He painted several pictures in London for the Marquis.

Stubbs's involvement with Rockingham renewed his association with the politics of opposition, but now with a different slant. The 'Rockingham interest' in Parliament was a young, Whig-minded and in some ways progressive group. They were deeply suspicious of the court and countered the Germanic proclivities of the House of Hanover by proclaiming their own devotion to traditional English liberties. They regarded the Hanoverians, whom their grandfathers had planted on the throne, as conditional monarchs, surviving on the nobility's sufferance. And, if the belief that *noblesse oblige* was what made them compete for administrative power in the first place, perennial distaste for the political machinations of the Hanoverian court (and its egregious interest in the dynasty's German domains) was one of the pillars of the young Whigs' actual policies.

Another was the latitudinarian spirit, which had so strongly informed the 1688 settlement. By the time this percolated down to the Rockingham Whigs, it had taken on some of the characteristics of what we would call liberalism: toleration, benevolence, freedom of thought and minimal interference by government. The Rockinghams were against undue taxation (the Cider Tax, the Stamp Act) not only because it stifled trade, but for its falling unfairly on certain groups. They upheld civil liberties, as in the case of John Wilkes and his followers, though Wilkes was too much the vulgar demagogue to attract them personally. They were also for the liberty (if not the independence) of Ireland and the American colonies, and were prepared to countenance the emancipation of Dissenters, Catholics and Jews.

When Stubbs first reached London, Rockingham and his friends were beginning to flex their political muscles at Westminster. They clustered around the King's second son, the Duke of Cumberland, who had been sacked as Commander-in-Chief of the army, and that wily old fixer the Duke of Newcastle, who was similarly sidelined.[1] In 1760 the old King died and his grandson and heir, now George III, appointed Lord Bute as head of the government. Bute was a friend of the King's

mother, Princess Augusta, and as George's old tutor was, in effect, a favourite honorary uncle.

Partly as a Scot, partly because he was a courtier with flimsy and sentimental claims on power, Bute was deeply unpopular across England, but the Rockinghams had a particular reason to hate him: they had already decided, by late 1761, that he was bent on destroying their families' interests and influence. The Duke of Richmond found himself at odds over this with his brother-in-law Henry Fox, whom Stubbs had painted in the Goodwood shooting piece and who in 1762 became Bute's political fixer in the House of Commons. That autumn Bute and Fox carried out a purge of Whig landed magnates from official posts, known as 'the massacre of the Pelhamite innocents', which cut deep enough to deprive Rockingham, in December, of the lord-lieutenancy and other offices in the West Riding, which he considered his by right.[2] Rockingham was angry enough to abandon his mentor Newcastle's strategy of limited opposition. He resigned his ceremonial post as Lord of the Bedchamber and launched a campaign of systematic resistance to Bute's government.[3] It was to this 'going into opposition' that Horace Walpole later attributed Rockingham's decision to abandon the equestrian portrait of the King.

Stubbs, working at that time for Rockingham, must have been affected in other ways. While he was up at Wentworth, sketching dogs and horses, he was far enough removed from the political hurly-burly. But in London it was a different matter and it was here that Rockingham presented his new favourite painter with another very large commission: a pair of canvases each measuring 8 feet by 11, of *A Lion Attacking a Stag* and *A Lion Attacking a Horse*. The aetiology of these breathtaking works has never been quite clear. Both subjects combined, or harmonised, explosive violence with classical stylisation, not as Stubbs had already done in *The Grosvenor Hunt*, but in a new, far more monumental, register. The larger-than-life size of the figures, and their entire removal from the human world, gives them a singularly immediate impact.

The paintings arrived at Rockingham's London home, 4 Grosvenor Square (Rockingham was Richard Grosvenor's tenant) in 1762, and were hung in the ground-floor salon or 'Green Room', where anti-Bute political meetings were often held. Visitors would have known perfectly well that a horse and a stag were Bute's two heraldic supporters, that is, the figures ranged on either side of his escutcheon or heraldic shield. Seen everywhere he went emblazoned on the sides of

his carriage, and referred to by topical cartoonists, they were already associated with his public life. In this light, Stubbs's two paintings can be read as the grandest possible type of party propaganda: they show the Lion of England, symbolic custodian of liberty and history, gralloching the supporters of the presumptuous Scottish Earl. [4]

Stubbs had already seen the marble group of the lion and horse in Rome. Did he suggest these lion attacks as witty subjects for Rockingham's two pictures? There is no doubt that other painters encoded political messages in their work. To give just one example, from the same year as Stubbs's Grosvenor Square commission, John Hamilton Mortimer's prize historical painting, *Edward the Confessor stripping his Mother of her Effects*, was a pointed reference to the supposedly malign influence of Princess Augusta, and her friend Lord Bute, on the newly crowned monarch. [5]

Stubbs went on repeatedly to paint the lion and horse (and not the lion and stag), his imagination finding that episode peculiarly gripping. This was in part because the scene evoked a fashionable idea, the sublime terror of the wild. It gave, too, new scope and impetus to his speciality of horse painting. But it could also be decoded as a political statement that was wider than mere anti-Butism. It spoke of opposition to the legitimacy of the Hanoverian dynasty itself, a reminiscence of Stubbs's old Jacobite ties, and the nonjuring of his grandfather seventy years earlier.

Hanover had long been associated with the horse. The Emperor Charles V is said to have addressed his horse in German (and his mistress in Italian, his wife in French, God in Latin etc.), a joke which might have come about because a galloping white or 'cream-coloured' stallion was the dynastic symbol of the Electors of Hanover. The deeply Germanic George I carefully husbanded his horses but his son went further, establishing a royal stud farm at Celle in Lower Saxony in order to define it as a pedigree breed, after importing English blood to strengthen the stock. Now the royal coach was drawn by a team of Hanoverians, while inns up and down the country once called the Royal Oak had been renamed the White Horse.

In 1721 the papal sculptor and medallist Otto Hamerani referred to this iconography when he produced a commemorative medal for James Edward Stuart. This is one of those Jacobite collectables that appeared from time to time throughout the century. On the obverse is the profiled portrait of the Old Pretender as an impossibly handsome Roman emperor. His nose is most aquiline, his hair a cascade of curls

and on his armoured breast shines a blazing sun. The words *'Unica Salus'*, 'the only safety', bracket his head. But what danger is it that looms? A turn of the medal reveals the scene of woe. The words of Ovid's captive wife Hermione, *'Quid Gravius Capta'*,[6] arch across the sky. Below we see a prospect of London from the south with a family of refugees who, having crossed the bridge, are carrying away a few salvaged belongings in sacks. To one side, a distraught Britannia laments and in the immediate foreground is the disastrous thing she weeps for: a muscular Hanoverian horse trampling down a lion – the lion of England. It is highly likely that Rockingham, a great connoisseur of medals, knew this desirable piece and may even have shown Stubbs an example.

In the Ovidian story from which the medal's quotation comes, Hermione's true lover Orestes returns and slays Neoptolemus, her forced and violating husband. In political terms, you could say that Stubbs's lion – the lion of England – plays the role of Orestes, biting back at Britannia's captor. I would not say this interpretation could ever have been sanctioned by the Rockinghams, except in jest. They were, after all, heirs to the families that had engineered the Hanoverian succession in the first place. But Stubbs's private feelings are another matter. On returning to the lion and the horse theme, as he did many times over the following years, he often chose to paint a white horse.[7] And his model for this was a real Hanoverian:

> The white Horse frightened at the Lion was painted from one of the Kings Horses in the Mews which Mr Payne the architect procured for him. The expression of Terror was produced repeatedly, from time to time by pushing a brush upon the ground towards him.[8]

Stubbs never worked directly for the King and had no entry to the Royal Mews in his own right. The cheek of his small raid on the Royal Mews to capture a Hanoverian horse, and frighten it with a brush, might have felt particularly satisfactory.

CHAPTER 33

Somerset Street

In 1763 he removed into Somerset Street.

Stubbs's domestic arrangements had hitherto been restless but now, in 1763, he bought a permanent home in London at 24 Somerset Street. It provided a base from which to travel on commissions, and to which he could return both to work on paintings and engravings, and to enjoy family life. The purchase proved wholly worthwhile and Stubbs inhabited the house contentedly for the rest of his life.

Somerset Street no longer exists – by 1909 it had disappeared under Harry Gordon Selfridge's palatial new Oxford Street department store – but in 1763 the street was pristine, so new that maps of the area, published in the same year as Stubbs moved in, had still not registered its existence.[1] The neighbourhood was, in fact, part of a network of new streets and squares on the north side of the Oxford Road (now Oxford Street) and westward from Cavendish Square. This development crept across Marylebone Lane and over the fields towards Tyburn, which is now Marble Arch, on 270 acres of land that had been held by the Portmore family since the time of Queen Elizabeth. Then the estate had been decidedly outlying, part of the parish of St Marylebone, which centred on the village at the top of Marylebone Lane. The Portmore farms provided dairy produce and vegetables for the city a mile and a half away, while the Tyburn and Marylebone springs were among the city's main sources of fresh water. Finally, the Tyburn gallows were a place of equal, if less wholesome, significance.

The ground landlord (Henry William Portman) sold long leases of ninety-nine years to developers, who put up the houses and sold on the leases at a profit. The first vestige of the new Portman scheme had appeared in 1757 with buildings going up for the first time on the north side of the section of Oxford Road, opposite the existing Grosvenor Estate development, and around the openings of what would quickly become Duke Street, Orchard Street and Portman Street. As these extended northwards, another street was constructed parallel with Oxford Road and about 150 yards in length, which linked Orchard and Duke. This was Somerset Street.

Given that Stubbs told Humphry he bought the house in the same year it was built, the property's specialised features could have been designed to his own specification. Walter Gilbey, whose *Life of George Stubbs* provides a detailed description of the layout, may have seen Somerset Street before its demolition, but he seems also to have had access to some earlier description of the Stubbs household.

> On entering the hall-door the visitor found, on the left a front and back parlour, to first attract his attention. Underneath these were the front and back kitchens, a good wine cellar, and beer and coal cellars . . . At the head of the light staircase, leading from the hall, lay the front and back drawing rooms. Over these, in turn, were two bed-chambers, in one of which stood the ponderous four-poster bedstead occupied by the artist . . . Stubbs's 'Exhibition Room', as it was termed, otherwise his studio and laboratory, which was the most essential part of the whole establishment, was situated immediately behind the dwelling-house, and was reached by a back door to the left of the entrance hall. It was nearly twenty-eight feet by twenty-one feet, fitted up with a lantern skylight, and handsomely ornamented in stucco . . . In the rear of the studio, we may add, an excellent coach-house and a four-horse stable . . .[2]

These are the lineaments of the living and working areas, as Gilbey gives them. Details such as the dimensions of the 'studio and laboratory' cannot have been plucked out of the air, but must have been based on somebody's measurements. Other details are more generalised. Gilbey writes that the house contained 'mahogany tables, mahogany book-cases and chests of drawers; pier-glasses, Brussels and Wilton carpets, china and Wedgwood table services and the like', which could simply have been drawn from a typical household inventory. The furnishings of Stubbs's studio are also mentioned, some of which was standard, while other items would be less easy to predict including

> cabinet articles in mahogany 'of ingenious construction and excellent manufacture' used by the artist and adapted by him to his various professional pursuits. The artist's traveling easel, and a telescope [i.e. telescopic?] mahogany engraving table of peculiar make, served to complete the picturesque effect of the place.[3]

Artists' studios at this date were more than just workshops, they were also 'Exhibition Rooms', places where patrons were received and could inspect the artist's work while taking a cup of tea or a glass of claret. George Romney had recently moved into a studio at 32 Cavendish Square, near Somerset Street, 'where the painting room was big enough

to entertain a crowd of guests'.[4] Wealthier painters such as Reynolds and Angelica Kauffmann had separate showrooms but even where this was not possible, as in Stubbs's case, it remained important that the painting room itself was an elegant space. With its stucco ornamentation and mahogany furniture, Stubbs wanted to ensure that his appeared as close to the ideal as possible, that is, 'like the galleries and cabinets of a gentleman connoisseur'.[5]

As well as patrons, sitters and models, studios were visited by tourists. At an unknown later date Dr James Atkinson of York visited Stubbs's gallery 'accidentally', by which he meant casually, or without an appointment.[6] In April 1777 the Liverpool antiquary, agronomist and schoolmaster John Holt was another who included Stubbs in a busy schedule of sightseeing. His diary is revealing about the context of such visits. Holt attends Bow Street Magistrates Court to take a look at Sir John Fielding, the blind judge whose brother was the 'immortal author of *Tom Jones, Joseph Andrews* &c. My curiosity greatly warmed.' He goes to Bedlam, where 'the yellings and bawlings of the poor wretches under confinement drove me from the place'. He then took himself to Oxford Road where he

> called at Mr. Stubbs' the celebrated horse painter, saw his inimitable productions. This was an excellent treat. Upon Romney, also, a portrait painter of high repute. Visited the buildings in the neighbourhood of Oxford Road; a deal of new ground has been built hereabout. Marybone Gardens at this time are in ruins, the ground intended for building upon. Walked to St. James's with an intent to see the King and Queen. Had a view of them both on the road from Buckingham House to St James's carried in chairs, attended by a few footmen and yeomen of the guards . . . To the disgrace of the court, the yeomen of the guards are the rudest set of people I have hitherto met with in this town. After dinner took a walk to Kensington. The gardens at certain seasons are open and free to every one out of livery or *who does not wear leather breeches* . . . Called on Sir Joshua Reynolds, and feasted my eyes with a sight of his excellent paintings – likewise upon Mrs Hogarth, widow of the late famous man; saw his excellent collection of prints, and purchased a few taken from the plates of that humorous man.[7]

If Stubbs was at home when Holt called, he must have found his own curiosity greatly warmed, for this visitor cut an unusual figure, 'a tall spare man' who did not shave and had a piping voice 'resembling that of the mutilated males of Italy. His clothes were large and loose, and his land boots or shoes, with high fronts, were precisely like those which may be discerned in Hogarth's prints.'[8]

As social centres, some artists' studios had a raffish, even immoral reputation. This was generally because women could enter them on an equal footing with men, so that 'disgraced' society women like Lady Sarah Bunbury (the Duke of Richmond's sister), and courtesans like Kitty Fisher and, later, Emma Hart, who may not have been acceptable in polite company, could always be seen at the studios of men like Reynolds and Romney. But Stubbs's practice was at this time mostly with men and animals – though perhaps some ladies brought in their lapdogs[9] – and in any case he projected an image all his life of sobriety and seriousness. It is difficult to see his home as a centre of gossip. According to his obituarist,

> he was always a very early riser who often walked from Seymour [i.e. Somerset] Street to Fleet Street, and back again, before the regular hour of breakfast. He enjoyed an excellent state of health; was remarkably abstemious, eating little food, and drinking only water for the last forty years.[10]

Actually, it is not true that he drank only water – Joseph Farington's diary has him drinking tea with the eccentric history painter James Barry[11] – but Stubbs's teetotalism and taste for vigorous walks was certainly part of his legend. He was happy wearing the social mask of the widower, residing at Somerset Street in sober domesticity, while caring for his fifteen-year-old son, George Townley Stubbs, now (or soon to be) living with him. The fact that his housekeeper Miss Spencer was a single girl of twenty-one was not, apparently, a cause for scandal.

Stud and Groom

Mr Stubbs . . . went for the first time to Newmarket to paint Snap
for Jenison Shafto Esq.

When Stubbs met him, in 1760, the stallion Snap was a ten-year-old
and had already been employed for five years at Mr Shafto's stud.
Stubbs's picture is in the characteristic vein of his early horse portraits.
Snap and his groom stand on a path, conceivably an exercise gallop,
leading over an upland heath. Beyond them the land slopes gently
down into a wooded river valley, before rising again to a level skyline.
This divides the picture space almost in half, while scattered afternoon
sunlight patches the landscape. The scene must be Wratting Common,
close to Shafto's Wratting Hall stud farm, with a view north-eastward
into the valley of the River Stour. Far away, picked out by the sun, are
the buildings of Newmarket – the first glimpse of the place in all of
Stubbs's work.

Newmarket might have been an insignificant Suffolk market town,
but two features had combined to shape its destiny. It stood on an
important highway, the main London-to-Norwich road, and was
surrounded by the wide expanse of its heath, a spread of springy turf
over Warren Hill and the Limekilns in the east, and away to a western
horizon that was defined by the Devil's Dyke, a massive seven-mile
defensive earthwork that had been raised by Anglo-Saxon tribes in the
seventh century. A thousand years later King James I, too, had a habit
of retreating behind the Dyke, for he found in Newmarket an agreeable
and accessible (but not *too* accessible) royal bolthole. The heath
provided easy gallops and excellent deer coursing. And its seventy-mile
distance from London deterred incursions by meddlesome prelates and
Whitehall men of business, fussily insisting that affairs of religion and
state were more important than drinking and sport.

Within two generations, the heath's qualities as an equine training
and racing ground had displaced its appeal as a hunting field, but the
place continued to rub up London the wrong way. People wondered
how this scrap of a town could provide such addictive counter-
attractions to the metropolis. The Duke of Grafton, originally one of

the foremost Rockinghams and Prime Minister in the late 1760s, lived at Euston Hall near Newmarket. He much preferred race meetings to Cabinet meetings, exasperating unsporting types like Horace Walpole, who described Grafton as 'like an apprentice, thinking the world should be postponed to a whore and horserace'. Jenison Shafto was a friend of Grafton's, if a rather less politically important one, and it was he who first brought Stubbs to Newmarket.

Jenison Shafto was one of the most energetic and committed racing men of the day. In 1760 he was trying to buy his way into Parliament which, after failing to clinch the borough seat of Scarborough, he succeeded in doing at Leominster, after redistributing some recent Newmarket winnings among the voters. His candidature had little to do with political principle, however. During a ten-year parliamentary career his allegiance drifted from Fox, to Grenville, then to the Duke of Bedford, and he spoke only once in the house, 'proposing the militia should be sent abroad [on 18 March 1762]. He did it ('twas said) to win a wager of £200 laid at Arthur's.'[1]

Membership of the House of Commons gave status, but breeding horses in order to gamble on them was Shafto's main thing. His success, at least for a time, appears extraordinary. Snap, his star performer, was a 'very fine horse of a beautiful shape, justness of proportion, great power of sinew, which was strong firm and vigorous, and was allowed to be as good a runner, if not better, than any horse of his time'.[2] Snap's sire Snip was a son of the incomparable Flying Childers, and grandson of the Darley Arabian, while on his dam's side he descended from the Byerley Turk. These last-named horses, with the Godolphin Arabian, form the holy trinity of stallions from whom all of today's thoroughbreds ultimately descend. On the track, Snap was undefeated though lightly raced with only four runs. He twice defeated the Duke of Cumberland's Marske over the Beacon Course at Newmarket for 1000 guineas, and again scored heavily for Shafto by winning the Free Plate at York, against all the crack horses of the north. But his true glory came after these exertions, as principal stallion in Shafto's stud. 'Snap for speed' was the catchphrase summing up the property he bred into his offspring and in twenty-one years he sired a prodigious 261 winners, who combined to collect £92,637 in stakes. Snap was champion stallion for four out of the five years between 1767 and 1771.

Compared with *The Grosvenor Hunt*, *Whistlejacket* and the

monumental pictures in Rockingham's Green Room, there is nothing perceptibly emblematic in the picture Stubbs painted of him, and no antique or classical influence. It strives rather to be a completely naturalistic image, a true portrait. Snap is dark-coated and streamlined, but with a dangerous gleam in his eye. It has been said that the groom is Thomas Jackson who, like so many of the foot soldiers recruited to the turf in the eighteenth century, was a Yorkshireman.[3] Jackson had worked for the famous horseman Cuthbert Routh of Malton, before coming south to Newmarket on his master's death in 1752. Routh was Snap's owner-breeder and Shafto bought the horse at his posthumous sale.

Jackson had evidently migrated with the horse. But he was a jockey and trainer rather than a stud servant, and in any case this individual looks too young to be Jackson. He seems a man in his thirties, whereas Jackson was almost sixty at this date. But whoever he was, Stubbs produces a profoundly sensitive portrait of a man acutely aware of his horse's temperament. The bond between a stud groom and his personal charge is a close one and, like any worthwhile relationship, it is based on mutual knowledge and respect. In his many stallion portraits (in which a groom is almost invariably to hand) this is exactly what Stubbs set out to convey.

Stubbs did not, however, try to suggest the context of the stud, any more than he had in his pictures of mares and foals for Grosvenor in Cheshire, or for Rockingham in Yorkshire. But four or five years later, he went to Grosvenor's racing stud at Oxcroft, close by Shafto's, and painted a *Mares and Foals beneath Large Oak Trees*, which for the first time incorporated important aspects of the stud farm itself.[4] Snaking away behind Grosvenor's horses is a sturdy fence of the kind absolutely necessary in a stud to separate the paddocks, some of which contain mares, others stallions. Seen straddling this fence is a single thatched building, whose practical purpose has never, as far as I know, been noticed by scholars. Yet it is surely the most important stud building of all: the covering shed. This could be entered from one paddock by the ovulating mare, and from the other by her intended mate, ensuring a controlled encounter that minimised the chance of her being covered by the wrong stallion. These fences and sheds, emphasising the precise location where the horses earned their feed, now became a usual feature of Stubbs's stallion portraits, and of the prints after them.[5]

CHAPTER 35

Horses in Training

The race-horse: an animal so peculiarly our own that England may defy the surrounding nations, for speed, for courage, and for beauty, to produce its equal.[1]

Just as Stubbs did not represent the stud farm in his earliest stud pictures, he avoided references to the racetrack in his first portraits of running horses, so that tranquil works such as *Molly Long-Legs*[2] and *Lord Rockingham's Scrub with John Singleton up* seem to suppress, almost defiantly, the truth of these horses' working lives. Racing was in fact an extremely arduous activity and was accompanied by a frenzy of human excitement. Contests were run in three heats, over four miles each, so that an animal might gallop a total of twelve miles in an afternoon, goaded all the way by sharpened spurs and flying whips. The races were preceded by loud argument and the shouting of bets, and were then conducted with owners, trainers and other spectators galloping furiously behind the runners on their riding hacks, yelling profanities and encouragement, while the crowd in the stands and enclosures near the finish roared the horses home.

Stubbs refuses to countenance any of this. Unlike a social illustrator like Thomas Rowlandson, he saw racing thoroughbreds not as miserable pegs in some high-stakes game of cribbage, but as personalities, and sometimes heroes, who transcended the human greed and dissipation that surrounded them. At first he emphasised this by posing his subjects against elegant (but unspecific) landscapes arranged according to the approved taste. In the case of his portrait of the Duke of Grafton's *Antinous*, painted about 1763, there is a distant view of Euston Hall, although here the background is not by Stubbs but his occasional collaborator and friend, the landscape specialist George Barret.[3]

From the mid 1760s, however, he made a significant change in his portraits of running horses: he began to paint them against the background of their working environment, the bare, windswept and not at all picturesque space of racing's 'headquarters' – Newmarket Heath, where the low horizon was perfect for showing off the contours

of the standing, profiled animals. One of the four rubbing-down houses (the subject of Stubbs's only known pure landscape paintings, which he completed for his own reference in the mid 1760s)[4] was a favourite identifying element and, in the background, Newmarket's parish church of St Mary, the windmill, the Beacon Course's viewing boxes and a running rail might also be shown. Conspicuously, however, there was still no acknowledgement whatever of the sport's raffish appeal for the gambling public.

Stubbs made one of his most complex canvases in this mode when he painted *Gimcrack on Newmarket Heath with his Trainer, Jockey and a Stable Lad*. The subject, shown running in the colours of Lord Bolingbroke, was a courageous, diminutive grey colt (he stood only 14.2 hands) and a great favourite with the public. He passed through the hands of six owners – Bolingbroke's tenure lasting only for a few months of 1765 – and Stubbs painted the horse several times. This canvas is unique among Stubbs's known work, a 'time-shift' composition in which the horse is seen, on the one hand, distantly galloping past the winning post well ahead of his field while, on the other, he stands in the foreground being rubbed down.[5]

Stubbs had a quick eye and seems to have been aware that, for the galloping horse, the 'flying' or 'rocking-horse' gallop was incorrect, which may be one reason why he preferred a standing pose. The true motion of galloping was not revealed until Eadweard Muybridge published his sequential photographs in 1878, though Stubbs could at least see that the hind legs, instead of pushing off the ground together, quickly follow each other. He also noted and captured the forward thrust of the head at the same moment, ensuring that the forefeet are never seen (as in many other horse paintings) incorrectly extending beyond a perpendicular line from the muzzle to the ground.[6] This is the only point in the galloping cycle that the eye has a chance of getting even half right in real time, which explains why Stubbs, in common with most other horse painters, was forced to show a field of runners all stretching out impossibly in step with each other, like horses on a roundabout.[7]

The work of the trainer's yard was necessarily different from the stud farm, but Stubbs was just as interested in the lad kneeling under Gimcrack as he was in the stud grooms he portrayed with Snap and other stallions. What was it like, the life of these Georgian stable lads? We have, as it happens, a highly evocative description, dating from the very time Stubbs himself first came to Newmarket. This is by the writer

Thomas Holcroft, who was apprenticed between the ages of fourteen and seventeen (that is, between 1759 and 1763) to the Newmarket trainer John Watson, on a wage of 4 guineas a year.[8] Watson worked for the important owner and Jockey Club member Captain Richard Vernon, whose all-white racing colours are those carried by the runner-up in the race shown in *Gimcrack on Newmarket Heath with his Trainer, Jockey and a Stable Lad*.[9] Holcroft's *Memoirs* contain a priceless stable lad's view of a racing establishment in Stubbs's day.

> All the boys rise at the same hour, from half-past two in spring, to between four and five in the depth of winter. The horses hear them when they awaken each other, and neigh, to denote their eagerness to be fed. Being dressed, the boy begins with carefully clearing out the manger, and giving a feed of oats, which he is obliged no less carefully to sift. He then proceeds to dress the litter; that is, to shake the bed on which the horse has been lying, remove whatever is wet or unclean, and keep the remaining straw in the stable for another time ... In about half an hour after they begin or a little better, the horses have been rubbed down, and reclothed, saddled, each turned in his stall, then bridled, mounted, and the whole string goes out to morning exercise ...
>
> Except by accident the race-horse never trots. He must either walk or gallop; and in exercise, even when it is the hardest, the gallop begins slowly and gradually, and increases until the horse is nearly at full speed. When he has galloped half a mile, the boy begins to push him forward, without relaxation, for another half-mile . . . The boy, that can best regulate these degrees among those of light weight, is generally chosen to lead the gallop.

There would be two of these 'sweats' or 'brushing gallops', both of which climaxed with the horse, always wearing a thick blanket, at full stretch on an upward slope. With rests, walks and watering in between, exercise would take, says Holcroft, up to four hours before the string returned to the stable, where the lad

> leads the horse into his stall, ties him up, rubs down his legs with straw, *takes* off his saddle and body clothes; curries him carefully, then with both curry-comb and brush, never leaves him till he has thoroughly cleaned his skin . . .[10]

With a second visit to the gallops in the afternoon, it was an extremely long day.

> About half after eight, perhaps, in the evening, the horse has his last feed of oats, which he generally stands to enjoy in the centre of his smooth, carefully made bed of clean long straw, and by the side of him the weary

boy will often lie down . . . [But] should sleep happen to overcome him, some lad will take one of those tough ashen plants with which they ride, and measuring his aim, strike him with all his force, and endeavour to make the longest wale he possibly can, on the leg of the sleeper.[11]

Holcroft had grown up in poverty and was later a journalist with radical views, as well as a translator, playwright and novelist. But despite the hard work and low status of stable life, he looked back only with pleasure on his time with John Watson.

I was warmly clothed, nay, gorgeously, for I was proud of my new livery and never suspected that there was disgrace in it; I fed voluptuously, not a prince on earth perhaps with half the appetite, and never-failing relish; and instead of being obliged to drag through the dirt after the most sluggish, obstinate and despised among our animals, I was mounted on the noblest that the earth contains, had him under my care, and was borne by him over hill and dale, far outstripping the wings of the wind.[12]

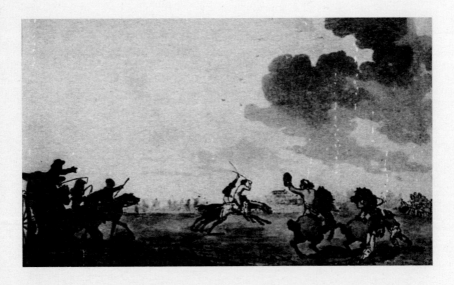

A Horse Race by Rowlandson, 1785. A vision of the frenzy of racing, which Stubbs pointedly ignored.

1. This undated *Portrait of a Young Man* by William Caddick might be the painting described in a nineteenth-century inventory as 'Stubbs by Caddick'.

2. A confident self-portrait by Hamlet Winstanley.

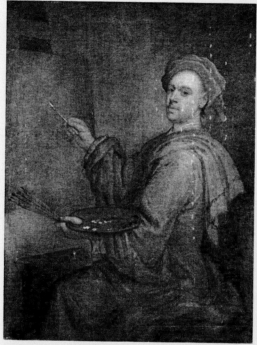

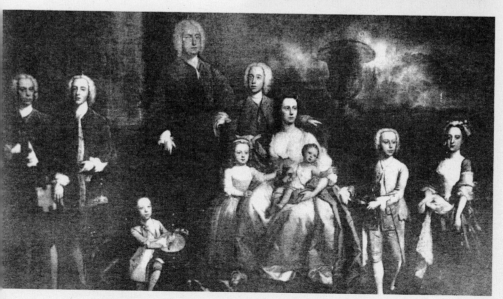

3. The Blackburne family painted by Hamlet Winstanley in 1741, at or close to the time when Stubbs was his apprentice.

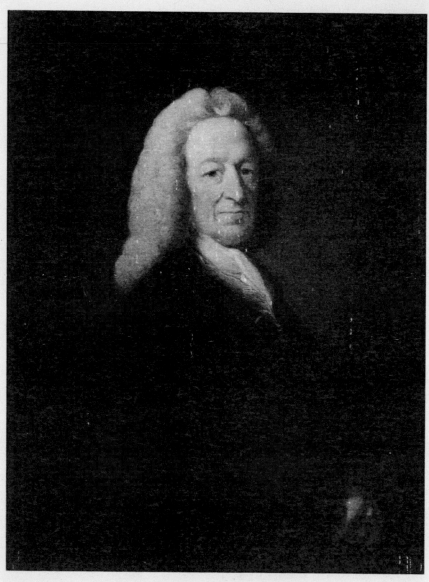

4. Richard Wilson, Recorder of Leeds,
by his relation Benjamin Wilson.

FACING PAGE
5–7. Three of Stubb's illustrations of foetal presentations and obstetrical instruments,
from John Burton's *An Essay Towards a Complete System of Midwifry, etc.*, 1751.
The forceps were to play an important role in Laurence Sterne's *Tristram Shandy*.
8. *(Below right)* Foetal illustration from the 1754 book by Burton's great rival William Smellie.
The artist, far ahead of Stubbs in sophistication, was Jan van Riemsdyck.

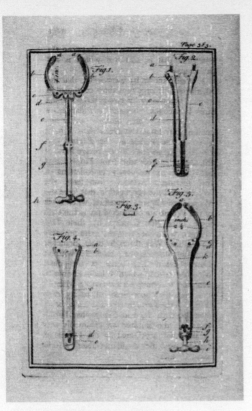

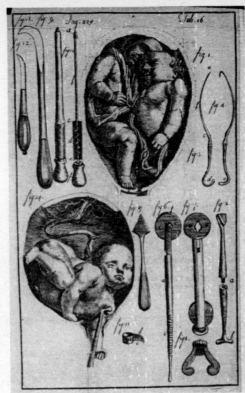

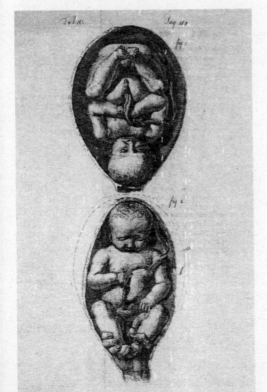

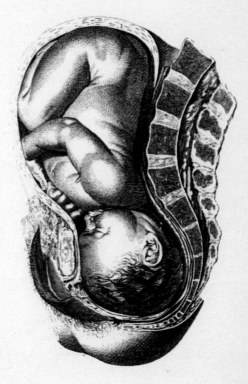

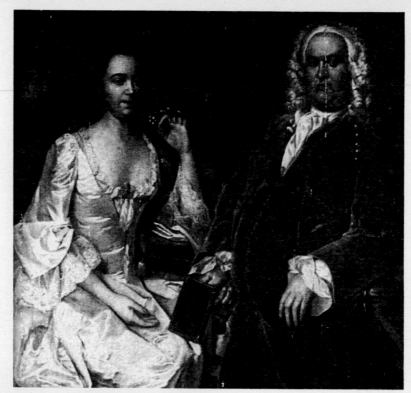

9. Sir Henry and
Lady Nelthorpe,
1746.

10. Sir John Nelthorpe as a boy, 1755.

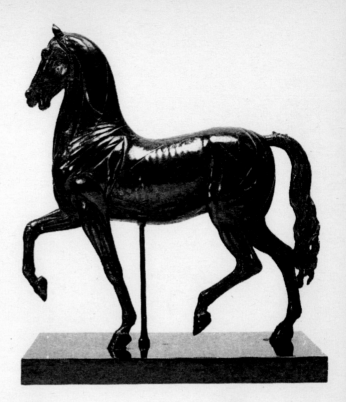

11. *Flayed Horse*, a bronze probably seen by Stubbs at the Villa Mattei in Rome, 1754.

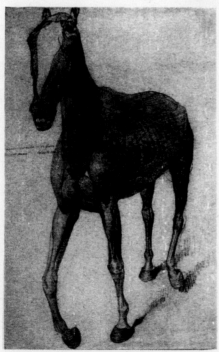

12. Horse, partially dissected, anterior view. A working anatomical drawing made at Horkstow, Lincs., 1756–8.

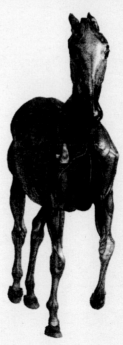

13. Plate from *The Anatomy of the Horse*, engraved by Stubbs and published in 1766. Note the slight change in angle compared to the working drawing.

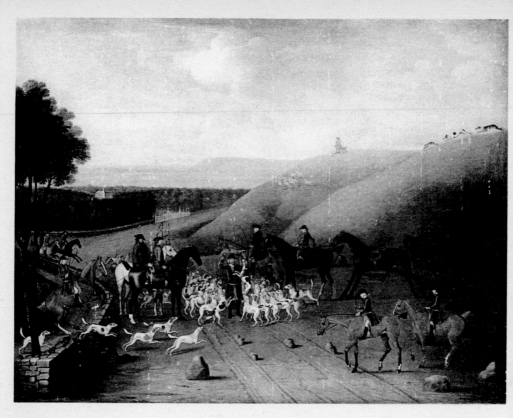

14. *A Kill at Ashdown Park*, 1743, by James Seymour, a composition similar to Stubbs's *The Charlton Hunt* (colour plate 6).

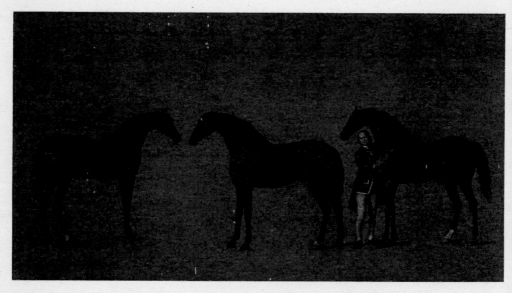

15. Lord Rockingham's stud groom Simon Cobb with three stallions.
The one embraced by Cobb is Whistlejacket.

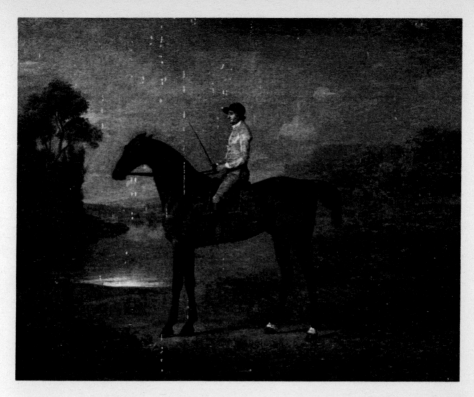

16. Lord Rockingham's Scrub, with John Singelton up, 1762.

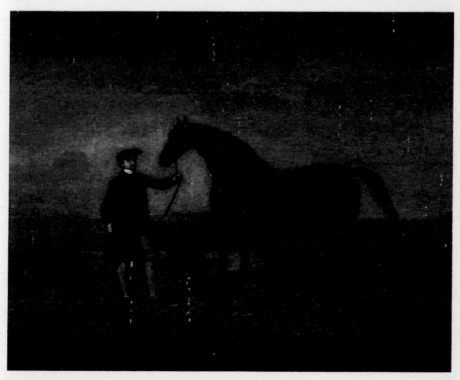

17. Jenison Shafto's highly successful stallion Snap, with his groom on Wratting Common, 1760.

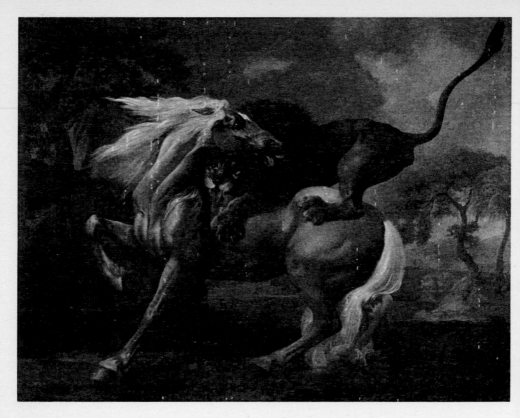

18. *Horse Attacked by a Lion*, 1762, an enormous canvas that hung with its pendant in the salon at 4, Grosvenor Square, Rockingham's London home.

19. Jacobite medal by Otto Hamerani, showing James Edward, the Old Pretender and, on the obverse, the Hanoverian horse trampling the British lion and unicorn.

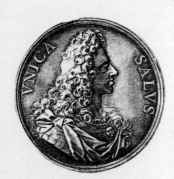

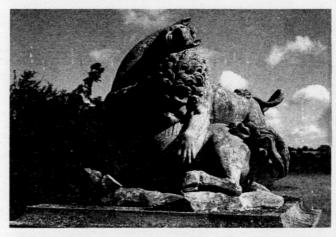

20. *Lion Attacking a Horse* in Portland stone by Peter Scheemakers, 1742. It was carved for the garden at Rousham House, Oxfordshire, after the antique sculpture in the Palazzo dei Conservatori, Rome.

CHAPTER 36

Flemish Stubbs

Mr Stubbs painted the celebrated picture of the Bricklayers and Labourers, loading Bricks onto a Cart.

The young Whigs' attachment to their sport and their land continued to bring commissions to Stubbs throughout the 1760s, and in mid decade he undertook a number of paintings about estate activities in close-up, which he later considered to be among his most interesting work. Estate scenes and farming landscapes from the Netherlands had been squirrelled away by collectors in England for more than half a century, and Stubbs – despite his claims to be independent of other artists – was not impervious to the influence of these paintings and, in fact, pieces he did for the Viscounts Midleton and Torrington at this time are both explicitly linked to Flemish models.

For the Irish peer George Brodrick, third Viscount Midleton, he painted *A Hound Coursing a Stag*, in a parkland setting.[1] The Flemish artist most famously associated with hunting scenes was Rubens, who had a line in wild animal hunts – lions, tigers, boars, deer – featuring dramatic tangles of dogs, hunters, horses and prey in the desperate final moments of a chase. Two of his assistant-followers, the Antwerp brothers-in-law Frans Snyders (1579–1657) and Paul de Vos (1596–1678), specialised in developing this type of work and numerous examples of their hunting scenes were to be found in English country houses in the mid eighteenth century.

Midleton, whose main English home was at Peper Harrow in Surrey, was an exact contemporary of Rockingham, a member of the same political and social circle, and a man of exemplary taste. He employed William Chambers to redesign his house, and Capability Brown to do the same to his grounds, so there is nothing surprising in him commissioning this painting of a greyhound as it runs down a stag in open country and leaps at full stretch to bring it to ground by the ear. The painting is a beautiful work, with an exceptionally fine, and surely not imaginary, landscape that includes, unusually in Stubbs, snow-covered uplands in the far distance.

Organised deer-coursing meetings had been held in England for at

least 200 years, normally in a railed or walled paddock (the course) within a deer park, typically laid out over a mile, with enclosures and a raised viewing platform for spectators, pens for the deer and kennels for the dogs. The deerhounds – rangy, long-haired sighthounds, standing as high as thirty inches to the shoulder – ran competitively for plates and money prizes, and gambling was extensive.[2] But formal coursing for deer in England had become almost extinct by the later Georgian period and it is evidently not what we see here. Rather, it is an unstructured course, apparently run by a single dog which is not a traditional deerhound (nowadays distinguished as the Scottish Deerhound) but a smaller, smooth-haired greyhound of a type still used for dog racing today.

Scholarly comment on the two animal figures has concentrated on the stag. It is, as Judy Egerton points out, the same individual, in an almost identical posture, as the stag brought to bay in the water by hounds in the much larger *The Grosvenor Hunt*, which in turn may have been based on studies of stags made during Stubbs's stay at Goodwood in 1759–60.[3] However, it is the hound that compels my attention, because this too had been seen before, though not painted by Stubbs. It bears, instead, a close similarity to a leaping hunting dog used again and again by Rubens and his associates in their hunting scenes. It seems certain that Stubbs had studied examples in one or more of the English country houses he had visited, and used it deliberately here. The upward diagonal thrust of his dog is almost identical to the compositional dynamic of several such paintings.[4]

Three or four years later, Stubbs was again asked by a Rockinghamite peer, George Byng, third Viscount Torrington, to emulate the Flemish tradition. The story is treated in some detail in Humphry's memoir.

> At Southile, the seat of the Lord Viscount Torrington, Mr Stubbs painted the celebrated picture of the Bricklayers and Labourers, loading Bricks onto a Cart. – This commission he received from the noble lord in London, who had often seen them at their labours appearing like a Flemish subject and therefore he desired to have them represented. He arrived at Southile a little before Dinner, where he found with Lord Torrington, the Duke of Portland with other noblemen and gentlemen.[5]

This reads like a much repeated anecdote. The men Torrington wanted to have painted were builders employed on the construction of a small house, apparently a model farmhouse or cottage, designed for the estate in trendy Palladian style by the architect Isaac Ware. The workmen were summoned while Torrington, Stubbs and the other

guests dined, and were told to put an old horse, 'Lord Torrington's favourite old hunter, this being the first horse His Lordship ever rode', between the shafts of their cart, thus giving 'the ostensible motive for ordering the picture'. It was, however, a ruse to prevent the men from realising *they* were the real subjects of the painting, and being inhibited in their natural behaviour. The painter then went to work.

> Mr Stubbs was a long time loitering about considering the old men without observing in their occupation any thing that engaged them all, so as to furnish a fit subject for a picture, till at length they fell into dispute about the manner of putting the Tail piece on to the Cart, and this dispute so favorable for his purpose agitated these Labourers & continued long enough to enable him to make a sketch of the men, Horse & Cart, as they have been represented. Thus having settled the design as time & opportunity served, he removed the Cart, Horse & men to a neighbouring Barn where they were kept well pleased & well fed till the picture was completed as it appeared in the Exhibition many seasons afterwards, the favourite subject of the year with universal admiration.[6]

What Torrington wanted, and to some extent got, was a Flemish-style composition of the kind he thought David Teniers or one of the Breugels might once have produced on the theme of 'rude mechanicals' engaged in rustic activities. But in a piece of useful detective work in 1980, modestly subtitled 'A Footnote', Francis Russell showed that Torrington owned three closely related paintings of everyday life on his estate, all painted by Stubbs and of uniform size.[7] *Labourers* (sometimes known as *Brickmakers*) was painted in the same year as *Lord Torrington's Hunt Servants Setting out from Southill*[8] and *Lord Torrington's Steward and Gamekeeper with their Dogs*.[9] These paintings were sold in January 1778, after the owner suffered financial reverses, but at the time of their creation they were a statement of his Lordship's commitment to the life of his estate, and of his patriarchal affection for its workers. This he shared with his brother, and eventual heir to the title, Colonel John Byng, the civil servant, diarist, and horseback tourist to almost every part of England. The Colonel cordially disliked his brother George who, in addition to their political differences, had done him some unspecified hurt, either financial or sexual.[10] But the mixed motives behind the third Viscount's commission for Stubbs – aesthetic, sentimental, proprietary – are also apparent in the fantasies Colonel Byng records about being

> adored in my country village by preventing oppression, by succouring the weak and needy, by finding them cheap fuel, by giving land sufficient to

each cottage, by distributing clothing to those who frequented divine service, by administering medicines gratis, by holding out to them support, comfort and consolation.[11]

All nine of the individuals in Stubbs's paintings would have been instantly recognisable to anyone who knew them, though only one can be named today.[12] Two of the *Labourers* are clearly brothers – in fact, twins in Stubbs's engraving – while the *Hunt Servants* outside the front door of Southill might be a father and son. The animals, too, are portraits, including not only his Lordship's childhood riding-pony in *Labourers* but his 'favorite old dog' lying asleep in the same work, and a Red Setter who appears prominently in both of the other two paintings.

Stubbs lived to see two elements of his Southill triptych humiliatingly 'improved' twenty years later by another hand. This was not the doing of the paintings' next owner, the meat salesman and Stubbs collector William Wildman, who knew better. It came after Wildman's posthumous 1787 sale, when Andrews Harrison, the successful bidder for *Labourers* and *Gamekeepers* (but not *Hunt Servants*) employed the undistinguished landscapist Amos Green to repaint their backgrounds.[13]

The difference between the original *Labourers* and Green's revision is instructive. Stubbs made two repetitions of his own design, in 1779 in oils on wooden panel, and again in 1781 for Josiah Wedgwood, this time in the form of a beautiful oval enamel.[14] His inclusion in all three works of Ware's pristine neoclassical model farm, with its clipped lawn, white-painted railed fence and wrought-iron kissing gate, undercut the 'Flemish' effect by offering a clean, light-filled view of the rational life, to set against the four peasants in the left foreground, arguing over the cart's tailgate. Green made away completely with this contrast, and substituted for the Lodge a 1790s cliché: thatched peasant cottages nestling in a green dell. As Francis Russell notes despairingly,

> presumably the Iveagh picture [*Gamekeepers*] was tampered with in the same way and for the same motive: to bring a picture painted by Stubbs for a very specific context into line with a popular conception of the picturesque in a rural dimension, and with which he can have had little sympathy.[15]

Harrison's vandalism was commercially motivated, for he lost no time in having the revised canvases engraved in mezzotint and issued by the

publisher Benjamin Beale Evans in 1790. Stubbs must have got wind of these moves in advance. Although he had exhibited his own second version of the composition at the Royal Academy in 1779 (no. 339), a painting which showed the New Lodge as before, he waited ten years to issue a print of it. When he did he was exactly twelve months ahead of Beale.[16] Stubbs's print, perhaps significantly, did not include the New Lodge. He engraved only the detail of the men, the horse and the cart, while the sleeping dog (which in the original is placed out to the right) was brought across to lie in front of the carthorse. In this way an unambiguously 'Flemish' effect is finally created, in contrast to Amos Green's movement towards picturesque sentimentality, a mode that had begun to take hold with the success of scenes of cottage life by the likes of George Moreland. In fact, Evans's and Stubbs's competing print issues both enjoyed success, so that Humphry could justly write a few years later that *Labourers* became a 'celebrated' work.

This 1790 print is after Stubbs's painting of Lord Torrington's Steward and Gamekeeper (1767). The figure on foot is the gamekeeper, Joseph Mann. Originally the background may have included a view of Southill, Torrington's country house, before Amos Green's 'improvements'.

CHAPTER 37

Game Law

His four shooting pictures . . . were sufficient to establish his reputation as a great painter, had he never covered another piece of canvas.

Sporting Magazine, May 1808

Of Southill's outdoor servants, portrayed in such unsentimental style by Stubbs, only one can now be named. This is Joseph Mann, the old gamekeeper trudging along behind Torrington's mounted steward in *Gamekeepers*[1]. Mann had been born at the turn of the century and was not a local man, but had come to the Southill estate from Hertfordshire in 1733. Already he looked middle-aged, with hair that had turned grey during a serious illness in his late teens, a premature *gravitas* that probably helped him to land the important job of huntsman. Before long Mann was doubling as head gamekeeper, another position which, in a great estate, carried much responsibility and prestige (though, as Stubbs's painting makes plain, rather less than that of the steward). To hold both posts simultaneously suggests that Mann was, as his legend suggests, a character out of the ordinary. In 1813 he was remembered as

a perfect adept in Shooting, Hare hunting and in the Arts of preserving Game. Domesticated so long in the same Family, and attentive to the same sports, he was looked upon by the neighbours as a Prodigy . . . and was called by all the county people Daddy. He was in constant, strong morning Exercise; he went to bed always betimes; but never till his skin was filled with ale. This he said 'would do no harm to an early riser' (he was ever up at daybreak) 'and to a man who pursued Field sports'. At 78 years of age he began to decline, and then lingered for three years. His Gun was ever upon his Arm; he still crept about, not destitute of the hope of fresh Diversion.[2]

As gamekeeper Mann had the job of enforcing the Game Laws. These harsh measures made poachers of those taking game, even on their own property or on common land, who were not possessed of ground worth £100 a year. This meant that the vast majority of English people were legally excluded from shooting, netting, trapping, hunting with dogs,

or even from owning a gun. Mann's general popularity in the county suggests he exercised his jurisdiction with paternal care, that is, not very strictly.

Many other keepers systematically abused their position, taking bribes or a cut of the poachers' bag. Others, with their employers' sanction, were draconian, opening fire on trespassers and sowing the forests and coverts with mantraps. As the liberal wit, and sworn opponent of the Game Laws, the Rev. Sydney Smith put it,

> there is a sort of horror in thinking of a whole land lurking with engines of death – machinations against human life under every green tree – traps and guns in every dusky dell and bosky bourn – the lords of the manors eyeing their peasantry as so many butts and marks and panting to hear the click of the trap and see the flash of the gun.[3]

Smith's is a brilliant and destructive Swiftian conceit – that these laws were framed specifically to enable men to enjoy hunting *other men*. Half a century earlier, the plot of Henry Fielding's *Tom Jones* hinged on Tom's illegally killing a partridge in company with Squire Allworthy's dishonest gamekeeper, Black George. But Fielding, like Smith, focuses his deadly irony not on the keeper and his kind, but on the real beneficiaries of the Game Laws,

> those gentlemen who are called *preservers of the game*. This species of men, from the great severity with which they revenge the death of a hare, or a partridge, might be thought to cultivate the same superstition with the Bannians in India; many of whom, we are told, dedicate their whole lives to the preservation and protection of certain animals, was it not that our English Bannians, while they preserve them from other enemies, will unmercifully slaughter whole horseloads themselves, so that they stand clearly acquitted of any such heathenish superstition.[4]

Between Fielding's and Smith's time, the Game Laws became a passionate political topic. In 1752 a Game Association was formed not merely to defend the law, but to push through a further tightening of it in 1755 and again in 1770. But meanwhile, as these measures proceeded, they provided a focus for the arguments of an increasing number of critics of country blood sports. These did not yet dwell on cruelty to animals, nor on what we call civil rights, but on the earnest question of whether hunting, shooting and racing were demeaning, even morally dangerous, to those who practised them. Some, like the Duke of Northumberland, felt country sports took nobles and gentlemen away from their public duties and attached them too much

to the muddy, benighted hinterlands of forest, marsh and heath. Others disliked the whole Boobyish milieu, the drinking and gambling, the obsessive risk taking and the dedicated boorishness of it all.[5]

Squire Booby himself was unconcerned by the views of the effete metropolis. But many devotees of blood sports were also sophisticated men about town. Needing to justify their double lives, they fell back on promoting their sport as a natural activity, like eating and drinking. Indeed, it was as a form of food production that hunting and shooting were singled out for praise, while also being healthy and, of course, manly. But sport was edifying, too, even when the quarry was the uneatable fox, for it readied a man for war and other dangers.

> The Artifices and Dexterity employed by wild animals to conceal themselves, or to avoid pursuit of the Dogs, are most worthy of admiration and perhaps in this art of self-preservation, the Fox has exhibited more proofs than any other Beast of Chase.[6]

As in all such controversies, there were Game Law reformers and total abolitionists. The admirer of the fox just quoted was the Rev. William Daniel, a fanatical sportsman who wrote one of the most popular books on rural sport in the Regency period. Daniel was a moderate reformer. He was capable of arguing that 'hunting was one of the first employments of Man; it was a kind of natural right, and was free to all. Considered as an Exercise it is best contrived for strengthening the general habit.'[7] Yet he refused to abandon the idea that 'game is a species of property' and that the landless poacher was a degenerate wretch, a 'prowling Vagabond' whose activities, far from 'strengthening the general habit', encouraged the 'secrecy of fraud' and 'a career of iniquity'. Daniel was in favour only of reducing the laws' penal severity, while retaining the property qualification. His argument in essence is that hunting and shooting are so morally worthwhile that they should be reserved to the most deserving, which assuredly did not include the poor.[8]

Stubbs entered this debate in 1766 or 1767, when he painted a picture of two men setting off for an autumn day's rough shooting. Over the next four years he developed this into one of his most interesting series, the four canvases known collectively as his 'shooting pictures', which he exhibited in successive annual shows at the Incorporated Society of Artists from 1767 to 1770.[9] A set of highly successful and influential prints were made of them by one of London's most skilled artist

engravers, Stubbs's friend William Woollett, assisted by a pupil, Thomas Hearne.[10] These are 'engraved after the Original Pictures in the Possession of Mr [Thomas] Bradford'. The prints were actually published by Bradford, a well-known Fleet Street print seller, with doggerel inscriptions by an unknown hand, evidently composed specially for the issue. They begin:

> Lo! The keen Sportsmen rise from Beds of Down,
> And quit th'Environs of the Smoaky Town.

The sportsmen's starting point, in the first scene, is an identifiable place, Creswell Crags, a limestone gorge on the Nottinghamshire estate of Lord Rockingham's friend the Duke of Portland. Through it flows the River Wellow and in the left middle ground, under a formation of rock rearing to the sky, Stubbs shows a thatched mill that seems, though obviously dilapidated, in working order, since dripping water indicates that the undershot mill-wheel is turning. On the right, the shooters are seen with their dogs, two pointers called, in the engravings' verses, Pan and Flora. The dark-coated man has barrel-loaded his gun with charge and ball, and is withdrawing the ramrod from the muzzle. His younger companion in the lighter coat attends to his gun's lock, priming the pan and placing the hammer and frizzle (against which the flint in the hammer strikes its spark) in the safe, half-cock position. These are the two stages of preparing a flintlock for firing.

In the second scene the morning has advanced, the weather is bright and the shooters have walked some distance. Emerging from woods, they pass a cottage while the dogs run ahead into the stubble of a cornfield:

> By Instinct strongly urged each try around,
> Now Snuff the Air, now scent the tainted ground.

In the third scene it is afternoon. We see the result of Pan and Flora's work in the stubble.

> A gentle Gale that blows along the Land
> The Game betrays; the Dogs they Draw and Stand:
> Search all the Objects that afford delight,
> There's none like this can please the Fowler's sight;
> Softly they step expecting instant Sport,
> The Covey springs to find some safe resort;
> Like Lightning flys the Shot, one falls to Ground,
> The rest well mark'd, again are to be found.

More successful as literature, and more informative, is William Cobbett's account of how a particularly conscientious pointer went to work:

> Ewing and I had lost our dog. We were in a wood, and the dog had gone out and found a covey in a wheat stubble joining the wood. We had been whistling and calling him for, perhaps, half an hour or more. When we came out of the wood we saw him pointing, with one foot up; and soon after, he, keeping his foot and body unmoved, gently turned round his head towards the spot where he heard us, as if to bid us come on, and, when he saw that we saw him, turned his head back again. I was so delighted that I stopped to look with admiration. Ewing, astonished at my want of alacrity, pushed on, shot one of the partridges, and thought no more about the conduct of the dog than if the sagacious creature had had nothing at all to do with the matter.[11]

It might be the very scene depicted by Stubbs in his third canvas, with the light-coated shooter bringing down a partridge on the wing while his companion ducks to avoid the shot. The successful kill is indicative of the shooter's skill, or luck, for the French amusement of trying to shoot a bird flying was still a novelty in England. It was also very difficult with a fowling piece of that era, when a slight, but unpredictable, delay occurred between the pull on the trigger and the discharge of shot.[12]

In Stubbs's final episode, the sportsmen are discovered in the woods at evening, counting their bag, the darkening scene intensified by the thick surrounding foliage. The older man rests 'sated with sport' under an ancient tree, while the other brings in a hare, the last kill of the day.

> Behold what Dainties in profusion spread,
> The mingled produce of the recent dead.
> Calm Eve's approach here bids the slaughter cease,
> And gives the winged tribes to rest in peace.

The day's bag consists of two hares and a cock pheasant, a woodpigeon and partridge, a snipe or woodcock and, rather surprisingly, a brace of lapwing.[13]

It was Stubbs's invariable practice to paint from life, but we don't know for certain who these two sportsmen are, though it is clear from the verse inscription that they are townsmen. Suggestions that they are William Woollett and Stubbs himself can be dismissed. The younger man might conceivably be Woollett, but neither shooter looks remotely like Stubbs. It is possible, however, that the men are Thomas Bradford, who issued Woollett's engravings, and William Wildman, owner of a

set of the paintings and a collector of Stubbs's work. Little is known of Bradford; I have not even been able to find his birth date, though he seems to have 'died or retired' by late 1774.[14] However, Wildman, in Stubbs's only portrait of him, with his two sons and the celebrated racehorse Eclipse, looks very like the dark-coated older man in the shooting pictures. The latter's age and build (particularly in the first episode) are close to Stubbs's Wildman, and in the face and jowls, and the slight twist of the mouth, they are strikingly like each other.[15]

Both Wildman and Bradford owned their own versions of the shooting series. The prints that the latter published are each inscribed 'Engraved after an Original Picture in the Possession of Mr Bradford', while the posthumous sale of Wildman's pictures included the four shooting pictures, which were sold in pairs. If the shooters are indeed these two solid citizens, the supposition would be that the commissioning, engraving and publishing of the paintings and prints was a joint enterprise, which involved Stubbs making two sets of paintings, one owned by each of the partners. The fact that Woollett's engravings are in a number of significant respects different from the only surviving set of canvases does suggest they were based on variants then owned by Bradford and now lost.[16]

The narrative of these paintings, simple though it is, had commercial appeal, and their influence was such that direct imitations were still coming out fifty years later.[17] The four-times-of-day format was a riposte to other well-known clock-following series, set in more urban contexts: in France, glimpses into the lives of fashionable ladies, invariably beginning with *La Toilette*; in England, caustic 'comic-history paintings' of London life by Hogarth.

Can anything be gleaned here of the painter's view of country sports, and of the Game Laws? It is significant that the hunters are not landowners. They come in plain attire, and unattended, from 'smoky town' to enjoy a day of healthy and useful exertion in the country air. They were, therefore, a pair of solid citizens. Yet it was illegal for such men to shoot over the Duke of Portland's land, even with permission.[18] We have already seen that works such as *The Grosvenor Hunt* show Stubbs quite ready to endorse blood sports from the point of view of the landed elite. But that was when the elite were his clients. Here, he presents another point of view: country sport as benign and beneficial (even though illegal) for city dwellers too.

But once again, there is no need to adduce these views to Stubbs himself: for him the formal exercise of brushwork, colour and

composition are paramount. He handles the landscape and greenery in these paintings with a very sure touch and, in the last especially, he powerfully manipulates light and shade to create a striking day's-end atmosphere. Woollett's ability carries much of this over into the engravings, which even the cheerful, jog-along couplets cannot spoil. Such qualities combine in the four paintings to create an experience greater than the sum of their parts, showing a Stubbs who has clearly emerged as a landscape painter of the highest self-confidence.

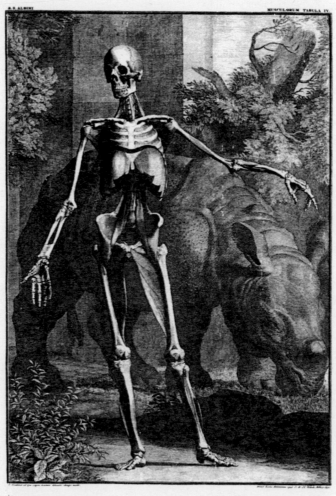

A plate by Charles Grignion after Jan Wandelaar from Albinus's human anatomy (1749).

CHAPTER 38

This My Performance

A noble and useful work indeed![1]

Stubbs turned forty in the mid 1760s and was now famous. He was also hugely busy and with only his apprentice – his teenaged son George Townley Stubbs – to help out, the pressure was intense. He pounded the rutted and potholed Georgian roads, and was away from home repeatedly and for long periods. In addition to many visits to the studs and stables of the Newmarket area, the English counties to which he certainly travelled during the decade after his arrival in London included:

Bedfordshire – Torrington's Southill
Cambridgeshire – Shafto's Wratting
Cheshire – Grosvenor's Eaton
Nottinghamshire – Portland's Welbeck
Suffolk – Grafton's Euston Hall
Sussex – Richmond's Goodwood
Yorkshire – Rockingham's Wentworth Woodhouse

It is also likely he went to:

Kent – The Duke of Dorset's Knole
Lincolnshire – Ancaster's Grimsthorpe and Yarborough's Brocklesby
Staffordshire – Lord Pigot's Patshull
Surrey – Midleton's Peper Harrow
Wiltshire – Bolingbroke's Lydiard Tregoze

His earnings were more than satisfactory. He could charge 35 or 40 guineas for his stock-in-trade paintings – medium-sized works with figures and landscape.[2] The portraits of Rockingham's Scrub and Shafto's Snap both measure 40 inches by 50, as do six other paintings datable to the same year, 1762. It was the standard size for half-length human portraits, too, and London's colour men supplied ready-stretched canvases of these dimensions for five shillings. As a point of comparison, Reynolds, the most expensive society painter, was then charging between 50 and 70 guineas for his own half-length portraits.[3]

Stubbs's two smaller animal portraits without a background, the Rockingham *Brood Mares and Foals* and its pendant with Whistlejacket, Simon Cobb and two other stallions, were wider by an extra 2 feet but, without the addition of a landscape, the price was much the same as *Scrub*. The 'anti-Bute' pendants in the salon at 4 Grosvenor Square, which include Stubbs's own backgrounds, are roughly two and one-third times as wide and high as *Scrub*. If the same price-to-size ratio is applied, Rockingham's bill for that great pair should have come to about 160 guineas.[4] In the Wentworth Woodhouse records is a receipt signed by Stubbs and dated 30 December 1762: 'Eighty Guineas for one picture of a lion & another of a Horse large as Life'. If this is for the Lion-and-Stag and Lion-and-Horse pendants it must mean 80 guineas *twice*, since 40 guineas each would be niggardly for works of such a size and quality.

At 59 inches by 95, *The Grosvenor Hunt* was not quite so large, but this is a very much more complex and populated production and, though its price is unknown, Grosvenor would not have thought 100 guineas unreasonable. What Rockingham paid for the solo *Whistlejacket* and *Scrub Large as Life* is also unrecorded, but in view of the prices already suggested, 60 guineas would seem about right. Based on these very loose assessments I estimate that, from seventeen canvases painted by him in 1762, ten of them for Rockingham, Stubbs earned almost 800 guineas. One ready reckoner of historical money values equates this to more than £80,000 in modern purchasing power.[5]

Meanwhile, Stubbs stuck to the task of engraving the Horkstow anatomical studies. As he was so frequently away from home, the engraving work went with him on the road: it certainly did when he went to Goodwood, for 'here also his plates were advanced' says Humphry in recording Stubbs's nine-month stint as guest of the Duke of Richmond.[6] But in order not to interrupt his painting work,

> the etchings of the plates were made early in the morning, in the evening, and oftentimes very late at night. – In about six years they were brought to a state for publication as they now appear.[7]

Well aware of the deficiencies of the hurried plates he had made for John Burton, Stubbs proceeded slowly. If he sought advice on technique, he had no need now to apply to house painters and clockmakers, for London was bursting with all kinds of engravers, their

work seen and discussed at every level of society. It is very unlikely that Stubbs turned for help to any of the technical illustrators such as Grignion, who had already scoffed at his pretensions. More plausibly, he forged links with fine art engravers, men who would soon be reproducing his paintings for the market, a process in which, for professional reasons, he would have taken a very close interest.

The first of these printmakers was Benjamin Green (1739–98), drawing master at Christ's Hospital. Green was just the kind of artist who appealed to Stubbs's experimental curiosity. He produced five versions of characteristic Stubbs works between 1765 and 1769, using the still innovative technique of mezzotint.[8] However, Stubbs seems to have forged closer links with the workshop of William Woollett, who reproduced the shooting series in the late 1760s using a more conventional mixture of engraving and etching, the linear style which Stubbs himself had adopted for the midwifery plates and perfected in the *Anatomy*.[9]

When at last they were finished, Stubbs's plates for *The Anatomy of the Horse* illustrated first the equine skeleton in three tables and then the 'Muscles, Fascias, Ligaments, Nerves, Arteries, Veins, Glands and Cartilages' in fifteen more. The tables closely follow the finished studies Stubbs had made after the Horkstow working drawings: that is, by first presenting three views of the bones, a lateral, frontal and rear view, and then by showing five stages of the dissection from the same three angles. The modelled and toned engravings are each matched by a linear outline key, with the parts referenced to the explanatory text by numbers and letters.

It was an identical procedure to that of Albinus, in the *Tabulae sceleti et musculorum corporis humani*. The English edition of that book, with plates re-engraved by Charles Grignion, also had Albinus's lengthy introduction in which he explained that the outline keys were used 'that the beauty of the figures might not be hurt' by being 'bespotted' with reference points.[10] Albinus's book was a crucial model for Stubbs, and was at his elbow both in Horkstow and throughout the engraving process.

Albinus's preface spells out the achievement of his illustrator Wandelaar in terms which, though grammatically not quite coherent, serve to summarise the brief Stubbs gave to himself at the outset of his own work.

> He studied dignity in the outlines, distinctness, force, grace and harmony in the light and shades so that every thing might appear full and distinct;

and at the same time the whole figure, though composed of several parts joined together, might nowhere be interrupted, further than nature has observed in those parts; in the symmetry, a certain harmony and equality, which ought to discover itself amongst all the different parts; and in the outward appearance, the distinction and difference between bone, flesh, tendon, cartilege &c.[11]

The Anatomy of the Horse's great departure from Albinus is Stubbs's refusal to countenance the lively, if sometimes peculiar, background landscape and ornamentation which Wandelaar introduced behind the skeletons and flayed bodies: in some a neoclassical sarcophagus is seen, in others (more mysteriously) a ghostly rhinoceros. Albinus praises these fancies as elegant adjuncts, which make their main subjects 'appear more raised or rounded'. But Stubbs, the master of *Mares and Foals without a Background*, could see no use for such distracting irrelevances.

Stubbs's text is in itself a tour de force. It runs to well over 50,000 words, naming and minutely describing the structures his scalpel had uncovered. This was dry and very exacting work. Sometimes, for clarity and to add interest, Stubbs mentions the equivalent parts of the human body.

> The tendon of the plantaris: . . . at 21 it divides to be inserted on each side of the inferior part of the great pastern posteriorly, and to give passage to the tendon of the flexor digitorum pedis, to which tendon it serves as a ligament to confine it to the great pastern when the fetlock joint is bent, and by that means it receives assistance from that tendon in bending the fetlock joint. – This is analogous to the plantaris and short flexor of the toes in the human body, viz. the part above 20 to the plantaris, and the part below 20 to the short flexor of the toes.[12]

Stubbs's debt to the prolix Albinus does not extend to his Address to the Reader. In a mere 400 words, this states concisely who the author thinks will find the book useful,[13] and emphasises 'concerning this my performance . . . that all the figures in it are drawn from nature, for which purposes I dissected a great number of horses; and that at the same time I have consulted most of the treatises of reputation on the general subject of anatomy'. On the title-page he describes himself, without apology, as 'George Stubbs, Painter'.

The book was put out to subscription months ahead of its completion and was finally published under Stubbs's own imprint in 1766, a full decade after he had embarked on the project. It was an expensive

purchase, priced at 5 guineas, but it received the kind of reviews a first-time author dreams of.

> We have here a noble and useful work, indeed! . . . what praise is not due to a private person who, at his own expence, and with the incredible labour and application of *years*, began, continued and completed the admirable work before us . . . In short, we are at a loss whether most to admire this artist as a *dissector* or as a *painter of animals*.[14]

A further encomium was received in due course from Europe. In July 1771 Petrus Camper of Groningen wrote Stubbs what can best be described as a fan letter.

> You will be curious to be acquainted with a Dutchman who admires with so much extacy your Tables. I'm public Professor of Medicine, Anatomy and Surgery at Groningen . . . I'm sure my acquaintance can be of little use to you, but yours to me of great consequence.[15]

Camper was very interested in the relation between anatomy and art, and he is particularly impressed by what he saw as Stubbs's outstanding *sympathy* for his subject, one that he himself regrets he cannot match. Once, he tells Stubbs, he contemplated producing an equine anatomy of his own but

> I am sure I could not have attained the elegancy & exactness of yours . . . I dissected but I did not love horses, though I kept them for proper use & for my family.[16]

Camper's words are acute. The attention which Stubbs gives to the animals he paints does amount to love. Yet it was not the prime motive of his art. Stubbs did not want to be a top *animal* painter, he wanted to be – and at another level he knew he was – a top painter.

CHAPTER 39

Myth Making

> After having often viewed & considered the Lion well, – he made
> a design and prepared his materials.

Stubbs thought that advertising the *Anatomy* to solicit subscriptions
had 'more than any other thing tended to throw him into Horse
Painting, & indeed to this he ascribes entirely his being a Horse
Painter'.[1]

The advertisement for subscribers did not appear until 1765, by
which time he was well launched on his horse-painting career. But the
remark is true in the sense that, by showing the Horkstow drawings
around London in 1758, he had attracted the almost exclusive
attention of the young Whigs, and their particular requirements tended
to limit him to horses and country sports from the start. There were at
the time plenty of portraitists and landscape artists to choose from, but
before Stubbs came to London, no first-class sporting painter had
emerged to follow James Seymour, who had died in 1752, and John
Wootton, who was alive but now in his eighties.

But Stubbs did not have the field quite to himself because another
gifted sporting artist had arrived on the scene at the same time as
himself. The Carlisle-born Sawrey Gilpin (1733–1807) finished his
apprenticeship with the marine painter Samuel Scott in 1758 and,
having attracted the attention of the Duke of Cumberland with his
studies of draught animals in Covent Garden market, was whisked off
to make a lengthy stay at the Duke's stud. So, while Stubbs was
studying horse, hound and deer at Goodwood and Eaton, Gilpin was
learning racehorse painting in Suffolk. He was the more conventionally
trained artist but, unlike Stubbs, no anatomist. His brother was the
Rev. William Gilpin who became the age's leading theorist of the
picturesque in nature and art.

Stubbs and Gilpin chafed equally against the low status of the animal
painter, and both made attempts to cross over into history painting
with subjects that capitalised on their established mastery of the
animal. Gilpin's excursions into the Grand Manner began in the late
1760s with a large-scale classical piece, *The Election of Darius* (a

decision which according to Herodotus was swung by the neigh of his horse) and a group of four works on Swift's Gulliver among the Houyhnhnms. But Stubbs took on the history men almost from the very start, as early, in fact, as 1761–2. In spite of the multiplying professional demands tugging at his coat, he produced a startling *Phaeton and the Horses of the Sun*, from an episode in Ovid's *Metamorphoses*, which he included in his first multiple submission to the Society of Artists exhibition, alongside two racehorses and 'A Brood of Mares'.[2]

In this cautionary Ovidian tale, Phaeton, mortal offspring of Helios the charioteer of the sun, dreams of driving his father's chariot for one day across the sky. Helios reluctantly agrees but the boy is an overreacher, an extreme sports fanatic with a glint of insanity in his eye. He drives too fast, cannot hold the team and plunges in a shower of sparks to his death, a scene that Shakespeare's Richard II invokes in vivid words to emblazon his own ignominious downfall:

> Down, down I come like glist'ring Phaeton,
> Wanting the manage of unruly jades.[3]

Stubbs paints the doomed boy with his face a mask of terror as he hauls vainly at the traces behind the four uncontrollable horses. Their downward plunge is pursued by a jagged thunderbolt of fury hurled by Zeus from within the enveloping, sooty clouds.[4]

Phaeton had such appeal for Stubbs that he revisited the episode a second time within two years. This 1764 version was repeated in enamel and jasperware relief (see p. 234 below), while both the original oil paintings had mezzotints done after them by Benjamin Green, with considerable popular success.[5] Finally, in Ozias Humphry's 1777 watercolour portrait of him, Stubbs poses with the enamel *Phaeton*, pointing his finger meaningfully at the head of a panic-stricken horse. It is tempting to link Stubbs's preoccupation with a myth of filial impiety to the relationship between himself and John Stubbs, the memory of which may have been awoken by Stubbs's own growing son. George Townley was now in his teens and Stubbs no doubt found himself having to deal often enough with signs of adolescent ingratitude.

But *Phaeton and the Horses of the Sun* has considerably wider significance than popular psychology might suggest. Stubbs's source-book was well chosen. Ovid has been one of the most influential of writers because his mythologies hit harder and cut deeper than other

people's. Stubbs's doomed boy, one of his very few nudes, is braced in a terrified position, which distorts and destroys his beauty. The artist discovers the mortal frailty, the ugly irrational truth, beneath the gilded delusions of regulated human society. Since Swift, that had been one of the great themes of eighteenth-century British literature; Hogarth too tackled it in his own way; and now Stubbs was doing so in his.

The year 1764 provided another diversion from horse portraits, with the arrival in England of Sir George Pigot, who for nine years had been enriching himself shamelessly as Governor-General of Madras. Home on leave, Pigot brought with him a magnificent 'hunting tyger', in reality a cheetah of the kind used by the moguls of India for coursing game, and invited Stubbs to paint the animal, with his two turbaned native handlers in a rocky desert landscape. To describe this as Stubbs's largest and one of his earliest wild animal studies is accurate enough, but it sells short an extraordinary masterpiece for which the Stubbs scholar Basil Taylor knew of 'no precedent in the history of English art'.[6]

By 30 June 1764 the animal itself had been presented to the King, whose uncle, Cumberland, arranged an inconclusive experiment in Windsor Great Park, setting the cheetah to course one of the Windsor stags. In front of a horde of spectators, Pigot's cheetah was humiliatingly repulsed by the chosen stag, and almost immediately bounded off into the forest where he killed a less cantankerous deer. A letter home from Hyderabad, written a few years later by a young administrator, Edward Strachey, tells how he should have performed.

> The cheetahs are kept winked on a cord, and when they get near enough the hood is taken off and they are slipped at the game. They run perhaps two or three hundred yards. If they don't catch the animal, (which they have singled out from the herd) in that time, then they crouch and do not attempt to take another. The first time the cheetah failed, but a second attempt had better success; he ran a considerable way after the deer and then sprang on him. When we came up he had the deer's throat in his mouth and its body between his legs.[7]

Stubbs shows the cheetah wearing the ribbon-tied crimson hood, the pacifier mentioned by Strachey, but now pulled up from the eyes to the top of his head, like a bonnet. One of the men is ready to release the matching crimson restraint from around the animal's haunches, while his partner motions in a pantomime of gestures towards the cheetah's intended victim.

The brushwork Stubbs put into the cheetah's silky spotted coat is of unusual softness, which provides a striking textural contrast to the Indians' creamy cotton clothing and the flinty landscape. The handlers themselves are treated with all the objective sympathy that is the artist's hallmark, making them 'the finest representation of Indians in British painting'.[8]

But, beyond these pleasurable details, the great reach of Stubbs's ambition in the 1760s is seen in this canvas. With *Phaeton*, Stubbs had taken on an existing myth: his cheetah virtually *creates* one in which the gorgeously arrayed cat is a god of the Orient, the humans are his priests and the deer is his blood sacrifice.

The same myth-making impulse was at work in the horse-and-lion encounters, of which Stubbs made at least twenty works in various media over a thirty-year span of time.[9] After his massive initial statement of the theme for Rockingham's London home, he set about creating something like a narrative around it: the lion stalks the horse, then confronts and spooks it; the lion leaps on to the horse's back, its claws raking the flanks, its teeth sinking into the withers; and, as the horse collapses in a heap, the lion voraciously tears its flesh.

I have mentioned possible emblematic or political interpretations of this ferocious, one-sided fight. But the sheer tenacity with which Stubbs pursued the subject eventually took him far beyond topical iconography, and into the area of myth and legend. The golden lion, the white horse, are forces of nature, living out their purposes against gloomy forests and harsh rocky landscapes, some of the latter clearly drawing on the topography of Creswell Crags. Did Stubbs know that the caves which honeycomb that gorge were strewn with the bones and fossils of prehistoric wildlife, including the ancestors of the big cats and the horse?[10] Even if he did not (the caves were systematically excavated only in the next century) the area's Sublime appeal made the Crags a perfect location in which to imagine violent and elemental struggles.

The theorist of the Sublime, Edmund Burke, had published his *Philosophical Enquiry into the Origin of our Ideas of the Sublime and the Beautiful* in 1757. Burke had taken a word, which meant (in Dr Johnson's definition) 'a grand or lofty style' of writing, and given it a specialised meaning in aesthetics: the Sublime. 'Whatever is fitted in any sort to excite ideas of pain and danger, . . . is a source of the *sublime*,' he wrote.[11] Burke was one of the first to consider aesthetic experience as not just a philosophical issue but a psychological and

physiological one. Beauty in his view springs from feelings aroused by joy or sorrow, and is characterised by a sense of clarity and smoothness. His Sublime, on the other hand, is violent, gloomy, vast, overwhelming, and the pleasure that it gives comes out of terror and the symptoms of terror.

All the big cats were in the Burkean sense intrinsically sublime. So was the horse – not the domesticated variety, but the horse as it once existed in nature,

> *whose neck is clothed with thunder, the glory of whose nostrils is terrible, who swalloweth the ground with fierceness and rage* . . . In this description the useful character of the horse entirely disappears and the terrible and sublime blaze out together. We have continually about us animals of a strength that is considerable, but not pernicious. Amongst these we never look for the Sublime: it comes upon us in a gloomy forest, and in the howling wilderness, in the form, of the lion, the tiger, the panther or rhinoceros.[12]

It is possible Stubbs knew Burke well enough to have discussed these aspects of the Sublime with him. Burke was appointed Lord Rockingham's secretary in 1765, and the budding politician and the artist could easily have met at Wentworth Woodhouse. In a letter dated 1767, to his protégé the painter James Barry in Italy, Burke expressed ideas about art and the old masters in terms that might have come directly from Stubbs's mouth.

> If I were to indulge a conjecture, I should attribute all that is greatness of stile and manner in drawing, to [their] exact knowledge of the parts of the human body, of Anatomy, and perspective. For, by knowing exactly and habitually, without the labour of particular occasional thinking, what was to be done in every figure they designed, they naturally attained a freedom and Spirit of outline, because they could be daring without being absurd. Whereas ignorance, if it be cautious, is poor and timid. If bold, it is only blindly presumptuous. This minute and thorough knowledge of Anatomy and Practical as well as theoretical perspective, by which I mean to include foreshortening, is all the effect of labour and *use* in *particular* studies, and not in general compositions. Notwithstanding your natural repugnance in handling Carcases, you ought to make the knife go with the pencil and study Anatomy in real, and, if you can, in frequent dissections.[13]

There may have been contact, of a kind, between Stubbs and Burke's ideas even before this, because Burke was very close to another artist, his fellow Irishman George Barret, who also knew Stubbs well. Not

only did the two painters live very near each other (Barret's home was in Orchard Street, round the corner from Stubbs's) but Barret's landscape backgrounds crop up in some of Stubbs's work round the mid 1760s.[14] As a landscape painter Barret is now virtually forgotten, but he enjoyed a reputation in the 1760s higher than that of Richard Wilson. Collaborations with him would have come under the category of 'a union of talents', though in Stubbs's eyes it must have been more a question of relieving the extraordinary pressure he was under at that time.

Significantly, both artists worked at the Duke of Portland's Welbeck Abbey, which was not only close to Creswell Crags, but was an environment in which theoretical discussions about art and nature were encouraged. According to the landscape designer Humphrey Repton, the Duke enjoyed imagining his property in terms of painted landscapes.

> He would often delight in following the tracks of deer or sheep, into the most sequestered haunts of the forest, and pause when any fresh scene of beauty or interest claimed particular attention, directing my eye to prototypes of Salvater or Redinger.[15]

So some talk of Burke's Sublime and of Creswell Crags is rather likely between Stubbs, Barret and the Duke, the more so since Barret completed the background for one of Stubbs's paintings of *The Lion and the Horse*, a small work later owned by the surgeon John Hunter.[16] However, Stubbs's association with Barret ended abruptly in 1767, when, according to another of Burke's letters, Barret

> had the ill-luck to quarrel with almost all his acquaintances among the Artists, with Stubbs, [Joseph] Wright and [Hugh Douglas] Hamilton; they are at mortal war and I fancy he does not stand very well even with [Benjamin] West.[17]

The Phaeton and the Lion and Horse paintings were the most extreme of Stubbs's essays in the Sublime style, and the latter were also extremely successful, being 'deservedly applauded by the best judges'.[18] So the reputation he had established with the young Whigs, and consolidated with *The Anatomy of the Horse*, continued to climb. The decade of the 1760s was the busiest of his life, but his phenomenal industry during that period paid dividends in wealth and fame. By 1769 he could justifiably call himself one of London's leading artists.

CHAPTER 40

Eclipse

Eclipse first, and the rest nowhere.
Colonel Dennis O'Kelly

The encounter of the greatest racehorse painter with the greatest racehorse deserves to be remembered as a legendary event. It happened in 1770, when William Wildman invited Stubbs down to the stables at Epsom where the phenomenal Eclipse was based for his second, and last, all-conquering season on the turf. Stubbs made an exquisite study of the champion unencumbered by bridle or saddle, and without a background, the long head and the white 'sock' on his offside hock prominent, the ears laid back, the chestnut coat shimmering. It is a beautiful but disarming portrait. Given the high excitability of racing society, and the exaggerated adoration of its equine idols, Stubbs would have been expected to produce an image which embodied his achievements or in some way celebrated his unparalleled status. In 1820 *The Sportsmen's Repository*, commenting on one of John Nost Sartorius's portraits of the big horse, reached for the Sublime in its attempt to characterise him:

> Never to the eye of a Sportsman was there a truer-found galloper in every part; and his countenance and figure as he stood in his box, notwithstanding his great size, excited the idea of a wild horse in the desert.[1]

Stubbs himself had tried something in this line with his portrait of Whistlejacket. But faced with Eclipse, an incomparably more successful racer, he makes no such attempt. Instead, what we see is a consummate professional equine athlete, a horse whose magic is conveyed precisely through the deceptive modesty of his bearing.

Eclipse was a seven-year-old when Stubbs painted him. In his birth year of 1764, on 1 April, the public had been expecting more than an April Fool for, as Old Moore's and other almanacs had been predicting for years, a solar eclipse, when the moon's trajectory would cross the sun and for a few minutes dim the light, was due to occur in the middle of

the morning. Scientific gentlemen all over the country readied themselves with smoked glass and other equipment to observe the event. When it happened on schedule, the ambient temperature in Edinburgh was recorded as falling by seventeen and a half degrees; at Liverpool, that centre of the watch and clock trade, a Mr Ferguson timed the onset and progress of the eclipse with his own 'adjusted clock to equal time' (a marine chronometer of some kind?); at Derby 'it was observed by Mr Burdett with a spiral micrometer of his own invention'.[2]

In folklore an eclipse, like a comet, is an ominous event, presaging great births and great deeds. In the horse world the annular eclipse of 1764 did not disappoint. On that day, as the moon ran its course over the face of the sun, an obscure mare, Spiletta, at the Duke of Cumberland's vast Cranbourne Lodge stud farm in Windsor Great Park, gave birth to a foal with a single white hock. That he would be called Eclipse was inevitable, but it is easy to see why superstitious people considered the naming predictive. He was, after all, to become a runner of such spectacular achievement, the founder of such a vast family of winners, that he put all others in the shade.

His parents had not been champions. Spiletta ran just the once and lost. The career of his sire, Marske, under Cumberland's purple colours, had disappointed his owner, who retired him abruptly to stud after two close defeats by Jenison Shafto's Snap. The royal Duke was a notoriously unlucky owner. In 1763 Horace Walpole, writing of the inevitability of things, looked forward to 'the beginning of October, [when] one is certain that everybody will be at Newmarket, and that the Duke of Cumberland will lose and Shafto win two or three thousand pounds'.[3] It was typical of his luck with horses, then, that the Duke should die in 1765 and miss out on being the owner of a racing legend.

Spiletta's chestnut foal with the one white hock was then a yearling and not a particularly pretty sight. He had a long, 'very ugly head' and a noticeably high rear end, but William Wildman saw something in him and was very disappointed when the Duke's posthumous sale started before the advertised time and he arrived to find his fancy had been sold for 70 guineas just a few minutes earlier. Brandishing his watch, Wildman insisted that the yearling be put up again and this time he secured the lot for 75 guineas.[4]

Wildman took this new asset from Windsor to his racing establishment at Mickleham near Epsom, where Eclipse was kept for four years

to mature in obscurity. The legend is that he was a particularly unruly colt and was broken only with difficulty by a rough-rider, who took him on poaching expeditions at night and was generally hard on him. But Eclipse's failure to appear on the track until the age of five is not attributable to a difficult temperament. Before the era of two-year-old competition, and before the institution of classic races for three-year-olds, horses commonly did not go into training until the age of five, when they were fully grown and could stand up to the punishing four-mile contests that were then standard.

Eclipse's first race entry was on 3 May 1769, a 50 guineas plate to be run over the Epsom course in three four-mile heats. Rumours had already been circulating after he had a sensational preparatory gallop, witnessed on the Epsom Downs by an old crone who told a late-arriving pack of touts and scouts that she had seen a horse 'running away at a monstrous rate', with another toiling in his wake that 'would never catch the white-legged one if he ran to the world's end'.[5] Because of this talk, Eclipse made his racing debut at 4–1 on, and in the first heat justified these tight odds by roundly trouncing all four opponents. The horses were watered and rubbed down. Then, while waiting for the bell to signal the second round, the greatest racing gambler of the day made his move.

Dennis O'Kelly's life is very like a novel by Henry Fielding, out of another by Thackeray. He had been humbly born about 1720 in County Carlow. After crossing the Irish Sea, he worked as a sedan chairman in London and, following an affair with a society lady, became a billiard and tennis marker. He probably played both games for money, but he also picked up scraps of racing intelligence from the club members and had soon gambled his way to a small fortune. Hitting a losing streak, he did time in the debtor's gaol, but O'Kelly was not to be so easily kept down. At the Fleet Prison he fell in love with a courtesan called Charlotte Hayes and the pair scraped together the money to land a series of spectacular gambles, which cleared O'Kelly's debts and set him up as a gentleman of the turf. By 1769 he had bought a sizeable house at Epsom, Clay Hill, complete with a large stable yard for a string of running horses.

O'Kelly was in every way a big man. His voice was loud, and Irish, his looks and figure were those of a fairground bruiser and he gambled with breathtaking sums of money. Under this bluff, at times boorish, exterior was a supremely able punter, as his actions on the day of Eclipse's first race testify. Being a friend and neighbour of Wildman, he

must have observed the horse's work on Epsom Downs and known something of his ability. But Eclipse's strolling win in that first heat set O'Kelly's blood on fire. The odds on the horse's victory in a simple bet would now be so long as to be worthless. But the great gambler had thought of a much more profitable way of backing him, a way which depended on Eclipse being even faster than anyone, apart from himself, suspected.

There were no bookmakers as such and gambling was more like an Internet betting exchange of today, where each wager is an individual transaction between two gamblers, the backer and the layer. Arriving at the betting post, O'Kelly boomed that he required odds against his posting the field. This meant that he proposed to name all the placings from one to five, attempting what today would be called a five-way forecast. As any racegoer will confirm, this is incredibly difficult to do and the layers piled in to take O'Kelly's money, giving generous odds. Even though Eclipse looked nailed-on to win, they thought, the placing of the other runners was still a lottery. It was only then, when a considerable amount of money was down, that O'Kelly gave his prediction, with one of the most famous utterances in the history of gambling: 'Eclipse first,' he announced, 'and the rest nowhere.' There must have been gasps of disbelief around the Ring, but the bet was perfectly valid. No horses could be allotted a final placing in a race if distanced, that is, beaten by a furlong or more, and O'Kelly's bet meant quite simply that Eclipse would distance the entire field. Of course, he did it easily and netted the Irishman a fortune. O'Kelly invested some of this by buying a half-share in the horse that had won him the money.[6]

For the next two seasons Eclipse, with his relentless galloping style and unfathomable stamina, was unbeaten. Attempts were made, as in the case of the steeplechaser Arkle in the 1960s, to handicap him with the heaviest weights any horse had ever carried, but still he took eighteen prizes, eleven of them King's Plates, the equivalent of today's most prestigious Group One contests. He was so feared that several times the opposition melted away completely and he walked over. Eclipse travelled widely (which for a racehorse in those days meant being walked by road) largely around Middlesex and Surrey, but also as far as Lewes, Canterbury, Winchester, Lincoln and Litchfield. In his second season he also raced at York and Newmarket, where he campaigned at both the spring and autumn meetings. It was to mark

one of these appearances at headquarters that Stubbs produced the finished portrait, of which there is a version at the Jockey Club and another in private hands.[7]

Every element of the scene is precisely placed. The background is the rubbing-down house and the expanse of Newmarket Heath, just as it appears in one of the two landscape studies Stubbs had made in the mid 1760s, at the time of the big Gimcrack portrait.[8] As usual the horse is eerily removed from the actual business of the place and no other horses or people are in view to distract the attention. The groom wears smart livery, while the jockey, Jack Oakley, is in Wildman's racing colours of red, black cap.[9]

The characterisation of the human actors in the tableau is both clever and truthful. Oakley approaches jauntily, greeting the horse with all the confidence of a man who knows they cannot be beaten; the groom, on the other hand, looks fraught, as if anxious to get Oakley safely mounted as soon as possible. This contrast in demeanour can be seen on any racecourse today, the difference between one whose business it is to win, and shine in front of the public, and another who waits in the shadows, knowing the best he can do is not mess up. The two-handed grip on the reins with which Eclipse's anonymous handler steadies his charge, the tension in the brace of his legs, the tight mouth, all betray his nerves.

Stubbs also painted Eclipse for William Wildman in a conversation piece, which includes portraits of Wildman and his two sons.[10] In both this and the Newmarket painting the horse is exactly as he appears in the oil sketch without a background, apart from the addition of saddle and bridle, and a plaited mane. By the time prints were issued of these two paintings, both in 1772 and by Benjamin Green and Thomas Burke respectively, Eclipse had been retired to O'Kelly's stud, where he stood for twenty-three years, outliving his owner by the last two of those.[11] His 344 winning progeny collected £160,000 in prize money, and went on to make Eclipse the most influential stallion in racing history, whose genes still ripple through every part of the thoroughbred gene pool. In the end he was crippled by bone disease and, at the age of twenty-five, was transported reverently in a van from Clay Hill to O'Kelly's mansion at Cannon's, near Edgware. When he died soon after, on 27 February 1789, O'Kelly's brother Philip ordered a wake, at which cakes and ale were laid on for the mourners.[12]

Stubbs must have been very interested in the sequel to Eclipse's death. A French anatomist, Vial de St Bel, was invited to Cannon's to

conduct an autopsy, and to preserve Eclipse's skin, skeleton and some of his organs. St Bel, who in the following year was appointed the first Professor in Anatomy at the Royal Veterinary College in London, tried to account anatomically for the animal's unprecedented superiority, measuring the carcase with great care, weighing the organs (the heart was 14 pounds), and drawing up his results in impeccably scientific style. But St Bel's scaled drawings look nothing like Eclipse did in life and one can imagine how Stubbs itched to be invited to do the investigations himself, and how much more interesting they would have been had he done so.

Rowlandson's dramatic view of the Betting Post at Newmarket, c. 1789. The large mounted figure on the right appears to be Denis O'Kelly.

CHAPTER 41

Conversation

A man might make a pretty landskip of his own possessions.
Joseph Addison.[1]

In 1757 the author of *A Preservation against Anglomania*, Louis Fougeret de Monbron, identified the things for which the English could, reluctantly, be praised by a Frenchman: 'Excellent horses, very good hounds and complete freedom from monks and wolves'.[2] As a put-down it doesn't work very well, because the English were themselves inordinately proud of these aspects of their national life. Protestantism, one's command of faithful and useful animals, and the taming of nature were the things they talked about over tea: reassuring and safe topics at a time when ladies and clergymen could not be scandalised, money and business were vulgar, and politics had begun to appear a little frightening.

It is just such conversations that are celebrated in the peculiarly English artistic convention of the 'conversation piece'. This was a form of group portraiture but, more, it was a genre that tried (as its name implies) to capture not chiefly the personalities of the sitters, but the bonds of family and society that bring them together. I have already mentioned how Philippe Mercier combined Dutch group portraits with the French *fêtes galantes* to suit a more English way of life, but it took English artists themselves to find the authentic native register. Hogarth's conversations are too vigorous and individualistic to serve as models; those of the Preston cabinetmaker's son, Arthur Devis, are much more typical of what was wanted.[3] Devis was a professional artist with a busy, mostly provincial, practice. His figures are doll-like, his backgrounds, both within and out of doors, are cleaned up and formalised, but his tea parties and parkland walks have a quality of unaffected charm which, as Ellis Waterhouse wrote half a century ago, 'had no parallel among contemporary European painters and his wood notes are among the most purely native in English painting'.[4]

As Joshua Reynolds's influence spread, the idealised portrait likeness, with increasingly dramatic overtones, gained a stranglehold over fashionable portraiture in late eighteenth-century Britain. But

Stubbs, like Devis, resisted these trends and when, in 1768, he was commissioned to paint Robert Saltonstall of Uxbridge, Middlesex, Isabella his wife and their four-year-old daughter, also Isabella, the result was the first of three exceptional conversation pieces in which he represented a placid, prosperous way of life in a land with neither wolves nor monks, but with a pronounced emphasis on the horse and the dog.[5]

Robert Saltonstall was from an apothecary's family in Pontefract, Yorkshire, but he himself had his business in London.[6] Like so many rich merchants, his object was to acquire land and become a gentleman, an achievement which Stubbs's picture celebrates.

Discussing the particular remit of the conversation painter, David Piper observed that

> in such essays the intention is no longer the impossible one that all portrait painters sigh after, to capture a man's whole character, to paint his spiritual and physical biography in the composed confines of a face, but to catch the character in action, reacting to a specific impulse, the features in movement before passion, like water in a wind.[7]

'Movement before passion' sounds a little too strong, for Stubbs's are pieces of extreme psychological understatement. Yet the Saltonstall conversation is a perfect example of what Piper means. The expected social roles get their full due here. Mrs Saltonstall's silk dress is conspicuously expensive while her husband is dressed for riding, and is booted and spurred, his arm hooked round the withers of a muscular bay hack. Embracing his horse, he looks the image of practical masculinity, as if about to leave for the office, while his wife forms a separate pair with their child. But as the composition itself tells us, these social spheres are not mutually exclusive. In one small detail, the gloves that Mrs Saltonstall is about to pass across to her husband, the image of the invaluable helpmeet is revealed, the one who runs out with riding gloves when her busy man absent-mindedly forgets them.

So far, so unsubversive. We can say that, for Stubbs, the conversations were tailored to the taste of the client and were journeyman work of a kind that was now beginning to tire him. He painted two other notable examples, very close in time to the Saltonstalls' picture, and of very high quality. *Captain Samuel Sharpe Pocklington with his Wife Plesaunce and his Sister* shows the ex-Captain of the 3rd Foot Guards, with his wife in wedding clothes and (probably) his sister Frances looking on.[8] Here the pose of Robert Saltonstall is more or less

repeated in the Captain and his horse, who dominate the centre of the canvas. Despite being retired from the army, he wears his old uniform and a sword. The women, with Mrs Sharpe Pocklington in her wedding dress (in a sense another old uniform), are pushed, almost squeezed together into the side of the picture. But the connection between the two groups, the element of 'water in the wind', is the wife's offer of a nosegay to her husband's double-bridled horse to smell. This action is the focal point of the composition but the hack, instead of inhaling the beautiful scent, seems more likely to seize a crunching mouthful. That image gives the sense of something that once actually happened, an anecdote later told and retold over the after-dinner port, causing much raucous male laughter.

The third conversation painted by Stubbs at this time is *The Milbanke and Melbourne Families*.[9] This more complex composition – it has four human figures, three horses, a light carriage and a dog – is linked to the Pocklington piece by Stubbs's reuse of the same ancient oak tree, whose boughs spread a protective cloud of foliage over the entire group. However, there is no obvious moment or movement here to unite the figures and other elements, as there is in the two previous conversations. Stubbs relies on false attachments between the forms to create unity, their outlines not quite overlapping, but making an undulating pattern in just the way he did with the *Mares and Foals* paintings.

Stubbs liked this work well enough to exhibit it at the Society of Artists in 1770 but a comment scribbled by a visitor against its title in his catalogue (no. 133, 'A Conversation') hints that the artist was already not quite moving with the times: 'horses very good, trees hard'.[10] The hardness of the trees, primarily the overarching oak, refers I think to the clarity of detail in which it is painted, the sheer *actuality* of it. This was all right for the horses, apparently, since the horse painter's job was to reproduce the equine appearance accurately. But landscape was different. It was seen as needing to be idealised, softened. Gainsborough's landscape style developed in a way that fairly exemplifies this. Compared with what he called his Dutch-influenced 'schoolboy stile', Gainsborough evolved a much fonder, and more general way of painting trees. Stubbs's oak in this conversation, although in fact freely transferable between works, is in itself too particular, too much a tree *portrait*, to please the critic at the 1770 show.

The portraits in the Melbourne and Milbanke conversation are 'hard' in the same way, with the same particularity and strength that is

found throughout Stubbs's work in human portraiture. And, in spite of the psychological limitations imposed by the genre, he reads these characters and their relationship with acuity. The most historically interesting of them is the young woman in the carriage, Elizabeth Lamb, née Milbanke. She had just married the man on horseback at the far right, Sir Peniston Lamb who, on no particular merit of his own, was on the verge of being made the first Viscount Melbourne. The males placed between the happy couple are her father, Sir Ralph Milbanke, and her brother John.

Lady Melbourne, as she was shortly to become, was painted by many leading painters in her life, but Stubbs was the first. She was sixteen, almost a child bride, but already he is able to reveal something of her strength of purpose and singular intelligence or – if that is not it – then the narrow-eyed calculation that saw her through life so successfully. A brilliant performer on the social scene, she was astute and had a deserved reputation as a wit. 'Never trust a man with another's secret,' she once said, 'nor a woman with her own.'[11] She herself had many secrets, believing that a wife's bedroom duties were complete after the production of a male heir (she was pregnant with Peniston Lamb's when Stubbs painted her) and she went on to take numerous lovers among powerful and influential men, including Lord Egremont and, briefly, George Augustus, Prince of Wales. Her husband was rather spinelessly tolerant of this, but he profited by it. For a man with few obvious talents except complaisance, his rise through the ranks of peers was rapid and his wife's activities may even have directly increased his bank balance. 'It is of very general report', wrote one gossipy diarist, 'that Lord Coleraine sold Lady Melbourne to Lord Egremont for £13,000, that both Lady and Lord Melbourne were parties to this contract and had each a share of the money.'[12]

So Stubbs's picture is hardly a show of married love like the Saltonstall conversation, but a statement about the unsentimental laws of dynastic marriage in high society. There is a look of devotion on the face of Lord Melbourne, astride his superb Arab stallion, as he gazes at his wife across the picture plane. But it is a look that also seems bemused and inadequate. She does not meet his eye, but glances shrewdly out of the picture as if weighing up opponents in a tense game of faro. Her father and brother stand between the couple as subsidiary characters in the tableau, the pale-faced John Milbanke cutting an elegant S-shaped figure, is particularly and painstakingly observed. In another five years he would marry the daughter of Lord Melbourne's

London architect, Sir William Chambers, Stubbs's old Roman acquaintance, and a man who would lead the way in the destruction of an institution greatly esteemed by Stubbs, the Society of Artists of Great Britain.

John Musters was a less complaisant husband than Penistone Lamb, but an equally hapless one. This wealthy landowner of Colwick Hall in Nottinghamshire married his beautiful but troublesome wife Sophie in 1776, when he was twenty-three and she nineteen. The following year Stubbs painted two portraits of the couple, both equestrian outdoor scenes, which triply celebrated the marriage, the remodelling of the house (by John Carr of York) and Musters's youthful rise to the county's High Sheriffdom. In one of the paintings the Musters were seen riding near the newly built stable block, attended by a huntsman with hounds from the Colwick pack. In the other they rode in front of the Hall itself, on a ridge, accompanied only by a hound and a terrier. Behind them, the roof and upper-façade windows could be seen as if peering over the brow of the ridge, giving one of the strangest views of a grand house ever painted – particularly as the ridge did not in fact exist, but was Stubbs's invention.[13]

In this brilliant and fascinating work, Sophie leads the way on her bay gelding, while John follows in a style that seems more custodial than adoring. She herself sits straight-backed, in a riding dress so forcefully scarlet that it foreshadows what would all too soon emerge – the Becky Sharp side of her personality. For the truth was that, while John Musters could not abide London, his wife loathed the country and all country activities. Required to attend court (Sophie was a Lady of the Bedchamber to Queen Charlotte), she had a perfect excuse to live more or less permanently at Musters's town house in Grosvenor Place. Here she took with alacrity to high society and was described by Fanny Burney in 1779 as 'the reigning toast of the season'. By the mid 1780s she was part of the fast set surrounding Prince George Augustus, and rumours were soon circulating that the Prince was smitten by her. He so badly desired to own her picture that, when she would not agree, it was arranged for an existing portrait by Joshua Reynolds to be 'stolen' from the artist's studio, after Reynolds had asked to have the canvas back from John Musters on the pretext of making alterations.[14]

This small conspiracy may have caused John Musters to take draconian revenge on his other portraits of Sophie, specifically those by Stubbs, which showed her in the roles she most obviously despised –

mistress of Colwick, sportswoman and wife to John Musters. In a fit of jealous anguish he summoned Stubbs to the country and ordered that his wife be painted out of both equestrian pictures. Rather surprisingly, Stubbs responded sympathetically to his client's madness. He agreed to remodel the Colwick Hall view as a portrait of two riderless hacks, while in the hunting piece he replaced Sophie with the figure of Musters's closest sporting chum, the Rev. Philip Story. It must, in truth, have pained Stubbs to do this and when overpainting them he took care to make the original figures fully recoverable. In the former case they now have been.

John and Sophie Musters eventually came to a sort of modus vivendi, for they remained married until 1819, when she died in Brighton. Bringing the body back to Colwick for burial, Musters erected a monument to his wife that included a carved portrait. In what may have been a spirit of morbid mischief – or was it wish-fulfilment? – it showed her in the role of Resignation.[15]

CHAPTER 42

Troubles at the Society

The troubles of the first incorporated society of Painters began.

The second half of the 1760s was a period of intense conflict among the London artists, which was in essence political, or at least unfolded in parallel with the most corrosive political issues of the day. The focus of these battles was the struggle for power within the infant Incorporated Society of Artists of Great Britain.

The Society's origins belong in the 1740s, with William Hogarth's early experimental exhibitions at the Foundling Hospital and the Vauxhall pleasure gardens. His idea was to free art from the bondage of private patronage by creating an open market in new art, which public exhibitions would promote. By 1759 the London artists had formed a society for this purpose and their first exhibition was an overwhelming success, selling over 6000 catalogues (at sixpence each) and proving that such shows could be both popular and profitable. By the next year, when Stubbs joined it, the Society had consolidated itself and, four years later, was incorporated under a royal charter. The annual exhibitions were increasing money-spinners, but discontent amongst the members had fomented almost from the start.

A group of elite painters and architects controlled the Society's committee, forming a 'Junto' (sometimes called 'the Cabal'), which was determined to make the Society the nations' leader of taste in visual art, through the promotion of the 'higher' disciplines of history painting and neoclassical sculpture. This explicitly slighted the work of less exalted Society members, such as landscape and sporting painters, printmakers, seal engravers and medallists – and they did not like it.

In 1765 Stubbs entered into these politics when the 'lower orders' staged a coup. They forced out eight of the twenty-four committee members and replaced them with more democratically minded artists, including Stubbs. But from the dissidents' point of view, the problem was still not solved. The Society's business continued under the domination of the old Junto, led by William Chambers, the sculptor Joseph Wilton, and the painters Francis Milner Newton and Richard Dalton. Protests continued. One gripe was that, despite having capital

of £3000, and £700 a year coming in from the exhibition, the Junto refused to found an art school, which the dissidents thought should be one of the main purposes of the Society.[1] However, it was the conduct of the Society's main event, the Spring Gardens exhibition that provoked the strongest opposition.

The annual shows continued to be a hot ticket, with almost 23,000 visitors in 1767. But the members were angry at the way the Junto used these to promote their own work at the expense of other people's, so 'that the works of many ingenious young men, advancing in their professions, were thrust into obscure corners and sequestered, as it were, from the public view, to make way for the pitiful performances of members of the committee and their supporters'.[2] A pamphlet, published by the directors of the Society after the eventual breakaway of the elitists, provides a narrative of these events from the dissidents' point of view. Stubbs, as one of the directors, would have approved of its contents and may have had a hand in its writing. The text provides a lively instance of the Junto's self-serving hanging policy.

> One of the committee occupied as usual, two principal situations; in one of which he hung a picture of her majesty, and in the other that of a lady of quality. The carpenters going to place a fine piece of shipping, belonging to a celebrated artist in that branch of painting, over that of the queen, the director called out with great vehemence, 'You must not hang that picture there'; 'Why?' – 'It will hurt my queen.' Accordingly it was taken to the opposite end of the room, when the director called out with still more violence, 'It must not hang there.' 'Why sir?' – 'O! It will kill my duchess.'[3]

This screeching behaviour – probably it was that of either the mediocre Dalton or the talentless Newton – may have been richly comic, but it was also an obvious abuse of office.

Meanwhile the Junto were suspected of secret financial machinations, though these could not be investigated since handfuls of pages had been mysteriously ripped from the Minute Book.[4] The Junto dismissed any complaints

> with a surliness little short of insult, and not without some hints and gesticulations, which seemed to signify that we must no longer look upon them in the familiar light we used, but that they expected to be considered our superiors.[5]

All this was in its way a simulacrum of national politics. Chambers, Wilton and the others considered themselves as princes among the

artists, because of their superior Italian education and classical taste. They believed in their absolute right to rule taste, in airy contempt for the disgruntled views of the rank-and-file.

> The meetings of the Society at the Turk's head had been for some time very much agitated with these Jarring Sentiments, nor could all the good humour of our jolly and facetious President, *Fran. Hayman* persuade the disputants to lay aside their mutual Bickerings, and drown their Heartburnings in bumpers of wine.[6]

The feelings, and in many cases the harder opinions, of many of the dissidents ran parallel to those of radical activists on the wider political scene. For much of the 1760s English political debate at national level revolved around one man and one issue. The man was the rabble-rousing anti-Hanoverian John Wilkes; the issue the ministerial attempts to silence him. Robert Edge Pine, who was 'among the most active of those turbulent members who first disturbed . . . the Chartered Society of Artists',[7] did several portraits of Wilkes and his imprisoned supporters. But the political debate was not confined to strict Wilkesites, for the question really turned on measures the government was provoked into taking, especially the notorious General Warrants, which by overriding habeus corpus enabled the arrest of the Wilkesites, including a lord mayor of London in 1771, who was promptly painted in the Tower by Pine as a gesture of support.[8] Rockingham and his party detested Wilkes, but they gratefully seized on General Warrants as a stick with which to lambast the administration, while Spitalfields weavers led the mob on periodic pro-Wilkes rampages.

The artists were not the only professional sub-group to reproduce these conflicts in their own internal wrangles. At the Royal College of Physicians the lower-ranking medical practitioners, known as Licentiates, or non-voting members licensed to practise by the Fellows, were also in revolt. They often surpassed the Fellows in skill and reputation, but were excluded from full fellowship out of jealousy, snobbery and resistance to new ideas. The Licentiates had been agitating for some years against the arrogance and legal privileges of the Fellows, going so far in the 1750s as to form their own Medical Society of Physicians. A prominent name among these activists, very familiar to anyone interested in Stubbs, was Dr William Hunter. Another was Dr John Fothergill, a Quaker friend of Josiah Wedgwood (and not to be confused with the Catholic John Fothergill of York Hospital). On 24 September 1767 the Licentiates' discontent with the

Royal College spilled over into a dramatic action known as the 'siege of Warwick Lane', in which a body of them marched on the College, broke down the locked gate, roughed up the College solicitor, smashed the windows and sledgehammered the main door. They then forced their way into the Quarterly Meeting of the Fellows, where they attempted a sit-in.[9] The following summer Samuel Foote turned the events into a hit farce, *The Devil upon two Sticks*, which packed audiences into the Little Theatre in Haymarket.[10]

On 8 October 1768 a rather less violent, but still highly agitated, meeting of the dissident artists of the Society was called at the Castle Tavern in Henrietta Street, at which the Junto's denial of the rights and liberties of ordinary members was denounced by speaker after speaker. At the St Luke's Day committee election, which followed, the Junto, to their astonishment and rage, were decisively defeated. Chambers in particular 'could not contain his intemperance but broke forth into much coarseness and indecency of expression', and later had to issue a choking apology.[11] It was now that the final breach came. The Junto and their friends resigned as a body from the Society and almost immediately founded the Royal Academy of Arts.

By limiting the number of Academicians to forty, and keeping out all the 'lower' artists, the new Academy constituted a living, self-elected Pantheon. Such pretensions could be mocked readily enough, but it soon became apparent that these men would be a serious threat to the Incorporated Society, of which Stubbs remained a director. Chambers and Dalton had persuaded George III to underwrite the Academy, and the great Reynolds (though not in himself a friend of Hanover) was leaned on to swallow his scruples and become their first president. The business and equipment of the St Martin's Lane school – once that of Hamlet Winstanley, among other more distinguished artists – had been successfully taken over and moved into premises previously used by Dalton as a print warehouse on Pall Mall, which was taken on a lease from Dalton. All these factors combined to give the Academy an aura of exclusiveness and authority which the Society lacked.

Stubbs was now made Society treasurer in succession to Chambers, but neither he nor his fellow directors realised the scale of the threat that faced them. The popularity of their own exhibitions still increased and the Society was in good financial shape. A pension fund was established. Lectures on matters close to Stubbs's own heart – anatomy, pigments and colours – were arranged for the members, and the

Society's own art school was inaugurated in Maiden Lane, offering among other things regular life classes. At the same time Stubbs's acquaintance with the Duke of Richmond might have helped secure access by members and their pupils to the Duke's gallery of antique casts at Richmond House.[12] So with cash in hand, a training programme up and running, and a newly invigorated membership of about 200, they were confident of seeing off the Royal Academy in style.

But meanwhile the Academy had got off to a good start. Its inaugural show was held in 1769 at Pall Mall and although there were only 136 exhibits, these attracted 14,000 visitors, just 1000 fewer than the attendance at the Incorporated Society's show the same year. At this point the Society's committee made the decision to expel all members exhibiting at the Academy, and thirty-five were summarily kicked out. This purge can only be interpreted in political terms: there were two parties, two opposing sets of principles, and it was not possible to be attached to both. The Society was felt in some way to represent the cause of radicalism while the Academy was an expression of the same reactionary forces that had tried to suppress John Wilkes. That the split was ideological was widely recognised, even outside artistic circles. The *Middlesex Journal,* a notoriously Wilkesite paper, published an open letter to the King:

> You disdain, Sir, to mingle your royal favour with the vulgar, ardent, honest wishes of the people, in support of the Society of Artists of Great Britain; and therefore instituted The Royal Academy, that the plumes of prerogative might nod in triumph over the Cap of Liberty.[13]

But however justified the expulsions from the Society seemed, they greatly weakened it over time. For just as radicalism, democracy and free speech were all losing tickets in the Georgian political lottery, so the elitism of the Academy proved to be a winning one.[14]

But all might yet have been well had not a second mistake been made: in 1769 James Paine was elected the Society's new president. Stubbs was of an age with Paine and knew him well enough. They may have first met in Yorkshire, where Paine, a protégé of Lord Burlington, had been active as an architect throughout the 1740s, especially at Nostell Priory, Wakefield, which he rebuilt for Sir Rowland Winn, and at Doncaster, where he created a splendid Mansion House. In 1744 Paine had also built Heath House, close to Randall's Academy at Heath, for a Mrs Hopkinson. Paine was no radical in the mould of Pine

or James Hamilton Mortimer, and even had some credibility at court. It was he who got permission for Stubbs to make studies in the Royal Mews of the Hanoverian horse for his 'lion and horse' paintings, but if Stubbs gave his support to Paine's presidency as a quid pro quo for this favour, he, like the rest of the Society, soon had reason to regret it.

In 1771 Paine quarrelled with Pine, who resigned, as did several other directors among Stubbs's friends, including Richard Wright.[15] Paine also took highly public exception in the same year to Ozias Humphry, who was by now another Stubbs friend in the Society, and who had fallen in love with Paine's daughter. In July the Paine family was at Tunbridge Wells, a spa resort associated with Dr Johnson and Reynolds, and second only to Bath in popularity. Stubbs was apparently taking a holiday there at the same time as Paine, for we hear of President Paine giving out loudly and libellously to Treasurer Stubbs, from the window of Paine's lodgings on the Pantiles, or Parade, about how he had sent Humphry packing. He claimed he could not 'have acted otherwise to the most abandoned profligate, and this he boasted of to Mr Stubbs in so public a manner from his study window, that [Stubbs] declares many persons from the end of the Parade must have heard it'.[16]

Determined to use the Society as a showcase for his architectural skills, Paine had by now pushed through a scheme to build a new and splendid exhibition hall, the Lyceum, on the north side of the Strand. These premises, with meeting rooms, offices and a roomy exhibition hall of 80 feet by 40, stood on land the Society had bought for £2552. But Stubbs, as treasurer, was unable to control the construction costs, which remained in the hands of a Building Committee drawn from Paine's overenthusiastic fellow architects. By the time the building was finished in 1772, another £5000 had been spent, which was far more than the capital reserve. The Society was heading for bankruptcy and Paine resigned under censure. For a few months Vice-President Mortimer held things together, but on the following St Luke's Day Stubbs himself was chosen as the next president. His task was to rescue the Society from destruction.

In his single year of office, 1772-3, Stubbs did his best to retrieve what was in reality a hopeless situation and the strain was intense. His most important action was the humiliating but unavoidable one of mortgaging the Lyceum to the auctioneer James Christie, who used it as a saleroom, with the proviso that the Society continued to hold annual exhibitions there. In the 1773 show, as president, Stubbs

exhibited ten paintings in what was otherwise a rather lacklustre event. These were probably not recent, as he was too busy for painting and in any case had accepted the presidency from a sense of duty, not to promote his own latest work.[17]

Stubbs was in a better position than most to know how damaging Paine's mismanagement had been. It could only be repaired if the Society kept a fair proportion of London's history painters, society portraitists and neoclassical carvers because, like it or not, these artists were the most famous. But the men (and a few women) of the best calibre had now almost all departed, including friends like Richard Wright and Richard Cosway (who had both defected to the Royal Academy in 1771) and the lovelorn Ozias Humphry, who had left for a four-year stay in Italy, taking with him one of the best of the Society's remaining painters, George Romney. Soon afterwards, in 1774, came news of the death in his mid fifties of Richard Wright, destroyed (so it was said) by the unkind reception of his work at an exhibition at York. Furthermore, Stubbs's own practice had suffered much from the four years as treasurer, and even more during his year as president. In 1773 he declined to stand again for office, and the Presidency passed to Sawrey Gilpin. For Stubbs

> interruption[s] . . . to his professional studies and domestic repose were always considered by him as a great evil, & produced in him a desire to withdraw from all academical associations.[18]

Following this phase of disillusion, withdrawal from the Society became irrevocable in 1775 when, swallowing his pride, Stubbs sent four pictures to the exhibition of the Royal Academy.

CHAPTER 43

Enamel

About the year 1771 he determined to make experiments &
improvements in Enamel painting.

The four paintings exhibited by Stubbs at the Academy in 1775 were
*Euston, a Dapple Grey Racehorse, the Property of William Wildman,
with Jockey up in a River Landscape; A Pomeranian Dog Belonging to
Earl Spencer; A Spanish Dog belonging to Mr Cosway;* and *A Portrait
of a Monkey.*[1] The range of subject matter remains within the animal
genre, although in each case there are background details in which
Stubbs emphasises his skill in other directions. Euston stands against an
Arcadian landscape, with blue faraway hills and a castellated Italianate
tower nestling beside a lake; Cosway's pet suggests a fancy piece, with
the Papillon dog leaping at a butterfly that dances teasingly in the air
just out of reach; and, while the monkey plucking peaches from a tree
is the beautifully observed zoological specimen, the cluster of fruit at
lower right adds a touch of genre, as if Stubbs is saying, 'I can do fruit
as well as any Dutchman.'

By introducing himself to the Academy in this way, Stubbs was
insisting that he amounted to more than an *animalier.* But there is
another immediately noticeable feature of this group of works: they
were all painted on wooden panels. Why did Stubbs choose to make his
Academy debut exclusively with works on this archaic support? It
marked a time when he was making a new start, and broaching new
interests, and the panel supports were a declaration of this. An
important stimulus to this fresh direction was his friend Richard
Cosway.

Cosway was a small, ugly man who compensated through his out-
landish dress and flamboyant social behaviour. As an artist he had first
attracted notice by producing good miniature portraits in watercolours
on small (3 inches high) ivory discs. But soon he was also doing portrait
drawings, larger oils and even, from time to time, mildly indecent
pictures on snuffbox lids. His capacity for self-promotion was equal to
his artistic talent. He was an extravagantly foppish dresser in the style

of the 'macaroni', dandies who knew the value of being talked about. Cosway and Stubbs had probably become friends by 1767, when both were directors of the Incorporated Society, and Cosway was living in Orchard Street, a minute's walk from Stubbs. It was an attraction of opposites, not just in outward behaviour, but in character too. In a vivid passage on Cosway as a collector, William Hazlitt celebrates the man's capacity to convert fantasy into truth by sheer force of personality:

> All other collectors are fools to him: they go about with painful anxiety to find out the realities: – he said he had them – and in a moment made them of the breath of his nostrils and the fumes of a lively imagination. His was the crucifix that Abelard prayed to – the original manuscript of *The Rape of the Lock* – the dagger with which Felton stabbed the Duke of Buckingham – the first finished sketch of the Jocunda . . . Were the articles authentic? – no matter – his faith in them was true.[2]

Hazlitt's phrase for the type of man Cosway was not – one who went about 'with painful anxiety to find out the realities' – would serve as a usable description of Stubbs's moral outlook. Yet there must have been something irresistible, even to Stubbs, about a man who found art, decoration and *objets de vertu* such tremendous fun.

Cosway had defected to the Academy from the Society of Artists in 1771, unable to stomach the regime of James Paine. As in the case of Richard Wright, Stubbs does not seem to have held this against him, since he painted and exhibited the portrait of Cosway's dog at the Academy in 1775. The monkey that went into the same show might, conceivably, have been Cosway's also. With his simian features, he was nicknamed Monkey Cosway or 'Jacko', and, determined good sport that he was, he joined in the game by keeping a monkey of his own.

> The last time I called [on Cosway] I found him laid on a Sofa in his night gown – and the calf of one of his legs bundled up; on my inquiring the cause he acquainted me that his monkey or baboon had tore a gt. Piece out of his leg; and that he was under Dr Hunter's hand for a cure; the poor animal has been put out of its pain by the same hand and the Dr. had the pleasure of dissecting him & put him in spirits, in terror to all monkeys.[3]

Stubbs's friendship with the fantastically dressed and assiduously networking Cosway was to have results far beyond providing a picture, or pictures, for his introduction to the Royal Academy. It was to give him a new type of painting altogether.

*

Towards the end of the 1760s Stubbs began to feel frustrated by the coarseness of the woven canvas. His method of oil painting had previously relied on the uncomplicated use of generously applied pigment, avoiding the 'old master' techniques of Reynolds and others, with their painstaking layers of thin translucent glazes and scumbles. On the other hand, Stubbs was evidently no sketchy *alla prima* painter, taking pleasure in emphasising his brushwork: he was an illusionist, who sought verisimilitude and the concealment of technique. He also valued order and permanence, and always tried to preserve as much visual detail as possible in his strictly proportioned compositions. But at close quarters the rough, flexible surface of a canvas, however carefully stretched and prepared, inevitably obscured detail and betrayed the mechanics of the craft. Oils on canvas also had a disappointing habit of cracking, fading and changing with time.

No major painter had worked seriously on wooden panels since the 1630s, when Rubens painted his late landscapes on oak boards. Stubbs did so now because he wanted to achieve a flatter, harder painted surface. But wood had its limitations and some of his panel paintings – particularly as he was simultaneously experimenting with the paint media – proved as mutable over time as canvas, fading and flaking, and being liable to damage from chipping, splitting and warping.[4]

Cosway was a great admirer of Rubens and was often seen in Rubensian costume. So he may have encouraged Stubbs's experiments with wooden panels. On the other hand he was certainly instrumental in getting Stubbs interested in another technique, which took him away from oil painting altogether.

> Mr Cosway had received some commissions to paint loose and amorous subjects from abroad, [and] in discoursing together, it was this artist who first suggested to [Stubbs] the idea of attempting subjects in this line in Enamel; upon which, having considered the matter he willingly acquiesced.[5]

Humphry's phrase 'subjects in this line' must be a slip or a misunderstanding. 'Loose and amorous' enamels by Stubbs are a tantalising thought, but a most unlikely one. In fact, the interest of Cosway's little paintings – probably snuffbox lids – was in their medium rather than their message, for fired enamel gave a hard, clear image whose colours never changed or faded. Nor was Stubbs much interested in making paintings so minuscule. On the contrary, the talk with Cosway inspired

him to conceive of enamels on supports 'of a stupendous dimension compared with what had been commonly used for enamel painting'.[6]

Enamelling was practised by the ancient Assyrians and Egyptians, as well as the Celts, but it had been chiefly used for tiles and jewellery. By the end of the seventeenth century, technical advances in Europe enabled it to come into vogue with miniature painters as an alternative to the traditional watercolour on vellum or ivory. The minute detail obtainable by the enamel painter, working under a powerful magnifying glass and with the finest possible brushes, was of a different order from other painted media.

So was its durability. This was the sovereign quality that led to the enamelling of frequently handled objects such as watch-cases and snuffboxes, indecent or otherwise. The technique was to cover a copper support with an opaque white glaze, which was fused to the support by firing it in a kiln. The painter then applied his vitreous colours directly on the white ground which, with further firings, were made to fuse to the base, creating a hard, exquisitely bright and detailed painted surface, whose colours were immune to the depredations of dirt, light and atmosphere. Stubbs may easily have seen simple enamelling in his youth at Liverpool, practised by men like William Laithwaite, the watch-case maker of Edmund Street. But now, under the stimulus of Cosway, he looked into the matter in more detail. But he immediately found problems.

First of all enamelling is very demanding and requires specialised equipment and technical knowledge. Other than soliciting the help of experts, Stubbs must have had recourse to do-it-yourself books, especially Jacques Philippe Ferrand's L'Art du Feu ou de Peindre en Émail.[7] The basic stages of the enamel painting process were: carefully to shape, clean and prepare a copper support; pulverise glass or some vitreous substance (the flux); mix this in the correct proportion with various acids to create a white enamel with which to cover the support; fuse this whitened flux to the metal surface in the kiln to create a white ground that could be painted on; mix a range of coloured oxides of metal and other chemicals with more vitreous dust; fuse these in a pot in the kiln and then mix with a drying oil to make a workable pigment; do this repeatedly to create the required palette of colours; apply the paint and fire again, probably more than once; apply a transparent layer over all and finish with a final firing. For the work to be finished, the colours must have fused with the white ground, while remaining distinct from each other. Incorrect mixtures, contamination and sloppy

preparation or procedure was potentially fatal, resulting in the enamels not fusing properly, coming off the base, changing colour or failing in some other way.

The second problem was that the known colours available for enamelling were too limited, or too difficult to use, for the kind of painting Stubbs wanted to do. He decided to solve this by creating a new range of what he called 'tints' for enamel painting. It was a considerable task, essentially a programme of chemical research, followed by successive experiments in a muffle kiln, whose results had to be carefully minuted and compared. The number of these trials is unknown – again the complete disappearance of Stubbs's papers leaves us floundering – but after 'two years with great expence & endless labour & study' he had come up with nineteen new enamel tints.[8] Their positions in the colour spectrum, and their chemical composition, was a secret that died with him.

The final problem was one of size, for Stubbs intended to be the first artist to do enamelling on a large scale. But at dimensions in excess of 18 by 15 inches a copper plate buckles in the furnace, and Stubbs created only one painting even of this size, the oval version of *Phaeton with the Chariot of the Sun*[9] with which he posed for his portrait in watercolour grisaille by Humphry.[10] Seven other smaller copper enamels were produced and in one case at least – the octagonal *A Lion Attacking a Horse* of 1770 – Stubbs carried out an additional experiment. For comparison, or as a 'control', he painted an almost identical version in oils on a wooden panel, which was likewise octagonal.[11]

Two of the smaller copper enamels, both circular, pack rather a surprise. Their titles are *Mother and Child* (painted 1772) and, more allegorically, *Hope Nursing Love* (1774), and these appear like classical/baroque hybrids. In each, the same young mother is shown, a highly neoclassical figure in both drawing and conception. But the naked male infant – who, in the second case, is given a putto's wings – is of a contented baroque plumpness that would have done justice to Guido Reni himself.

In fact, both enamels are partly derived from Reni's *Virgin and a Sleeping Child*, especially *Mother and Child*, with its very similarly presented sleeping infant.[12] Even if he did not see this well-known painting in Rome, Stubbs must have known the copy on a wooden oval that Lord Grosvenor bought in 1758, and also Boydell's subsequent engraving.[13] This makes Reni's one of very few old master paintings to

have directly inspired Stubbs, even though he entirely re-imagines it. What had been at heart a Marian devotional image became in his hands a domestic scene.

Though there is a neoclassical formality, even a coldness, about these two little enamels, they are the most intimate of Stubbs's paintings, concerned as they are with the humanity of mother love, of nursing and nurturing. Who were these figures? It used to be suggested they were Mary Spencer and George Townley Stubbs but, since G. T. Stubbs had been born when Mary Spencer was seven years old, this cannot be true. Mary, in any case, would hardly have disposed of the two images in 1807 if they had contained her portrait.[14] A better guess is that for these compositions Stubbs drew on studies he had made years earlier of 'Mary Townley Stubbs' and one of her three sons as babies in York, Hull or Liverpool. These enamels were not isolated. In Stubbs's studio sale were two lots identically described as 'Two Naked Infants in different reclining attitudes, and 1 ditto seated'. There was also a 'Hope Nursing Love, seated in a Landscape, the Child beautifully foreshortened and admirably coloured'.[15]

Stubbs's laboratory work on enamels was conducted during his most intense involvement with the troubled Society of Artists, the years of his treasurership and presidency. At the same time he was struggling to maintain his commercial practice. Humphry tells us that

> these experiments were made, as his engravings had been, at leisure days & hours between the commissions he held & was executing, never laying any task aside.[16]

During these five years, 1768–73, Stubbs's commissions seem to have reduced in quantity, though not in quality. During this time he completed the entire 'shooting' series, painted Gimcrack once more (as a stallion), and made three portraits of Eclipse as well as other racers including Hyena, Otho, Laura (under a stormy sky), Trentham, Firetail and Pumpkin, each in a Newmarket setting. He did brood mares for Shafto, Lord Palmerston and Lord Grosvenor, and portraits of Lord Pigot, Penistone Lamb, Lord Curzon, Sir Frederick Evelyn, William Evelyn, Lord Carlisle's groom William Shutt and an anonymous *Lady Reading in a Park*. Finally, he carried out conversation pieces of the Saltonstalls, the Sharpe Pocklingtons and the Milbankes and Melbournes.

It does not seem a bad five years' work. Yet Stubbs saw things differently, for

it must appear from the time that was required to do [the experiments] that his general business for oil pictures was beginning to fail him.[17]

It was not (yet) failing him badly, but there is now the sense here that the heady days of fame in the mid 1760s were already over and would not return.

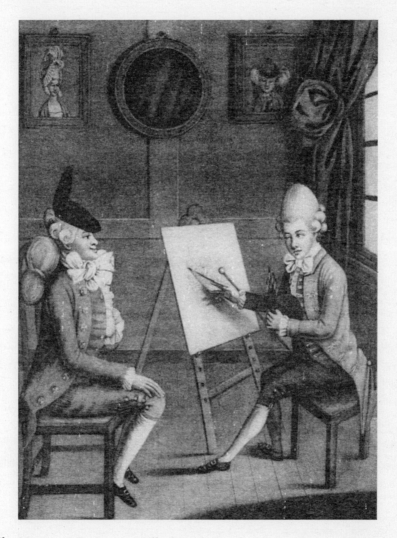

The Macaroni Painter, or Billy Dimple, 1772, a satire aimed at Richard Cosway.

CHAPTER 44

The Wide Creation

The wide creation waits upon his call
He paints each species and excels in all.
verse comments on Stubbs at the
Society of Artists' exhibition, 1766.[1]

In the first half of 1762 a 'painted African ass' arrived in England from the Cape of Good Hope, carried by the man-of-war HMS *Terpsichore*, Sir Thomas Adams, captain. The animal was a zebra mare, which Sir Thomas presented to George III's bride, Queen Charlotte. The zebra was turned out to graze at her newly acquired home, Buckingham House, as an ornament to the paddocks which lay behind the house, alongside Buckingham Gate. Nothing like this had been seen in London before and people flocked to watch the mare picking at the royal grass. 'The whole animal is party-coloured,' says a handbill advertising her exhibition,

> or beautifully striped in a transverse Direction, with long and broad Streaks, alternately of a deep, glossy and shining Brown, White and Black. There is a fine display of Elegance and Symmetry in its whole form and it is remarkable for swiftness.[2]

The zebra's fascination was increased by what she betokened, the fast-growing riches of overseas trade and conquest, the extraction of value and beauty even from the world's darkest, least promising (least England-like) places.

> It is remarked, by the Curious, that this Creature (singular and beautiful as it is) was brought from a Country whose Inhabitants are noted for Deformity and Ignorance.[3]

In the search for a precedent, the extraordinary creature was identified with the wild ass in the Book of Job,

> whose house I have made the wilderness, and the barren land his dwellings. He scorneth the multitudes of the city, neither regardeth he the crying of the driver.[4]

Queen Charlotte's zebra scorned captivity all right, becoming in the handbill's words 'so vicious as not to suffer any stranger to come near

her'. Referred to as the Queen's Ass, she was taken into the songs and poems of satirists and wags, one of whom, Henry Howard, expressed the wish to 'kiss (if no treason) her majesty's Ass'.[5]

In one of the earliest prints to appear, the zebra is grossly misrepresented, looking more or less like a donkey dressed up in an Edwardian striped swimming costume. Stubbs, who was drawn to any exotic quadruped but must have taken a special interest in this unexpected relative of the horse, immediately realised that an accurate painted image was needed. He did not work for the court and this was not an official, or even a private, commission, but his own initiative. Since the zebra was 'generally feeding in a paddock near her majesty's house' she could probably be viewed from the roadside and he may simply have sat on a stool by the railings bordering Buckingham Gate and made his sketches and colour notes from there. But, in any case, there does not seem to have been any hindrance to public access and no special permission was required to draw her, as was the case with the horse in the Royal Mews.

The zebra was soon being used as cartoonist's shorthand for the silliness of the Bute regime – in one caricature *The Zebra Loaded or the Scotch Pedlar a Northern Farce now Playing in the South*,[6] the Princess Augusta rides the zebra which is led by Lord Bute and greeted with the huzzas of a tartan-trousered crowd. The animal's alien provenance – the way it stands out instead of fitting in – is equated with the Scottishness of the royal favourite.

In Stubbs's portrayal, too, the zebra stands out, but in a quite different way. Behind her is the English greenwood, as distant as could be from the 'wilderness and the barren land' which was assumed to be her home. The zebra's markings, brightened by clear, glassy sunlight, forcefully strike the eye compared with the deep receding greens of the background. This gives the zebra an alarming vulnerability, which she bears with the same dignity that Stubbs impartially grants to all his sitters.

Looking at the painting, I wonder if he grieved for the animal. His image of her is not in any way sentimental, let alone lachrymose, yet the zebra is a strange, beautiful creature traduced by incompetent hack artists, recruited by caricaturists to a cause not her own, sung and joked about, gawped at and called out to. Above all she is a long way from home. The portrait of her remained with Stubbs all his life.[7]

There is little doubt that another who cast an appraising eye over the zebra, and over Stubbs's painting too, was the Scottish doctor William

Hunter. Hunter's professional skill and social accomplishments had already put him well on the way to becoming one of the richest medical men of his day, one who, unlike Bute, overcame most of the disadvantages of being a Scot, though not, as we have seen, the prejudices of the Royal College of Physicians. His annual income at its height is said to have been £10,000.[8]

In Stubbs's eyes Hunter must have seemed like a compound of Charles Atkinson and John Burton, raised to a rather grander level. Like Atkinson, Hunter was a surgeon and the most active anatomist in London, having taught and demonstrated the subject since 1746. By 1767 he was rich enough to build a large new home at 16 Great Windmill Street, Soho, complete with his own anatomical theatre where he would dissect executed criminals for the benefit of his fellow medical professionals. But Hunter was not just a teacher, he was the consummate performing anatomist, who also sawed through skulls and plucked out organs to packed houses containing the highest society.

On the other hand, like Burton, he also practised as a physician and specialised in society midwifery. Hunter's reputation in this field was crowned by the publication, in 1774, of his *Anatomy of the Gravid Human Uterus, exhibited in figures*. This book's spectacular and, for the time, shockingly explicit illustrations, the originals done in red chalk and with amazing technique, were by Jan van Riemsdyck, who had previously worked with William Smellie. Riemsdyck's plates display the relevant part of the female body jointed, like a piece of meat, and opened up starkly revealing the details of the reproductive organs and the foetus.[9]

Hunter was both learned and cultured, a man who took delight in collecting specimens not just as biological models, but as beautiful or intrinsically interesting objects. He was also a world-class numismatist, 'the most notable coin-collector of the century'.[10] Like John Blackburne, William Constable, Marmaduke Tunstall, Sir Ashton Lever,[11] the dowager Duchess of Portland,[12] the Duke of Richmond, Lord Rockingham, Sir Joseph Banks, John Hunter and all the other Georgian scientific enthusiasts with whom Stubbs came into contact, William Hunter saw his collections as banks for the depositing of knowledge, just as Messrs Coutt and Mr Hoare kept depositories for securities and cash.

It was Hunter's scholarly interest in exotic species, and their relevance to ticklish scientific questions of the time, that led to his employment of Stubbs. In September 1770 an odd-looking creature, a

young bull moose, arrived in England from Canada. It had a mane like a horse, ears like a donkey, feet like a goat and a vestigial dewlap 'of the size of a man's finger' dangling below its throat. The moose entered the menagerie of the scientifically-minded Duke of Richmond at Goodwood and it was there that William Hunter hurried when he heard of its arrival. He quickly commissioned Stubbs to paint it.

For Hunter the moose was rather more than a mammalian novelty. Its interest arose from a puzzle that dated back to 1697, when the Irishman Thomas Molyneux of the Dublin Philosophical Society had described a remarkable find from an Irish peat bog, the skull of a giant deer, with an almost incredible eleven-foot span to its antlers. Like traces of other giant mammals no longer to be seen alive (such as the woolly mammoth, a few of whose gargantuan teeth and tusks had recently been found beside the Ohio river), such discoveries were a serious challenge to a view of the universe that had been widely held since Plato: the Great Chain of Being.[13] The Chain was still a very popular notion, in large part because Alexander Pope had put it at the centre of his best-selling philosophical poem, *An Essay on Man*. By positing, as it does, a perfectly adjusted mechanical universe, a 'plenitude' in which every element has its place and function, this verse bravura became almost a Scripture for the beliefs of the early English Enlightenment. It was enormously influential:

> Vast chain of Being, which from God began,
> Natures aethereal, angel, human, man,
> Beast, bird, fish, insect, who no eye can see,
> No glass can reach! from Infinite to thee;
> From thee to Nothing! – On superior pow'rs
> Were we to press, inferior might on ours;
> Or in the full creation leave a void,
> Where, one step broken, the great scale's destroy'd:
> From Nature's chain whatever link you strike,
> Tenth, or ten thousandth, breaks the chain alike.
> And if each system in gradation roll,
> Alike essential to th'amazing whole,
> The least confusion but in one, not all
> That system only, but the whole must fall.
> Let earth unbalanc'd from her orbit fly,
> Planets and Suns run lawless thro' the sky,
> Let ruling angels from their spheres be hurl'd,
> Being on being wreck'd, and world on world,
> Heav'n's whole foundations to their centre nod,
> And Nature tremble to the throne of God:

All this dread ORDER break – for whom? for thee?
Vile worm! – oh Madness! Pride! Impiety![14]

For a Georgian rationalist, to question these doctrines, whether madly, proudly or impiously, was a serious transgression. But now, finds like the Irish Elk and the Woolly Mammoth were imperilling them as never before. The problem was that, as Pope states, a deistically perfect universe could neither be added to nor subtracted from, which meant no new creations and no extinctions. And the popular idea of a *clockwork* universe found extinction particularly offensive: any pieces that fell off would stop the clock.

So where in the world were live examples of mammoths and 'Great Irish Elks'? Hunter had already come to the firm conclusion that the mammoth, despite superficial resemblances, was not an elephant and that 'in former times some astonishing change must have happened to this terraqueous globe' with the consequence that 'though we may as philosophers regret it, as men we cannot but thank Heaven that [the mammoth's] whole generation is probably extinct'.[15]

Nor did Hunter think that the 'Irish Elk' was really an elk, suspecting that this species, too, was defunct. But to be able to assert the fact, he needed to be sure that it was not just a moose writ large.[16] Stubbs's picture was made, therefore, as part of a very specific scientific inquiry. Like a racehorse portrait, the moose painting was to be an image of record. This point is underlined by the way in which, when a second bull moose came to England two years later, Hunter carried Stubbs's picture with him when he and a group of scientific friends went to examine it.

But the painting's function extended also to the lecture room. In the same way that, as I have suggested, Stubbs's obstetrical oil paintings were used in the late 1740s, this image was to be a visual aid, as a lecturer today employs slides or digital projection. Hunter had already commissioned a Stubbs painting for this purpose, *A Nylghau*, apparently completed in 1769, when a pair of these animals from India were presented to the Queen.[17] Hunter's paper on this 'Indian animal, not hitherto described' was some time in preparation and it was not until 28 February 1771 that he read it to the Royal Society, with Stubbs's painting propped on an easel beside him.

> Good paintings of animals [he told the Fellows] give much clearer ideas than descriptions. Whoever looks at the picture, which was done under my eye, by Mr. Stubbs, that excellent painter of animals, can never be at a loss to know the Nylghau, wherever he may happen to meet with it.[18]

The *Duke of Richmond's First Bull Moose* was originally intended for the same purpose. This is evident from what is, for Stubbs, a rather inelegant insertion in the lower left corner – a set of exemplary antlers from a full-grown moose, giving additional information to compensate for the lack of flamboyant headgear in the younger animal portrayed. In the event, Hunter found the moose at Goodwood altogether too young to be usefully compared with the Irish Elk and decided not to read his paper at the Royal Society after all. Goodwood's second bull moose, which he saw two years later, was a little older, although still immature. Hunter asked Stubbs in 1773 to make a drawing, but in the end that study was never completed in oils. Perhaps it, too, was not mature enough for a decisive comparison between its skull and that of the Irish Elk. At all events Hunter never did publish his views on the subject.[19]

All this entailed detailed conversations between Stubbs and Hunter, and it was just at this time that Hunter accepted Reynolds's invitation to be the Royal Academy school's first professor of anatomy. Stubbs was still treasurer of the Society of Artists and had himself arranged anatomical demonstrations at the premises in Maiden Lane. So, though hardly likely to be present at Hunter's inaugural Academy lectures, it is certain he was keenly interested in what Hunter was going to say.

The lecture series began conventionally enough, with two traditional anatomical demonstrations. But in his third address Hunter was more ambitious. In keeping with the Academy's intellectual pretensions, he departed from muscular structures and the architecture of the skeleton to broach the aesthetics of art and their relation to the observation of nature. In doing so, he diverged sharply from the views of the president of the Academy. Reynolds, in his contemporaneous discourses to the Academy, recognised the importance of drawing from observed models, but was always muddling this with a pursuit of 'ideal imitation'. Hunter's mind was in no such confusion.[20] His third lecture asks 'how far the artist should copy Nature herself precisely; or how far this work should be the copy rather of what his own poetick or creative mind makes out in imitation of nature'? His answer is that

> a painter executing a single figure in the ordinary situation of quiet life cannot copy Nature too exactly, or make deception too strong . . . It gives him a ready eye, correct judgement and distinct memory, and by dividing the larger portions of the body into their smaller constituent parts it brings out an arrangement and order in what would otherwise appear confusion.[21]

That 'ready eye, correct judgement and distinct memory' is very Stubbsian, and these remarks in general agree completely with what we know of Stubbs's ideas about art and nature. The dates are important here. Hunter was speaking in October 1770, about a year after he had watched Stubbs painting the nylghau 'under my eye', and immediately after presumably doing the same during Stubbs's work on the Goodwood moose. The two anatomists must have talked together about the way in which art follows the lineaments of nature, for it seems obvious that Hunter – 'not widely read in the theory of art'[22] – drew upon these discussions when framing the central arguments of his third lecture.

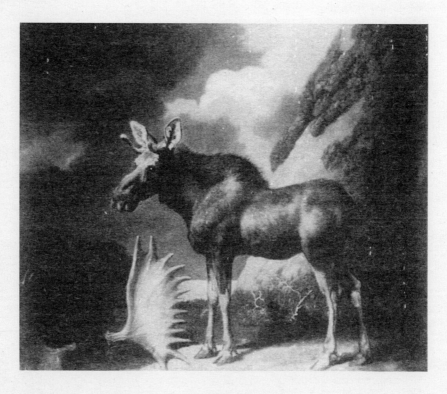

The Duke of Richmond's First Bull Moose, 1770.

CHAPTER 45

Printmaker

*He likewise engraved at Different leisure time of various sizes from
pictures of his own painting.*

For eighteenth-century painters, to be approached for the first time by
a commercial printmaker wanting to reproduce their work was a
moment of elation, a breakthrough moment, comparable to a play-
wright or novelist of today receiving enquiries from a film company.
But until the mid 1760s no print of a Stubbs painting had appeared.
Then, in 1766, to cash in on the fame won by the horse Gimcrack
during that season, Thomas Bradford proposed issuing a mezzotint of
Gimcrack with John Pratt up, which Stubbs had painted the previous
year for his patron William Wildman, who was also Bradford's friend.[1]
The Carlisle-born William Pether, one of the best engravers in London
(who was also a political radical and, at that time, one of the dissident
members of the Society of Artists) was selected as the engraver, and he
produced a fine mezzotint, published on 17 May 1766.[2] The artist must
have been consulted during the printmaking process, and this was
perhaps the first time he had the chance to see a mezzotinter at work.

At roughly the same time, the firm of Ryland and Bryer of Cornhill
also decided to bring out a print after Stubbs, the earlier of his two
Phaeton and the Horses of the Sun compositions.[3] William Wynne
Ryland, the senior partner, was himself a very good engraver, especially
in stipple, and was patronised by the royal court. He would have grown
rich, had he been able to control his finances, but the firm of Ryland
and Bryer was to be declared bankrupt in 1771. Despite going on to
develop a franchise in stippling after the popular history paintings of
Angelica Kauffmann, Ryland never found it easy to make ends meet. By
the 1780s he had begun to put his engraving skills to a more sinister
use. Arrested on a charge of making forged East India Company bills,
Ryland was tried and found guilty. He attempted suicide, failed and
was hanged for his crimes at Tyburn on 29 August 1783.

Eighteen years earlier Ryland had not proposed to do the engraving
of *The Horses of the Sun* himself. The chosen artist was Benjamin
Green, working in mezzotint. Issued without a publication date (but

probably 1765 or 1766) it is an impressive technical performance and a very handsome print, lettered with Joseph Addison's translation of Ovid ('The Horses flying through the Plains above / Ran uncontroul'd where-e'er their Fury drove . . .') alongside the original Latin verses. Although it is notoriously difficult to estimate sales of individual prints, not least when the publisher is as unbusinesslike as Ryland and Bryer, it must have been successful enough to prompt the engraver to plan further Stubbs prints in 1767.[4] However, he was unwilling to collaborate again with Ryland, and so decided to publish the issue himself.

> This Day are Publish'd PROPOSALS for a Metzotinto PRINT, to be publish'd by Subscription, from an original Painting by Mr. Stubbs, of the HORSE and LYON, by BENJAMIN GREEN, Fellow of the Society of Artists of Great Britain and Drawing Master of Christ's Hospital. The Print is 22 inches by 16, and will be ready to be delivered to subscribers on 24th Day of August next, Price 7s.6d.
>
> Those Persons who chuse to subscribe are only requested to send their names, as no Money will be received but on Delivery of the Print, to Benjamin Green at the Golden Head, in Little Britain; Messrs Ryland and Bryer in Cornhill; the Print Warehouse, in Pall mall; or to Mr. Austin's in Bond Street.
>
> N.B. If Encouragement is given, it will be carried on to a set of six or eight Prints.[5]

Encouragement must have been given, for Green went on to bring out *Brood-Mares, Lord Pigot* (both 10 May 1768), a different *Lion and the Horse* (1 September 1769), the second *Phaeton* (18 March 1770) and *The Lion and the Stag* (1 October 1770). That sales were brisk is shown by Green's advertisement for the second *Lion and Horse*, which states that prints could be had from 'most of the shops', especially in Cornhill, Cheapside, Ludgate Hill, Fleet Street and Haymarket. In publishing, then as now, good distribution of copies is clear evidence of a marketing success.[6]

Mezzotint, despite its Italianate name, was invented in Holland about 1640 and brought to England in 1660, according to tradition by Prince Rupert of the Rhine, the Royalist general, admiral and keen *amateur* artist, on his return from Cromwellian exile. The mezzotinter proceeds by roughing the whole surface of a copper plate with a thick, even burr so that, if covered in a non-fluid ink and printed in that state, it produces a velvety black page. The image is then made by scraping the burr away with a flat, pointed instrument, similar to an arrowhead.

The deeper the scrape, the lighter the tone becomes, until the pure white highlights are pits in the plate itself, below the level of the burr. These scrapes, which can be done by strokes, licks and dabs, gives mezzotint engraving its distinctive feature, quite different from any other kind of printmaking, and slightly akin to brushwork. If etching was the method most attuned to freehand drawing, mezzotint was the most painterly engraving technique.

After the print by Pether, and the seven by Green, the next George Stubbs mezzotint was made in 1770, and much closer to home, for the engraver was twenty-two-year-old George Townley Stubbs. This print, his father's *The Lion and Stag*, was the first to appear over the younger Stubbs's name and the original from which it was taken, too, had been a novelty – George Stubbs's first enamel painting on copper, which he had completed a year or two earlier.[7]

Details of George Townley Stubbs's training are not known; indeed biographical material on him is altogether skimpy, even more so than that on his father.[8] It is not adequate to assume he was trained solely at Somerset Street, although it must have been here that he learned drawing and probably began etching. But the fact that his first print is a mezzotint, a process which his father had never used, suggests that when he was about seventeen – that is, around the time Benjamin Green was beginning to reproduce the Stubbs paintings – G. T. Stubbs was taught how to scrape a plate by a professional mezzotinter. It is not a large step to suppose that this was Benjamin Green himself, not only a fine printmaker, but a professional drawing master of repute, whom Stubbs knew as a fellow director of the Society of Artists, which Green had joined in 1767.

G. T. Stubbs made his public debut with the *Lion and Stag* print, exhibiting it in the 'honorary' (i.e. amateur) section of the Society of Artists exhibition in May 1770 (no. 276). It was an anonymous offering ('by a Gentleman') although, since this was the second year of his father's treasurership of the Society, the secret can only have been an open one. It looks as if the publisher John Wesson, who had previously worked with Ryland and Bryer and was now setting up on his own, made an entrepreneurial swoop during the exhibition and signed up young Stubbs on the spot. He certainly issued the engraving (after asking for revisions) on 24 July and followed up by publishing a second mezzotint by G. T. Stubbs, yet another *Horse and Lion,* on 20 September.[9]

The second print shows its protagonists in what is known as 'Episode B' of their saga, with the lion getting ready to spring, while the horse backs away in terror. The horse has an oddly angular look around its head and neck, like a representation of a carving. This sophisticated effect is not (as used to be thought) the result of the elder Stubbs's hand in the scraping. We now know that G. T. Stubbs at this time was not a boy of fourteen but a man of twenty-two, so there is no need for such a contrived explanation. The chiselled planes of the cheek and neck nevertheless do look deliberately sculptural in the classical style. The effect must have been arrived at after discussions between painter and engraver. George Stubbs's own etching-with-roulette-work of the same subject eighteen years later also uses it.[10]

By 1774 G. T. Stubbs was to be found at various addresses other than Somerset Street: Edward Street, Great Titchfield Street and, by September 1776, 'Mr Torrond's No. 18 Wells Street', a drawing school where he had presumably taken a job. What relations with the family were like is impossible to say, but G. T. Stubbs continued to make mezzotints after his father's work in the early 1770s which were issued by various publishers. One of these was probably William Wynne Ryland who, in February 1771, brought out a set of three portraits of Lord Grosvenor's stallions, all after Stubbs paintings, *Bandy*, *Pangloss* and the unnamed Arabian.[11] This date coincided with the start of the covering season, when Grosvenor's stud manager at Oxcroft was advertising the stallions' services in the *Sporting Calendar*.[12] The use of prints to publicise stallion services gives insight into the Georgian bloodstock world. It is not impossible that the portraits were sold, or even presented, to the owners of mares that had visited these stallions.

In 1776 and 1777 both Stubbses, son and then father, made their first separate appearances as print publishers. From his address in Wells Street, G. T. Stubbs issued three new releases, *The Lyon*, *The Lyon and Lioness*, and *Stallion and Mare*.[13] All these were again in mezzotint. Then, the following year, George Stubbs himself made an entry into the market. His *Horse Affrighted by a Lion* is a large print (about 18 inches by 14) taken from his 1762 canvas depicting 'Episode A'. The first reproduction he made personally from any of his own paintings, it was for sale at a conventional price, 7s.6d.[14] Stubbs followed this in 1780 with *Two Tygers at Play*, on sheets of matching size, and also issued from 24 Somerset Street. This was based on a painting that Stubbs had exhibited at the Academy in 1776 (no. 203). Both prints are etchings, with some added work with the graving tool, and technically are very

much Stubbs's own. The nearest work by other engravers would be the 'lozenge networks and "worm lines" of a Woollett'[15] as seen, for instance, in the 'shooting' series. But Stubbs had evolved a much more closely packed, less schematic form of expression with his own etching needle, producing a more complex visual texture than Woollett.

But now, while the father was launching himself as a printmaker and publisher, the son was distancing himself from Somerset Street. He began by making prints after works by one or two of his father's friends and colleagues. From the Cosways he produced *Sappho* (1777), *Il Milanese* (1780) and *The Duchess of Devonshire* (1782); then he engraved another society beauty after a portrait by Hugh Douglas Hamilton, *Elizabeth, Countess of Derby*. But by the early 1780s we begin to find a new influence entirely. A scattering of satirical, or at least moralising, prints appeared, done in collaboration with another engraver, Charles White, after designs by an obscure Irish seal engraver, James Wicksteed, with whom G. T. Stubbs shared lodgings in Henrietta Street.

These new ventures did not prosper. In 1785, now aged thirty-seven, G. T. Stubbs 'late of Newport Street in the co. of Middlesex printseller dealer and chapman' was made bankrupt.[16] As well as illustrating the precariousness of the printmaker's livelihood, there are indications that his financial difficulties lay behind a worsening relationship with his father. One would expect the older Stubbs to do everything in his power to avoid the shame of his son's bankruptcy. But debt can be compulsive and there may have been a long history of the father paying off the son's creditors, until a point was reached when he either would not, or could not, go on.

Immediately after his insolvency, G. T. Stubbs became involved with the publisher Samuel William Fores, etching anonymously (as he would have to if his creditors were still not satisfied) for a series of political caricatures attacking George, Prince of Wales, and his secret Irish wife Mrs Fitzherbert.[17] In two examples at least – a pair entitled *His Highness in Fitz* and *Out of Fits, or the Recovery to the Satisfaction of all Parties* – these are explicitly sexual scenes, which show the couple first in flagrante and then in a state of post-coital collapse. The Catholicism of Mrs Fitzherbert is explicitly referred to in the form of a crucifix, which seems suspended over the rump of *His Highness in Fitz*.[18] G. T. Stubbs was certainly responsible for other risqué cartoons, one of which, *The Go-Between or Barrow Man Embarrass'd* (1787), shows a Covent Garden porter trying to steer his barrow of oranges

between two fashionable ladies, whose gigantic bosoms combine to block his path.[19]

But after these excursions into anti-establishment bawdy he was reconciled to his father in 1788, mezzotinting two recent paintings, *Horses Fighting* and *Bulls Fighting*, the second of which had been shown by Stubbs the previous year at the Royal Academy as an oil painting (no. 83).[20] These prints, which bear the names of both George and George Townley Stubbs, were published by Benjamin Beale Evans and are the first prints after his father's work that G. T. Stubbs had made for eleven years. Both mezzotints show that, at his best, G. T. Stubbs was a printmaker to be reckoned with.

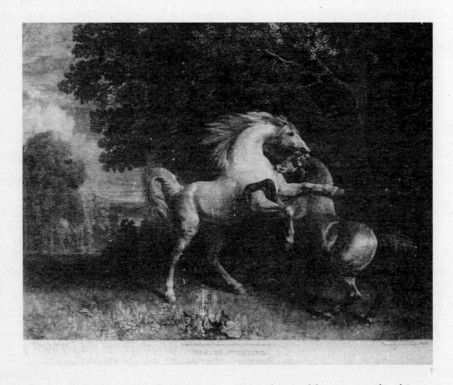

Horses Fighting, mezzotint by George Townley Stubbs, 1788, after his father's painting.

CHAPTER 46

Wax and Wedgwood

My compts to Mr. Stubbs. He shall be gratified but large Tablets
are not the work of a day.

Josiah Wedgwood

When his career had taken flight in the early 1760s, Stubbs appeared a
self-taught but fully fledged artist of astonishing technical assurance.
But he did not stand still. His career was a continual restless search for
new techniques and fresh means of expression.

The revival of panel painting, whose results were seen in public at the
Royal Academy in 1775, came in step with another new interest:
encaustic, or wax-based painting.[1] This provides the clearest evidence
yet seen of Stubbs's neoclassicism, for encaustic was one of the two
principal painting media of the ancients, the other being fresco. Stubbs
was not the only fashionable painter who tried to reinvent encaustic at
this time. It was pursued both in order to reconnect with the classical
tradition and to overcome specific problems with conventional oil
painting.

Encaustic had been popularised in a book by Johann Heinrich
Müntz, who had made wax-painting experiments for Horace Walpole
at Strawberry Hill, and who published his *Encaustic, or Count Caylus's
Method of Painting in the Manner of the Ancients* in the first year of
the reign. Müntz's sales pitch claimed qualities for encaustic that
exactly fitted Stubbs's requirements:

> You will have all the effects and sweetness of painting in oil, and the
> colours will not be liable to fade and change . . . nor can the colours crack
> and fall in shivers off the canvas.[2]

Ancient encaustic, it appears from the few existing sources,[3] was a
process whereby dry pigments were ground and mixed with melted
wax. After application, the colours were heat treated, or 'burned in',
possibly by having a hot metal rod rolled over the surface. So far so
good. But with little real knowledge of how Apelles and his colleagues
proceeded, Müntz's conclusions were less than definitive and his
guarantee of quality far from cast-iron. Artists continued to

experiment, frequently with disastrous results. The most prominent example was the notoriously short half-life of certain paintings by Joshua Reynolds, but some of Stubbs's paintings of the 1770s would turn out to be equally fragile.

His experiments with wax related closely to, and largely explain, the parallel interest in panel painting, as this was the support favoured by encaustic painters in the ancient world. Stubbs does appear to have used oils, both drying and non-drying, for some of his panel-painting colours, but there are others in which he employs various combinations of beeswax, stearine fats, pine resin and other resins, with no oils present. Such colours were opaque and would tend to be quicker drying than oils, behaving more like gouache. For the 'alla prima' painter like Stubbs, this would mean a consistently thinner painted surface than in artists using multiple layers of transparent glazes to create colour effects. It meant, too, that he could – indeed, he had to – work quickly. As a final consequence the paint surface proved difficult to clean, particularly as a later conservator might have little idea what preparations Stubbs had been using.[4]

The very fact that hardly any classical paintings in encaustic had survived underlined the point. By contrast, if you dug up an enamel that had been buried for 2000 years, a wipe with a damp cloth would probably reveal its colours intact. This reflection caused Stubbs largely to abandon wax painting in the late 1770s, in favour of new trials with enamel. He was determined to establish this as a method equal, if not superior, to oils. He would use enamels, in effect, to fulfil Müntz's empty boast about encaustic. But in order to succeed, he would have to produce enamel works larger than had ever been seen before, and that depended on finding a painting support to replace the traditional, but size-limited, copper plate.

His first stop on the way was Eleanor Coade, one of the most remarkable women of the age, who had invented Coade Stone in 1769 and was already successfully manufacturing and marketing it in Lambeth. Her product was a very hard-wearing ceramic, specifically a form of stoneware made of a composite of clays and other ingredients whose exact secret would die with Coade in 1821. As she refined her product she found it possible to mould 'everything in Coade Stone which could be carved in natural stone'[5] from chimney-pieces to bird baths, and from classical statues to garden elephants. Coade Stone was almost indistinguishable from real stone, and it made her a fortune.

The first enamel by Stubbs, on a support other than copper, is *Lion*

on a Rock, a rectangular piece of only 9 inches by 12. This is dated 1775. If the suggestion turns out to be right that it is on Coade Stone,[6] Stubbs would have purchased a small slab of Coade for the experiment. But when he went to show this to Mrs Coade, and discussed much larger tablets, he found she was 'not willing to undertake the commission'.[7] Coade's business was still developing in the mid 1770s and it was too risky and expensive to carry out the necessary research and development.

Stubbs struck luckier with the potter and pioneer industrialist Josiah Wedgwood of Staffordshire. He made the approach through Wedgwood's partner Thomas Bentley, who had been a prominent Liverpool shipping merchant since 1753 and was now running the London end of the ramifying Wedgwood operation. Bentley's business partnership with Wedgwood, which was formalised in 1769, was based on deep mutual respect. Wedgwood was an organiser of genius, Bentley an astute salesman, but Bentley was also a crucial influence on product development. The company's founder had all the necessary technical expertise and matched this with driving ambition, but he was self-educated and lacked confidence in his own taste. The polished Liverpool merchant had the cultural nous to hold informed and accurate views on what the retail market was looking for. His judgement was sound enough to propel the company's products to the pinnacle of neoclassical fashion.[8]

Stubbs and Bentley must have had mutual Liverpool acquaintances and are likely to have met during Stubbs's residence in the city between 1754 and 1756. Bentley, who then lived in Paradise Street, was a member of a prominent literary society called the Liverpool Philosophical Club, and he also had a bent for science, in particular chemistry.[9] But whatever their previous connection, the two men also met in London for it was here, in 1775, that Stubbs spoke to Bentley about the supply of ceramic plaques for the production of large-scale original enamel paintings. The question was passed to Wedgwood, who noted in his Commonplace Book, 'Tablets for Mr Stubbs – The proportions he likes are 3 feet by 2 and 3 by 2′4″ – or in general 4 by 3 and 3 by 2.'[10]

Such large ceramic tablets had never been made before and the technical challenge was immense. But this was just the kind of thing Wedgwood relished, as he wrote to Thomas Bentley in 1774:

The Fox-hunter does not enjoy more pleasure from the chace [sic], than I do from the prosecution of my experiments when I am fairly enter'd into the field, and the further I go the wider this field extends before me . . . but the too common fate of schemers is ever before my Eyes, and you have given me many excellent lectures upon the bad policy of hurrying things too fast upon one another.[11]

The next mention of Stubbs in the Wedgwood papers is two years later, when reference is made to what sounds like the product of a coffee house discussion: a painter's palette made in ceramic. Wedgwood was enthusiastic, or else he was keen to humour Stubbs, for he brought the idea as far as a prototype in Queen's Ware. But this, he thought on consideration, Stubbs would find 'too heavy for his hand'.[12] In the meantime Stubbs had made another of his own experimental enamel pieces, cutting the bottom out of a Wedgwood Queen's Ware dish and using his enamel tints to paint *A Sleeping Leopard* on it.[13] Probably Wedgwood held a conference with Stubbs in 1777 and saw this piece. Liking it, he returned to Staffordshire to initiate trials for much larger-scale plaques. In November he wrote to Bentley,

My compts to Mr. Stubbs. He shall be gratified but large Tablets are not the work of a day – We have been labouring at the apparatus for that purpose from the day I came down, & can report – *some progress*.

Wedgwood had decided to try out a clay composition similar to the biscuit earthenware used for making his celebrated Queen's Ware line. In December he fired three experimental pieces, one of which (at 22 inches by 17) was successful, and this was sent down to Somerset Street. Stubbs used it to paint an enamel version of Rockingham's *Lion Attacking a Stag*, in which he duplicated the rather heraldic pose of the lion, while altering the position of the dead stag.[14]

Something still larger than this was wanted, but progress was slow and ten months later Wedgwood asked Bentley to reassure their customer that trials were continuing. One problem seemed to be that of fitting a larger plaque into the kiln and of firing it evenly.[15] Success was achieved soon after, however, because on 28 November Stubbs was invoiced 'to Tablets, £27–6s', and several more of the same were delivered over the following months, mostly oval but one or two rectangular.[16] Eventually Wedgwood successfully fired an oval slightly over 3 feet wide, the largest he achieved. Stubbs's deal may have included firing his paintings in the company kiln behind their premises at 12–13 Greek Street, Soho, and smaller invoiced amounts, such as

£1.4s.9d billed to Stubbs on 30 December 1778, may refer to this service.

The bills were high and, by now, Stubbs was not as prosperous as he had been. In spring 1779, Bentley received a long letter from his partner about the state of Stubbs's account.

> 30 May . . . At present I think we should give Mr Stubbs every encouragement to establish the fashion [for enamel painting]. He wishes you know to do something for us by way of setting off against the tablets. My picture and Mrs. Wedgwoods in enamel will do something. Perhaps he may take your governess & you in by the same means. I should have no objection to a family piece, or rather two, perhaps in oil, if he shod. visit us this summer at Etruria. These things will go much beyond his present trifling debt to us.
>
> Now I wish you to see Mr. Stubbs, & if the idea meets your approbation, to tell him that if it is convenient for him to pay in money for what he has hitherto had, it will pay something towards the kilns, & alteration in kilns we have made, & other expenses we have been at in our essays, & the next £100 or £150 in tablets, perhaps more, shall be work & work – we will take the payment in paintings.

In the same letter he details just what he has in mind for the family pictures: one of his daughters at music and its pendant of his son Jack, in the guise of a Natural Philosopher,

> standing at a table making fixable air with the glass apparatus &c., & his two brothers accompanying him. Tom jumping up & clapping his hands in joy & surprise at seeing the stream of bubbles rise up just as Jack has put a lump of chalk to the acid. Joss with the little chemical dictionary before him in thoughtful mood, which actions will be exactly descriptive of their respective characters.

In fact, it was in summer 1780 that Stubbs travelled to the luxurious Wedgwood family home, Etruria in Staffordshire. It was an extended stay of more than three months. He socialised with his host, gave drawing lessons to the children (who were being home-educated) and visited neighbours and the surrounding countryside. But this was above all a working visit with a variety of professional jobs to be done under the inquisitive and fascinated eye of his host.

One was to paint some urns or jars 'with ground figures, trees & sky without any borders or divisions, in short to consider the whole surface as one piece of canvas'. Wedgwood took his guest down to the works to throw some jars and Stubbs seems to have painted these 'with free masterly sketches', though none was produced for the market. Stubbs

perhaps finally jibbed at sinking to the level of a pottery painter. He did, however, agree to model an oval relief for the Wedgwood saleroom, to be produced as a plaque in the trademark blue-and-white jasper. Stubbs, who had never modelled in clay before, was typically obdurate about the subject matter.

> 13 August. He has fixed upon his subject for modeling, *the lion & horse* from his own engraving. He objected to every other subject & he is now laying in the horse whilst I am writing a few letters this good Sunday morning. He does very well so far, & with a little practice will probably be as much master of his modeling tools, as he is of his pencils.

The model was finished a week later and meanwhile Stubbs had begun work on a family picture. He had dismissed Wedgwood's carefully thought-out scheme for a pendant pair showing his children, an idea that had come not from any real consideration of Stubbs's work, but from Wedgwood's recent patronage of Joseph Wright of Derby, whose paintings of philosophical experiments had brought him fame in the 1760s. Instead, Stubbs proposed a conversation piece of all the Wedgwoods and their horses.

The work progressed slowly. On 13 August 'our little lassies and their coach are just put into colours & the characters of the children are hit off very well. I have given him one sitting, & this is all we have done with the picture.' On 21 August 'we have begun to make the horses *sit* this morning, & I write this by Mr Stubs in the new stable, which is to be my study whilst he is painting there'. And, three weeks later,

> our picture goes on very slowly, but we may report *some progress* . . . the likenesses in those that approach towards being finished grows weaker as the painting increases. Mr Stubs says the likeness will come in & go off many times before finishing so I can say nothing to this matter at present, only that the first sketches were very strong likenesses, & the after touches have hitherto made them less so, but I daresay he will bring them out again.

Wedgwood enjoyed showing his new friend off in the neighbourhood. Stubbs's name was obviously well known in Staffordshire, though not as a portrait painter.

> 25 September . . . nobody suspects Mr Stubs of painting anything but horses & lions, or dogs & tigers, & I can scarcely make anybody believe that he ever attempted a human figure.

In spite of this, Stubbs picked up a few portrait commissions from Wedgwood's friends, including 'a portrait of Mr Swinnerton' and 'Mr

& Mrs. Fitswilliams at breakfast as large as life'. However, the originality and ambition of Stubbs's work puzzled these provincials for, as Wedgwood wrote, 'his pieces I rather apprehend are beyond the limited conceptions of this country'.

Meanwhile progress on the Wedgwood conversation piece was slow.

21 October. Time and patience in large doses, are absolutely necessary in these cases & methinks I would not be a portrait painter upon any condition whatever. We are all heartily tired of the business, & I think the painter has more reason than any of us to be so.

What was going on? Stubbs was normally capable of finishing such work in a quarter of this time and, though he was interrupted by attacks of toothache, his dilatory pace was really the result of trying to accommodate the opinions of his sitters.

28 October. Mr Stubs thinks he has quite finished our picture but he is a little mistaken for I shall get him to make a few alterations still, but it must be by degrees, for I have plagued him a good deal in the last finishing strokes & he has been very good in bearing with my impertinence.

Two obstinate men were trying with almost comic politeness to get the better of each other. True, Wedgwood attempted to see the painter's side of things, while Stubbs patiently tried out Wedgwood's stream of suggestions, and those of the rest of the family, before rejecting or remodifying them. The relative failure of the painting – it is one of Stubbs's least harmonious works – must be due to the fact that it was designed virtually by committee. Stubbs had worked to a brief before, but his aristocratic patrons had generally been content to give him broad parameters and trust his judgement thereafter. But, quite apart from the meddling of Wedgwood and his family, Stubbs's financial indebtedness – which was the real reason for his visit – made his position at Etruria awkward. The Wedgwoods were charming and welcoming, but they were also hypercritical, and he felt he had to try to accommodate them. Even as late as 12 November, when the family piece had been three months on Stubbs's easel and the artist had announced his imminent departure, Wedgwood writes,

12 November. I intend . . . to prevail upon Mr. S. to give us another day or two at our family piece which does not appear to me to be quite finish'd. My wife I think very deficient – Mary Anne more so, & Susan is not hit off well at all. I say nothing of myself but on the whole . . . there is much to praise and a little to blame.

Stubbs may have come away with the same opinion, for it terminated his interest in family conversation pieces.

The visit ended after one more piece of work was done. In the same 12 November letter Wedgwood writes that 'the model of Phaeton is in some forwardness. He works hard at it every night almost 'till bedtime.' Stubbs was making a second decorative relief for mass production in jasper ware and two weeks earlier had asked his host to have a copy of his Phaeton print sent up from a London print shop so that he could work from it. Wedgwood did so, though he had ideas of his own on the subject.

> 28 October 1780. I have objected to this subject as a companion to the frightened horse as that is a piece of natural history, this is a piece of unnatural fiction, & I should prefer something less hackney'd & shall still endeavour to convert him, but would nevertheless wish to have the Phaeton [print] sent lest he should be obstinate, in which case I think it will be better to have that than nothing.

Stubbs again proved obstinate and the Phaeton is what Wedgwood got. The jasper ware plaque produced from it, which appeared in the Wedgwood catalogue in 1783, is among the finest made for the firm by any artist.[17]

Apart from some tiny horses modelled for buttons by Edward Birch RA, these were the last Wedgwood products derived from Stubbs's work. The Bentley letters reveal one final spin-off from his visit, however – the revival of the pottery palette:

> 4 November. The little pallets are making and you may sell them separately at about a shilling. We are making some large ones under Mr Stub's direction which he says must come in general use if the price does not prevent it. Having finish'd single ones to his entire satisfaction, we are now making some dozens for your rooms.[18]

CHAPTER 47

The Academy

I find Mr S. repents very much his having established this character for himself. I mean that of horse painter, & wishes to be considered as an history, & portrait painter. How far he will succeed in bringing about the change at his time of life I do not know.

Josiah Wedgwood wrote these words to Thomas Bentley, in the same letter of 25 September 1780 when he reported that 'nobody suspects Mr. Stubs of painting anything but horses & lions or dogs & tigers'. Stubbs had then been Wedgwood's guest for two months, giving plenty of time for a genial and attentive host to persuade even a reserved man to open up, and Stubbs here was confiding the eternal frustration of the type-cast actor, the unpromoted subordinate, the specialist who wants to be a generalist.

However, it was not only to Wedgwood that Stubbs complained, for his irritation at being labelled a horse painter had begun to be common knowledge in artistic circles. Two years later, the satirist John Wolcot ('Peter Pindar') reflected in his *Lyrical Odes to the Royal Academicians*:

> 'Tis said that nought so much the temper rubs
> Of that ingenious artist, Mr Stubbs,
> As calling him a horse-painter, how strange
> That Stubbs the title should desire to change.
>
> Yet doth he curses on th'occasion utter
> And, foolish, quarrel with his bread and butter;
> Yet after landscape, gentlemen and ladies,
> This very Mr Stubbs prodigious mad is.
>
> So quits the horse – on which the man might ride
> To Fame's fair temple, happy and unhurt;
> And takes a hobby-horse to gall his pride,
> That flings him like a lubber in the dirt.[1]

Wolcot's jibes were particularly wounding because they were written in response to the Royal Academy exhibition of 1782 (now held in and around the Great Room in Chambers's new-built Somerset House),

where Stubbs had decided to make public the full extent of his enamelling experiments over the previous decade.

As Wolcot could see, Stubbs's choice of subject in these paintings revealed his ambition to wriggle off the peg on which the men of taste had suspended him. He showed five enamel paintings in all. Three were more or less within his usual compass – a self-portrait, *A Young Gentleman Shooting* and *Portrait of a dog*.[2] The other two, however, were startling, in that they derived from literary models, *A Young Lady in the Character of Una* from Edmund Spenser's *Faerie Queene*, and *The Farmer's Wife and the Raven*, an illustration of one of John Gay's *Fables*.[3] Stubbs knew these works were good and innovative, and was deeply upset to find Wolcot and others sneering at their subject matter, while not even considering their revolutionary new medium.

Since its founding in 1768, the Royal Academy had grown confidently, as the Society of Artists and a third group, the Free Society of Artists, declined. But it was not until the Academy moved into the splendid apartments set aside for it by Sir William Chambers in his great neoclassical office block, Somerset House on the Strand, that the crushing victory over the rival societies was confirmed. In the first Somerset House exhibition in 1780, 61,000 visitors crammed in at a rate of 1000 a day. Above the door of the Great Room was a Greek inscription, forbidding entry to any 'Stranger to the Muses' – that is, to anyone lacking in proper taste and respect for the arts. The words were both flattering and admonitory. Entry was a shilling: if you had that, you could call yourself a person of discrimination, but at the same time you were expected to subscribe to the paradigms of taste framed by the Academicians who admitted you.

The shilling ticket had an unfortunate side effect: it attracted accusations of commercialism. Large profits were certainly made, but the Academy affected horror at the suggestion that they wanted the lucre. An advertisement printed in the 1780 catalogue announced that the Academicians would have dearly liked to provide free entry but

> they have not been able to suggest any other Means than that of receiving Money for Admittance, to prevent the Rooms being filled by improper Persons, to the entire Exclusion of those for whom the Exhibition is apparently intended.[4]

The question of propriety was of the greatest importance to the Academy. Artists too were graded and categorised so that all should

know their places, with pride of position given to improving history works, interpreted in literary terms and evaluated by the superior intellect of the virtuoso. Such painting ought to have been beyond the capabilities of a mere *animalier*, a painter seen, in artistic terms, as a clodhopper, who could no more aspire to education, books and the higher taste than could the animals he represented. Like Dr Johnson's view of female preaching, then, the point was not whether Stubbs's 'literary' paintings were good or bad; it was that they had been attempted in the first place.

The non-consecutive catalogue numbers given to these 1782 exhibits indicates that the enamels were scattered throughout the exhibition rooms, with the effect of seriously dissipating their impact. Some may have been 'skied' or consigned to areas outside the Great Room, among assorted exhibits – drawings, watercolours, even shell pictures or scenes knitted in human hair – by lesser-known artists or amateur gentlemen and ladies.[5] The hanging committee may indeed have considered them too garish to be seen alongside the old-masterly brown tints favoured by most oil painters,[6] but there would be no more effective or calculated way of wounding Stubbs than by evaluating his marvellous new enamels at the same level as curiosities. An additional sore point was the Academy's failure to include in the catalogue the quotation from Spenser that Stubbs had asked for – another slap at his literary pretensions.

The committee may even have deliberately set out to guy him. In 1780, five years after his 1775 debut, he had been elected an Associate and then, a year later, a full Academician. But he fell into dispute with the Committee over their demand that he present a 'diploma piece' as a condition of the honour. Stubbs flatly refused to do so, on the grounds that this was a new regulation, brought in after his election, and so should not apply to him. In Humphry he is said to have 'formed an unconquerable resolution not to send a [presentation] picture'. The committee's response to this intransigence was to refuse to confirm his election and they may additionally, and spitefully, have gone one step further by hanging his next submissions way 'above the line', or otherwise inconspicuously.

The failure of the 1782 enamel submissions was doubly disappointing because in the previous year he had tested reactions to the idea of large enamelled paintings by exhibiting *Horses Fighting*. It was a toe in the water, but the painting had been well received. Horace Walpole, not always an uncritical fan of Stubbs, but a significant

barometer of taste, admired him for having 'invented enamelling oil paintings'.[7] Meanwhile the *Morning Chronicle* had called the work 'masterly' and praised the artist for showing how to defeat the ill effects of pollution, especially smoke on visual art.[8] Now, only a year later, as he came forward with a range of works in the same mode, he was comprehensively belittled.

On 11 February Joshua Reynolds, the president, announced that Stubbs's election as a full Academician was annulled, on the grounds that he had failed to present a diploma piece. For the next four years Stubbs withdrew into himself, declining to exhibit, issuing no prints and allowing his practice perceptibly to decline, with a falling-off in the commissions that had sustained his reputation and income for the previous twenty years. They would never fully recover.

CHAPTER 48

Seasons

Yet after landscape, gentlemen and ladies,
This very Mr Stubbs prodigious mad is.

What Stubbs did during this period of withdrawal counts as some of his most interesting work. First, although he did not publish any prints, he worked quietly at engraving, refining his technique through a series of plates that would ultimately display his 'virtuosity as a printmaker at its fullest extent'.[1] Second, he began to develop a vibrant new pictorial theme of agricultural work in early and late summer, his *Haymakers* and *Reapers*.[2]

The actual landscapes in which these scenes are placed convey a rural England that is still quite recognisable today, though the specific location is unidentified. The weather in them is clear, warm and still, although the sunlight is muted. In *Haymakers*, the hay has been cut and is being raked and pitchforked on to the hay wagon, drawn by two heavy horses harnessed in line. In *Reapers*, men move in a crouching gait along the edge of the standing corn, sickling it down while others form it into sheaves, tie them with carefully plaited straw binders and gather the sheaves into stooks. This is watched by the farmer, or farm bailiff, on his rounds. He sits his hack and surveys his day labourers with a beady eye.

There were eventually nine versions of the two subjects, two of each in oils on board dated 1783 and 1785 respectively, a pair of stipple engravings published in 1791 and three more oval variants on biscuit ware enamel, one dated 1794 and the others 1795.[3] They all play variations on the two themes, repeating figures and groups but not necessarily in the same relation to each other or to the landscape. Even in the stipples (based on the 1785 pair) Stubbs makes revisions. There were also, it seems, original field sketches and chalk or graphite compositional drawings in his studio. These were sold posthumously as 'Six Studies of the Reapers, and two unfinished drawings of ditto', 'A Capital drawing, the original design for the Corn Field with Reapers', 'Ditto, ditto, the original design for the Painting of the Hay Field and Men loading a Hay Cart'. As with all but a handful of Stubbs's drawings, they have since disappeared.[4]

The pictures show men and women at work, but it is not gruelling work and is carried out with no sense of strain. To anyone familiar with the whole range of Stubbs's work, the atmosphere of these placid and orderly compositions is entirely characteristic. The women rake hay in unison just as the Duke of Richmond's three racehorses gallop. The kneeling reapers are of the same stuff as the stud grooms and stable lads who had so often caught the painter's impartial eye. In *Reapers*, a dog reclines beside a jug of water and a 'breaker' of beer, and the heavy horses in *Haymakers* stand in line, massive and patient, the bridle, collar and traces of the lead horse detailed with meticulous accuracy. The surroundings are a gentle, acquiescent vision of arable England. If Stubbs was indeed 'mad' for landscape, there is no madness here.

Standing in front of the ruralism of Stubbs's *Reapers* and *Haymakers*, visitors to Tate Britain must constantly be tempted to give way to warm feelings about the pre-industrial eighteenth century. With their calm refusal to be either sentimental or sensational about country life, the paintings really do seem the most authentically positive Georgian images on Millbank. But their realism must be viewed with a sceptical eye.[5]

The labourers represented are too refined, and the whole scene is too idyllic, for these paintings to be read as realistic documentaries. The briefest glance at history shows that the 1780s were a particularly turbulent time not just in the city – the Gordon Riots laid waste to London in 1780 – but in the countryside too. The last remnants of feudalism were being torn to shreds by the accelerating enclosure of common land, by the spread of tenancies and the engrossment of estates. Less and less was farming followed as subsistence; now it was pursued as investment, and an increasingly profitable one. As a result the poor were driven from the land in considerable numbers, many becoming day labourers who had to live, quite literally, from day to day. This is not to say that life a generation or two earlier had been anything but tough for the rural poor, only that social change had been quickening at a rate that now drew loud attention to itself. And, as people began to notice, some started to organise and resist.

The resistance, whether it took the form of tearing down fences, breaking machines or burning toll-booths, was happening in cross-current to a novel and particular movement in educated opinion. This began to see rural poverty not as symptomatic of social change, but (in a startling category shift) as *the problem itself*. The accelerating economy required accelerated work but how could the idle and landless

poor, set 'free' from their old feudal obligations, be induced to put their shoulders ever more strenuously to the wheel? Under pressure from this puzzle, educated opinion, and fashion, began to lose their former pastoral affection for an imagined, and safely distant, rustic innocence. Now the blithe peasant whiling away the hours in bucolic dalliance was no longer indulged in the imagination of the town, but seen as a drunkard, a poacher, a layabout, while the sin of sloth formed the stern text of many sermons, and the theme of numerous newspaper denunciations. Exactly contemporary with Stubbs's paintings, an account of a Midlands hiring fair gives some flavour of this trend.

> This morning rode to 'POLESWORTH STATUTE': a hiring place for farm servants; – the only one, of any note in *this* part of the country; and probably the largest meeting of the kind in England. Servants come (particularly out of Leicestershire) five and twenty or thirty miles to it, on foot! The number of servants collected together in the 'statute yard', has been estimated at two or three thousand. A number however, which is the less extraordinary, as Polesworth being the only place, in this district, and this the only day, – farm servants for several miles round consider themselves as liberated from servitude on this day.
>
> Formerly much rioting and disturbance took place, at this meeting; arising principally from gaming tables, which were then allowed, and for want of civil officers to keep the peace. But, by the spirited exertions of the present high constable, MR. LAKING, these riots have been suppressed and prevented.
>
> The principle nuisance, at present, arises from a group of BALLADSINGERS, disseminating sentiments of dissipation, on minds which ought to be trained to industry and frugality. A ballad goes a great way towards forming the morals of rustics; and if, instead of the trash which is everywhere at present, dealt out at all their meetings, songs in praise of conjugal happiness, and a country life, were substituted, fortunate might be the effects.[6]

The same writer, William Marshall, interviews a countryman, Old George Barwell, whose twinkle-eyed stoicism is perhaps less convincing than the grim circumstances which underlie it.

> He has sometimes barely had bread for his children: not a morsel for himself! Having often made dinner off raw hog peas; saying that he has taken a handful of peas, and ate them with as much satisfaction as, in general, he has eaten better dinners: adding, that they agreed with him very well, and that he was as able to work upon them, as upon other food: closing his remarks with the trite maxim – breathed out with an involuntary sigh – 'Ay no man knows what he can do till he's put to it.'
>
> Since his children have been grown up, and able to support themselves,

the old man has saved, by the same industry and frugality which supported his family in his younger days, enough to support himself in his old age! What a credit to the species![7]

Stubbs's rural vision is in line with the direction pastoral ideas – that is, how the educated imagination claimed and interpreted the countryside – had been moving during the Georgian period. Earlier English pastoral had been a charming rural fantasy, in which no one did any work, but dallied and danced and made music. By the turn of the eighteenth century this began to give way to what was seen as a refreshing new realism. The poet John Gay had written in the preface to his pastoral verse:

> Thou wilt not find my shepherdesses idly piping on oaten reeds, but milking the kine, tying up the sheaves, or if the hogs are astray driving them to their styes.[8]

Gay may have been in ironical mood here, but he points to a real change, a reformed pastoral of uncomplaining toil whose best-known representative today is Thomas Gray's 'Elegy in a Country Churchyard' ('How jocund did they drive their team afield!'), composed in 1751.

This version of pastoral was not really new, however. The form in general was popular with the Georgian educated classes because it went back (at least) to the strains of rural celebration in their favourite Roman poets Horace and, especially, Virgil. The latter's *Georgics* had particular appeal at this time because, in them, Virgil (in contrast to his earlier *Eclogues*) turns away from the delight of pastoral leisure (*otium*) to the stern necessity of agricultural labour (*labor improbus*), giving detailed poetic instructions for the proper running of a farm, while extolling the virtues thereof in contrast to the horrors of war and the vices of city life.

Writing in the style of *The Georgics* was good literary business in eighteenth-century Grub Street. The most important and widely read British imitator was the London-based Scot James Thomson. His *The Seasons*, written between 1727 and 1744, was a long-winded, season-by-season poem that went into many editions, inspired numerous painters and illustrators, and even provided the libretto for Joseph Haydn's oratorio *Die Jahreszeiten* (1801).

One of these painters was William Woollett's pupil, the topographical artist and former pastry cook Thomas Hearne, who, in 1783, exhibited at the Society of Artists a watercolour entitled *Summertime*. Two years later it was engraved, together with a harvest scene,

Autumn, and both were printed over lines from Thomson's poem. There is a close correspondence between some aspects of Hearne's piece and Stubbs's *Haymakers*.[9] Hearne shows a hay cart being loaded by men at the edge of a hayfield, and under a spreading oak. Two female workers, in clothing almost identical to the costumes shown by Stubbs, rake the hay side by side. Another pauses for a rest, standing in a very similar declaratory pose to the young woman in *Haymakers*, though without her central placement or her extraordinary and challenging outward gaze.

Did Stubbs see and then develop the design of Hearne's picture? Given the friendship of Stubbs and Woollett, and the fact that Hearne had carried out some of the work on Woollett's engravings of the 'shooting' series, they must have known each other.[10] But there is surely more reason for the influence to flow from Stubbs to Hearne than the other way. Hearne was the younger, much less distinguished, artist. He may easily have seen Stubbs's field sketches (which, if he did, means they were done in the summer of 1782) and asked permission to reinterpret them in his own medium. Stubbs had withdrawn from the art scene and knew he would not be exhibiting at the Academy. He could have indulged his young friend, if only as a means of testing the market ahead of some future release of his own more substantial offerings.

At all events it is clear that Hearne connected his work directly with that of James Thomson, and the extract from *The Seasons*, published under his 1785 haymaking print, was substantial:

> Now swarms the village o'er the jovial mead;
> The rustic youth, brown with meridian toil,
> Healthful and strong; full as the summer-rose
> Blown by prevailing suns, the ruddy maid,
> Half-naked, swelling on the sight, and all
> Her kindled graces burning o'er her cheek.
> Even stooping age is here; and infant-hands
> Trail the long rake, or with the fragrant load
> O'ercharg'd, amid the kind oppression roll.
> Wide flies the tedded grain; all in a row
> Advancing broad, or wheeling round the field,
> They spread the breathing harvest to the sun
> That throws refreshful round a rural smell;
> Or, as they rake the green-appearing ground,
> And drive the dusky wave along the mead,
> The russet hay-cock rises thick behind,

In order gay: while, heard from dale to dale,
Waking the breeze, resounds the blended voice
Of happy labour, love, and social glee.[11]

The clear convergence of *Haymakers* and Hearne's picture, and the overt association between the two Hearne prints and these lines from Thomson's *The Seasons*, makes it a confident bet that Stubbs, too, was thinking in literary terms. In an entirely typical reflex Stubbs had refused to be cowed by the scolding some gave him for his literary presumption at the Royal Academy in 1782. He had not abandoned his new literary mode.

On the other hand, unlike Hearne, Stubbs was not thinking of James Thomson. Some of Thomson's words do find an elusive resonance in the Stubbs painting, particularly when they attend to the senses ('wheeling round the field, / They spread the breathing harvest to the sun / That throws refreshful round a rural smell'). But none of Stubbs's women is a 'ruddy maid', with 'all her kindled graces burning o'er her cheek'. Nor are there, as in Hearne, children rolling in the hay. A possible Thomsonesque plot has been suggested for *Reapers*, in which the overseer is eyeing up one of the women, while her swain looks daggers at him. But this is purely fanciful and, even if it had been in Stubbs's mind, it was peripheral to the overall purpose of the painting.

Stubbs's real model was Virgil, whose poems are plotless. There is no evidence about whether or not Stubbs knew Latin, but the *Georgics* were available in many English versions, a recent one being that of the disastrously long-serving headmaster of Winchester, Joseph Warton, a third edition of whose Virgil translations had been published in 1777. Book 3, in particular, would have caught Stubbs's attention with its long passages about the breeding, rearing and training of horses, and its bits and pieces of wild horse lore. *Haymakers* and *Reapers*, however, would reflect Book 1, concerned with seasonal fieldwork or, as the first line announces, with 'What culture crowns the laughing fields with corn'.[12]

Virgil's combination of poetry and practical detail would appeal strongly to a man like Stubbs whose job, as he saw it, was to wrap useful facts in art, and show the beauty in truth. 'It might also be observed', writes one modern scholar, 'that *Reapers* contains step-by-step instructions on how to cut and bind a sheaf of corn.'[13]

Despite these practical touches, and the minute attention Stubbs pays to details like the harness of the horses, the overarching purpose of this

pastoral is to formulate an ideal, a counterweight to the artificiality and falseness of life in the city. Stubbs (like Virgil) may have been deluded in the belief that happiness and peace, impossible in the town, could be attained through working the land. But that is the notion these pictures express, in a form that exhibits the artist's unique ability to marry visual realism with classical decorative devices, such as the frieze and the profile. The thought is picked up in a sheet in the Tate Britain archive, drawn and written in 1977 by a primary school pupil, seven-and-a-half-year-old Daniel Bennett, giving his own personal response to those same paintings: 'When I look at this picture I am sure that in my heart I am a Country Boy. I think George Stubbs was a Country Boy in his Heart.'[14]

IV

LONGEVITY

1786–1806

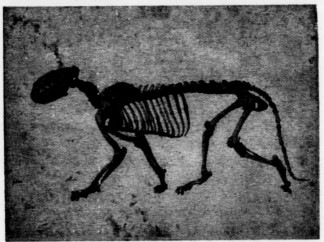

Three preparatory drawings for Stubbs's *A Comparative Anatomy*:
 i. fowl skeleton, lateral view;
 ii. human skeleton, anterior view, in crouching posture;
iii. tiger skeleton, lateral view.

CHAPTER 49

Return to the Fray

The justest and most natural representation of a combat.

John Lawrence

After his Virgilian withdrawal from London's artistic life, Stubbs returned to the Academy in 1786 with just two pictures, *Haymakers* and *Reapers*, in the versions now belonging to Tate Britain. They were exhibited under the numbers 94 and 77 (apparently therefore not as a pair) but Stubbs had not yet finished with these subjects (he went on to produce prints and enamel versions of both) or, indeed, with Virgilian themes in general. The following year he sent three new pictures to Somerset House, one of which was the kind of thing he was trying to rid himself of – a *Portrait of a Hunter*[1] – while the other two continued his association with the *Georgics*: *Horses Fighting* and *Bulls Fighting*. They were exhibited under numbers 83 and 84 – in other words, as a pendant pair.

Horses Fighting is now chiefly known through an enamel version[2] and an engraving by George Townley Stubbs. Like its pendant, it was painted on a panel using one of the special wax-based pigments and the Humphry manuscript has an interesting, slightly confusing, marginal note about it.

> The two horses fighting were from two Coach Horses of Lord Grosvenor. This picture in Enamel was painted immediately from Nature without any previous study as has usually been done for pictures in this line of the art.[3]

What can this mean? There is evidently confusion between the enamel and its source the panel painting, since it is impossible to produce an enamel in the way described. But it is difficult, also, to see how even a smallish panel painting of 2 feet by 2½ could be made during the short period of a fight between two stallions. A reasonable guess is that, rather than concocting the scene from imagination and his private stock of horse imagery, Stubbs personally witnessed the contest and laid down a sketch directly on to the panel, which he later worked up into his painting. The stallion fight might have been staged just for his

benefit, or else he was present incidentally at a spectacle that Lord Grosvenor had put on for the amusement of his gambling friends.[4]

Bulls Fighting provides a contrast in animal battles. The stallions' is a furious, stand-up fight with bites and kicks. They rear in an attempt to batter each other with their forehooves, each also using its teeth to get a hold, one attacking the crest of the opponent's neck, the other the point of the shoulder. The two Durham shorthorns, on the other hand, a white and a tan, go to it head to head, their horns lowered. Each attempts to use forward momentum and his thick horny skull to try first to stun the other and then, with a twist of the head, to gore him with the horns.

Again it is possible to make reference to Virgil. A famous passage in the *Georgics* describes a fight between bulls:

> The Beauteous heifer strays the darksome wood;
> With mutual rage they rush; thick streams the sable blood;
> From their broad brows the clashing horns rebound,
> With bellowings loud the groves and skies resound.[5]

Stubbs shows no flanks running with sable blood, no gashed necks or chests. Sideways on, as in a relief, the bulls are simply seen touching foreheads together against a background of dense and gloomy woodland. Immediately after this they will scuttle backwards, then launch their full weight forward in an almighty head-butt. But at this stage the action is ritualised, almost decorous, like boxers touching gloves at the start of the first round and quite unlike the raging we see in *Horses Fighting*. It would have been an ideal subject for one of Wedgwood's vases.

The deliberate comparison between the combat styles of the horses and the bulls was not grasped by all the Academy critics and Stubbs came in for scathing criticism over *Bulls Fighting*. It was widely considered, according to one of Stubbs's defenders John Lawrence, 'tame and spiritless, because the animals were not represented with all the fiery and active ferocity of tigers and stallions'. Lawrence himself, on the other hand, appreciated what Stubbs was driving at.

> The truth is the picture is the justest and most natural representation of a combat between those sedate and heavy animals, the bulls, which is anywhere to be found on canvas, and which the painter had often seen in nature – his critics never.[6]

The mezzotint after this sombrely magnificent painting, again by George Townley Stubbs, was published (like the pendant) on 1 May

1788 by Benjamin Beale Evans. It accurately reproduces the original but at some point the plate was reworked, as if in response to the critics. In the fifth state recorded by Lennox-Boyd, the bulls themselves remain unchanged, but the landscape is completely re-engraved.[7] Instead of the clear light and calm skies of the painting, we now see the woods tossing in a stormy wind, the boughs cracking and the fences broken.

This mezzotint carries a dedication to Robert Bakewell, the Leicestershire farmer who is therefore the probable owner of the painting. Bakewell was of the same generation as Stubbs and, though a true countryman, was a man of similar temperament. Short, stout and plainly dressed, he sits his brown cob (in a 1785 portrait by John Boultbee) as nothing more nor less than what he was, a yeoman farmer.[8] Yet he was also one of the most significant experimenters in England, who almost single-handedly kick-started the eighteenth-century agricultural revolution. Following the example of the creators of the thoroughbred horse, Bakewell used selective breeding to improve sheep, pigs and longhorn cattle. He retained the skeletons and pickled organs of his best livestock not just as exhibits, but as reference points in his breeding experiments, which enabled him to 'double the amount of meat, on less feed, in half the time'.[9] Such feats, which may to some traditionalists have seemed conjuring tricks (especially as he would never reveal his secrets) made him famous. He also bred working horses, of which his most splendid stallion, known only as K, was deemed amazing enough to be brought to London for public exhibition.

This horse is not known to have been painted by Stubbs and Bakewell does not seem to have otherwise been a Stubbs customer. In any case, by this stage of his life he was not rich. But if he did not himself buy *Bulls Fighting* after the 1787 exhibition, it may have been presented to him as some kind of honorarium payment. Bakewell was endlessly generous with time and advice to such improving landowners as Thomas Coke of Holkham Hall, Norfolk, and Lord Egremont of Petworth House in Sussex.

Three years after the two fighting pictures, Stubbs painted another bull, in a more peaceful image of a single beast known as the Royal Lincolnshire Ox. This was in early 1790 when the ox, a creature of prodigious size, had come to be exhibited in London by his owner, John Gibbon. Stubbs's painting of Gibbon and his gigantic charge, which had been won at a cockfight, was likewise put on show (but at the Royal Academy) and is one of the first in a long British tradition of

prize bull portraits, though the only one Stubbs himself is known to have done. The Lincolnshire Ox, an 'unimproved' shorthorn, was a monster who stood 6 foot 4 inches and weighed almost 3000 pounds. Gibbon had transported him from Long Sutton, Lincolnshire, in a covered wagon drawn by eight horses, to Hyde Park, where he was tethered and could be seen daily. Stubbs portrayed the ox in St James's Park close by, after Gibbon had sought advice from Sir Joseph Banks about which painter would be most suitable. Stubbs's fee for the job was £64.12s.6d.[10]

Standing between the ox and his proprietor is Gibbon's black-and-white fighting cock, which had won him the ox. They make an orgulous trio of male figures, standing in line as if deliberately inviting a comparison of species, a comparison in which Gibbon – at least in point of physical splendour – comes off rather the worst. Stubbs, it might be remembered, would shortly embark on his crowning scientific project, the comparative anatomy of the human, the tiger and the chicken. This scene in St James's Park looks like a kind of rehearsal.

The rest of the ox's life was not edifying. Determined to squeeze as much money as possible out of this phenomenon, Gibbon withdrew him to the Royal Riding House and levied an entrance fee of a shilling (sixpence for children and servants). George Townley Stubbs was engaged to produce an etching after his father's panel portrait, for which the engraver was actually paid more than his father had been – 75 guineas. Although it is not in his usual mezzotint, it is one of the printmaker's better efforts and the issue made a small profit. Subscribers were entitled to free tickets for a sight of the incredible original and at half a guinea a print, with a guinea for proofs, about 300 subscribers signed up.[11]

Gibbon planned to slaughter the ox in spring 1790, having bet £400, as the print's inscription stated, that 'he would cut 9, 10, 11, and 12 Inches thick of solid Fat upon the ribs'. But he changed his mind and, in May 1790, the animal was put under the hammer at Tattersall's. It was bought for 185 guineas by Mr Turk of Newport Street, a showman. He removed the ox to the same building that James Paine had so disastrously designed in the late 1760s for the Society of Artists, the Lyceum in the Strand, now enjoying a new lease of life as a zoo under Thomas Clark. For almost a year the ox joined 'three Stupendous ostriches . . . one of them measures upwards of eight feet high, although but a young One', and another prodigious exhibit, the third rhinoceros seen in England, which Stubbs was also to paint in

1791 for Dr John Hunter.[12] The ox was doted on by the public and 'is so remarkably docile that a great number of Ladies view him every day'. He also gained a reputation for his mental prowess. As a bill advertising him claimed,

> This Animal has apparently acquired these Superiorities by his own Sagacity, his food is Hay, which he Dips in Water that stands within his reach, before he eats it. This act of rationality in the Brute is pleasing, its Effects are obvious, and may prove Instruction to the Feeders of Cattle.[13]

Why this dipping of the hay was a rational act, and why it was thought to give the ox his huge size, is not explained.

Like so many similarly exploited animals, the Lincolnshire Ox's eventual fate was a melancholy one. The intention had been to celebrate the King's birthday on 4 June 1791 by slaughtering him for an enormous public feast. But lack of exercise caused swelling in his legs and the wasting of muscles. On 19 April he lay down and refused to get up. He was slaughtered the next day and his meat was said to be 'exceedingly fat and rich; insomuch that it did not stiffen . . . it took salt very well'.[14]

The exploitation did not end with his death. Two weeks later, the following handbill was distributed.

> BY PERMISSION. WILL be exhibited in the Cross Chamber on TUESDAY and WEDNESDAY, the third and fourth of this Instant, a conspicuous PART of the late Royal LINCOLNSHIRE OX, which was slaughtered at the Lyceum in LONDON, after being exhibited ONE YEAR and TWO MONTHS. Admittance ONE Shilling. Subscribers to the Print, Gratis.[15]

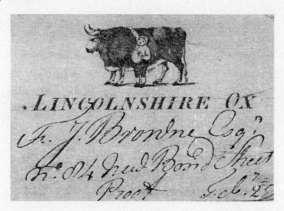

Subscription ticket for a proof-copy of the Lincolnshire Ox print.

CHAPTER 50

A Fable

Mr. Stubbs informs the public that he has nearly finished a print size 28 × 21 inches . . .

Morning Chronicle, 3 April, 1788

Between *Bulls Fighting* and *The Lincolnshire Ox*, Stubbs suddenly launched an unprecedented assault on the prints market. During his four years' self-exile he had continued to engrave and the out-turn was a dozen new plates, mostly etching and soft-ground etching with the use of a variety of other tools such as punch, roulette and rocker. He decided to issue these prints all on a single day, 1 May 1788. On this day, too, Benjamin Beale Evans issued George Townley Stubbs's fine mezzotints of *Horses Fighting* and *Bulls Fighting*. In the history of printmaking by major artists there can have been few more red-lettered days than this.

The twelve Stubbs prints were published from Somerset Street, at various prices from 1s.6d up to £1.6s. They included his own engraving of *Horse Affrighted by a Lion*, which his son had mezzotinted eighteen years earlier. There were various big cats and four small etchings of hounds, taken from the sketches he had made at Goodwood of the Charlton pack in 1760.[1] But the most ambitious of the new prints, and the most expensive, was *The Farmer's Wife and the Raven*. It was an etching measuring 21 inches × 28 inches (520 × 696 millimetres), the largest size of plate on which he had yet, or would ever, work and larger than any print made by another artist of his work.

The subject is from the *Fables* of John Gay, who was also the author of the sensational hit play *The Beggar's Opera*. Lazy and grossly fat, Gay may have (as Johnson said of him) 'lacked the dignity of genius' but the *Fables* were an enduring success. Published in 1727, ostensibly as short, light-hearted moralities for children – they were dedicated to the Duke of Cumberland, then a boy but later to become the Butcher of Culloden – they were really satirical reflections on adult themes. One of Gay's greatest bugbears was court politics and the ludicrous figure of the courtier, 'a pimp of luxury' and 'the fawning slave of man's deceit'. The *Fables'* anti-court bias, not to mention their teeming cast of

animal characters, gave them obvious appeal for Stubbs but there was one in particular that spoke to him, at this moment in his career, with special directness. It concerned a painter with a preternatural ability to capture likeness.

> He hit complexion, feature, air,
> So just, the life itself was there.
> No flatt'ry with his colours laid,
> To bloom restored the faded maid;
> He gave each muscle all its strength,
> The mouth, the chin, the nose's length.
> His honest pencil touched with truth,
> And marked the date of age and youth.
> He lost his friends, his practice failed;
> Truth should not always be revealed;
> In dusty piles his pictures lay,
> For no one sent the second pay.[2]

The Farmer's Wife and the Raven is Fable 37. It tells of a woman riding to market with a basket of eggs, dreaming of the day's expected profits when her spavined old mare trips and spills her with a thump on to the ground, in a mess of broken eggs. Spotting a raven in a nearby tree, she heaps the blame on him as a bird of ill omen, but the raven sharply corrects her. The disaster is none of his doing. Had she ridden to market more carefully, and on a less crocked-up horse, the eggs would not have been broken.

The fable appealed to Stubbs on several levels. Firstly, it shows humanity's failure to understand the natural world. The deluded woman has not seen for herself the reality of the raven, but simply accepted as fact what others have told her about it. Then it points to our inability to deal with our own stupidity and weakness. In this case it is the woman's lack of preparedness, her failure to grasp the importance of *method*, that brings about her downfall, rather than the raven's croak. Thirdly, in its general spirit, this is an Enlightenment fable. It turns away from backward-looking superstition and towards reasonable foresight, from tradition and revelation to experiment and experience.[3] Finally, and more allegorically, the fable appealed to the Leonardo in Stubbs. It teaches that the woman will fall again, and go on falling, unless she absorbs the lesson of the raven, that is, the lesson of nature.

With a young son around the house – Richard Spencer, his only child with Mary that we know of, had been born in 1781 – the inspiration for

the paintings and the print that followed may have come as he blew the dust off an old favourite book from his own childhood and began leafing through it. When Stubbs was a child of nine, the fourth edition of Gay's *Fables* had appeared, with illustrations by John Wootton, Stubbs's predecessor as England's leading horse painter. Wootton's idea for 'The Farmer's Wife and the Raven' is so close to Stubbs's that it is not a distortion to say Stubbs's picture is actually a *version* of Wootton's.

So here is the latest case of Stubbs admiring and adapting the work of another artist, in contradiction of his own dictum that he never did so. Was Stubbs guilty of doublethink? The statements of his belief in working *only* from nature in Humphry, and in the Wedgwood letters, could not be more clearly made. Yet here, even in a version of a fable which instructs us to follow nature, we yet again find Stubbs doing no such thing.

The work of any artist is inevitably interpenetrated by that of others and, if they live in a city, the man-made visual culture is more all-pervasive than nature itself. So it is not surprising that Stubbs borrowed from artists like Giambologna, Reni, Seymour or Wootton – only that a man who staked so much on his own honesty should deny ever having done so.

The Farmer's Wife and the Raven, John Wootton, woodcut illustration from John Gay's *Fables*, 1731.

Cosway and the Prince

What a fairy palace was his of specimens of art, antiquarianism
and vertù . . . Fancy bore sway in him and so vivid were his
impressions that . . . the agreeable and the true with him were one.[1]

One of the strongest threads running through Stubbs's professional life
was his avoidance of royal patronage. This prohibition had seemed to
carry the weight of a moral absolute yet, in 1790, he suddenly accepted
a court commission for no less than fourteen new paintings, not from
the King or Queen, but from their eldest son George Augustus, Prince
of Wales, later Prince Regent and eventually King George IV. He had
erupted on to the social and cultural scene after coming of age in 1783.
Surrounded by a circle of supporters, virtually all of whom were
loathed by the King his father, he had immediately set about
establishing himself as a sportsman, art collector and irredeemable
scapegrace. Among his closest cronies was the indispensable little fixer
– and Stubbs's friend – Richard Cosway.

Young George Augustus seemed deliberately to cultivate contra-
diction. He was, on the one hand, good-looking, intelligent and well
read, and could be excellent company. He had a witty tongue and his
mimicry was extremely funny; he sang in a strong, accurate tenor voice,
played the piano passably and the cello with skill; above all, he was
developing a love and knowledge of architecture and the fine and
decorative arts, far deeper than that of his parents, or indeed of any
king of England since Charles I. But his father, in trying to ensure
George Augustus would become a disciplined and dutiful son and heir,
had imposed an isolated education and an oppressive moral regimen on
him that, predictably, had the opposite of the desired effect. George III
and Queen Charlotte, despite their devotion to each other, were cold
and unresponsive parents, and had difficulties with all their seven sons.
None, however, was so flagrantly disobedient and out of control as
their eldest.

The Prince of Wales's excesses quickly became notorious. In early
adulthood he would frequently get his way by throwing tantrums, as
children do. He drank heavily and was a compulsive glutton and lecher,

as well as being addicted to shopping and spending – for which he used, of course, not his own but the taxpayer's money. His filial impiety grew so great in his twenties that he took the foolhardy step of marrying the twice-widowed Catholic gentlewoman, Mrs Maria Fitzherbert, after she refused to become his mistress. This secret ceremony offended against everything the King expected of his heir: propriety, Protestantism and (for dynastic reasons) the transparency of royal marriages.

From the age of eighteen the Prince had lobbied the King for his own independent household and income. After prolonged negotiation (and plenty of tears before bedtime) the King reluctantly gave his son Carlton House, a royal residence on Pall Mall, which had once belonged to a previously wayward Prince of Wales, the present Prince's grandfather Frederick. With the house came a grant of £50,000 a year and the revenues of the Duchy of Cornwall worth £12,000, plus another one-off payment of £50,000 to satisfy the Prince's creditors. With the debts cleared and money in his pocket, the Prince set about rebuilding and decorating his new home in luxurious style. The work, which continued with additions and redecorations over the next thirty years, made Carlton House the most opulent private residence in London, as Prince George Augustus spent recklessly beyond his means.

It boosted his immature ego to prefer the company of his elders: the Prince was six years younger than Mrs Fitzherbert and all his other early mistresses were older than himself. He likewise cultivated the friendship of senior men such as Charles James Fox, John Wilkes, Colonel Anthony St Leger and the war hero Banastre Tarleton. Richard Cosway, who became one of the Prince's neighbours when he moved to Pall Mall in 1784, was out of a very different mould from these mentors, but he was just as important.

The outlandishly costumed Cosway both amused and attracted the Prince, who adored personal adornment almost beyond anything. He and Cosway had other things in common, too. Both had married Catholic women called Maria,[2] loved fine company and conversation, and enjoyed horses and carriages. When in the mid 1780s William Blake – who as a boy had been taught by Cosway at Par's drawing school in the Strand[3] – wrote An Island in the Moon, his bizarre novella lampooning London intellectual society, he seems explicitly to notice the relationship between the Prince and Cosway, whom he calls Jacko. The reference comes in a speech by the garrulous Miss Gittipin, a stream-of-consciousness that seems to anticipate Molly Bloom by 150 years.

I might as well be in a nunnery. There they go in Postchaises and Stages to Vauxhall & Ranelagh. And I hardly know what a coach is, except when I go to Mr Jacko's. He knows what riding is, & his wife is the most agreeable woman. You hardly know she has a tongue in her head and he is the funniest fellow, & I do believe he'll go in partnership with his master, & they have Black servants lodge at their house. I never saw such a place in my life. He says he has six & twenty rooms in his house, & I believe it, & he is not such a liar as Quid thinks he is.[4]

The grand Cosway home referred to – the central section of Schomberg House on Pall Mall – had previously been occupied by the mountebank sex therapist James Graham, who had rented out his patent 'Celestial Bed' to couples desiring to conceive perfect children for £500 a night.[5] Schomberg House was not quite next door to Carlton House, but close enough for their gardens to have a party wall. The Cosways threw lavish musical parties, so popular that their guests' carriages caused the first recorded incidences of traffic gridlock in the area. Guests were entertained by the best musicians and served gourmet foods by black servants 'in crimson silk and elaborate lace and gold buttons and later on in crimson Genoa velvet, in imitation of the footmen at the Vatican'.[6] The walls were hung with Cosway's large collection of old master paintings, including many of the most bankable names: Titian, Veronese, Rembrandt, Van Dyck and above all Rubens.[7]

Such display was the very thing to enrapture the Prince of Wales and the 'master' whom (as Blake says) Cosway was going into partnership with was undoubtedly the Prince. Their joint business was the rapidly growing Carlton House collections. Cosway had been drawing or painting his patron since 1783, when he produced an allegorical image of the twenty-one-year-old as St George, being armed by Wisdom, Prudence and Valour.[8] The following year the Prince appointed Cosway his Primarius Pictor and commissioned him to paint the ceiling of the Grand Salon at Carlton House. The subject was the sun god Apollo, epitome of classicism and enlightenment, driving his chariot across the heavens, a painting in which, as the Morning Post commented, 'Apollo does not sustain the horses in reins, as has been usual'.[9] It must have been a very large painting, as Cosway was paid (or at any rate promised) the enormous sum of £9000 for it. The ceiling disappeared with the demolition of Carlton House in 1828, but it would be interesting to know if the artist had any help from Stubbs in realising the celestial horses. He might have needed it. A nineteenth-century critic's comment on this aspect of Cosway's work is caustic.

When animals are introduced the result is generally painful. The lion under Princess Charlotte's bed has the expression of an Alderman. His dogs belong to no known breed and his cows would never have been admitted to an Agricultural Show. Cosway was only at home on the shady side of Pall-Mall, a veritable 'boulevardier', and Nature, beyond that of his sitters, did not come within the compass of his studies.[10]

But apart from being the Prince's personal painter, Cosway advised him on all his art purchases, exercising a virtual surveyorship over the collection and was in an ideal position to promote the work of his friends. Stubbs had already been persuaded to make a one-off painting for the Prince in 1782. This was a portrait of John Christian Santhague, who had been Page of the Backstairs during George Augustus's boyhood, and remained for forty years one of the Prince's most trusted servants. The picture, showing Santhague out walking three of the royal dogs, was among the last of Stubbs's experiments in wax on panel.[11]

It is unclear whether Cosway could have had a role in arranging this commission but there seems little doubt that he was closely involved in the 1790 series. Now the sixty-four-year-old Stubbs's star was growing dim and he must have looked, to his friends, badly in need of commissions. Cosway was generous in his encouragement of artists he both liked and thought worthwhile (William Blake was another of his protégés), and it would be natural for him to recommend Stubbs to George Augustus, since he was obviously the perfect man to benefit from the Prince's profligate spending on horses and art.[12]

Stubbs probably met George Augustus in Somerset Street. The Prince was a regular guest at number 14, five doors from Stubbs, into which his younger brother William – the Duke of Clarence – had recently moved with his mistress.[13] It was probably here that Stubbs, Cosway and George Augustus evolved a scheme for a long series of paintings to celebrate the latter's outdoor interests, embracing his dogs, horses, carriages, soldiers, even the deer in his deer park.[14]

Only one of the projected series was to contain the patron's portrait, but it turned out to be a sparkling effort. George Augustus, his growing obesity carefully concealed, is seen riding a spirited chestnut at a fast trot beside a lake (said to be the Serpentine) while saluting the viewer with a jaunty wave of his whip. As usual he wears his Garter star pinned to an impeccably cut dark-blue riding coat, his high shirt collar is sharply starched and beneath his beaver hat is glimpsed an extravagant coiffure.

In this painting two of the Prince's terriers scamper ahead of him, for George Augustus was a dog lover who also ordered separate portraits of three other pets: a single of a poodle, or water spaniel, and a double portrait in a landscape of his favourite Spitz dog Fino with a small brown spaniel companion called Tiny.[15] But it was horses, rather than dogs, that dominated the commission. The most interesting of the races is *Baronet with Sam Chifney up*, in which the horse is shown at full stretch winning the inaugural Oatlands Stakes at Ascot in 1791, a historic race in that it was the first ever public handicap involving more than two horses.[16] Chifney had been retained by the Prince as his personal jockey for the unprecedented annuity of 200 guineas. With his long love locks (clearly visible in the portrait), his dandy's wardrobe and the public adulation that surrounded him, he is a significant figure in the history of sport – the perfect prototype of today's sports superstars.

Chifney's horsemanship was regarded as very individual. He affected, unconventionally, to ride his races with a noticeably loose rein – that is, 'off the bridle' – although he was also able to hold up or 'wait with' a horse before unleashing his trademark last-furlong 'rush' to snatch victory at the post. It seems difficult to reconcile his loose reins with these waiting tactics, but he himself commented that 'my reins appear loose, but my horse has only proper liberty'.[17]

In 1791, as Stubbs was working on the Carlton House paintings, a sensational scandal erupted around Chifney: he was accused of cheating while riding the Prince's horse Escape.[18] In those days there was no absolute ban, as there is today, on jockeys betting, and Chifney is supposed to have laid his horse (that is, backed Escape to lose) in a race run at Newmarket on 20 October 1791. It is even possible that the Prince was in on the wager, though he himself was not directly accused of race fixing. In the event Escape duly came last and, following this form, he started at odds of 5–1 against in a second race the following day, in which he opposed two of the same horses and three others. This time Chifney backed himself to win – and win he did, by an easy margin. These suspicious circumstances provoked a Jockey Club inquiry and a warning to the Prince that, if he continued to employ Chifney, 'no gentleman would start against him'. Indignantly the Prince refused to abandon his jockey and he deserted Newmarket instead, while continuing to pay his retainer to Chifney. 'Sam Chifney,' he said when the two met at Brighton in 1801, 'there's never been a proper apology made; they used me and you very ill. They are bad people – I'll not set foot on the ground more.'[19]

By this time Chifney had been effectively 'warned off' by the Jockey Club for a decade. He decided to raise money by writing a sensational book in his own vindication, an early example of the celebrity sportsman's (and royal servant's) best-selling memoir. But *Genius Genuine,* published in 1804, so far overstepped the mark in its boastfulness and indiscretion that the Prince was outraged. He broke with the jockey, who died in the Fleet prison for debtors in 1807, after selling his royal annuity and gambling away the proceeds.

Another equestrian portrait by Stubbs in the Carlton House series was of the racy Laetitia Lade in her hunting costume, controlling a rearing horse. This remarkable woman was a member of the Prince's inner circle, the same group to which Sophie Musters (to her husband's despair) also belonged. Laetitia was wife to the Prince's honorary racing manager Sir John Lade, but had originally been a servant in a brothel in St Giles and, so it was rumoured, the mistress of John Rann, or 'Sixteen-String Jack', the notorious dandy-highwayman who went to the gallows in 1774. Perhaps Rann taught Laetitia to ride, for she could do so as expertly as any jockey. She swore like one too and the Prince much enjoyed flirting with her and buying her expensive gifts. [20]

A different aspect of the Prince's outdoor life is represented in *Soldiers of the 10th Light Dragoons.* This shows a trooper and three foot soldiers from the regiment of which, to his delight, the Prince had been appointed Colonel in January 1793, the year of Stubbs's painting. George treated the regiment like a plaything, indulging himself up to the hilt with martial fantasies, egged on by the fact that there was a new war brewing on the Continent. He attended manoeuvres on the Sussex Downs and the regimental camp near Brighton where, in a tent of unparalleled luxury, he celebrated his thirty-first birthday. The expressions on the four soldiers' faces are deadpan, betraying none of their private feelings about the regiment's fatuous but temporarily besotted Colonel.[21]

Besides his dreams of being Alexander the Great, the Prince liked to see himself as a charioteer in the Hippodrome, and his celebrated de luxe 'highflyer' phaeton, an elaborate sports chariot designed for furious driving, is the centrepiece of *The Prince of Wales's Phaeton.*[22] Stubbs's judgement of social distinctions is extremely fine in this work. The State Coachman Samuel Thomas, waiting to oversee the hitching up of two magnificent carriage horses to the phaeton, combines undeniable authority in his sphere with a palpable Dickensian afflatus. The 'tiger-boy' who waits alertly for the order from the senior man to proceed

with hitching the team does not betray resentment at his servitude, but equally there is no joy in his face. The glance across towards Samuel Thomas, like the expression of the troopers in the regimental painting, is perfectly opaque, revealing character exactly by not being openly demonstrative of character.

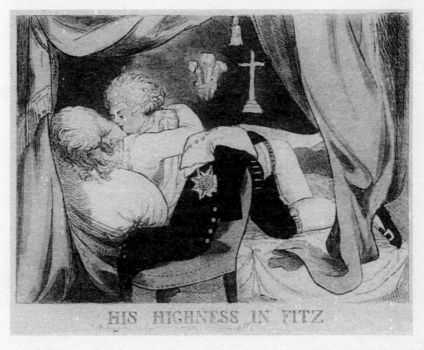

His Highness in Fitz, a caricature attributed to G. T. Stubbs, 1786. Note the crucifix, alluding to Mrs Fitzherbert's Catholicism.

263

CHAPTER 52

The Turf Gallery

In 1790, a gentleman unknown to Mr Stubbs called on him, who must be distinguished by the name of Turf, and proposed a scheme to him . . .

On 14 February 1793 Carlton House received a bill from picture framer Thomas Allwood (endorsed by Stubbs as 'a true bill') for gilded frames at £13.17s.0d each. These frames, all on the same pattern, still surround the paintings for which they were made.[1] The uniformity of framing and size (the paintings all measure 4 feet by 5) shows conclusively that the commission had been intended from the start as a thematic gallery of the Prince's sporting interests, the first time he had reverted to this format for twenty years.

But now, as this series was being created, an even larger gallery of paintings was being mooted, this time as part of a public, not a private, concern. The proposal, from the mysterious visitor to Somerset Street, this 'Mr Turf', was that Stubbs would paint

> a series of pictures (portraits) from the Godolphin Arabian to the most distinguished Race Horses of the present time, a general chronological History of the Turf, specifying the races & matches with particular anecdotes and properties of each horse, with a view to their being first exhibited & then engraven, & published in numbers.[2]

The publication was not just of the prints, for the 'numbers' were to be the individual issues of *A Review of the Turf*, which formed what would now be called a part-work, intended when complete to be bound as a book. It was planned to include the engraved portraits of no less than 145 famous racers with a descriptive and historical text. This was a hugely ambitious and risky scheme for a man approaching seventy, but Stubbs was assured that 'a sum of 9000 pounds was deposited in the hands of a Banker' and that he could draw on this as he completed each picture.[3]

Stubbs appointed George Townley Stubbs, after their recent reconciliation, as engraver and partner, then advertised for subscribers and began work on the paintings. In most cases these were repeats of work

264

done earlier in his career and it might be asked why he bothered to produce copies in oils, when engraved plates could have been prepared from the existing pictures. But it is precisely the making of new paintings, and Stubbs's proposal to exhibit them to the paying public in a special Turf Gallery, that marks this scheme as being particularly of its time.

In 1788, the Prince of Wales had been guest of honour at the Royal Academy's annual dinner. Having received a barrage of loyal toasts, he was passed a note from another guest, Edmund Burke, which read,

> This end of the table, at which, as there are many admirers of the art, there are many friends of yours, wish to drink an English tradesman who patronizes the art better than the Grand Monarque of France.

The Prince obligingly rose and proposed a toast to Alderman John Boydell, the print seller, 'for the honour of the arts and in recompense for Mr Boydell's enterprizing zeal in their support'.[4] The enterprise so extolled was Boydell's Shakespeare Gallery, two years in the planning and shortly to open in Pall Mall. Boydell had hired most of London's top history painters to depict Shakespearean scenes, sixty-four of which were shown in the Gallery's first two years. It was ostensibly a patriotic showpiece for British culture, but it was also a marketing device of considerable power, as well as an extension of what the print shops had been doing for some time.

Those who could afford prints bought them, but the print was much more than a collector's fetish or an item of interior decoration. A tour of London's print shop windows – showing the latest fine art prints, or the most topical caricatures by Rowlandson or Gillray – remained one of the capital's most essential free entertainments. The inaugural display of new issues by a particularly admired artist attracted crowds, and were avidly discussed in the coffee houses and gaming clubs, at assemblies and tea parties, on stage coaches and as the port went round after dinner. The Shakespeare Gallery cashed in on this interest, but extended it to include the display of the original oil paintings after which the prints were made, and sold, in different sizes and at various prices. Boydell's Gallery was a great fashionable success to which the public flocked in considerable numbers and competitors soon began to appear – Macklin's Poet's Gallery in Fleet Street (to which both Richard and Maria Cosway were contributing artists) and, later, Henry Fuseli's Milton Gallery in Pall Mall. The

Stubbs Turf Gallery was undoubtedly meant to be one of these rival attractions.

The Gallery's companion publication *A Review of the Turf* had become, as is clear from Stubbs's appeal for subscribers, an encyclopaedic scheme.

> This singular publication will be embellished with beautiful engravings, and present a complete and accurate Review of the Turf, from the year 1750, to the present time.

Stubbs also took trouble to stress the uniqueness of his proposal.

> At a period when protection is daily solicited for embellished editions of various authors, it may be deemed extraordinary to submit one of a different cast to the public consideration; where the chief merit consists in the actions, and not in the language, of the HEROES and HEROINES, and with whom, possibly, LITERATURE may exclaim 'She neither desires connection or allows utility'.
>
> As such an history of an animal, peculiar to this country, the horse surely may put in its claim to general notice; and although the numerous volumes of CHENEY and HEBER, downwards, may give critical knowledge to the diligent and deep explorer, they certainly do not impart sufficient information to the superficial observer; yet both may regret, that there is not a regular series of PAINTINGS and ENGRAVINGS of those horses, with their HISTORIES which have been or are now famous.[5]

This is one of very few pieces of discursive writing that can confidently be ascribed to Stubbs and it is interesting to find him pointing up two contrasts that were evidently of great importance to him: firstly between literary heroes and the heroes of action; and secondly, among the latter, between human heroes, who generally receive their due in history, and animal heroes, who don't. The idea of the heroic or noble horse had been important in much of Stubbs's previous work,[6] but it is striking to read him insisting that his racehorse paintings are also *history* paintings. To suggest there was no qualitative difference between pictures of the Prince of Wales's Baronet winning the Oatland Stakes and, say, General Wolfe taking Quebec was a provocative one in the art politics of the time.

The Turf Gallery opened on 20 January 1794 in Conduit Street, Hanover Square, with seventeen paintings by Stubbs on display, fourteen of which were versions of previous work and three were new.[7] This was a time of unaccustomed business for G. T. Stubbs, too. He issued nineteen stipple-with-etching prints after his father's paintings,

of ten different horses, nine of them engraved in both the larger and the reduced size, with *The Godolphin Arabian* in the smaller format only as a 'free offer' to subscribers. The give-away print was intended to form the frontispiece to the bound volume of text, whose initial two parts were issued in the first year. In full, this publication was entitled *A Review of the Turf from the Year 1750 to the Completion of the Work; Comprising the History of every Horse of Note with Pedigrees and Performances. Embellished with Prints, from Pictures Painted, and Plates Engraved, by Messrs G. & G. T. Stubbs.*[8] The two issues contain alphabetical histories of no less than sixty-four horses, with names from Aaron to Astraea, showing the enormous scale of the work envisaged.[9] But in the end Stubbs's text was destined never to get beyond the letter A. As his obituarist T.N. put it in 1809,

> Mr Stubbs went to work with so much spirit, that many racers, the progeny of the [Godolphin] Arabian, beautifully glowed on the canvas, in a space of time incredible to those unacquainted with his industry. But the tree was without a root, and the want of that nourishment necessary to keep it alive withered all the branches, and that which at first seemed to flourish so fair, fell to nought.[10]

Presumably initial subscriptions were disappointing and the £9000 guarantee promised by 'Mr Turf' had either not materialised, or been withdrawn. As T.N. put it,

> the principal in the firm, from a cause I am not permitted to mention, deserted the concern, and so of course stagnated an adventure, that, had it been pursued to its intended completion, must have been an honour, as well as an ornament, to the British nation.[11]

At any rate, there was no money to issue further textual pages of *A Review of the Turf* and that side of the project withered immediately. The gallery evidently struggled on a little longer, for in 1796 George Townley Stubbs brought out four additional engravings of the exhibited paintings and the exhibition itself seems to have remained at the Conduit Street premises until 1797, where also, presumably, the prints were on sale. None of the paintings Stubbs made for the gallery was sold until after his death nine years later.

The questions remain: who was 'Mr Turf', and why did the scheme fail? The answers to these questions are, in my view, the same. Both Humphry, in his manuscript memoir of 1797, and T.N., Stubbs's obituarist in 1808–9, contribute to the aura of mystery surrounding the

Turf Gallery's backer. Their heavy-handed reticence is in itself a clunking hint that 'Mr Turf' was, in fact, the Prince of Wales, but there are further pointers to the same conclusion. Of those who owned the initial seventeen horses represented in the gallery, the Prince was the only one still active on the turf in 1790. More important, the whole project was explicitly dedicated to him 'by his oblig'd and devoted servants G. & G. T. Stubbs' and such dedications are a good, if not infallible, pointer to a particular patron. G. T. Stubbs underlined the association by now styling himself, on each of the fourteen Turf Gallery prints, 'Principal Engraver to His Royal Highness the Prince of Wales'. He had not previously done this.[12]

It has been argued that the Prince would not have had enough funds to be 'Mr Turf', and could not, in any case, have involved himself with propriety in a business enterprise.[13] But these two points are, to an extent, self-cancelling, for his gross financial problems might very well have induced George Augustus to seize what he saw as a chance to make real money. Of course, for a Prince of Wales to engage in trade was not at all *bon ton* but, as is obvious from the case of Mrs Fitzherbert, the rules governing royal conduct meant nothing if they got between George Augustus and what he wanted. And, as was also the case over his secret marriage, his transgressions would never be openly admitted, even if everyone did know about them.

Certainly, he was in chronic and increasing debt at this time and would have found it virtually impossible to put down a sum of £9000 in cold cash. But the Prince was a habitual financial fantasist and there is no suggestion in Humphry that the money was actually deposited in the bank, only that (with a telling choice of word) it was 'intimated'. In accounting for the failure of the *Review* and the gallery's collapse, Humphry tosses in the fact that the outbreak of war with France had severely damaged the export trade for prints. The war may have contributed to a fall in print sales generally, but it is hard to believe such a very English set would have been expected to sell widely in Europe. In any case, if this was the reason for the collapse of Stubbs's scheme, why was T.N. forbidden to say so? Moreover, with £9000 behind it, the *Review* and gallery ought to have been insured against such vicissitudes. The obvious conclusion is that, when early subscriptions failed to buoy up the scheme, and there was a call on George Augustus's cash, it was found never to have existed.

Most of this has been put forward persuasively by others.[14] I would add some additional points, the first about the Prince of Wales as a

tradesman. Looking back to the Royal Academy dinner in 1788, when George Augustus publicly praised Alderman Boydell, it seems quite possible that this planted the seed. A public exhibition to the glory of the British thoroughbred would be a fine complement to the private gallery of outdoor pursuits, painted by Stubbs, that was coming together at Clarence House. But, much more important, it would give George Augustus precisely what he most needed: money in his pocket and from an independent source.

Watching the Shakespeare Gallery establish itself in Pall Mall to vast acclaim, the Prince would have had reason to believe that the Turf Gallery and *Review* could turn a useful profit. The rate of subscription for the complete letterpress, with both sets of prints, was fixed at 90 guineas which, taken together with the £9000 of predicated backing, means the initial target was a hundred subscribers. With all Jockey Club members signing up, along with their associated cronies in the racing world, this must in 1790 have seemed an easy target to achieve. Then, a year later, came the Escape affair – an irrelevance if Mr Turf was anyone other than George Augustus, but virtually fatal to the enterprise if it was generally known, or whispered, that he was indeed the *Turf Review*'s backer.

So, just as George Augustus had married Mrs Fitzherbert because it suited him, and denied her for the same reason, the Prince had tried to play tradesman in secret partnership with Stubbs, defaulted when (largely through his own fault) the going became commercially rough, then made sure the whole affair was hushed up by invoking his royal immunity.

There may have been another reason, however, for George Augustus to pull out of the deal. What if George Townley Stubbs's labours on behalf of Samuel William Fores in 1786 had reached the Prince's burning ear? *His Highness in Fitz* is no refined satire that one could answer with a witty or throwaway *bon mot* of one's own and so be called a good sport. It is a bare faced pornographic libel calculated to ridicule George Augustus's infatuation for Maria Fitzherbert, maximise the couple's embarrassment, enrage the King and discredit the court in general. If he had always known about G. T. Stubbs's involvement, the Prince would surely not have pursued the Turf Gallery idea, or else beaten a path to the door of some other artist. If he got wind of the matter after the scheme had begun, however, this would surely have been enough, with or without other constraints, to end at a stroke his goodwill towards the Stubbs family.

Whether it was financial or social embarrassment, or a mixture of the

two, that caused 'Mr Turf' to abandon the Turf Gallery and *Turf Review*, the association between Cosway, Stubbs and the Prince did not survive the débâcle. George Augustus, at various later dates, purchased three more Stubbs paintings, but he did so on the open market[15] and there were no further direct commissions after 1794. The Prince, never in any case a constant friend, took up with the younger animal painters Sawrey Gilpin and James Ward. Meanwhile, Cosway's influence at Carlton House had begun to diminish and would soon disappear altogether.

The Prince of Wales's Baronet with Sam Chifney up, a mezzotint by George Townley Stubbs after his father's painting for the Carlton House series, 1794. This was one of the prints offered for sale at the Turf Gallery, Conduit Street.

CHAPTER 53

Comparative Anatomy

A work truly philosophical.

The late 1780s and early 1790s had left an unpleasant taste. Having come back into the public eye after his troubled retrenchment, Stubbs had been belittled by the critics. Having swallowed his anti-Hanoverian feelings in pursuit of a crowd-pleasing project, he found its spoilt and bloated sponsor welshing on the deal. But Stubbs does not seem to have indulged in regrets or backward looks. His life continued its ongoing movement forward into new projects, new experiences and new ideas. And so, as Conduit Street struggled on for a year or two longer, under the ineffectual hand of his son, Stubbs had already embarked on a fresh voyage of discovery, the *Comparative Anatomy*.

One of the precursors of this extraordinary scheme is his interest in physiognomy. By purporting to correlate one's outward appearance with moral truth, this proclaimed itself an 'art to read the mind's construction in the face', an easily opened window to the soul. It was not a new idea. Leonardo had taken an interest in physiognomy, and it had resurfaced in various forms through the writings of the English philosopher of science Francis Bacon, and the French materialist René Descartes.[1] In between it became, and was to remain for an astonishingly long time, a popular social science, both in the sense of being an early attempt at behavioural psychology and as an amusing game that could be played over tea.

Physiognomy was ramshackle science, but its popularity in the eighteenth century is not surprising. City life had become an endless succession of encounters with perfect strangers, as country boy William Wordsworth found to his considerable terror when he hit London in 1791: 'the face of every one / That passes by me is a mystery!'[2] In these circumstances, the ability to assess character instantly by 'reading' the saliences of a face was felt to give social and economic advantages, as well as to promote one's personal security.[3]

Physiognomy strongly marked literature, in and after the Regency period, largely through the influence of the best-selling Swiss author J. K. Lavater. His *Essays in Physiognomy* were put into English by the

former Newmarket stable lad Thomas Holcroft in 1789, the first of at least four early translations. The famous description of Samuel Taylor Coleridge, by Holcroft's friend and biographer William Hazlitt, is thoroughly Lavaterist.

> His mouth was gross, voluptuous, open, eloquent; his chin good-humoured and round; but his nose, the rudder of the face, the index of the will, was small, feeble, nothing – like what he has done.[4]

Artists were even more liable than writers to look for physiognomical short cuts to insight. Leonardo's dictum that 'the good painter has two things to paint, that is, man and the intention of his mind' was well known[5] and Lavater had echoed da Vinci by claiming that 'the painter . . . if he be not a physiognomist is nothing'.[6] He even professed to be of use to animal painters by showing how (for example) horses revealed their true characters in their heads.[7]

But for artists the classic work on the interpretation of human facial expression was that of Charles Le Brun, who had been one of Louis XIV's favourite painters. Stubbs owned (unless he borrowed it) a copy of Le Brun's visual index of the emotions – *Conférence . . . sur l'expression générale et particulière* (1698) – in which Terror, Anger, Grief, Laughter et cetera were displayed through facial typologies. He seems to have used Le Brun's paradigm of terror in his design for the horse's head, neck and mane in his *Lion and Horse* paintings.[8] But he wanted to take the physiognomical enquiry deeper than this, using Le Brun as the basis for a set of experimental heads – there were at least four – modelled in wax. The original waxes are long gone but it is clear from G. T. Stubbs's engravings of them that they showed not the surface of the face and neck, but the head flayed to reveal the maxillo-facial muscles, and those of the neck and shoulders, under the influence of different emotional states.[9]

Physiognomy would later interest Charles Darwin and in the age of his grandfather, the proto-evolutionist Dr Erasmus Darwin, it dovetailed neatly with new theories on species development put forward by Jean Baptiste Lamarck, whose doctrine of 'the inheritance of acquired characteristics' became well known. Lamarckism and Lavaterism both proclaim the power of inner forces in the body to create outward changes, but stress equally that these are the result of interactions with the outer world. The fleshy lips of the sensualist and the hawk-nose of the natural leader, like the long neck of the giraffe and the hedgehog's

spines, manifest an individual's inner desires and responses towards the environment. At this point species change (or evolution) comes into the picture.

As has already been noted evolution, a dynamic view of nature, was in direct conflict with the static Great Chain of Being. This question divided many eighteenth-century luminaries such as the Swede Carl Linnaeus (who held that species could not change) and the French Comte de Buffon (who held that they could, and did). Erasmus Darwin, a physician and close friend of Josiah Wedgwood, was deeply interested in these matters. Stubbs had met him at Etruria in 1780 and they kept in touch until at least 1783, when Stubbs painted Darwin's portrait, a delightful enamel in which the doctor is shown consulting a book, possibly his own first publication, *A System of Vegetables*, which came out in that year. Stubbs surely kept an eye on Darwin's subsequent publications, particularly as they so closely paralleled his own interests.

Despite the fact that *A System of Vegetables* was a translation from Linnaeus's Latin, Erasmus Darwin disagreed with the Swede on the immutability of species and in 1794 he published Buffon-esque views which his grandson Charles would one day build upon so momentously. In one passage Darwin wrote,

> From thus meditating on the great similarity of the structure of the warm-blooded animals, and at the same time of the great changes they undergo both before and after their nativity; and by considering in how minute a portion of time many of the changes of animals above described have been produced; would it be too bold to imagine, that in the great length of time, since the earth began to exist, perhaps millions of ages before the commencement of the history of mankind, would it be too bold to imagine, that all warm-blooded animals have arisen from one living filament, which THE GREAT FIRST CAUSE endued with animality, with the power of acquiring new parts attended with new propensities, directed by irritations, sensations, volitions, and associations; and thus possessing the faculty of continuing to improve by its own inherent activity, and of delivering down those improvements by generation to its posterity, world without end?[10]

Within a year of the publication of these words, Stubbs was to begin the *Comparative Anatomy*, his own meditation on 'the analogy between the Human frame the Quadruped and the fowl . . . [which he intended to carry on into the vegetable world] a work truly philosophical'.[11]

*

On 8 July 1796 Joseph Farington's *Diary* reports in amazement:

> Humphry called on me . . . He had been with Stubbs who is preparing a
> work of comparative anatomy. At 72 Stubbs is forming plans with as
> much resolution as might be expected at 40.[12]

The full title of the planned work was *A Comparative Anatomical
Exposition of the Structure of the Human Body, with that of a Tiger
and a Common Fowl*. In this endeavour Stubbs again had the example
of Leonardo before him. He wrote in his subscription proposal that 'the
knowledge of Anatomy is as necessary [to painters] as to the Physician
or the Surgeon. Leonardo da Vinci and Michael Angelo de Bonaroti
were excellent Anatomists.'[13] But he also had in mind the work of an
important scientific mentor. This was John Hunter, younger brother of
William, one of the most energetic natural scientists in London who
had died in 1793.

John Hunter was born in 1728 in East Kilbride. He had come to
London and learned to dissect under his brother William, whose
anatomical demonstrations he took over in 1774. John Hunter went on
to make a deeper impression on medical history than William, working
on the lymphatic vessels, bone growth, sense of smell, treatment of
wounds, venereal disease and teeth. But, alongside his human physio-
logical research he continually dissected and preserved animal species,
not out of idle curiosity (there was nothing idle about John Hunter) but
because he wanted to make *comparisons*. It has been written of Hunter
that

> his older contemporary Linnaeus and his young contemporary Cuvier
> were both occupied in classifying organisms. To do this they always
> sought differences. It was similarities, however, that attracted Hunter. He
> experimented on and anatomized over 500 species. He set out to trace
> systematically, through all these, the different phases of life, as exhibited
> by their organs, their structure and their activities.[14]

Hunter's ultimate objective in all this work was to set out a new scale
of being, based on congruences rather than fixed difference. He opened
his collection to selected visitors in May 1788, when the *London
Chronicle* noted:

> What principally attracted the notice of the *Cognoscenti* was Mr Hunter's
> novel and curious system of natural philosophy running progressively
> from the lowest scale of vegetable up to animal nature . . . Mr Hunter
> attended himself, and gave a kind of peripatetic lecture on the several

articles, which took up between two and three hours.[15]

Hunter's was not a museum of curiosities like Ashton Lever's grab-bag Holophusikon. It was a huge and laborious teaching aid, which afforded him

> the satisfaction of shewing to the public a series of anatomical facts formed into a system by which the oeconomy of animal life was illustrated. He shewed it to his friends and acquaintances twice a year, in October to medical gentlemen, and in May to noblemen and gentlemen, who were only in town during the spring. This custom he continued to his death.[16]

Stubbs's *Comparative Anatomy* may have been originally conceived on a similarly ambitious scale and was possibly worked out in consultation with Hunter, before the latter's sudden death on 16 October 1793.

Stubbs tackled the new project with all of his famous single-mindedness.

> His Assiduity and perseverance are almost unexampled in the annals of mankind, often employing himself from the dawn of day in summer till midnight, so great was the Ardour with which he engaged in the grand undertaking.[17]

One hundred and twenty-five anatomical drawings associated with the project have survived. Among them there are some additional animals – an owl, a leopard and a different breed of chicken.[18] It is true that Stubbs's *Sporting Magazine* obituarist speaks of him 'promising a complete classification of the animal world'[19] and also that Mary Spencer, annotating Humphry's biographical narrative, had even written of his intention to extend the inquiry to vegetables. But these Hunterian ambitions can have been present only in the preliminary discussions, or in pipe dreams. Stubbs, in his seventies, had to be realistic and anyway, as we have seen with *The Lincolnshire Ox*, the idea of a triple comparison had in itself a strong aesthetic appeal for him.

He therefore determined on a series of thirty engraved tables which in some ways would echo what he had done in *The Anatomy of the Horse*. He completed fifteen of them, delicate stipple engravings which he published with their associated text in three parts, two numbers in 1804 and the third in 1806. In these the skeletons occupy the first tables; intermediate stages show subcutaneous structures, including a simple flayed view; in the case of the human, there are nude studies and,

in that of the chicken, a study of the creature fully plucked. There is no equivalent to this in the tiger. Where one might expect a shaved tiger to be the 'outermost' level treated, this is in fact a flayed view of the creature pacing forward, showing connective tissue and the superficial vascular system. There is no explanation for this anomaly.

Stubbs's completed engravings are a technical triumph. The stipple gives a sharp enough imprint but the effect is caressingly soft compared with *The Anatomy of the Horse*. These plates study the human subject from the front, back and side, in each case as nude, flayed and skeletal. In the frontal and dorsal views the subject is standing upright, but the side view has him walking vigorously forward, giving these images a striking originality. The animals in lateral profile are also moving forward, but there is no equivalent to the standing frontal and dorsal views in the case of the tiger and the chicken and, again, there is no explanation for this.

The fifteen published tables were issued complete with numbered outline diagrams keyed to Stubbs's simultaneously issued text, just as in *The Anatomy of the Horse*.[20] At his death Stubbs left four volumes of manuscript text in what looks like fair copy, two in English and the others in French. It is not clear if these represent the complete text of the work as planned but they are surely the bulk of it. The *Comparative Anatomy* drawings show how Stubbs took his dissections further, in some cases revealing the viscera and inner organs, a departure from his restriction in the case of the horse to levels showing bone, muscle, nerve and vascular systems only.

Of the fifteen remaining plates originally envisaged, none was engraved, but at least seven finished drawings exist among the astonishing surviving bundle – the most complete record we have of Stubbs's preparatory work in any major project.[21] They show that Stubbs intended to present the human subject in at least one additional position. In two brilliant finished drawings he is seen in a crouching attitude, like a runner poised for the starter's gun. Stubbs intended to use this pose to press home the analogy with the quadruped, but he does not seem to have got around to making flayed or dissected versions of it. Or perhaps he did, and the drawings were lost, for a late additional note in Humphry states,

> He had when he died published the first three numbers of his Comparative Anatomy. All the Drawings were finished, and the explanation wrote to the remaining three Numbers, which only wanted the Engraver and printer, to finish the work, which will be done.[22]

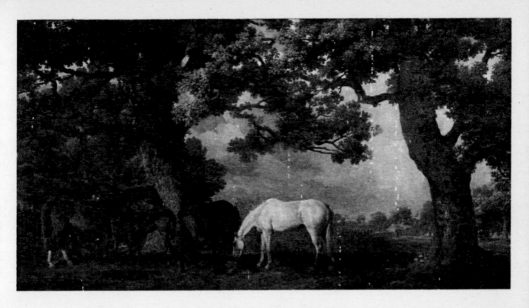

21. Mares and foals beneath oak trees, painted in 1773 for Lord Grosvenor.
Note the thatched covering shed.

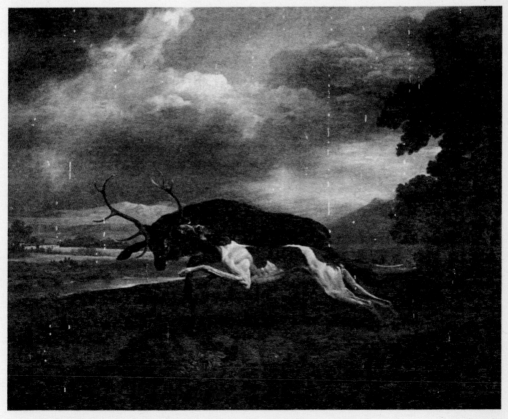

22. A hound coursing a stag, painted c. 1762–63.
The greyhound closely resembles dogs in hunting pieces by Rubens and his followers. Compare also
the attitude of the stag with the one in *The Grosvenor Hunt*, colour plate 7.

23. *Shooting*, a series of four sequential scenes from dawn to evening, painted by Stubbs, engraved by William Woollett, with anonymous verses. The shooters may be William Wildman and Thomas Bradford.

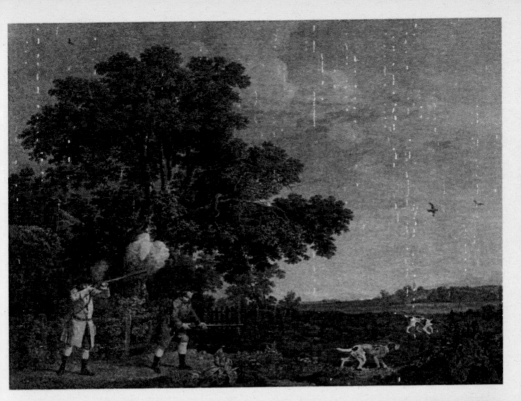

24. Lord Torrington's estate workers, arguing over the fitting of a cart's tailgate. This enamel, dated 1781, records the appearance of Stubbs's original oil painting of 1767, later 'improved' by Amos Green, who replaced the neoclassical farmhouse with picturesque thatched cottages.

25. Eclipse by the rubbing down house, Newmarket, in a mezzotint of 1772 by Thomas Burke, after Stubbs's oil painting. The jockey wears Wildman's colours of red jacket, black cap.

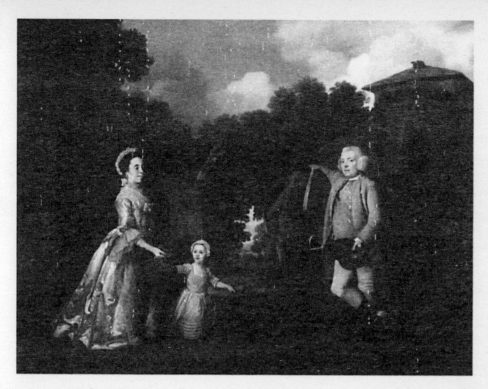

26. The Saltonstall family of London and Pontefract, 1769, one of Stubbs's
earliest conversation pieces.

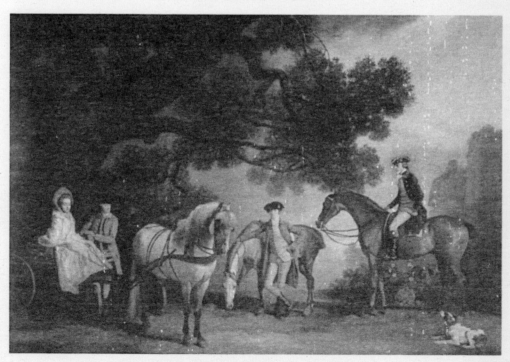

27. The Milbanke and Melbourne families, 1770.
When this was exhibited the trees were criticised for being 'hard'.

28. Stages in the restoration of *John and Sophie Musters Riding at Colwick Hall* (1777), after Mrs Musters had been painted out as an act of revenge by her husband. (See book jacket.)

29. *Mother and Child*, 1772. This may be Stubbs's mysterious first wife, 'Mary Townley', with one of their sons. The composition derives from Guido Reni.

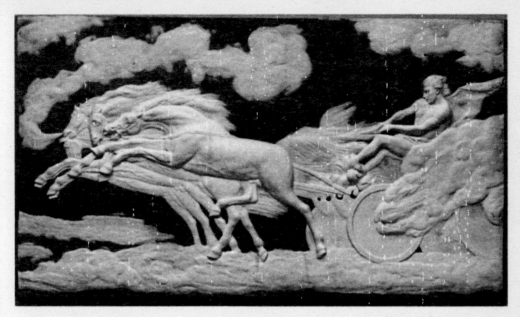

30. *The Fall of Phaeton*, a plaque commercially produced by the Wedgwood factory, after a relief modelled by Stubbs while he was Wedgwood's guest in 1780.

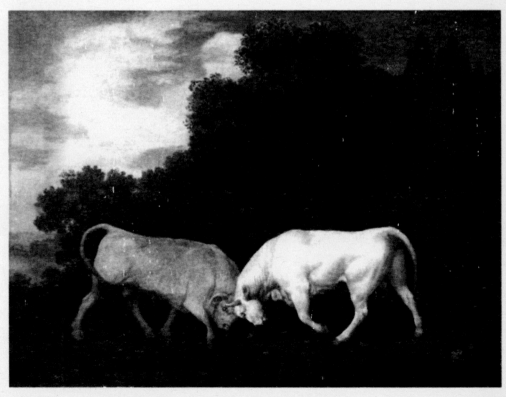

31. *Bulls Fighting*, 1786, one of Stubbs's most Virgilian paintings.

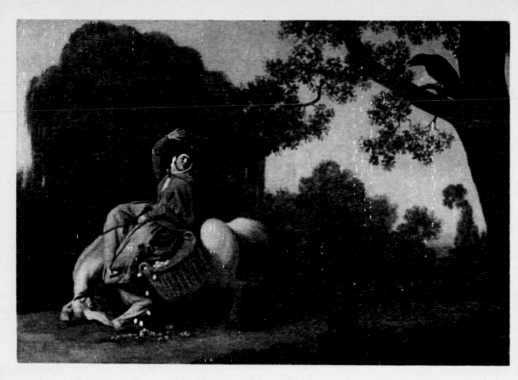

32. *The Farmer's Wife and the Raven*, 1786, illustrating a fable by John Gay.
Compare Wootton's version of the same subject, p. 256, which Stubbs may have known as a child.

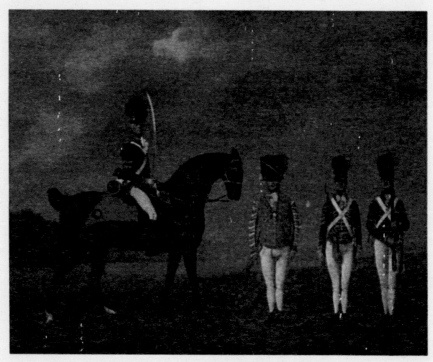

33. *Soldiers of the 10th Dragoons*, 1794, the regiment whose proud colonel
was George Augustus, Prince of Wales.

That pious hope was not realised, and the reason is probably the resounding silence with which the three published parts of the *Comparative Anatomy* were apparently received. Perhaps the work would have had more impact if Stubbs had been able to publish it all at once, as he had with the horse. In the event his heirs saw little prospect of making a success of it and the scheme was quietly shelved.[23]

He must have been very disappointed at the muted public response to his three published parts. But did he understand why? The market for such works was fairly restricted, while the vision which Stubbs put forward was a disturbing, and even rather a subversive, one.

The Great Chain of Being owed its original and, to some extent, continued influence to the fact that it was orderly and secure and, most important, that it legitimised man's place on the top rung in the ladder of corporeal creation. There were not yet many brave enough to question that supremacy and it is fair to say that Stubbs did not himself do so in any explicit way, there being nothing, for instance, to that effect in his explanatory text. If anything, in its unfinished state the published *Comparative Anatomy* privileges the man by devoting nine of the plates to him, and only three apiece to the tiger and the chicken. But even so it manages to be at the same time ambivalent and a little subversive about human hubris.

The *Comparative Anatomy* seems ambivalent because, with its text doing nothing but naming parts, it has no overt argument. By demonstrating the structural similarities between species, it may follow that Stubbs endorsed the kind of radical conclusions drawn, for example, by Erasmus Darwin from the same premise, or it may not. A non-verbal argument presented in this way is bound to be inconclusive and, indeed, logically circular: the species are the way they are because of the way they are. Stubbs seems quite content to allow his designs to beg the question in this way.

The work has another, more subversive, level, however, and it is reached by way of Stubbs's manipulation of scale. At a casual glance, any comparability of human and chicken seems negligible if the two species are shown to scale, as happens, for example, with the cock and the man in *The Lincolnshire Ox*. But to emphasise structural similarities, the *Comparative Anatomy* entirely abolishes the size differential, showing a chicken that is as big as a man, or – if the chicken's perspective is taken – a man no bigger than a chicken. Imaginatively, then, these drawings can be said to do in their own way what Swift had done with his Houyhnhnms and Yahoos: they make it

possible for species to interchange. Scientifically, they may even be said to foreshadow how the wall between man and animal would one day be breached by Charles Darwin's work on evolution, which so shocked the Victorian man in the street. [24]

What did Stubbs really think? Did he regard the species as fixed in a harmonious 'Great Chain'? It has been maintained that he did, on the grounds that his work seems always to be trying to exemplify the 'harmony and divine goodness of nature'. Alternatively, did he see the species as shifting from kinship to competition, from harmony to conflict in a desperate struggle for survival, perhaps expressing the conflict in his 'lion and horse' paintings?[25] He does not tell us. If we say Stubbs is not asserting but subverting arguments about man's place in the order of nature, we might see him as standing at an ironical distance from the debate. That may look too postmodern a reading of Stubbs's mind, yet it is true that there had been other examples in which a sly, deadpan humour seemed to underlie the surface of his painting: *Soldiers of the 10th Light Dragoons*, *The Lincolnshire Ox*, *The Zebra*, and even such an apparently simple work as *A Portrait of James Stanley*, as long ago as 1755. So perhaps this is intrinsic to all of Stubbs, the result of what happens when the artist's clear-eyed presentation of nature itself becomes the subject of the painting, apart from all consideration of its ostensible purpose.

Terror, or Fright, from 'Views of the Passions'. G.T. Stubbs's stipple engravings after his father's wax models of ecorché (flayed) heads are a curious combination of physiognomy and anatomy.

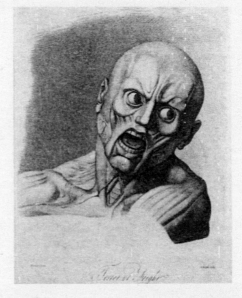

CHAPTER 54

Hambletonian

The greatest concourse of people that ever was seen at Newmarket.

At Easter 1799 there was much talk of war. Napoleon Bonaparte was fighting the Turks in Syria, while, in his absence, the Austrians were, for the moment, beating the French in Italy. Meanwhile two British armies were converging on Seringapatam to settle final accounts with the Tipu Sultan of Mysore and, in England, income tax had been introduced for the first time (at a rate of 10 per cent) to pay for the cost of it. But at Newmarket on 25 March, the Easter Monday, all this was put to one side. It was the opening of the century's last flat-racing season, and on this day one of the most exciting horse races in history was to be staged: the match between Sir Harry Vane-Tempest's Hambletonian and Mr Joseph Cookson's Diamond. The event generated one of Stubbs's greatest paintings.

Although they were run at public meetings scheduled in the Racing Calendar, match races were private wagers between gentlemen horse owners. They were conducted under rules agreed between the parties, with the weights allocated by a mutually acceptable third party. The ritual associated with making such a match was very much part of the fun.

> A handicap Match is A, B and C to put an equal sum in a hat; C, who is the handicapper, makes a match for A and B, who, when they have perused it, put their hands into their pockets, and draw them out closed; then they open them together, and if both have money in their hands, the match is confirmed; if neither have money, it is no match. In both cases the handicapper draws all the money out of the hat; but if one has money in his hand, and the other none, then it is no match; and he that has money in his hand is entitled to the deposit in the hat.[1]

The thrill of match racing was often enhanced by its personal nature, in which known rivalries, even vendettas, were settled over four miles of Newmarket turf. But from time to time these matches acquired wider significance, as sporting events are liable to do, giving focus or expression to passions and prejudices which ranged far beyond racing and into regional rivalry, economic discontents and atavistic tribal

279

memories. The Hambletonian–Diamond match was one of those races.

The owner of Hambletonian was a young Northumberland land magnate, aged twenty-eight, a pugnacious baronet with vast estates and a large racing string, who was also reckoned one of the handsomest men in England – and one of the hardiest drinkers. His horse, a grandson of Eclipse foaled in 1792, was a prolific winner, but could be a difficult ride. He had never been beaten in a finish but once, at York, had thrown away his race by running out of the course. As a three-year-old he took the St Leger at Doncaster and, in a rare sortie to the south, won the Newmarket Spring Cup. For the next three years, however, most of his racing was in the north.

Diamond, his adversary, was the same age, and the best racer in Newmarket. A 'beautiful brown bay colt, strong, bony and compact, he was considered to be the best bottomed horse [i.e. the best stayer] in the kingdom'.[2] Diamond had won five major races in 1797 as a five-year-old, and six more in the following year, including a match for which he was taken north to Doncaster to take on, and beat, Vane-Tempest's Shuttle for a purse of 1000 guineas. Vane-Tempest swore to avenge the defeat in the next season and earmarked his unbeaten star for the job. The risks were considerable. This time, by convention, Cookson would have home advantage, so Hambletonian must be walked to Newmarket from Yorkshire. There were also serious doubts about his fitness. The horse had missed the whole of the 1798 season with a leg injury and there was no guarantee he would find his old form again. Nevertheless Vane-Tempest issued the challenge of a match over the 4 miles, 1 furlong, and 138 yards of the Beacon Course. At 3000 guineas, the stakes were to be three times the amount that had been lost at Doncaster by Shuttle. Cookson accepted.

The handicap was agreed (Hambletonian 8 stone 3 pounds, Diamond 8 stone) and the date was set for Lady Day 1799. Word spread quickly and Windsor-chair jockeys and penny punters in pubs and coffee houses around the country noisily debated the two horses' merits. Gradually this became more than a horse race. It was a national event, a contest between two halves of the kingdom, the North versus the South. The excitement was intense and it kept growing.

Hambletonian's team was a highly professional one. Tom Fields, his trainer, had been born at Pocklington, Yorkshire, in 1751. He was reckoned the best north-country jockey in the 1780s, riding for connections of the north's leading trainer Charles Dawson. Later Fields got a yard of his own, from where he both trained and rode many

horses, as he had Hambletonian in all his previous races. But by 1799 Fields was forty-eight, and with so much at stake Vane-Tempest judged him too old to take on Diamond's partner, the expert Irish rider Dennis Fitzpatrick, then at the very peak of his reputation. The result was that Fields was 'jocked off' and Frank Buckle, whom most people regarded as the best rider in the country, and Fitzpatrick's deadly rival, was engaged in his place.[3]

Once Hambletonian had travelled to Newmarket, Fields's preparation of the horse also came under its owner's scrutiny. With the money staked and bet – Vane-Tempest and Cookson had upped their liabilities with a side bet of an extra 800 guineas – Vane-Tempest was racked by nerves. Then, with only a few days to go and not trusting in Fields to get the horse right, he approached a man regarded as the north of England's best judge of horseflesh, John Hutchinson, and asked if he would take a look. Hutchinson did so and reported to Vane-Tempest that, in his opinion, Hambletonian was short of work and needed one last gallop to put him right. Tom Fields, already smarting over losing the ride, flew into a rage. Thrusting the key of the stable into Hutchinson's hand, he told him he and the horse 'might go to the devil', then swung round and stumped off.

Hutchinson calmly took over the supervision of Hambletonian and, two days before running, gave the horse 'an additional sweat at an easy pace, though heavily clothed'. When this had been done the contender went back to his box and awaited his appointment with Diamond.[4]

Over the Easter weekend the crowds started to assemble and by the day of the race there was

> the greatest concourse of people that ever was seen at Newmarket. The company not only occupied every bed to be procured in the place; but Cambridge and every town and village within twelve or fifteen miles were also thronged with visitors. Stabling was even more scarce than the accommodation within doors.[5]

Betting for the race was partisan and at astronomical levels, perhaps as much as £300,000. Hambletonian attracted most of the late money, as his Yorkshire supporters flooded into Newmarket for the race. Going to post, Hambletonian was clear favourite at 5–4 on.

> At three quarters past one o'clock, both horses started in a fine condition as possible – Francis Buckle (Lord Grosvenor's rider) who rode Hambletonian permitted Dennis Fitzpatrick, who rode Diamond, to take the lead at starting, to prevent any accident of his horse running out of

the course; after the horses had run about a mile and a quarter, Hambletonian took the lead and . . . they ran at amazing speed, Hambletonian leading his adversary by about two lengths after which they continued so closely together that doubts were entertained by the betters on both sides.

These doubts arose because Vane-Tempest's horse was a known 'lurcher', one who liked to lay up close and let his opponent cut out the pace. Diamond, renowned for his stamina, would not at all object to this, so Buckle's forcing tactic, and Fitzpatrick's yielding of the lead, were unexpected. It was, in the end, Buckle's boldness that paid off, but only just, and amid hysterical scenes.

It was universally allowed that Hambletonian won by half a length. His last stroke in passing the winning post was supposed to be seven yards. He appeared to be more spurred than Diamond, but not at all whipped.

The northern celebrations were wild. In London anxiety as to the result was such that Mr Hall of Moorfields had arranged for a dispatch rider, using a relay of three fast horses, to bring the result to the Cocoa Tree coffee house within a matter of hours. Vane-Tempest himself arrived at the Cocoa Tree a few hours later and celebrated his triumph with an all-night session.

Once his hangover cleared, Vane-Tempest formed an idea for another celebration, a commission for George Stubbs that would fix the fame of the race for all time.[6] No doubt he wanted an image of the glorious victory, the two horses locked together as they flashed past the post, and his own hero putting in that decisive seven-yards-long final stride to take the prize. Stubbs, with his aversion to scenes of racing action, must have argued against this and we know how stubborn he could be. Possibly he suggested something like the 1765 portrait of Gimcrack, which included both the winning moment and the rubbing down simultaneously. And perhaps the two men finally agreed on a pair of paintings, one of the race's finish, the other of the aftermath. In the end, however, Stubbs would only complete the latter.

Following this commission, Vane-Tempest tried to emulate the example set eight years earlier by the Prince of Wales by becoming an entrepreneur of prints. On 31 May 1799 he placed advertisements in the press announcing that engravings of his horse, after the two Stubbs paintings, would soon be available, and emphasising that only these would be authentic. 'No artist whatever,' he wrote, 'except Mr. Stubbs,

has had my permission to take any likeness of Hambletonian since he was in my possession.' Vane-Tempest thought he could establish a monopoly of Hambletonian prints, a move which provoked the editor of the *Sporting Magazine* to say it 'partakes too much of PUFF for a gentleman's signature to accompany'.[7]

Of the two paintings planned, Stubbs finished the great life-size rubbing-down scene, and exhibited it at the Academy in 1800. Alongside this astonishing work, he presented a preparatory sketch for the other composition in progress, showing the race's climax. It is unfortunate that this sketch or drawing is now lost, for it was never to be developed by Stubbs into a painting as, at this point, his relationship with Vane-Tempest broke down. The client apparently did not like Stubbs's painting and, when he received a bill from Somerset Street, he refused to pay. Stubbs immediately stopped work on the second canvas and, in April 1800, sued for his money.

> [Ozias] Humphry and [Thomas] Lawrence told me that abt. 3 weeks ago they attended as witnesses for Stubbs, a trial between him and Sir H. Vane Tempest for payment of a large portrait of a Horse for which Stubbs demanded 300 gns – [George] Garrard also appeared for him. On the other side [John] Hoppner and [John] Opie appeared, & the former was very violent against the claim of Stubbs, for whom, however, a full verdict was given. It was at the Sheriff's Court.[8]

In this litigious atmosphere, Stubbs declined to complete the painting of the finishing post. Vane-Tempest's projected prints did not appear either, although another print seller opportunistically issued two pirate images of the race, no doubt to Vane-Tempest's fury. These were nothing to do with Stubbs, but were engraved by John Whessell after paintings by John Nost Sartorius, and show the horses 'preparing to start' in one and locked together at the finish in the other. Eventually, in 1819, a version of Stubbs's sketch for the race's finish was painted by James Ward, commissioned by, or presented to, Vane-Tempest's heirs. By this time, however, the baronet himself was past caring, having died from the effects of a lifetime's dissipation six years earlier.[9]

The reason for the row over Stubbs's fee is in the nature of *Hambletonian Rubbing Down*. It is a sombre work, not at all the celebration Vane-Tempest wanted. As ever in Stubbs's scenes at the rubbing-down house, there is no hint of the huge and unruly mob that had swarmed and surged around the area on race day. Instead, the artist is alone on the heath with his three subjects: the horse, his trainer

and the rubbing-down lad. Stubbs views these figures from almost exactly the same position as he did in *Gimcrack on Newmarket Heath*, though a little further away from the buildings and against a slightly higher horizon. Yet now, instead of a calm, assured and victorious racehorse, viewed proportionately to the land in which he belongs, Stubbs paints a huge animal staggering from exhaustion, filling the eye and dwarfing the landscape. Despite Buckle's spurring, the viewer is spared the blood on his flanks, but Hambletonian's unbalanced posture, foam-flecked mouth and laid-back ears tell us that this noble and courageous horse is utterly spent.

The big-hatted trainer at his head, and the rubbing-down lad braced against his withers while pausing for breath, are equally telling portraits. They are not so much a supporting cast as essential adjuncts of the horse himself. The interdependency of professional horsemen and working horses is, as ever in these works, Stubbs's prime subject. Hutchinson was at this time sixty-four, and is certainly not the figure at the horse's head. This might conceivably be Armstrong, Hutchinson's chief groom, who was regarded as almost as talented a horse handler as his master and who,

> at one period in his life, was possessed of a very respectable property; unfortunately, in after life, habits of dissipation wasted his substance and he eventually died of indigence in the Malton workhouse.[10]

However, it seems more likely that the man holding Hambletonian is Tom Fields, he having had the sense to swallow his pride and return to duty as the race was run. At the moment re-created in the Stubbs painting, Hambletonian was hurting and exhausted, and there is a look of mute sympathetic suffering on the trainer's face, as if having reclaimed his stable star, he can only despair at what has been done to him.

Having been exhibited at the Academy, thousands of people had the opportunity of seeing the painting. Yet, despite its great size and power, it does not seem to have been particularly well received. This was a sign impossible to ignore and from now on, although there were a few hunters still to paint, Stubbs would never again attempt a horse portrait on a large scale, and nor would he return to Newmarket Heath. *Hambletonian Rubbing Down* is his final farewell to horse racing.

CHAPTER 55

Old Friends

I called upon my friend Stubbs this morning.

After the collapse of the *Turf Review*, Stubbs lived quietly, working on his *Comparative Anatomy* and making a few forays into painting, most dramatically when he took on *Hambletonian Rubbing Down*. In 1794 he had made his will, a simple document appointing Mary Spencer, George Townley Stubbs and Richard Spencer joint executors, and leaving everything 'to be equally divided amongst them'. But any intimations of mortality at this stage were misleading, for he had another twelve years ahead of him. We know more of this last period than we do of his early youth, but not much more, and with no greater sense of forming a complete picture.

Although G. T. Stubbs tried to keep the Turf Gallery going, the further stallion prints he issued in 1796 after his father's exhibited paintings[1] were dying splutters and soon afterwards the lights went out permanently at Conduit Street. Some time in 1797 G. T. Stubbs moved to Marylebone High Street, where he established a new print shop, re-advertising all fourteen of the *Turf Review* sheets at various prices between six shillings and £1.10s. In the meantime he developed a line in prints after the genre paintings of the Cheshire-born artist, and first professor of painting at the RA, Edward Penny, with titles like *The Silly Family Dispute* and *The Dispute as Sillily Made Up*, and another series of 'Figures done after the Grecian Manner', some of which represented the famous costumed 'attitudes' that Emma Hamilton used to strike for admiring audiences at London and Naples, among them, notoriously, Admiral Horatio Nelson.[2] If the scarcity of surviving impressions of these new performances by G. T. Stubbs is a guide, there was little public interest in any of them. And so, it would seem, he continued to be a drain on his family's resources.

A few references to Stubbs in the diary of the landscape artist Joseph Farington between 1793 and 1806 add occasional colour to the story of Stubbs's old age. For example, on 3 February 1794 Farington, busy lobbying in advance of that year's elections to the Royal Academy, visits Ozias Humphry.

Called on Bonomi, but did not see him. Called on Humphry & satisfied him [Thomas] Lawrence was eligible by age [to be an academician]. Stubbs was there sitting for his portrait. I engaged him to sit for a profile to Dance.

5 February. Called on G. Dance to inform him Stubbs will sit for his profile. I afterwards called on Stothard.

8 February. I din'd with Dance: Stubbs there who had sat for his profile. Stubbs gave us an account of his progress in Arts from infancy.[3]

The portrait for which Stubbs was sitting to Humphry is not the watercolour, where he poses with his enamel *Phaeton* (that was done in 1777) but a head-and-shoulders pastel.[4] Here and in the profile by Dance, as in all but one of the portraits of him, he wears a plain coat and white stock. The fringe of white hair around his bald pate is worn long, and tied with a ribbon at the back. Humphry's pastel is a powerful view of Stubbs, aged almost seventy and favouring the observer with a sternly penetrating look.[5] In the Dance, with the different constraints of the pose, he cuts a more composed and abstracted figure. Dance was an architect whose weekend hobby was to make pencil portraits of 'Eminent Characters' in strict profile, sittings which would be followed by a pleasant dinner. Stubbs clearly enjoyed being an eminent character and was not averse to talking about his life. It is a pity the diarist chose not to pass on even one choice anecdote from that evening.

The evidence in Farington is that Stubbs was on good terms with a number of his fellow artists in the Royal Academy, although he was not a regular attender at Academy dinners. The solidarity of artistic friends has already been seen in the Vane-Tempest lawsuit. From this and other references Stubbs's particular chums – mostly coming inevitably, given his age, from a younger generation – were Ozias Humphry, the animal painter George Garrard, the miserly sculptor Joseph Nollekens and the impoverished Irish history painter James Barry. The last of Stubbs's friends from his own age group, the landscape draughtsman Paul Sandby, died a few months before he did.[6]

The relationship with Barry was curious. Although still Professor of Painting at the Academy, he too was constantly short of money, yet obsessively careful not to put himself under financial obligation to others. One day Farington had a conversation about him at the Royal Academy Club.

11 November 1796. Rigaud mentioned that Barry is now in the habit of going to Stubbs, and drinks tea with him on condition of paying 6d. every

time. Barry affects not to eat or drink with any person, as he cannot invite them in return.[7]

Barry was only to be professor for another three years, after which he became so needy that a subscription fund of £1000 was raised for an annuity, to save him from starvation. The wound to Barry's pride must have been as painful as his hunger.

Humphry remained a particular friend and it was to him that Stubbs entrusted, in January 1797, the facts of his life as he himself wished them to be remembered. Stubbs was seventy-two when he did so and was well aware that in the course of his lifetime – but especially since Johnson's *Lives of the Poets* and Boswell's *Life of Johnson* – public interest in the biographies of famous men had grown into a phenomenon of publishing. Humphry, the assiduous collector of anecdotes and friend of twenty years, may have seemed an ideal Boswell through whom Stubbs could solidify his reputation and ensure his heritage.

He continued to enjoy rude health, and was particularly proud of his abstemious habits and stamina as a pedestrian. Six or seven years after first compiling the biographical notes, Humphry added the following sidebar.

> Aug: 31 1803. Memorandum: I called upon my friend Stubbs this morning; to whom I went with a view to introducing to him Mr Saml Daniell one of the nephews of my friend Thos. Daniell, R.A. F.S.A. &c. We found him engaged in engraving his series of Anatomical plates, of which he had just completed his first number. This day he will have attained his 79th year and still enjoys so much strength & health that he says within the last month having missed the Stage, he has walked two or three times from his own house in Somerset St to the Earl of Clarendon, at the Grove between Watford and Tring, Herts – a distance of sixteen miles carrying with him a little trunk in his hand![8]

These journeys to the Grove, near Watford, were related to the patronage, and friendship, of Thomas Villiers, second Earl of Clarendon. The name of the family seat sounds distinctly suburban to a modern ear, but the Grove was an extensive estate with a mansion of medieval origin. The Earl was an enthusiastic encloser and improver, and a lover of rural sport.

Stubbs did some twelve paintings for Lord Clarendon, three of which he exhibited at the Royal Academy – in 1801 *Portrait of a Mare* and *A Park Scene at the Grove*, and the following year *Portrait of an Indian Bull in the Possession of the Earl of Clarendon*. The Earl kept a variety

of exotic species in his park and, beside the Indian bull, his moose and a bison were also painted by Stubbs. By far the best known of the Clarendon commissions, however, is the *Park Scene*, nowadays known as *Freeman, the Earl of Clarendon's Gamekeeper*.[9]

There are three actors in the scene: the keeper, his greyhound and the doe that the dog has coursed and brought down within the shadows of the wood. The triangular arrangement appears unprecedented in the work of Stubbs, who generally placed groups in linear arrangements, and it endows the piece with a special mystery. The doe is about to receive the *coup de grâce* from the keeper's knife, but Freeman looks out at the viewer with an expression not unlike that of Hambletonian's trainer, a challenging, troubling look.

It is a haunting canvas, in which evening light is used to create an unforgettable aura of mystery, and real ambivalence. Freeman's work is solitary, almost furtive, in these crepuscular woods, unattended by shouts, hunting horns or the drumming of hooves. It makes Stubbs's picture seem a negation of the chase as a celebration of nobility, a notion he had once endorsed.

The mezzotint after this painting is entitled *The Death of the Doe*,[10] explicitly drawing attention away from the idea of the image as a neutral 'park scene' or documentary servant portrait. The death is dramatised, and deliberate pathos is injected, though this leaves a far from melodramatic impression. Rather, it seems that the artist's old equanimity in the face of the violent destruction of animals has been disturbed. It is a piece that invites not so much exegesis, let alone deconstruction, as meditation.

CHAPTER 56

Last Days

I fear not death.

As he struggled to finish the *Comparative Anatomy*, it seems that at last Stubbs began visibly to age. In 1804 Farington reported on his gauntness, and he was obviously no longer the substantial 13 stone 12 pounds that he had been when Joseph Banks weighed him as a visitor to the Banks home in 1782.[1] Despite Lord Clarendon's patronage, money had been short since the collapse of the *Turf Review*, yet he had obstinately refused to lower his professional charges. Joseph Farington noted this when, on 8 July 1801, one Daniel Wakefield called on him

> to ask who I would recommend to paint a portrait of a Horse for his Brother, I recommended Garrard as I concluded Stubbs would be too expensive and Gilpin had declined painting portraits of animals.[2]

From the little we know of the court case against Vane-Tempest, it seems that not all his fellow artists thought Stubbs's high charges appropriate and, though friends like Humphry and Lawrence had backed Stubbs's claim, Vane-Tempest was supported by the leading painters John Opie and the habitually spiteful John Hoppner. Stubbs's continued insistence on valuing his work so highly was partly a matter of self-esteem, but may also have been a regulatory device, keeping away low-value commissions when he wanted to concentrate on the *Comparative Anatomy*. At the same time that enterprise was, in itself, a loss maker, for which Stubbs needed continual subsidy.

Although very little can be said for sure about Stubbs's finances, it is a reasonable guess that his poverty was exacerbated by the expense of keeping his two sons, in whose financial responsibility he was to show, at the very end, a queasy lack of confidence. Although Richard Spencer, who turned twenty-one in 1802, remains an unknown quantity in his father's life, a little more can be gleaned of G. T. Stubbs. Since leaving Conduit Street he had almost ceased to work – his last known prints were a series of seventeen physiognomical heads, four of them after his father's *écorché* models and the others from designs by the artists Henry Singleton and Frederick Wells. In a letter of 1802 to Humphry,

G. T. Stubbs declined an offer to engrave 'Your very fine Head of Mr Stubbs' because of 'the number of different things I am engaged in'.[3] Since none of these different things resulted (as far as we know) in published prints, he was either engaged in some other business entirely (which in view of his father's attitude to him at the time seems unlikely) or he was flannelling. The way in which his father made a dramatic late amendment to his will suggests the latter. G. T. Stubbs would not be the first son to fall short of a famous father's demanding standard. Just how far he fell, and whether with the help of gin, laudanum, or some other common agency of ruin, cannot be known.

The neediness of the Stubbs household was real, but it was not fully apparent to the world until after the artist's death. As Farington reported eleven months later,

> Nollekens told me that when Stubbs died there was no money in the house but about £20 was owing to him by a person. His house was mortgaged to a lady friend of his and he owed her money besides.[4]

It was rather typical of Nollekens, a notorious skinflint, to keep a sharp eye out for the pecuniary difficulties of his fellow artists. The 'lady friend' he mentions was Stubbs's wealthy benefactress, and collector of his pictures, Isabella Saltonstall. A few years earlier Stubbs had painted her as a young woman, in the guise of Una from Spenser's *The Faerie Queene*, a maiden in desperate straits who is preserved only by the friendship and protection of a faithful lion. Now, ten years after Una and the lion (and twenty after he had first represented Isabella as a toddler tugging at her mother's skirts in the Saltonstall conversation piece), the wealthy spinster turned the tables to become the saviour and protector of Stubbs's family, advancing him large sums of money in order to deflect his creditors and avoid either the degradation of the Marshalsea debtors' prison, or the ignominy of a sponging house.

Stubbs did mount one late effort to raise cash. In the spring of 1806, four years after ceasing to exhibit at the Royal Academy, he offered no less than eight works, all from his studio stock and seven of them in the enamel technique, at the inaugural exhibition of the British Institution.[5] Enormous enthusiasm had greeted this new initiative, which provided an extra location for artists to show and sell their work. But the opening event at the Institution's newly acquired premises in Pall Mall (previously occupied by Boydell's Shakespeare Gallery), though a great popular triumph, was not a success for Stubbs. The enamels all came back to him unsold.

The day before his death, Stubbs was apparently in excellent health. 'He accustomed himself to long walks by way of exercizes,' wrote Mary in a note inserted into Humphry's biography, 'and on the 9th of July 1806, he as usual walked eight or nine miles and returned in very good Spirits'. One of the calls he had made that day was on Nollekens, to whom 'he appeared to be as well as usual'.[6] Then he

> went to bed about nine o'clock and at three, on the following morning awoke, as well he said, as ever he was in his life. On getting up in bed he was struck with a most excruciating spasm in his breast, and by the moaning he made was heard by his female friend (who slept in the adjoining room). On interrogation, he said the pains wont kill him. At four o'clock he arose, dressed himself, went down stairs and up again several times to arrange some papers.[7]

These actions on the last morning of his life show that the power of decision (as well as climbing stairs) had not abandoned him. Among the papers he was anxious to arrange was the will that had been drawn up in 1794. By now he obviously no longer believed that 'the pains wont kill him', so he read through the will, picked up a pencil and struck through the names of his sons, both as legatees and executors. He was happy to leave Mary Spencer as his only heir, but another executor was needed. In a shaky hand he inserted 'I. Saltonstall' as executrix in place of his sons. By this time Stubbs was already experiencing further pains and did not (as his witness Thomas Ricketts later swore) feel well enough to go over the changes in ink.[8]

Mary was alarmed enough to send out for Ricketts and one or two of their other friends, who hurried round to Somerset Street. Stubbs continued to behave calmly, inviting the friends to stay for their breakfast and even sitting down with them. Yet it is clear he was now aware of the imminent prospect of death for, as the food was served, and with a degree of insouciance, he raised the subject himself.

> He said to his surrounding friends 'perhaps I am going to die' but continued he 'I fear not death, I have no particular wish to live. I had indeed hoped to finish my Comparative Anatomy ere I went, but for other things I have no anxiety' . . .
> His friends, who were assembled all thought him a great deal better, [when] he left them at breakfast and returned to his bed. One of the party immediately followed him and her screams brought up the rest of the company who found him sitting in an armchair, another chair he had placed so as to rest his legs apart, wrapt himself up in his Gown, and the

moment she arrived breathed his last. Thus on 10th July 1806 at 9 o'clock in the morning closed the career of this celebrated Artist a rare example in the annals of his professional history.

He was interred in the St Marylebone burial ground, in a grave whose precise location can no longer be identified.

George Stubbs at seventy by Ozias Humphry, 1794.

CHAPTER 57

The Lost Legacy

When Stubbs died there was no money in the house.

Joseph Farington

For Mary Spencer the consequences of there being 'no money in the house' after Stubbs's death, and of the fact that her home, and many of the pictures, now belonged to Miss Saltonstall, promised to be dire. Her stepson, the shady and indigent George Townley, at this time approaching sixty, could hardly be relied on to bail her out and Richard Spencer, her own twenty-five-year-old offspring, although vaguely described as a 'tradesman',[1] seems to have been equally unable to assist – or unwilling. He doubtless resented the fact that he had been cut out of his father's will and had not even been allowed to bear the family name.

Within a year of Stubbs's death the need to sell 24 Somerset Street, with all its contents, was pressing. If there were any initial attempts to stave off this clearance, they were unsuccessful and the sale was held by the auctioneer Peter Coxe on 26 May 1807. Ninety-eight lots, consisting mostly of paintings, drawings and prints by Stubbs, were put up and sold for a total which one catalogue annotator estimated at £3500, but which Farington heard had gone above £4000.[2] Even at the lower estimate, this was a good result and presumably satisfied Isabella Saltonstall, who 'bought in a number of lots for her own collection'. On the other hand, 'it is understood that after her debt is paid there will be little left'[3] and by November of the same year Stubbs's considerable library of 1800 volumes was sold by the bookseller, William Stewart.[4] It is possible to make an educated guess at some of the titles that fell under Stewart's hammer, but frustratingly no catalogue of the book sale has survived. We are equally ignorant of how much money Mr Stewart's efforts brought in.

This dissemination of Stubbs's legacy has resulted in incalculable losses. It is true that some of the pieces sold in the Coxe sale have subsequently resurfaced, including the working study of Eclipse, the finished portrait of Queen Charlotte's zebra, a good selection of large enamels and two landscape studies in oils of Newmarket's rubbing-

down house.[5] But Stubbs's ledgers and sketchbooks, almost all his working drawings and compositional sketches, and a number of significant finished works remain untraceable. There were, for instance, three large Hercules paintings, one of which depicted the hero choosing a life of virtue and hard work over one of laziness and vice, a very Stubbsean theme, reminiscent of the artist's long-ago attraction to Knowsley Hall's painting of Cupid hesitating between a martial career and one in the arts. Stubbs's attachment to Hercules was great and long-lasting, and it is particularly deplorable that not even one of these works is extant.[6] Nor are several friends' portraits, religious and bird pictures, a 'Portrait of a White Persian Cat, a Particular Favourite of Mr Stubbs' and nine drawing books, including 'One Book with 200 landscapes, Views and Sketches'.

Mary Spencer wrote in her notes to the Humphry *Memoir* that her man had been 'in his particular branch of art unequated . . . and esteemed by all who knew him'. Yet neither she nor his sons set out to protect or preserve his reputation posthumously. It is true that, having excluded the remnants of the *Comparative Anatomy* from the Coxe sale, Mary did intend to complete their publication herself. But she failed in fact to do so, eventually selling the entire collection of plates and drawings in 1817 to Edward Orme who republished them, but in a form completely at odds with Stubbs's original tripartite intentions.[7]

Stubbs had also been unfortunate in his choice of a Boswell. Ozias Humphry may have been an obsessive accumulator of notes and queries, but as a writer he was feckless, never even finding the energy to put the copious notes he made towards his autobiography into publishable form, let alone to expand the memoir of Stubbs. Humphry died in 1810 and his son William Upcott seems to have toyed with the idea of publishing the Stubbs memoir, but never got very far. Both he and his father knew that the notes in their present form were 'too diffusive' for publication. But, more fatally, they had begun to consider them also too 'unimportant for the public eye'. Stubbs's star had already sunk too far below the horizon.

The family continued for a while to live in the parish of St Marylebone. Richard Spencer must have married his wife Elizabeth elsewhere, as there is no record of it in the Marylebone parish marriage register. The couple evidently returned, however, for their first child Mary Ann, born in 1810, was baptised there on 8 June 1811. A few months earlier Richard himself had pointedly taken adult baptism in Marylebone, in

order to claim the surname of Stubbs, which his father had so firmly denied him, but he only enjoyed the privilege for four more years, for he died in 1815. By this time three daughters had been born to him and Elizabeth, all baptised in St Marylebone. Presumably two died in infancy as only the second of them, Louisa, is mentioned in the will of Mary Spencer who herself died in 1816, at an address in Upper Baker Street, leaving Louisa as her main heir. The surprising evidence from Mary's will – which also included a few small legacies to members of the Ricketts family – is that by some unknown means she had repaired her finances and managed to leave as much as £2000.[8]

George Townley Stubbs, who had been artistically inactive since the beginning of the century, had already died leaving no indication that he ever married or had issue. What subsequently happened to Louisa Spencer Stubbs is obscure and, while various claimants have asserted their descent from the painter, none has been able to substantiate the claim. In any case, if there were any direct descendants, they knew little of their famous ancestor. Within a generation of his death, the legacy of George Stubbs had more or less evaporated.

Of Wrath and Instruction

For a century and a half after his death George Stubbs's reputation was, at best, that of Squire Booby's favourite painter, a beer-and-beefsteak Tory artist with little to say about anything that did not reek of manure, dubbin and gunsmoke. Then, in the 1960s, he was rediscovered by art historians, and an alternative Stubbs stepped from the shadows: the man of the Enlightenment, the Liverpool Leonardo. This new image has now generally superseded the old but, of course, neither is the whole Stubbs.

I was first attracted to him because he painted racehorses with unparalleled skill, and produced memorable images from the early years of a sport that I loved. But, soon after beginning this biography, I became increasingly absorbed in Stubbs the artist-scientist. I searched out articles about his work in anatomy, zoology, chemistry and mathematics, and began to build a picture not merely of a superlative sporting painter, but also of an outstanding progressive rationalist of the Georgian age. It came as a complete surprise, then, to discover that he took his first serious steps in this direction under the tutelage of men so different from the expected Enlightenment paradigm.

Doctors Burton, Drake and Atkinson were undoubtedly devoted to the advancement of knowledge through reason and experimental enquiry. But they were deep-dyed Tories and mystical Jacobites as well, while Atkinson, as a practising Catholic, must be assumed also to have accepted the range of papist 'superstitions' so hated by the Enlightenment mind. These men were passionate antiquaries, too, as content to grub around among monastic ruins, old charters and medieval heraldry as to investigate the medulla oblongata of the brain, or perform Galvani's electrical experiments on a dissected frog. Intellectually, they were therefore as stimulated by the past – and by tradition – as they were by the new philosophy of the future.

Was this the case with Stubbs? In trying to decode his beliefs across a span of 250 years, I found there was little enough to go on. The mere fact that he'd associated with the Tories of York seemed a flimsy basis

for an assertion that he was ever a Jacobite, or a crypto-Catholic. A little more weight was added to the case when I discovered that his grandfather was (almost certainly) a nonjuror, and that Stubbs himself had named his second son after the Young Pretender. But it was not until I followed him to London that real clues appeared, clues that are well founded in Stubbs's actual and documented behaviour.

At the Society of Artists, he unequivocally opposed elitism, court toadyism and Royal Academy privilege, while standing for artistic freedom, and the rights of the 'minor' artist-craftsmen. These positions might also suggest a Wilkesite radical – an implausible ideology for Stubbs from any point of view – but the word liberty had no Radical monopoly in a century when Tories from Swift onwards had so loudly taken up that cry. In the politicised art world of the 1760s, there was a group of right-inclined dissidents in the Society, led by the engraver and well-known Jacobite Robert Strange, and it was with these men that I believe Stubbs instinctively lined up.

As with Burton and Drake, it is perfectly possible for a man with Tory leanings to be caught up in what might be thought progressive causes – reason, experiment, neoclassical purity. All sorts of political categories were differently arranged then. Both William Hogarth and John Gay were complex mixtures of reaction and radicalism, while Samuel Johnson could support both common sense and the Stuart claim to the throne without shattering his formidable integrity. Yet the example of Johnson can seem a troubling one, since he did, in fact, suffer from severe depressions and bouts of introspection, at times coming close to madness. An even more extreme example was Swift. To be a reactionary intellectual in the eighteenth century was to invite inward conflict between old faith and advanced knowledge and, though the split was ultimately reconcilable, it required the painful re-evaluation of deeply rooted beliefs.

For all Stubbs's denigration of his visit to Rome in 1754, that experience was the hinge of his career, for it was then, I am sure, that he undertook this re-evaluation. His encounter with classicism and Catholicism in the home-city of the Pope and the Old Pretender forced him to adjust his previous ideas about tradition – political or artistic – and to seek to reconcile these with progress and reason. He came back resolving to adopt 'philosophical' principles in his art, both through the direct study of nature and the exploration of how classical design represented underlying natural realities.

Stubbs's politics in the Society of Artists suggest that, even after

setting this new course, the competing claims of the old and the new, faith and knowledge, permanence and change, still bothered him. But few such anxieties appeared on the surface of his work, which overall is remarkably of a piece. He betrays, for example, little evidence of any overt tension between a public and a private artistic self, as can be seen in another equally anti-Academic but more fragile painter of the period, George Romney. Stubbs's artistic equanimity remained largely unruffled for the very reason that, as has been said of him, 'the order which he conferred upon his subjects was so absolutely an expression of his own deepest consciousness both of art and nature'.[1] Order is the key word here. What Stubbs was ostensibly celebrating was, at the deepest level, the essential orderliness of nature and society. This was not the retrogression of a man in a state of panic about future change, but the idealism of a rational and well-grounded conservative.

The evidence about Stubbs's personality may be sparse, and found largely towards the end of his life, but it is consistent with this picture. Through Mary Spencer we see the rudiments of a Tory humanist saint, fundamentally at peace with himself and with nature. Humphry, Farington and the obituarist T.N. all portray Stubbs similarly, as the epitome of hard-working common sense, the clean living man who was moderate and rational in everything.

Yet a few shadows of doubt flicker over this image. One is cast by Stubbs's long fascination with the lion attacking the horse. The local political connotations of this were quickly overridden in his mind, as the subject came to represent the violent rupture of cosmic principles that he held very dear.[2] In terms of any harmonious theory of nature, conflicts in the wild, especially between two contrasting, but equally 'noble', beasts, could only be considered complex and jarring events. Milton in *Paradise Lost* evoked pre-lapsarian bliss by showing the lion dandling the kid in his paw. But with knowledge of sin came labour, pain, conflict and rage. Having devoted so much of himself to representing the harmony of nature, most particularly in equine form, a lion attack was indeed a dissonant and painful event to Stubbs. It may have been even more – a shuddering reminder of Original Sin and the principle of evil. There is no reason to suppose that Stubbs would have agreed with Blake's revolutionary paradox that 'the tigers of wrath are wiser than the horses of instruction', but he does not deny that they are stronger, and more terrifying.

For Stubbs the lion and the horse became an obsession, and it was an eighteenth-century commonplace that obsession repels reason. As

Sterne put it in *Tristram Shandy* 'when a man gives himself up to the government of a ruling passion, – or in other words when his HOBBY-HORSE grows head-strong, — farewell cool reason and fair discretion!'[3] At the same time, Sterne regarded hobby-horses as the most useful keys to unlock character, for 'if you are able to give a clear description of the nature of the one, you may form a pretty exact notion of the genius and character of the other'.[4] Stubbs's continual resort to his leonine-equine hobby-horse leads to the conclusion that, deep in his own mind, he was not as completely easy with the concept of natural order as would first appear.

The second flaw in the image given by Stubbs's heirs and obituarists concerns his debt to classicism, a debt Stubbs was keen to deny. This denial as I have argued above, must be questioned. It seems that it was done in the interests of a higher aim, the subsuming of the ancients into an overall philosophical vision of natural order. But Stubbs had nothing to gain by claiming that he did not draw the marble group of the lion attacking the horse in the Capitoline Museum, or that he never studied with profit a classical frieze, or statue, or artwork of any description, either in Rome or elsewhere. Stubbs's pretence that he learned nothing whatever from other artists, but only from nature, is so palpably false as to be almost pathological.

I wonder if it is, in fact, a remnant of the old Tory individualism, the no-nonsense countryman, still persisting beneath Stubbs's calm exterior. Squire Booby too, if pushed, would spit in the eye of neoclassical metropolitan culture and say he learned everything he needed to know from standing in a trout stream, pushing through a covert, or pounding on a stout hunter across a mile of heath. The Squire might never have heard of Stubbs's Italian antecedent from Vinci, but he can be well imagined bluffly acceding to Leonardo's challenging proposition that 'Man has great power of speech, but what he says is mostly vain and false; animals have little, but what they say is useful and true'.[5]

This leads naturally to a third hairline crack (if that is what it is) in Stubbs's mask of perfection: the ironic glint in his eye, the mildly subversive sense of humour. It is seen in some of his earliest portraits and remains with him, making a final appearance in *A Comparative Anatomy* as a silent – and partly, but not entirely, incidental – reproof to human pretensions. Stubbs does not allow this playfulness to negate his perfectly serious belief in the ultimate connectedness of creation, which is the foundation of his work as an artist. But it shows, at least,

that he was a humorous man – not always an outstanding quality in saints, whether secular or otherwise.

A belief in connectedness and the fear of violent rupture, an attachment to nature and the ability to laugh, are not in themselves marks of genius, any more than of sainthood. The question is, what use did Stubbs make of them? His work was the product of a deeply committed and principled sensibility which untiringly searched for what is essential, permanent, and beautiful in the flux of creation. But inextricable from this central philosophical quest was his apprehension of opposition and contrast, his variations in a minor key, his glimpses of horror and an occasional penchant for comedy. At times very clearly, and at others rather mysteriously, it is these elements that give Stubbs's art its human depth, and its creative width.

Notes

A list of abbreviations used below is at the head of the Bibliography.

Introduction

1 Quoted, but not attributed, in Oliver Millar's Introduction in Arts Council, 1974, p. 11.
2 Mayer, 1876, quoted Taylor, 1955, p. 11.
3 OH, p. 200, col. 1.
4 Upcott's transcription remained unpublished until it appeared in Hall, 2000.
5 OH, p. 208, col. 1.

CHAPTER 1

Liverpool: a London in Miniature

1 The ports survey: Grenville Collins's *Coastal Pilots* quoted Bazendale, 1994. The Port of London already had enclosed docks at Blackwall and Rotherhithe.
2 Fiennes, 1947, p. 183; Defoe, 1724.
3 Vestry Books: Peet, 1912.
4 Poor relief: Peet, 1912; Robert Stubbs's ale: Picton, 1883; his inn: GDNB, 8 March 1708, 12 February 1712. His death: PR St Peter's Liverpool, 14 March 1714.

CHAPTER 2

The Skin Trade

1 The Stubbs name was common in Cheshire throughout the fifteenth and sixteenth centuries, but was hardly found at all in neighbouring south Lancashire. The significant exception was Warrington. On the origins of the Stubbs name: P. H. Reaney, *Dictionary of English Surnames*, 3rd edn., rev. R. M. Wilson, 1991.
2 The business was headed successively by Thomas (1586–1627), his sons Thomas (1618–66) and Ireland (1627–65), and his grandson Ireland (1663–1724). In the nineteenth century the family would enter a new phase of prosperity, when the talented Peter Stubs founded a tool-making business at the Bridge Street premises. As Peter Stubs & Co., toolmakers of Warrington, it was to became world famous and is still trading in the twenty-first century. On the Warrington Stubbses, see Dane, 1973.
3 I am supposing that Robert's birth record is that in Warrington PR: '1665 christened Robert, son of Richard Stubbs, 10 May' and that the Richard who went to Liverpool was an older son of the same family. His birth has not been traced, but he was probably born in the early 1650s. The senior Richard Stubbs died in Warrington in 1670. PR Warrington 1653–80. LPRS, vol. 95 (1955).
4 In addition to Richard and his eldest son John, other Stubbses are described as Liverpool curriers in the parish records of the early 1700s. Samuel Stubbs, 'Dayl St, currier', who would die in 1741, fathered six children between 1709 and 1719. His birth is not recorded but he is likely to have been another of Richard Stubbs's sons. So is Charles Stubbs, 'Dayle Street currier', who married Ann Lulnor (or Luten) at St Peter's church in June 1716 and had four sons 1717–24.
5 Poor Rate Register 1708: Peet, 1908. The size of the Stubbses' house is estimated by

comparison with that of their neighbours (and perhaps future relations) the Pattens, see inventory of John Patten's estate, 1710 (Lancs Record Office Wills).

6 For names in the 1696 Loyalty Association, see Stuart-Brown, 1930, pp. 18 ff. The article to which Richard Stubbs did not subscribe begins, 'Whereas there has been a Horrid and detestable Conspiracy formed and carried on by Papists and other wicked and traitorous persons for Assassinating His Majestie's Royal Person in order to encourage an invasion from France, to subvert our Religion, Laws and Liberties, Wee whose names are hereunto subscribed do heartily, sincerely and solemnly profess, testify and declare that his present majesty King William is the Rightful and Lawful King of these Realms, and that neither the late King James, nor the pretended Prince of Wales, nor any other person, hath any right whatsoever to the same. And we do mutually promise and engage to Stand by and assist each other to the utmost of our Power in the Support and defence of His Majesty's most sacred Person and government against the late King James . . .'

7 The most lurid of these accounts is by Doherty, 1974, p. 1, who goes on to draw a striking, but entirely factitious, paradox: 'the boy brought up in the stench and shambles of the slaughterhouse, in a context of violent cruelty and callousness, was as an adult able to produce some of the most orderly classical art of the eighteenth century'.

8 Tannery site: CFL, p. 39. Ducking stool (apparently still used in 1714): CFL, p. 40. Leather Hall: Picton, 1886, p. 55.

9 Leather industry: Berg, 1985, p. 39.

10 Currier's shop: Watt, 1906, pp. 369–70.

11 John Plumbe's diary for 1727 (26 January): Plumbe-Tempest MSS, Liverpool City Library.

12 In parish records, John, Charles and Samuel are all described as curriers, as is William, though he is also said to be a cooper.

13 PR St Nicholas Liverpool, 29 May 1722 (LPRS, vol. 101).

14 William, like Richard Stubbs, was an incomer, originally from Westhoughton, in the parish of Deane, thirty miles north-east of Liverpool on the road between Wigan and Bolton. West Derby in general was one of England's prime centres for the manufacture of watchmaking tools, watch movements and other horological parts. The case maker, a skilled worker in silver and brass, could also engrave and enamel. His social standing would have been on a par with that of the Stubbses. See Weiss, 1982, ch. 3 and Loomes, 1975, pp. 8, 12.

15 William Laithwaite's marriage: PR Childwall, 31 July 1694, 'William Latherd of Liverpool, to Mary Grace of Little Woolton by License' (LPRS, vol. 122).

16 The Stubbs/Laithwaite marriage licence: Cheshire County Record Office, Chester. Mary's birth: PR St Nicholas Liverpool, 23 June 1697 (LPRS, vol. 35). The name Laithwaite had an astonishing variety of alternative spellings, including Lathert, Laithwood, Lathway, Leatherd and Lewthwaite.

17 Hugh Patten's birth: PR Warrington, 28 October 1675; his house: Peet, 1908.

18 He might have been John Patten, born Warrington 1647, son of Thomas Patten of Patten Lane (Pedigree of Patten family of Warrington in Gregson, 1869). No further details are given of his possible descendants, as there would not have been had they been illegitimate, or if John had quarrelled with, and cut himself off from, the wider (and richer) Patten family in his native town.

19 John Patten's garden: 'Patten's Late Garden' is marked on 'A Plan of Liverpool with the Docks', 1766. Patten's circumstances: Liverpool Parish Records, LPRS, vol. 101; Peet, 1908; inventory of John Patten's estate 1710, Lancs Record Office, Preston.

CHAPTER 3

Honest John

1 Except for short spells of hot weather in May and June, the months of 1724 (in Blundell's annual year-end summary) were all 'wett', 'windy', 'very wett', 'extreamly wett' and, in 'October, November, December, very much Raine and Winde': GDNB, vol. 3, summary of weather for years 1724 and 1725.

2 See CFL, pp. 20–41.

3 The Ormond Street address: Poor Rate Register for 1743, Plumbe-Tempest MSS, Liverpool City Library. The RC chapel: Stonor, 1957, pp. 30 ff.

4 On John Holt, Kirkdale and Warrington Academy: Turner, 1957, pp. 5–6, 41; McLachlan, 1943, pp. 46–7.

CHAPTER 4

Drawing Up

1 OH, p. 211, col. 1. Caddick and Wright are mentioned only casually, in a marginal note, as children who drew with Stubbs. Caddick: MPPP (Text) pp. 63–7.

2 Stubbs remained on close terms with Wright, who moved to London 'near King's Road, Pimlico' in the 1760s when Stubbs, too, was settling in the capital. In technical quality, Wright hovers somewhere between Stubbs and Caddick. He was good enough to win first prize for sea pieces at the Society of Artists in 1764, 1766 and 1768, and was undoubtedly capable of representing the drama, power and majesty of the sea to the satisfaction of contemporary critics and buyers. At the same time, there is a certain artificial crowding, an anxious, compendium quality in his work (or the little of it that survives) which compares unfavourably with Stubbs's characteristic economy. Wright's end was a sad one. With high hopes, he mounted a major exhibition of new work at York, timed to coincide with the big August race meeting of 1773. The exhibition flopped disastrously and shortly afterwards the artist's young assistant and only surviving son, Edward Wright, died aged twenty. Deeply grieved and discouraged, Stubbs's friend himself died shortly afterwards. MPPP (Text), pp. 236–7.

3 OH, p. 211, note to p. 4 of MS. Stubbs was in fact at least ten at the time of the move to Ormond Street.

4 Holt was a common name and Dr Ralph Holt cannot be suspected of being a relation of John Holt of Kirkdale.

5 *Williamson's Advertiser*, 6 August 1757.

6 Ibid., 18 February 1766.

7 OH, p. 200, col. 2. This is one of Mary Spencer's marginal notes to the MS.

8 Limner was a very old term, derived from 'illuminator' and dating back to the monastic *scriptoria* of the Middle Ages. The shortened form was 'luminer', becoming 'liminer' and finally 'limner'. By the eighteenth century it referred technically to miniature painters who, like the old monks, often worked on vellum with watercolours. For this reason the term was sometimes extended to watercolourists, still an insignificant group. In untechnical provincial language, however, 'limner' covered anyone following the itinerant trade of portrait painting, illustrating, sign-painting etc. It was applied to Stubbs in several parish register entries. Goldsmith's limner: *The Vicar of Wakefield*, ch. 16.

9 Letter from Gregson to William Roscoe, 1824, quoted Darcy, 1976, p. 4.

10 This indignity was suffered for four years by William Hogarth's father in London, after the collapse of his coffee house at St John's Gate. The elder Hogarth had relied on his unique ability to be 'always ready to entertain gentlemen in the Latin tongue', but such intellectual badinage did not pay his bills and he went under.

11 The story of GS's 'delicate constitution' is in TN, May 1808, p. 54. It is not in

Humphry. Stubbs's knowledge of bookkeeping is seen in the meticulous accounts he kept for the Society of Artists, during his time as Treasurer, 1769–71. See Royal Academy of Arts Library, SA/19.

12 OH, p. 200, col. 2.

13 Ibid., col. 1.

14 Remarkably full registers kept by Liverpool's Catholic priests, first in Edmund Street and then Chapel Yard, have survived and the Stubbs name is not found in them. 'The Catholic Registers of Liverpool 1741–73', CRS, Miscellanea VII, 1911.

15 The burial of John Stubbs is recorded in the PR of St Peter's, Liverpool. The Humphry memoir states incorrectly that George Stubbs was fifteen at this time.

CHAPTER 5

Winstanley of Warrington

1 The three adjectives are applied to Kneller by Oliver Millar in Millar, 1963, vol. 1, p. 22. The letters of condolence are mentioned in the short memoir written by Hamlet Winstanley's brother, dated 1776 and eventually published in *Notes & Queries*, November 1877, pp. 137–40. This, the only authoritative contemporary account of Winstanley's life, seeks to correct 'the mistakes made by Horace Walpole and others'. Based on George Vertue's art-historical notebooks, Walpole's *Anecdotes of Painting in England* had been published between 1762 and 1771.

2 Sir Edward's town mansion, Patten House, on Preston's Churchgate (now Church Street), had been inherited through Sir Edward's mother Elizabeth, born a Patten and closely related to the rich merchant Pattens of Warrington and Liverpool. See Hunt, 1992, pp. 116, 122–3. If, as I have suggested above (ch. 2, n. 18), Stubbs's maternal grandfather was John Patten, born Warrington 1647, this would have made Stubbs himself a distant cousin of the eleventh Earl of Derby.

3 Between July 1721 and March 1723, Lord Derby spent £1467.2s.6d on twenty-six 'capital' pictures, as well as 'sevl. Pictures of small value for the gallery': Scharf, 1875.

4 'On 8 June 1723: the Rt Honble the Earle of Derby debtor to Hamlet Winstanley. For work done 18 June 1722 to 7 June 1723 at 10s.6d pr Die comes to ... £185.17s.' Quoted Russell, 1987, p. 150. Other artists and agents who took part included the Fleming Peter Tillemans, Tillemans's apprentice-assistant Arthur Devis of Preston, the horse painter John Wootton and Liverpool's Joshua Molyneux, who later specialised in sea pictures. Thomas Wright, another minor artist, acted, like Winstanley, as an agent, buying pictures on Lord Derby's behalf. Shortly after 1730 Wright compiled a catalogue of the Knowsley pictures, listing them room by room. On the Knowsley collection, see Russell, 1987. On Tillemans and Devis see Steven Sartin in Cross, 1983, pp. 19–36.

5 The Knowsley archives preserve Winstanley's Italian dispatches to his patron, some with mysterious references to a 'Me.M.', who was assisting in the hunt for suitable acquisitions and who appears to have been a Jacobite exile. Winstanley was not the only artist Derby subsidised in this way: Joshua Molyneux also went to Italy about this time at the Earl's expense. Lord Derby was a Whig and supporter of the 1688 Revolution which threw James II out of England, so his dealing with cardinals and Jacobite exiles is intriguing. It is difficult now to guess the cardinal's identity, but he was not an Englishman, since none was in the College of Cardinals at the time.

6 Casino Rospiglioso, Palazzo Pallavicini, Rome. The Reni fresco is dated 1612–14.

7 *Belshazzar's Feast*: Scharf, 1875, cat. no. 70. The Chatsworth picture: Scharf, 1875, cat. no. 287.

8 Vertue's Notebooks were published in the annual volumes of the Walpole Society between 1930 and 1955; the 'Age of Van Aken', see Piper, 1992, pp. 122–4.

9 Pope to Mary Wortley Montague: *Correspondence*, vol. II, p. 22.

10 Similarities exist between the portrait styles of Winstanley and Parmentier, as can be seen by comparing the treatment of the face in the former's portrait of Thomas Patten of Warrington (Warrington Town Hall) and Parmentier's of the Yorkshire clergyman Marmaduke Fothergill (York Minster Library).

CHAPTER 6

Knowsley

1 The youthful self-portrait: Scharf, 1875, cat. no. 353. Miniature self-portrait: Hall, 2000, cat. no. 1.
2 OH, pp. 200–1.
3 Henry Pickering had been described as Winstanley's apprentice in a letter from Winstanley to Edward Stanley of Lincoln's Inn, 27 June 1727: see Russell, 1987, p. 155.
4 The painting, then thought to have been a collaboration between Van Dyck and Frans Snyders, had been bought in the 1720s from Sir John Lowther for £59.10s. Winstanley's etching of it is in his book *The Knowsley Gallery*. In 1875 Scharf reattributed it 'probably' to Seghers.
5 Pannini paintings: Scharf, 1875, nos 271 and 294; Thomas Wright's room-by-room inventory of paintings at Knowsley: reprinted in Russell, 1987.

CHAPTER 7

Self Help

1 Libraries: the club which became the Lyceum met originally to discuss articles in London's influential periodical, the *Monthly Review* (Smithers, 1825, pp. 319 ff.). There was also a library available to the public but consisting only of theological works in the vestry of St Nicholas Church. The Will of Ralph Holt, surgeon of Red Cross Street, Liverpool, dated 6 July 1774, proved 1777, is in the Lancashire Record Office, Preston. Liverpool cultural life: Darcy, 1976, ch. 2.
2 On the Knowsley collection, see Scharf, 1875.
3 Wright as house and ship painter: Dibdin, 1918, p. 60. Caddick and Stubbs: Holt and Gregson MSS cited by MPPP, pp. 63–4.
4 Richard Holt, potter: Brown ed., 1993, p. 19. Chaffers: Stonehouse, 1854, p. 74.
5 Wright: Smithers, p. 402. Caddick: MPPP, p. 63. John Holt made an eccentric will (dated 1765 and witnessed by Joseph Priestley) in which he expressed the division of his estate by means of a complicated mathematical formula, Turner, 1957, pp. 5–6 and 41; full text Warrington Library MS 1322.

CHAPTER 8

Captain Blackburne

1 Sinclair, 1882, pp. 220–1.
2 Wigan court leet: records reprinted in Sinclair, 1882, pp. 222–37.
3 Macauley: quoted from his review-essay 'William Pitt, Earl of Chatham', 1834.
4 In Liverpool the Blackburnes had, in effect, a monopoly on the refining of salt. Since 1702 the law had forbidden all new refineries from being built more than twenty miles from Cheshire's salt-producing areas, while allowing existing plants like the Blackburnes' to continue trading. See Hughes, 1934, pp. 225, 395–6.
5 On the Weaver Navigation, see Barker, 1951.
6 Neal, 1779.

7 The whereabouts of the Blackburne family portrait of 1741 is at present unknown, but it is illustrated in Blackburne, 1881 and Hatton, 1991. I am indebted to Joan Appleton for telling me the history of the 1743 portrait, now in the Warrington Museum. This was once attributed to George Dance but is now given to Winstanley. It is not clear whether the removal of the pineapple was a *pentimento* of the artist or of some later Blackburne, who may have thought it ridiculous. My description of Blackburne's hothouse is from Whitaker, 1816, p. 35, which describes Richard Richardson's hothouse at Bierley Hall, Leeds. Whitaker says this was built immediately after Blackburne's, by the same contractor and no doubt along the same lines.

8 Beamont, 1886, p. 189. The exactness of the dates shows that Beamont was using a good documentary source, though regrettably he does not give it.

Chapter 9

The Tyrant of Leeds

1 Paine, 1792, ch. 5; 1994, p. 189.
2 The county vote was enjoyed only by freehold property owners worth forty shillings, but the boroughs showed considerable variation in what qualified a man to vote. In general, however, heads of households voted, and did so in public, making it a bad move to vote against the preferred candidate of a powerful magnate, particularly if the noble was also one's landlord.
3 Sisman, 2000, p. 211.
4 Defoe, 1927, p. 612.
5 Quoted from the diary of Sir Robert Wilson by Randolph, 1862, p. 42.
6 Turnpike roads: Wilson, 1971, pp. 145–9. The 1753 massacre: Rudé, 1964, p. 35 and Parsons, 1834, pp. 128–9. Parsons gives a much exaggerated death toll of thirty-eight but it might be noted that even the lower death toll given by Rudé is comparable to that of Manchester's better remembered Peterloo Massacre of 1819, when eleven died after troops opened fire on a crowd agitating for electoral reform.
7 The two pamphlets were reprinted in the twentieth century by the Thoresby Society. The first appeared in *Thorseby Miscellany*, 1st Series, vol. XXII (1915), pp. 58–84, where the editor G. D. Lumb wrongly identified Bitterzwigg as the Rev. Francis Fawkes. The second, 1765, pamphlet, is in *Thoresby Miscellany*, 2nd Series, vol. XII (1954), pp. 283–99. Here the authorship of John Berkenhout is established.
8 Or under his gross mismanagement, according to R. G. Wilson, who comments that, while furiously defending their legal entitlement to run the Navigation, and thereby to make 'vast concealed profits', the proprietors and the managers they appointed had entirely neglected to invest or improve the waterway. See Wilson, 1971, pp. 139–41.
9 By driving him out of Leeds, Wilson may have done Berkenhout a good turn. He was successively a soldier, a physician, a natural scientist and a diplomatic emissary to New York and, although the American visit was wholly unsuccessful – he was thrown into prison by the Congress – by the time of his death in 1791 John Berkenhout was a man of some repute in England.

Chapter 10

Yorkshire Art

1 If the Leeds West End cannot now be said to rival Georgian Bath and the Edinburgh New Town, this was the result of the rapacity of his nephew Christopher. On taking over the inheritance, he needed money to finance his racing interests and allowed whole-scale industrialisation to overwhelm the Georgian theme. See Beresford, 1985–6, p. 166.

2 Parmentier was born in 1658, and schooled in Paris by his uncle, Sebastian Bourdon. He had worked for William of Orange at the Binnenhof in The Hague, and at the Het Loo palace, and in London he joined a team of French decorators under Charles La Fosse working on the splendid wall and ceiling decorations at Montague House, the town residence of Lord Montague which, until 1840, stood on the site of the British Museum. But the competition in London was intense and the Frenchman moved north by 1700.

3 Parmentier's career: Croft-Murray, 1962, vol. 1, p. 67 as well as catalogue entries under 'Parmentier' and vol. 2 Corrigenda; Waterhouse, 1978, pp. 128–9.

4 I am grateful to Judy Egerton for this reference.

5 'Freemen of York', Surtees Society, vol. 102, 1900, p. 265.

6 French lessons: OH, col. 1, p. 201.

CHAPTER 11

York and War

1 Lees-Milne, 1962, pp. 158–60. The building is today what may be the world's most architecturally distinguished pizza parlour.

2 The view held by many in 1745 that the rebellion was capable of success has been supported by more recent historians from Sir Charles Petrie to Frank McLynn and Christopher Duffy.

3 The various ways in which Jacobitism expressed itself are discussed in Oates, 2002, especially pp. 207–8.

4 Monkman, 1990.

5 McLynn, 1988, p. 192.

6 Arch, 1980, pp. 28–9.

7 Ibid., p. 27.

8 In these and other Yorkshire towns civic pride, for one, ensured that they all devoutly believed in the Pretender's unique desire to plunder them. On Hull, see Duffy, 2003, p. 232. On Leeds, see Kitson and Pawson, 1930, p. 24.

9 Walpole, *Correspondence*, 19, 109–10.

10 Ann Worsley: Whitehead, 1985, pp. 59, 61 and 63.

11 Quoted Whitehead, 1985, p. 63.

12 Ibid., pp. 64–6.

13 Oates, 2000, p. 49.

CHAPTER 12

Family, Religion and Politics

1 This record is from the Bishop's Transcripts of the St Helen's register (Society of Genealogists Library, microfilm no. 1188). I am grateful to David Alexander and Judy Egerton for putting me on the track of Stubbs's Yorkshire-born children. The birth of baby George used to be dated eight years later, in 1756, when Stubbs had begun living with Mary Spencer. Stubbs the Younger's earliest signed engravings are from 1771, though they do not look like the unaided work of a boy of fifteen. The assumption used to be that their real maker, his father, had perpetrated a harmless fraud by having his son sign the plate, perhaps out of paternal pride. Now we know better.

2 Mary Townley was baptised 31 May 1731. She and her younger sister Susan Townley (16 June 1732) are in the PR of St Peter's, Liverpool. Their sister Ann (11 May 1735) is in the PR of St George's, Liverpool. The 1743 Poor Rate returns for the city are an

isolated survival from the 1740s. They are in the Plumbe-Tempest papers, Liverpool City Library.

3 Aveling, 1970, p. 115.

4 York's lodge was one of the oldest in Britain, possibly some kind of survival of the organisation formed by the medieval masons who built York Minster. A York Grand Lodge was formally constituted in 1725, which claimed primacy over Freemasonry in England, though it was later supplanted by London's Grand Lodge, which enjoyed royal patronage.

5 Quoted Daynes, 1929.

6 Both finished portrait and sketch are lost. Alice may have been from another family of Catholic Atkinsons in York, that of Thomas Atkinson, a prominent York architect-builder and designer of the Catholic chapel at the Bar convent. In Thomas's case, the connection with Dr Drake may be that he, too, was a mason. The Papal ban on Freemasonry for Catholics was not enforced in England at this time. On the Atkinsons, see Aveling, 1970, pp. 370–2. For Stubbs's preliminary sketch of Alice Atkinson, see Frederickson, 1990, vol. 2, p. 951.

7 The portrait is now in the Ferens Art Gallery, Hull. On Draper Fothergill, see Fothergill, 2002, pp. 250 and 345. Another of George's relations, Marmaduke Fothergill, was a landowner who consistently appears as one of the prime supporters of the York Hospital.

8 Society of Genealogists Library, microfilm no. 1188.

9 It might be here pointed out that by calling his eldest son George and his next Charles Edward, Stubbs and his wife were basting both sides of the ideological turkey. But in using George for his eldest son he was recycling his own name (and, perhaps, that of his father-in-law). This was an occurrence so regular in a first male baptism as to be a familial duty rather than a political statement.

10 'Catholic Registers of Liverpool, Book I: 1741–1773', *CRS Miscellanea VII*, 1911.

11 Catholics were about 4 per cent of the population. Dissenters accounted for about 10 per cent. The remaining 86 per cent conformed. Aveling, 1970, p. 125.

CHAPTER 13

Vile Renown

1 This paradox had been seen in England even before the Enlightenment proper, for example, in William Harvey, the most important pioneer scientist in England in the age of Charles I who was a convinced monarchist. The reverse paradox is seen in the popular herbalist Nicholas Culpeper – a Leveller in politics but a medical conservative, advocating natural remedies and decrying scientific medicine.

2 Margaret C. Barnet, 'Medicine and Health Services in York', in Stacpoole, 1972, pp. 895–900.

3 *York Courant*, Tuesday, 30 July 1745.

4 See Porter, 1982, p. 303.

5 Quoted by Egerton, 1976, n. 15.

6 Atkinson, 1834, entry under 'Burton, John'. This source is wholly independent of the Humphry manuscript and shows that Charles Atkinson was Stubbs's earliest serious anatomy teacher, not only for the human figure but for the horse.

7 Quoted in this form by Petherbridge, 1997, p. 14.

8 Descartes had notoriously located the soul in the pineal gland, while the early investigator of the nervous system, Thomas Willis, divided the soul in two, of which the lower, or animal, soul was to be found in the nervous system. The search for the soul's precise physiological location is one of the comic motors that drives the 'plot' of *Tristram Shandy*: see Sterne, 1997, vol. II, ch. 19. See also ch. 8 above.

9 Blake, 1927, p. 873.
10 Ezekiel 37:6.
11 See Whitehead, 1985, p. 68.

CHAPTER 14

In the Schoolroom

1 Tattersall, 1974, p. 113.
2 TN, July 1808, pp. 155–7. The identity of the author is unknown.
3 OH, p. 201, col. 2.
4 *York Courant*, 3 December 1745. Similar advertisements were placed by Randall from time to time in other regional newspapers, such as the *Leeds Mercury*.
5 *York Courant*, 26 April 1745. I am grateful to Mr John Goodchild's independent Local History Study Centre in Wakefield for help in researching the Heath Academy.
6 On Gargrave, see *The Gentleman's Magazine*, vol. XVI, NS (1841), p. 36.
7 Tattersall, 1974, p. 113.
8 See Bermingham, 2000, pp. 40, 45 and 121.
9 Leonardo, 1721, pp. 29 and 37. Leonardo published nothing in his lifetime and the *Treatise* is a shortened version of a compilation of his notes on art collected in the so-called Codex Urbinas, which is in the Vatican Library. In the original notebook Leonardo had written more fully on the necessity of studying nature: 'I say to painters that no one should copy the manner of another because, where art is concerned, anyone who does will be the grandson rather than the son of nature. Since natural things exist in such wide abundance, one prefers, and one is obliged, to have recourse to them rather than to the masters who have learned from them. And I say this not to those who want to grow rich through art, but to those desiring fame and honour from it.' (Quoted Pedretti, 1965, p. 32.)
10 Two stray quotations from Leonardo's writing that I came across during the revision of this text serve to underline the commonality of thinking between him and Stubbs. 'O writer, what words of yours could describe this whole organism, as perfectly as this drawing does?'; 'When you want to achieve a certain purpose in a mechanism, do not involve yourself in the confusion of many different parts, but search for the most concise method'(Quoted Nicholl, 2004, pp. 19–22.)

CHAPTER 15

Burton the Jacobite

1 OH, p. 201, col. 1. In his transcript of Humphry's original text, William Upcott replaced 'rencontre' with the less expressive 'encounter'.
2 Lord Chesterfield considered that dancing 'teaches you to present yourself, to sit, stand, and walk genteely, all which are of real importance to a man of fashion' (*Letters Written by . . . the Earl of Chesterfield to his Son*, 1774, 10 June 1751).
3 See Winn's advertisement in the *Leeds Mercury*, 11 April 1738, in *Miscellanea*, Thoresby Society Publications, vol. XXIV, 1936.
4 A marginal note in Humphry prompts the memoirist to ask for 'particulars' of this episode but, if he did, none are recorded. Burton gives a trenchant account of the Yorkshire election in Burton, 1749, pp. 5 ff.
5 Like many eminent physicians of the day, he studied at Leyden under the great medical educator Boerhaave.
6 Letter dated 30 November 1745. British Library Add MSS 35889, f. 55. Transcribed Whitehead, 1985, Appendix 1.

7 Cash, 1975, p. 171.
8 Brockwell, 1915, p. 43.

CHAPTER 16

Dr Slop

1 Monkman, 1990, p. 125.
2 Its full title was *British Liberty Endanger'd; Demonstrated by the following NARRATIVE wherein is prov'd from FACTS that John Burton has hitherto been a better FRIEND to the English Constitution, in Church and State, than his Persecutors.*
3 Burton, 1751, p. xix.
4 Epistle l, 6, 67. In Conington's translation: 'If you can mend these precepts, do/If not, what serves for me may serve for you.'
5 Burton, 1751, p. xv.
6 For a full account of the genesis of Burton's book, see Cash, 1968, pp. 133–7. On the wider debate about obstetrics, see Porter, 2001, pp. 224–7.
7 John Toland, *Letters to Seren* (1704), quoted by Porter, 2000, p. 117.
8 Sterne, 1997, vol. II, ch. 9, p. 85.
9 Cash, 1975, p. 180, n. 2. Cash gives the reference SP 36/83, 'information of Cuthbert Davis, sworn before James Fenton, LLD, 18 April 1746'.
10 Sterne, 1997, vol. II, ch. 19, p. 120.

CHAPTER 17

Dame Nature

1 Sterne, 1997, vol. I, ch. 7, p. 11. The accuracy of Sterne's description is shown by the editors of the Florida Edition of the Works of Laurence Sterne, vol. 3, pp. 54–5.
2 Burton, 1751, p. xiii.
3 Sterne for his part understood perfectly well how ideas about art and science overlapped. *Tristram Shandy* is stuffed with references to fashionable art theory.
4 The Humphry manuscript says that Stubbs was 'At this time, in the twenty-second year of his age', which on the face of it refers to 1745–6, i.e. the year following Stubbs's twenty-first birthday. But in my view Stubbs cannot have been in York until early 1746 (New Style), by which time Burton was in prison, where he remained until March 1747, long past Stubbs's twenty-second birthday.
5 OH, p. 201, col. 2.
6 Ibid., col 1.
7 'Two Embryos painted in Oil, 5 views of the bones of the pelvis, 2 ditto of skulls' was one of the earliest lots in the Stubbs posthumous sale and immediately followed another work from Stubbs's early life – the sketch for his portrait 'of Alice Atkinson, who died at York aged 110'. So it is reasonable to assume that these small anatomical oil paintings, none of which is now known, were a spin-off from the preparatory work Stubbs did for Burton's copper plates.
8 OH, p. 201, col. 2.
9 Ibid. An example of a house painter who was also an artist is George Fleming of Wakefield, master of the very bad York artist Thomas Beckwith (1731–86). See John Ingamells, 'Painting and Sculpture in Yorkshire 1700–1900' in Stacpoole ed., 1973.
10 *A Treatise on the Theory and Practice of Midwifery,* by William Smellie MD, 1752.
11 Burton, 1751, pp. xvii–xviii.
12 The *Shorter Oxford Dictionary* defines inconsiderate not only as 'thoughtless' but 'unadvised, precipitate'. Smellie's plates are the work of Jan van Riemsdyck, a Dutchman who specialised in anatomical illustration and who twenty years later

collaborated with Stubbs's friend the physician and man midwife William Hunter. His work for Smellie is large, detailed and highly finished, a world away from Stubbs's little plates for Burton.

13 As Tim Clayton points out 'a plate could be etched and printed very quickly, both operations being essentially simple so that etching was an ideal process where a design needed to be produced quickly and cheaply': Clayton, 1997, p. 14.

14 OH, p. 201, col. 2.

15 Ibid.

16 'who enjoys the greatest fame among his countrymen and whose works have won him well-deserved glory'. Preface to *Une Système Nouveau et Complet de l'Art des Accouchements Tant Théoretique que Pratique etc. . . . traduit de l'Anglais de J. Burton par M. Le Moine, Docteur-Régent de la Faculté de Médicine en l'Université de Paris* (Paris, 1771).

17 Sterne, 1997, vol, II, ch. 9, p. 89.

18 In practice Burton did not persist with the 'contrivance', but reverted to a 'modified Dusée forceps with the addition of a lock and better handles', Radcliffe, 1948, p. 352. See also Cash, 1968, p. 149.

19 Atkinson, 1834, entry for 'John Burton of York'.

CHAPTER 18

Hull

1 Burton, 1758, p. vi.

2 Twenty years later Stubbs would produce exquisite drawings of Marmaduke's specimen of a mouse-lemur. See JE, no. 84. Details of the Constable/Tunstall brothers are drawn from Gooch, 1997, pp. 553–64.

3 These are of the stallions Blank and Spectator, each posing with a groom. See JE, nos 44 and 45.

4 If, as suggested above, it was a birthday portrait, it would presumably have been painted during the first three weeks of July.

5 On portraiture, smiles and characterisation in this period, see Piper, 1992, pp. 136–8.

6 Dr R. B. Fountain notes his 'puzzling prosperity'. Fountain, 1984, p. 1.

CHAPTER 19

Grand Tour

1 He was to find there another northern artist, and late convert to the Grand Tour, Joseph Wright of Derby.

2 An indispensable reference for the study of all British artists in eighteenth-century Italy is Ingamells, 1997.

3 OH, p. 202, col. 1.

4 T.N., his obituarist in the *Sporting Magazine,* tells us that Stubbs's benefactor was the Earl of Grosvenor 'who, with others, mingled purses and sent the young artist to Italy' (May 1808, vol. 32, p. 56). Grosvenor was an important picture collector and later patron of Stubbs, but there is no evidence that he knew the artist at this time, and T.N.'s proposition is an unlikely one.

5 See Kenworthy-Brown, 1983, p. 123.

6 On the British Academy, see Russel, 1750, vol. 2, pp. 361–2; on Stubbs's friends, OH, p. 202.

7 Sir William Beechey, quoted by Parris, 1973, p. 29.

8 Kenworthy-Brown, 1983, p. 47. It is now in the Metropolitan Museum of Art, New York.

9 The characterisation of Chambers is from Brewer, 1997, pp. 238–9.
10 Scott, 2003, pp. 97–100.
11 The Richmond Gallery, see Scott, 2003, p. 122. Here it is claimed that 'within a couple of years the Duke's support had lapsed', although in fact that the Society of Artists received the Duke's invitation to study the gallery in 1770. See p. 204 and n. 12 below.
12 Stainton, 1983, p. 10.
13 Zoffany's painting is in the collection of HM Queen Elizabeth II. Titian's is still in the Museo d'Uffizi, Florence. On Patch, see Ingamells, 1997, entry for Patch.

Chapter 20

Nature and Art

1 As Shakespeare anticipated it in *As You Like It*, II.i.16–17.
2 It may seem a paradox that, as the prestige of classicism rose to apotheosis, so did that of nature. Yet no contradiction was perceived at this stage.
3 Richardson, 1722. A second edition was published in 1754, the year of Stubbs's Italian visit.
4 OH, p. 202.
5 On Stubbs the classicist, see also Nicholas J. Hall, 'Fearful Symmetry: George Stubbs Painter of the Enlightenment', Hall, 2000, pp. 11–35 and Malcolm Warner, 'Stubbs's Classicism', Warner, 2004, pp. 65–79.

Chapter 21

In Excelsis

1 Russel, 1750, p. 46.
2 Ingamells, 1997, entry for Stubbs, n. 1.

Chapter 22

His Mother's House

1 Taylor, 1971, p. 33; Haskell and Penny, 1981, no. 54.
2 Weston, 1776, pp. 55–6.
3 Avery and Radcliffe, 1978, nos 170, 174.
4 Hall, 2000, no. 12.
5 Roscoe, 1999, no. 210.
6 Stubbs's presence in Liverpool in mid August 1754 is predicated on the fact that he was the child's biological father. But he had been travelling abroad and the possibility of his wife's infidelity during this time cannot be discounted, particularly as the marriage ended so soon afterwards and was never mentioned by Stubbs in later life. There are of course many other interpretations of the bare fact recorded in the parish register. Since the new child's mother is not named she might have been another woman altogether.
7 Poor Rate Register for 1756: Plumbe-Tempest papers, Liverpool City Libraries.
8 OH, p. 202, col. 1. The chronology here looks dubious and I would estimate Stubbs spent two years at most in Liverpool.
9 Mary Stubbs may have remarried since John Stubbs's death, which would account for the fact that her own death is untraced in the registers. No such marriage has been noted in Liverpool, but if there was a third husband, he might have brought her money which Stubbs inherited.
10 Walker Art Gallery, Liverpool.

11 Draper, 1864, p. 335.
12 OH, p. 202, col. 1. The whereabouts of this picture are not known.

CHAPTER 23

Inside the Horse

1 Swift, 1727, Book IV, ch. 4; 1934, pp. 234–35.
2 Thomas, 1983, pp. 20–1.
3 For an extended discussion of these issues see Thomas, 1983, especially ch. 3.
4 Stubbs, 1766, preface.
5 Atkinson, 1834, entry under 'John Burton'.
6 *The Gentleman's Magazine*, vol. 76, October 1806, p. 979.
7 OH, p. 202, col. 2.
8 Leonardo da Vinci's projected treatise on horse anatomy was never completed and his notes and working drawings have disappeared. But judging by the extensive fragments of human anatomy in his surviving notebooks in the Royal Library, Windsor Castle, Leonardo would have been well in advance of Ruini.
9 Stubbs, 1766, preface.
10 It is now in the Talbot Rice Gallery, Edinburgh. Sorensen, 2002, p. 33, dates it to the early eighteenth century.
11 Sorensen, 2002, p. 33.
12 'An item necessary to the perfect delineation of the horse'. Quoted ibid.
13 Sorensen, 2002, pp. 33–6.
14 Bronowski, 1973, p. 113.

CHAPTER 24

Mary Spencer

1 This is stated in a marginal note in the original Humphry manuscript, but not transcribed in OH.
2 Byng, 1954, pp. 368–9.
3 Taylor, 1987.
4 The fate of Charles Edward, the hopeful young 'Jacobite' son, is as obscure as that of his mother, but he assuredly did not grow to adulthood.
5 OH, pp. 202 and 211. No independent account of these dramatic events has been found.
6 Fountain, 1984, pp. 1–2 and n. 18. Spencer does not bear the title 'Captain', but only 'sailor', in these records. Fountain suggests that his elevation in OH may have been Mary Spencer romancing her father's name.
7 The caveat is that she is described at her death, in 1816, as being eighty-three, which gives a birth date of 1734 (Fountain, 1984, n. 19). No Mary Spencer was registered among the Liverpool births in that year and I think Fountain is right in assuming this to have been a slip or a mix-up.
8 She was born 14 April 1726 (Register of St Peter's church, Liverpool).
9 His failure to acknowledge Richard may have had a simpler explanation: that Richard was not, in fact, his child. See ch. 46 below.
10 OH, p. 202, col. 2.

CHAPTER 25

Scalpel and Pencil

1 OH, p. 211, col. 2. The use of the word 'lengths' to indicate a period of time is curious, but perhaps dialect. It would appear to mean 'weeks'.

2 Ibid.

3 James Whatman of the 'Turkey' Paper Mills, Maidstone, Kent was England's leading papermaker. The laid paper Stubbs used at Horkstow 'weighs about 100 to 150 gsm in today's terms' and the sheet dimensions are approximately 18 × 12 inches. Essay by Catherine Rickman in Savage, 2002.

4 See Doherty, 1974, p. 9. Pouncing was an old process whereby images were transferred from one sheet of paper to another. The lines of the original drawing were pricked with tiny holes and it was then placed over a second sheet. A fine dust of sanderac, pipeclay or charcoal was shaken over it, of which specks fell through the pinpricks to show the outline of the drawing on the lower sheet.

5 The paper weighs '50 gsm or less', Catherine Rickman, in Savage, 2002.

6 Doherty, 1974, p. 41. In a short, speculative article, Desmond Taylor identified a house in Horkstow as being Stubbs's possible residence. Here the scullery, which Taylor believes was the dissecting room, measures 16 feet by 14 feet 5 inches. It has 'easy access from the yard', across which is an eighteenth-century ice house. See Taylor, 1987.

7 Bryan Kneale RA, in Savage, 2002.

8 Leonardo, 1721, p. 117. In Leonardo's original the first two sentences read: '*La figura che senza moto sopra li suoi piedi si sostiene, darà di sè equali pesi oppositi intorno al centro del suo sostentaculo ... Sempre la figura che sostiene peso fuor di sè e dalla linea centrale della sua quantità, debbe gittar tanto peso naturale od accidentale dall'opposita parte, che faccia equiparanza di pesi intorno alla linea centrale.* (A figure which stands on its feet without moving maintains equal and opposing weights around the central axis of its support ... A figure which carries a load outside itself, or [outside] the central line of its mass, must always throw the same weight, whether intrinsic or extraneous, on to the opposite side to balance the weights on either side of its axis.)' Pedretti, 1965, pp. 33 and 81. Leonardo's phrase '*naturale ed accidentale*' seems to contrast the weight which is a part of the body, such as an arm, and that which bears on it from outside.

9 Essay by Taylor in Egerton, 1976, p. 17.

CHAPTER 26

A Lincolnshire Van Dyck

1 In the spring of 1755 Reynolds had produced his portrait of Peter Ludlow, following Van Dyck's whole-length of the Earl of Strafford, which was in the collection of Lord Rockingham at Wentworth Woodhouse in Yorkshire. Gainsborough's most celebrated example is perhaps *The Blue Boy*, whose sitter is mocked up in 'Van Dyck' costume.

2 Such associations could, of course, always be ambiguous. A rock may be a reminder of the solid and the staunch but is also, in itself, dull and stupid. In my opinion this doubleness was an important part of Van Dyck's sophisticated vision. By the eighteenth century, not least in many later Stubbs works, the rocky landscape would provide different associations and contexts, of which more will be said below.

CHAPTER 27

Wonderful Immensity

1 Boswell, 1831, vol. I, p. 70.
2 Ibid., vol. I, p. 434, where Boswell dates the conversation 5 July 1763. But Johnson's remark is not quoted in Boswell's London journal entry for that date, or for any other in 1763.
3 Boswell perfectly understood the centrality of conversation when he wrote, of his *Life of Johnson*, 'his conversation alone, or what led to it, or was interwoven with it, is the business of this work' (Boswell, 1831, vol. II, p. 229). It was William Smollett, in a letter of 1759 to John Wilkes, who called Johnson 'the Great Cham of Literature'.
4 Boswell, 1831, vol. II, p. 77.
5 The first halting steps towards a police force were taken by the Fielding brothers, magistrates at Bow Street court. Henry Fielding, the novelist, had obtained secret service money in 1749 to establish the small band of Bow Street Runners, which proved highly successful in reducing the number of local felonies.
6 Jarrett, 1974, p. 14. This was not just a London thing, as we have already seen in the Leeds Turnpike Riots, see pp. 41–42 above.
7 Ibid., 1974, pp. 48–9.
8 Johnson, 1950, p. 258. The passage is from *The Rambler*, no. 185.

CHAPTER 28

Ridicule and Applause

1 OH, p. 202, col. 2. See also Lippincott, 1983, p. 160.
2 The fashion-conscious Horace Walpole had himself painted in 1757 by Reynolds, proudly posing with a Grignion print, commissioned by himself, of an antique marble.
3 Albinus's book had been published at Leyden in 1747, illustrated by Jan Wandelaar's delicate plates.
4 Ozias Humphry's explanation for the drawings' failure is rather different: 'Many of the drawings were of entire figures – but others were of parts only, such as Ears, Noses and Limbs; so that the engravers, who had been unaccustomed to such studies, & not understanding them, were fearful of being bewildered' (OH, p. 202, col. 2). This is not particularly coherent. That there were separate studies of 'Ears, Noses and Limbs' is not surprising, although no such sheets have survived among those in the Royal Academy library. Nor, in the published work, is there anything corresponding to such studies. Whatever happened to them, it is not at all clear why an engraver in eighteenth-century London should have been bewildered by such details. A better explanation for Stubbs's rebuff might be that, as an unknown, penny-plain, provincial anatomist, working on mere animal anatomy, he was demanding apparently inflated financial terms.
5 The mention of this arrangement with Reynolds comes in a marginal gloss by William Upcott in the margin of his father's manuscript (OH, p. 203, col. 1). In the sale catalogue, this painting is 'No. 67: PORTRAIT OF THE MANAGED HORSE, originally painted by Mr Stubbs for Sir J. Reynolds' (see Fredericksen, 1990).
6 For a discussion of this theme, see ch. 39, p. 183.
7 Aylward, 1953, p. 58.
8 Angelo, 1828, p. 29. Domenico Angelo moved from Leicester Fields to Carlisle House, on Soho Square, in 1763.
9 Aylward, 1953, p. 28.
10 Of the young Whig noblemen mentioned, only Bolingbroke and Grosvenor were not fully 'paid up' members of the Rockingham political group. Although little interested in

politics, Bolingbroke was closer to the Duke of Bedford's interest than to Rockingham's, while Grosvenor was a Pittite. See their entries in Namier and Brooke, 1964.

11 Mingay, 1963, p. 151; Foreman, 1998, p. 17; Bloy, 1986, p. 50.
12 Willey, 1940, p. 1.

CHAPTER 29

Goodwood

1 Discussions of individual series which I have found particularly useful include: Millar, 1963, cat. nos 1109–21 (paintings for the Prince of Wales); Taylor, 1965 (the 'lion and horse' series); Russell, 1980 (the Southill series); Barrell, 1980, pp. 25–31 (*Haymakers* and *Reapers*); Egerton, 1984, cat. nos 73–6 (the 'shooting' series).
2 And the cartoons on which they were based. A highly prized example is Raphael's set of New Testament cartoons, now in the Victoria and Albert Museum.
3 Tillyard, 1994, p. 15.
4 Egerton, 1984, no. 28.
5 In the Paul Mellon Collection, Upperville, Virginia. See Egerton, 1984, no. 170.
6 Lennox-Boyd et al., 1989, nos 75, 78–80.
7 Reese, 1987, p. 208.
8 Quoted Tillyard, 1994, p. 86.
9 As Judy Egerton points out, the Havannah expedition sailed on 5 March 1762, with Albemarle as the newly appointed C-in-C. Stubbs's memory may have confused this appointment with an earlier promotion.
10 Egerton, 1984, no. 31.
11 As suggested in JE, no. 28. A preparatory sketch for this detail, in oil on paper and one of the few surviving working sketches by Stubbs, is in the YCFBA.
12 Deuchar, 1988, p. 51.
13 In the collection of Tate Britain.
14 'a tangential meeting of two objects which do not in fact lie in the same plane or at the same distance from the eye', Taylor, 1957, p. 9.

CHAPTER 30

The Grosvenor Hunt

1 Kimbell Art Museum, Fort Worth. JE, no. 49.
2 OH, p. 203, col. 1; JE, no. 38.
3 For Stubbs and Lord Grosvenor, see Egerton, 1979.
4 Taylor, 1955, p. 24.
5 Taylor, 1971, opposite p. 49.
6 Jean-Baptiste Oudry's large painting *Louis XV Hunting the Stag in the Forest of St Germain* (1730) has a similar design to *The Grosvenor Hunt* and it is possible Stubbs knew about this work, though he can hardly have seen the original since it was privately owned by the King of France. There are a number other intriguing parallels between Stubbs and Oudry, including a pronounced interest in the conflict of big cats and wild horses.
7 Stanhope, 1774, letter dated 30 June 1751.
8 *The Connoisseur*, no. 78, 24 July 1755. Quoted Pears, 1988, p. 18. The articles in this periodical were written chiefly by George Colman and Bonnell Thornton, well-known wits who formed the backbone of the Nonsense Club. Their ideas about oafish squires may have been infected with a degree of nonsense, but the point is that many people shared them.

9 Waterhouse, 1978, p. 132.
10 Dorment, 1986, p. 381.

CHAPTER 31

Rockingham

1 A detailed account of Rockingham's county activities and finances are in Bloy, 1986.
2 Wilson, 1765, p. 3.
3 See Armytage, 1956, p. 69, for Rockingham's experiments on coal. Bloy, 1986, pp. 98–111, considers the mining operations in detail.
4 Young, 1771, vol. I, xvi.
5 Darwin, 1859, ch. 11.
6 This was first done by H. F. Constantine, see Constantine, 1953.
7 Egerton, 1984, no. 35.
8 OH, p. 206. A 'scrub' meant an individual of stunted growth, a runt.
9 This painting is now in the collection of Lord Halifax.
10 JE, pp. 125–31.
11 OH, p. 205, col. 1.
12 The most formidable doubter is Judy Egerton: 'The notion that Whistlejacket was designed to bear a rider is likely to have arisen only in the minds of those to whom the idea of a horse as sole hero of a huge canvas was unprecedented', JE, p. 245.
13 Quoted JE, p. 245.
14 Taylor, 1971, p. 206.
15 As pointed out by Malcolm Warner in Warner, 2004, p. 11.
16 OH, p. 205, col. 2. The life-size of Scrub is in a private collection.

CHAPTER 32

Political Paint

1 So, quite soon, would William Pitt, the 'Great Commoner', but he was not so close to the Rockinghams.
2 Hoffman, 1973, p. 45.
3 For a historical treatment of these events, see O'Gorman, 1975, chs 1 and 2. O'Gorman argues that Rockingham's party stood as a bridge between the old Walpolean or Pelhamite system and true party politics, a transition whereby 'the politics of place [i.e. patronage] gave way to the politics of issues and conditions, of ideology and theory' (p. 19).
4 For a full discussion, see Fordham, 2004, ch. 4.
5 John Sunderland saw this painting, conversely, as sympathetic to the Queen and critical of the King for his inhumanity towards his mother (Sunderland, 1974, p. 321). But, as he mentions, one of King Edward's complaints against his mother was that she had taken the Bishop of Winchester as a lover, which looks a very topical reference in 1763, when an affair between Bute and Queen Mother Augusta was widely believed in.
6 'What worse captivity?', part of Hermione's cry for help to Orestes to be rescued from her hateful Spartan marriage, in Ovid's *Heroides* VIII. The phrase was used from time to time as a Jacobite motto.
7 Taylor, 1965, in an appendix, lists nine such paintings completed between 1762 and 1771. Six of the horses are whites.
8 OH, p. 209, col. 2.

Chapter 33

Somerset Street

1 'A New and Correct PLAN of the CITIES and suburbs of LONDON and WESTMINSTER & Borough of SOUTHWARK with the COUNTRY adjacent, the NEW BUILDINGS, ROADS &c. to the year 1763 from an ACTUAL SURVEY corrected and engraved by J. Gibson'. Reproduced in Picard, 2003 (endpapers). The fact that this map went out of date between Gibson's survey and his map's publication gives some idea of how quickly these streets were built.

2 Gilbey, 1898, pp. 48–51. Sir Walter Gilbey (1831–1914) was an authority on horses, especially shires, and the first Victorian Stubbs enthusiast to amass a significant collection of his paintings. He was also the distiller of Gilbey's London Gin. In describing 24, Somerset Street, as Basil Taylor wrote in 1971, he 'does not declare the identity of his description – evidential or speculative – or refer to any source for his statement, so it is unusable' (Taylor, 1971, p. 57). Nevertheless I think it reasonable to suppose that Gilbey personally inspected the house before it was dismantled (he tells us that in 1898 'hardly a brick of it now remains'). Gilbey also collected books and papers about Stubbs and may have had some documentary authority, for he places six words about the Stubbs studio in (unreferenced) quotation marks. On this basis, and with Taylor's warning in mind, I think it worth reprinting some of what he says.

3 Gilbey, 1898, p. 50.

4 Brewer, 1997, p. 224.

5 Ibid.

6 See p. 60 above.

7 THSLC, vol. VI (1854), pp. 62–3. George Romney had recently returned from Italy, after his tour with Ozias Humphry, and his Cavendish Square studio was a well-known attraction. Marylebone Gardens had opened in 1737 as a fashionable pleasure garden, but had been a resort for day trips from town since the time of Pepys, who appreciated its noted bowling green.

8 THSLC, vol. VI, p. 66. This John Holt (1743–1801) lived at Walton, near Liverpool. He was no relation of either his namesake the schoolmaster of Kirkdale and the Warrington Academy (who had recently died) or of Stubbs's early anatomical adviser Dr Ralph Holt of 8 Red Cross Street, Liverpool (who still lived). An etched portrait of Stubbs's visitor by one of his pupils is reprinted in loc. cit., p. 57.

9 *A small rough lap dog painted for Mrs French* was sold in the Peter Coxe sale.

10 *The Gentleman's Magazine*, October 1806, p. 895. Reprinted Hall, 2000, pp. 198–9. The author was probably William Upcott.

11 JF, 11 November 1796.

Chapter 34

Stud and Groom

1 Quoted by Namier and Brooke, 1964, vol. 3, under 'Jenison Shafto'. Arthur's Chocolate House was in St James's, 'the resort of old and young; courtiers and anti-courtiers; nay, even ministers' (Lady Hervey in 1756, quoted Weinreb and Hibbert, 1993, under 'Arthur's').

2 Whyte, 1840, p. 468.

3 JE, no. 41.

4 Ibid., no. 90.

5 The first appearance of a covering shed in a stallion portrait seems to be *The Duke of Ancaster's Bay Stallion Spectator, held by a Groom* (JE, no. 45). Neither this painting nor the Grosvenor mares is dated, but they were probably done at about the same time. The covering shed appears identical in both works. Similar sheds are also seen in seven

of the stallion portraits that Stubbs exhibited at the Turf Gallery in 1794: the Godolphin Arabian, Dungannon, Sweetbriar, Anvil, Protector, Mambrino and Sweetwilliam.

CHAPTER 35

Horses in Training

1 TN, 1809, p. 49.
2 JE, no. 37.
3 Ibid., no. 43. Barret arrived from Dublin in 1762 and the painting was exhibited at the Society of Artists in 1764.
4 Ibid., nos 52 and 53.
5 There are two extant versions, one at the Jockey Club Rooms, Newmarket, the other in a private collection (JE, no. 55). The closed shutters of the King's Stand indicate that the background action is not an official race but a private trial, testing the mettle of Bolingbroke's new racer against one of Richard Vernon's and two of Grosvenor's. This may have been preparatory to the 1000 guineas match to which Bolingbroke successfully challenged Sir James Lowther's champion Ascham in July, in advance of which the owners would need to agree handicap weights (see p. 279). For this information I am grateful to Mr David Oldrey of the Jockey Club.
6 Later painters such as Herring tended to exaggerate this for dramatic effect, with the result that their galloping horses are impossibly flattened out with, in some cases, their bellies all but brushing the ground. A grotesque extreme is Benjamin Haydon's *Marcus Curtius Leaping into the Gulf (Exeter City AG)*.
7 Smythe, 1963, p. 50, explains that the galloping horse '*never* has more than two feet on the ground on any occasion, and these are always the two feet of the *same* side of the body, excepting during the one phase of the gallop, when the horse lands on two diagonal feet (opposite fore and hind) with the fore limbs advanced and both hind feet set rather far back. This is the nearest any horse ever gets towards adopting the conventional pose depicted by artists long ago, who painted all racehorses and hunters as constantly at full stretch, with the fore limbs reaching out past the head in front and the hind limbs similarly stretched out behind the body.'
8 Holcroft and Hazlitt, 1926, p. 39.
9 Vernon was the owner, and Watson the trainer, of the second horse in the trial shown in *Gimcrack on Newmarket Heath*.
10 Holcroft and Hazlitt, 1926, pp. 43–4.
11 Ibid., p. 42.
12 Ibid., p. 45.

CHAPTER 36

Flemish Stubbs

1 JE, no. 80. Dorment, 1986, pp. 382–4 (illustrated).
2 A restored and exceptionally splendid example of a seventeenth-century deer-coursing paddock with a stone-built grandstand (the latter once thought to have been designed by Inigo Jones) is at Lodge Park, Sherborne, Dorset, now owned by the National Trust.
3 Stubbs's posthumous studio sale associated a *Landscape with a Stag* with *A Scene from Nature in Goodwood Park* by including them both in the same lot, 54 (Fredericksen, 1990, p. 952).
4 One well-known example would be Rubens's *Landscape with a Boar Hunt*, painted 1616–18, where a hound leaps from the right foreground to join in the fray at the death of the boar (Gemaldegalerie, Dresden). A simpler treatment of the pattern is in Van Dyck's mythological oil sketch for a lost or abandoned painting, *Two Nymphs*

Hunting a Stag (Museum Boymans-van Beuningen, Rotterdam), which concentrates on one stag and a single dog. There are several similar Deer Hunt compositions by Paul de Vos – one in the Prado, Madrid, and another in the Hermitage, St Petersburg. The leaping posture of the dog is so common in these works as to be idiomorphic for Rubensian hunting art. It perhaps derives ultimately from a Hellenistic marble in Rome of a leaping hound, which Stubbs himself could have seen in 1754.

5 OH, p. 204, col. 1.
6 Ibid.
7 Russell, 1980.
8 JE, no. 46.
9 Private collection, illustrated in British Sporting Art Trust, 1980, p. x.
10 Horace Walpole to Lady Ossory: 'poor Mrs Byng. I remember at the time that Lord Torrington was the sole cause of his brother's ruin' (1 August 1780); and, 'What must Lord Torrington feel, if he has any feeling, to know his brother eats the bread he has from a Minister whom the elder has always opposed? This I should think would wound one to the quick' (12 September 1780).
11 Byng, 1954, p. 1.
12 See ch. 37 below.
13 In the case of *Labourers,* this has been shown by X-radiography, see Dorment, 1987, p. 386.
14 The other is the oil painting on wooden panel, dated 1779, at Upton House (National Trust).
15 *Gamekeepers* was not repeated by Stubbs and the original has not been X-rayed as far as I know. It has been suggested that Stubbs originally included a view of Southill House (Lennox-Boyd, 1989, no. 88).
16 Stubbs published his *Labourers* on New Year's Day, 1789; Beale brought his out on 2 January 1790.

Chapter 37

Game Law

1 The title of the print issued by Benjamin Beale Evans in 1790 (Lennox-Boyd, 1989, cat. no. 88), although in fact only one keeper is represented.
2 Daniel, 1813, vol. 4, p. 94.
3 Auden, 1957, pp. 236–7.
4 Fielding, 1749, Book III, ch. 2.
5 Deuchar, 1988, pp. 98–105.
6 Daniel, 1812, vol. 1, p. 201.
7 Ibid.
8 Ibid., pp. 272–5.
9 They now hang together at YCFBA.
10 JF, XIV, p. 5006 (20 April 1817). See also Lennox-Boyd, 1989, p. 94.
11 Cobbett, 1930, vol. 1, pp. 293–4.
12 See LB, p. 60; Vandervell and Cole, 1980, p. 100. The problem was remedied in 1787, with the introduction of Henry Nock's Patent Breech.
13 The Rev. Daniel would not have been surprised, however. 'In October the Lapwings are very fat, and are then excellent eating . . . In October and November they are taken in the Fens in Nets, in the same manner as the Ruffs are, but are not preserved for further fattening, but killed as soon as caught,' Daniel, 1812, vol. 3, p. 169.
14 LB, p. 90.
15 *Eclipse with William Wildman and his two Sons* is in the Baltimore Museum of Art, Baltimore, Maryland. Unlike the *Shooters*, it is heavily restored, which tends to blunt the resemblance.

16 LB, pp. 92–3. But see the doubts of Judy Egerton in Egerton, 1986, p. 93. She points out that, alone of the Stubbs works in Wildman's collection, the family did not sell his portrait with Eclipse, and feels they would also have retained the shooting paintings if these, too, had contained his portrait. On the other hand, the fact that the painting depicted illegal acts might have swayed the family towards selling, while Eclipse was a very much more notable associate than Thomas Bradford.

17 George Morland, Henry Alken and Dean Wolstenholme were among the more accomplished artists to produce shooting narratives in four scenes.

18 Auden, 1957, p. 214.

CHAPTER 38

This My Performance

1 Unsigned review of *The Anatomy of the Horse*, 'The monthly catalogue for February', *Monthly Review*, 1767, p. 160.

2 Rockingham paid Stubbs £194.5s. for five pictures in August 1762. See Constantine, 1953.

3 Penny, 1986, p. 58.

4 Note that the price is not calculated on the area of the canvas, but on its longest dimension, with other factors such as the number of figures coming into play. Had it been based on square inches, the big paintings would have cost six times more than *Scrub*, an unlikely differential and one not used by artists of the time.

5 Economic History Services website (eh.net).

6 OH, p. 203, col. 1.

7 Ibid.

8 The Green prints were *Phaethon*, *The Horse and Lion*, *Brood Mares*, *Lord Pigot* and *The Lion and Horse* (LB, nos 2–7).

9 Doherty, 1974, p. 11; LB, p. 41.

10 Given in facsimile by Doherty, 1974, Appendix I.

11 Ibid., p. 317.

12 Stubbs, 1766, p. 42.

13 See p. 110 above.

14 *Monthly Review*, August 1767, p. 160.

15 Reprinted in *The Gentleman's Magazine*, October 1806, p. 896, and in OH, p. 210, col. 1.

16 Ibid.

CHAPTER 39

Myth Making

1 OH, p. 202, col. 2.

2 Taylor, 1971, Appendix I, p. 53.

3 3.iv.178–9.

4 Saltram House, Devon (Morley Collection), National Trust. The story of Phaeton is told in Ovid's *Metamorphoses*, Book II.

5 LB, nos 3 and 8. See ch. 45 below.

6 Quoted JE, no. 79.

7 Quoted Dalrymple, 2002, pp. 123–4.

8 The judgement is quoted by JE, no. 79, from Archer, 1979, p. 413.

9 Taylor, 1965, Appendix; JE, p. 91. Taylor notes nine oil paintings, two enamels, three prints and one modelled relief. JE adds a tenth oil (no. 63). LB, nos 4 and 7, refer to two more unlocated paintings and a third, the collaboration with Barret, is mentioned

below.

10 JE, p. 102. It has even more recently been discovered (by Paul Bahn, Paul Pettit and Sergio Ripoll in April 2003) that some of the cave walls also display Europe's most northerly rock art. They show the outlines of animals hunted by palaeolithic man.

11 Burke, 1958, p. lvi.

12 Ibid., p. 61. Burke misquotes the Book of Job, 39:19, 20, 21.

13 Burke, 1958, p. 293.

14 These include *Antinous* for the Duke of Grafton, JE, no. 43.

15 From the *Memoirs* of Humphrey Repton, quoted Daniels, 1999, p. 157. 'Salvater' is Salvator Rosa and 'Redinger' is Johann Ridinger, engraver (chiefly) of animal subjects.

16 'I have a picture of Barret and Stubbs. The Landscape by Barret and a horse frightened at the first seeing of a Lion by Stubbs. I got it for 5 guineas,' from a letter Hunter wrote in 1778, quoted in JE, no. 66. The amount of 5 guineas suggests a small piece, but no such work is known today.

17 Burke, 1958, letter to James Barry dated 24 August 1767. Wright may alternatively have been Stubbs's Liverpool friend the marine painter Richard.

18 Review of *The Anatomy of the Horse* in the *Monthly Review*, August 1767, p. 160.

CHAPTER 40

Eclipse

1 *The Sportsman's Repository*, 1820, p. 37. Cook, 1907, reproduces several of Sartorius's paintings of the horse which, disappointingly after reading this, are all equally wooden.

2 *The Gentleman's Magazine*, April 1764, p. 193.

3 HW, letter dated 29 December 1763 to Lord Hertford, vol. 38, p. 272.

4 The amount varies from one source to another, 40 to 80 guineas. Applying the suggested factor of 100 for Georgian prices gives a modern equivalent of £4000–8000, in other words, a great bargain. See Cook, 1907, p. 74.

5 Ibid., p. 77.

6 It is sometimes said that O'Kelly's bet was struck over one of Eclipse's later, Newmarket outings. But I agree with Cook, 1907, p. 79, who argues that by that time Eclipse's ability to distance his field was well known, not least to the Newmarket gambling fraternity.

7 LB, no. 32.

8 Of the two plain landscape studies of the rubbing-down houses on Newmarket Heath, the one corresponding to the painting of Gimcrack rubbing down is in Tate Britain, while the one used for Eclipse is in YCFBA. See JE, nos 52 and 53.

9 There is some dispute about whether the jockey was Oakley or Sam Merrit. Cook found that 'it was nearly always Oakley who rode him', though 'at York in 1770 he was ridden by S. Merriott', Cook, 1907, p. 78.

10 See ch. 37, above, p. 175 and n. 15.

11 The prints are LB nos 31 and 32.

12 Cook, 1907, p. 132.

CHAPTER 41

Conversation

1 *The Spectator*, vol. 3, no. 414, pp. 551–2.

2 Quoted Jarrett, 1974, p. 155.

3 Devis, 1712–87, had much of his practice in the north-west, but he was based at Great Queen Street in London.

4 Waterhouse, 1978, p. 194. For the most complete recent treatment of Devis, see Sartin, 1983.
5 JE, no. 108.
6 Judy Egerton suggests that the battlemented tower in the picture represents Pontefract Castle, a reminiscence of Saltonstall's origins.
7 Piper, 1992, p. 133.
8 JE, no. 107. The painting, dated 1769, is in the National Gallery of Art, Washington DC.
9 In the National Gallery, London (NG 6429) and the subject of a brilliant essay by Judy Egerton in Egerton, 1998, pp. 248–55.
10 Walpole, 1939, p. 79. But this annotation is said not to be Walpole's.
11 Quoted Foreman, 1998, p. 49.
12 Lord Glenbervie, quoted Foreman, 1998, p. 48.
13 According to Bell, 1936.
14 Graves and Cronin, 1899–1901, vol. 2, pp. 682–3. The purloined portrait of Sophie Musters by Reynolds, in which she poses with her pet spaniel, was found after George Augustus's death at the Brighton Pavilion and is now at Petworth House. The spaniel Fanny was also painted by Stubbs, twice. For further details see JE, nos 116 and 117.
15 JE, p. 158.

Chapter 42

Troubles at the Society

1 Strange, 1775, pp. 68–9.
2 Ibid., p. 65.
3 *Conduct of the Academicians*, p. 14.
4 The missing pages covered November 1764 – March 1765, and June 1765 – March 1766. See ibid., pp. 20–1. An examination of the Society's minute books, now held in the Royal Academy Library (SA/2 and SA/3), confirms this.
5 *Conduct of the Academicians*, p. 15.
6 From the *Memoirs* of the landscape artist Thomas Jones, quoted Allen, 1987, p. 7.
7 Edwards, 1808, under Robert Edge Pine. Later, in America, Pine (1730–88) painted a famous portrait of George Washington.
8 Sunderland, 1974, p. 322.
9 Stevenson, 1952, pp. 111–13; Clark, 1966, pp. 559–63.
10 Corner, 1952, p. 135.
11 Strange, 1775, pp. 91–9. *Conduct of the Academicians*, p. 39.
12 Announced in *The Gentleman's Magazine*, 7 August 1770. See LB, p. 12.
13 Quoted LB, p. 11, n. 9.
14 Brewer, 1997, pp. 236–8.
15 LB, p. 17.
16 Williamson, 1918, p. 40.
17 Of his 1773 paintings, *Landscape, a Farmyard with Cattle* strikes an interesting new note, and the two-year-old *Portrait of a Kangorou from New Holland* was to become a very well-known image through its use in natural history books for the next seventy years. LB gives details of 111 repetitions or near-copies of it (nos 361–472), mostly in natural history books, the latest dated 1852. Never having seen a live kangaroo, Stubbs had worked from a stuffed skin brought back by Captain Cook and made as a result some unavoidable anatomical mistakes.
18 OH, p. 203, col. 2. As a reflection of how little work he had been doing, Stubbs had just one exhibit in the 1774 show, predictably *A Portrait of a Horse*.

Chapter 43

Enamel

1 The paintings were shown together, nos 301–4. *Euston* was recently sold at Sotheby's, London, for £2.5 million (30 November 2000, lot 9). The Pomeranian has been identified as *Mouton, a Dutch Barge Dog*, i.e. a Keeshound rather than the more commonly seen Pomeranian, though both were classed as Spitz dogs and probably no great distinction was made between them. See Fountain and Gates, 1984, no. 13. Cosway's dog and the monkey are JE nos. 99 and 85.
2 Hazlitt, 1856, p. 296.
3 John Towneley to his brother Charles, who was a close friend of Cosway, in August 1773, quoted Lloyd, 1995, p. 30. The monkey painting, which is dated 1774, could have been in progress when Cosway was bitten, or painted posthumously from drawings taken from life. But this is pure speculation. It was not uncommon for monkeys to be kept as pets – Atkinson, 1834, tells us, for instance, that John Burton had one in York. The Dr Hunter mentioned by Towneley could have been either William or John, both of whom were also among Stubbs's friends.
4 Shepherd, 1984.
5 OH, p. 203, col. 2.
6 Ibid., p. 204, col. 1.
7 Published in 1721. In the 1790s William Upcott (transcriber of his father Ozias Humphry's life of Stubbs) made a translation, also for his father. It was unpublished but the MS survives in the library of the National Gallery, London. Given the friendship of Stubbs and Humphry at this time, Egerton's suggestion that Upcott worked from Stubbs's copy is an attractive one. See Hall, 2000, p. 50.
8 OH, p. 203, col. 2.
9 Taylor, 1975, no. 94.
10 JE, no. 2.
11 Ibid., no. 65.
12 An alternative source is Reni's *Virgin and Child*, in which Mary covers the sleeping infant with a sheet. Stubbs could have seen the original in Rome but, in any case, there was a popular engraving by J. Gerardin. On these paintings see Pepper, 1984, nos. 115 and 117.
13 See Pepper, 1984, no. 115, where Lord Grosvenor's purchase of a replica is noted, as is the print. Another copy is listed in the Earl of Yarborough's collection until 1929. Stubbs, of course, knew the first Earl, but Pepper gives no indication of when the Yarborough copy was acquired. An imprint of Boydell's print was owned by Robert Strange, who later sold it to Stubbs's friend Dr William Hunter.
14 She did not, for instance, sell a portrait of herself 'as Circe' (an interesting characterisation) by William Caddick of Liverpool, apparently painted in 1780, nor her portrait by Stubbs's pupil Miss M. Stewart. See Fountain, 1984, p. 2 and n. 42. Caddick's unlocated painting was exhibited at the Royal Academy in 1780. See MPPP, p. 64.
15 The Infants fetched a guinea apiece. *Hope Nursing Love*, on the other hand, must have been a finished painting, as it fetched 10 guineas. Frederickson, pp. 955 and 956.
16 OH, pp. 203–4.
17 Ibid., p. 204, col. 1.

Chapter 44

The Wide Creation

1 'By an Impartial Hand', *The Exhibition: Or a Candid Display of the genius and Merits of the Several Masters, whose Works are now Offered to the Public at Spring Gardens*

(1766). The impartial hand has not been identified.

2 From a handbill advertising the exhibition of the zebra, reproduced Cormack, 1999, p. 38.

3 Ibid.

4 Job 39:6–7.

5 Quoted Fordham, 2004, p. 48.

6 Ibid.

7 Stubbs's painting was exhibited at the Society of Artists in 1763 alongside *Lord Grosvenor's Bandy* and the two great lion paintings for Rockingham, and was the fourth of his works to be issued as a print, in July 1771, under the name of his son, George Townley Stubbs. See LB, no. 26.

8 Porter, 2001, p. 144.

9 It seems unlikely that many eighteenth-century women were shown van Riemsdyck's pictures. Even today they are capable of affronting feminists: 'More than a discourse on fetishism, these images evoke notions of the "abject" female womb-body which, according to psychoanalyst and theorist Julia Kristeva, is as much related to perversion as it is to horror,' Ludmilla Jordanova in Peatherbridge and Jordanova, 1997, p. 86.

10 Scott, 2003, p. 316, n. 45.

11 Lever's dates are 1729–88. I have not traced any direct links between Stubbs and this remarkable, obsessional collector, whose personal museum, 'Sir Ashton Lever's Holophusikon', opened at Leicester House in 1774 and filled sixteen rooms with specimens of natural history, geology and ethnology. However, some contact is quite likely. Lever, who also lived at Alkrington Hall, Middleton, Lancashire and owned chunks of central Manchester, was a nephew of John Blackburne of Orford and a great sportsman, who hunted in Lincolnshire, established horse racing at Manchester and founded a society for the promotion of toxophilia, or archery. Joseph Banks hated Lever and, when the latter ran into financial difficulties, Banks successfully opposed the British Museum's purchase of the enormous but unsystematic Lever collection. The whole story of the Holophusikon is told in Smith, 1962.

12 The third Duke's mother who amassed a huge collection of natural specimens at her museum, the posthumous sale of which in 1785 was a marathon event lasting thirty-eight days (see Walpole, 1936). The Duchess was one of the period's foremost patrons of natural science but her collection resembled that of William Constable in that it also held classical artefacts, art objects and all sorts of *vertu*. She bought the Barberini Vase (later known as the Portland Vase) from Sir William Hamilton for £2000 in the last months of her life. It was from this that Josiah Wedgwood made the copy which he regarded as his finest production.

13 The classic and unbeatable analysis of this is Lovejoy, 1936.

14 Alexander Pope, *An Essay on Man*, Epistle I (1733), lines 237–58.

15 PTRS, vol. 58, December 1758, pp. 34–45.

16 The American moose and the European elk are the same animal, though this was then a matter of debate. Gilbert White of Selborne mentions the question in Letter XXIX (12 May 1770) of *The Natural History of Selborne* after describing a disappointing visit to Goodwood to look at the Duke's cow moose. The animal had died before he could get there and White found the stench it's corpse gave out 'hardly supportable'. This was several months before Stubbs's bull moose arrived.

17 This Indian antelope is generally now called the nilgai and is less numerous in India than in Texas, where it was originally introduced for hunting.

18 PTRS, vol. 61, February 1771, p. 170.

19 His paper is still in the Hunter Papers at Glasgow University. It was eventually published by Rolfe, 1983.

20 I am indebted to Kemp, 1992, in my general account of Hunter's aesthetic, as well as for certain details.

21 Quoted Kemp, 1992, pp. 80–1 and 83.
22 Ibid., 1992, p. 83.

CHAPTER 45

Printmaker

1 See ch. 37 above.
2 LB, no. 2.
3 It was published as *Phaëthon*, ibid., no. 3.
4 As argued by LB, pp. 68–9.
5 Ibid., p. 73, figure 51.
6 For details of the Green series, see ibid., nos 4–9.
7 Hall, 2000, no. 4.
8 See LB, Appendix II, a biographical essay which heads a preliminary checklist of G. T. Stubbs's work in printmaking. I am indebted to the information that this gathers together.
9 On Whesson, see LB, nos 15 and 16.
10 Ibid., no. 70.
11 Ibid., nos 19–21.
12 Ibid., p. 108.
13 Ibid., nos 46–8.
14 Ibid., no. 59. The painting is JE, no. 62.
15 Parris, 1974, p. 5.
16 JE, p. 19, note 16. The fact that he is not also called an artist is not really significant since bankruptcy proceedings could only relate to his activities as a tradesman.
17 The attribution is convincingly argued in LB, p. 374.
18 Ibid., figures 65, 66.
19 JE, p. 19, figure 5.
20 LB nos. 82 and 83.

CHAPTER 46

Wax and Wedgwood

1 I have drawn information from Mayer and Myers, 2004, for information on this subject.
2 Cited ibid., n. 65.
3 The most important clues about ancient Greek paints are in Lucian and Pausanias and the Roman encyclopaedist Pliny the Elder.
4 Shepherd, 1984. As this author notes, some of these substances '(e.g. beeswax or non-drying fats) are most susceptible to attack by those solvents that the most conscientious restorer would have considered "safe" (e.g. turpentine) . . . Thus, unwittingly, damage was done.'
5 See Hilary Chelminski, www.chelminski.com.
6 Hall, 2000, no. 18. This enamel is in a private collection in Canada.
7 OH, p. 204, col. 1.
8 The reciprocal relationship between Wedgwood and Bentley is explored by Burton, 1976, pp. 35–41.
9 Burman, 1997, p. 82.
10 Vincent-Kemp, 1986, p. 22.
11 Wedgwood to Bentley, 5 March 1774, quoted Burton, 1976, pp. 136–7.
12 Wedgwood to Bentley, 18 October 1777.
13 JE, no. 86.

14 Tattersall, 1974, item C. As already noted, his initial enamel on copper had also been a *Lion and Stag*.
15 Wedgwood to Bentley, 17 October 1778. I take it that he was trying to fire them in a diagonal position to exploit the largest corner-to-corner dimension of the furnace, for he writes, 'I only want an inclin'd plane [support?] that will stand our fire.'
16 Tattersall, 1974, p. 117.
17 It was produced in other formats, including white relief on black basalt. See Hall, 2000, no. 29.
18 Reprinted by Taylor, 1961, p. 221.

CHAPTER 47

The Academy

1 Wolcot, 1816, vol. 1, p. 21.
2 These were catalogued as nos 173 (as *A Portrait of an Artist*, JE, no. 4), 79 (JE, no. 120) and 363 (presumably *Mrs French's Lap Dog*, Virginia Museum of Fine Arts).
3 Nos 70 and 120 respectively. The young lady was Isabella Saltonstall.
4 Quoted Brewer, 1997, p. 246.
5 Paintings were said to be skied when hung near the ceiling. This was a slight as it made them difficult to see.
6 Tattersall, 1974, p. 24.
7 HW, vol. 29, p. 137.
8 *Morning Chronicle*, 5 May 1781, cited Myrone, 2002, p. 51.

CHAPTER 48

Seasons

1 LB, p. 42. These prints are discussed in ch. 50, below.
2 In my discussion of this group of works I follow up suggestions made by Judy Egerton (JE, pp. 166–8) and Christopher Lennox Boyd (LB, no. 90).
3 The 1783 pair of paintings is at Upton House (National Trust); those of 1785 are in Tate Britain (JE, nos 124 and 125); of the enamels, two are in the Lady Lever AG, Port Sunlight, Merseyside and the other is in YCFBA. For the prints see LB, 89, 90.
4 Fredericksen, 1990, p. 953, and Gilbey, 1898, Appendix D.
5 John Barrell finds them 'the most refined and artificial images of the rural labourer that the century produced', which cut against the trend towards a more authentic depiction of country life in painters such as George Morland. Barrell warns against allowing the Stubbs paintings, replete with deceptive charm, to fuel 'a nostalgia for the eighteenth century as a period of imagined social and artistic stability'. See Barrell, 1980, pp. 25–7 and Williams, 1974, pp. 9–11.
6 William Marshall in 1785, quoted Jennings, 1985, pp. 83–4.
7 Ibid., p. 85.
8 From the 'Proeme' to *The Shepherd's Week*, Barrell, 1980, p. 13.
9 As pointed out by Judy Egerton. See JE, p. 168.
10 See ch. 37, p. 173 above.
11 Thomson, *The Seasons*, 'Summer', 352–70.
12 Ibid., line 1.
13 LB, no. 90.
14 This was unearthed by Martin Myrone. See Myrone, 2002, p. 59.

CHAPTER 49

Return to the Fray

1 Exhibited as no. 126. This may have been included at the request of the hunter's owner, as it seems unlikely Stubbs would at this stage have volunteered such a picture. For its purchaser, on the other hand, exhibition in the Great Room at Somerset House was prestigious, as well as increasing the value both of a piece and of the horse portrayed.
2 Formerly collection of the late Paul Mellon.
3 OH, pp. 204–5.
4 Grosvenor was by this stage in deep financial difficulties, though he still maintained a fairly reckless style of life. He did not, however, own this picture.
5 The *Georgics* of Virgil trans. Joseph Warton, 1763, Book III, lines 286–9.
6 Lawrence was writing in reminiscence of the exhibition in his *A Treatise on Horses and the Moral Duties of Man Towards the Brute Creation*, published 1798 and quoted JE, no. 128.
7 LB, no. 82.
8 Versions in the National Portrait Gallery, London, and Leicestershire Museums. See Moncrieff, 1996, p. 14.
9 Ibid., p. 15.
10 LB, no. 92.
11 Ibid. Full details are given here of the history of the print, which is exceptionally well documented, including the earliest survival of a British print's subscription list.
12 JE, no. 87.
13 Handbill preserved in the Walker AG, Liverpool.
14 Moncrieff, 1996, p. 59.
15 Walker AG, Liverpool.

CHAPTER 50

A Fable

1 See pp. 134–35 above.
2 Gay, 'The painter who pleased nobody and everybody', lines 12–25. The last three words allude to the practice by painters, which Stubbs followed, of charging patrons half their fee on signature, and half ('the second pay') on delivery.
3 It should be added that the Enlightenment was not always the enemy of traditional belief, but it demanded that belief always be tested against everyday reason – the philosopher John Locke's quality of 'reasonableness'. For a good recent summary of this enormous topic, see Porter, 2000, especially chs 3 and 5.

CHAPTER 51

Cosway and the Prince

1 William Hazlitt on Richard Cosway, Hazlitt, 1856, p. 296.
2 Maria Cosway, née Hadfield, an artist in her own right, had been born in Florence, where her parents kept a highly rated English hotel for Grand Tourists. It is not impossible that Stubbs stayed there during his own visit to Italy in 1754.
3 According to Ackroyd, 1995, p. 101.
4 *An Island in the Moon*, ch. 8 (Blake, 1927, p. 876). Quid is said to be Blake himself. One of the black servants mentioned, the African Quobna Ottoba Cugoano (a.k.a. John Stewart), became a leading campaigner against the slave trade. With Cosway's encouragement he lobbied the Prince of Wales on the subject and, in 1787, wrote a

pamphlet. See Lloyd, 1995, p. 46.

5 Barnett, 1995, p. 65. One of the wings of the house had been occupied for a time by Thomas Gainsborough.

6 Ibid., 1995, p. 67.

7 Blake's scorn would have been provoked by Cosway's emphasis on Venetian art, and on Rubens, whom Blake detested. But despite all this Cosway remained on friendly terms with Blake until the end of his life.

8 The ironies packed into this choice of subject must have been thought hilarious by the Prince's friends, and deeply provoking by his father.

9 27 November 1788, quoted by Barnett, 1995, p. 75.

10 Sir Philip Currie in his memoir of Cosway, printed in Daniell, 1890, p. xv. 'The shady side of Pall Mall' refers not only to Cosway's residence, but to the popular song, which ends 'In town let me live and in town let me die/For in truth I can't relish the country, not I;/If I must have a villa in London to dwell,/ Oh give me the sweet shady side of Pall Mall!' The subject of animal art does seem to have come up between Stubbs and Cosway, who owned a book of animal prints by the Dutch seventeenth-century artist-engraver Paulus Potter, with some of Stubbs's own animal prints interleaved. Though lacking an inscription, this (as suggested by Barnett, 1995, p. 38) might have been a presentation from Stubbs to his friend.

11 The Santhague portrait is now in very poor condition, having been damaged, like many of Stubbs's wax-painted panels, by inept cleaning. See OM, cat. no. 1114.

12 On Cosway and Blake, see Ackroyd, 1995, pp. 99 and 182. An official report on the Prince's debts and expenses in 1792 calculated that his annual stabling bills alone were £30,000, almost half his total income. This covered the purchase and upkeep of innumerable saddle horses, carriages and their teams, racing stables and studs, kennels, and deer parks at Bagshot, Kempscott and Brighton. See Aspinall, 1963–9, vol. 2, p. 226.

13 She was Dorothea Jordan, the actress, who eventually bore ten royal bastards by the Duke, five sons and five daughters. In 1791, when his lease at Schomberg House expired, Cosway himself moved back to Marylebone, at an address in Stratford Place, round the corner from Somerset Street.

14 For the deer park John Brookes supplied fourteen and a half brace of deer (at £50 a brace) in 1791–2, one brace of which became the subject of Stubbs's *A Red Deer, Buck and Doe*. See OM, cat. no. 1126.

15 *The Prince of Wales on Horseback* (1791), *A Rough Dog* (1790) and *A Portrait of Fino and Tiny* (1791), OM, cat. nos 1109, 1125 and 1124.

16 Longrigg, 1972, p. 73. This form of race, in which the weights carried by the field are adjusted according to their previous performances, aims to even out the field and make the outcome harder to predict and is today the staple of everyday racing throughout the world. Match races, on the other hand, had been run as handicaps for generations.

17 Quoted Rice, 1879, vol. 1, p. 82. The picture is OM, cat. no. 1118.

18 For further details of the affair, see Laura Thompson's full account in Thompson, 2000, pp. 98–110.

19 Ibid., p. 109. The Prince did not give up racing altogether, although he always boycotted Newmarket. His favourite racing haunts from now on were Brighton, Lewes and Ascot.

20 *Lady Lade* is OM, cat. no. 1112.

21 Ibid., cat. no. 1115.

22 Ibid., cat. no. 1117.

CHAPTER 52

The Turf Gallery

1 OM, p. 122.

2 OH, p. 207, col. 1.
3 Ibid., col. 2.
4 The dinner is described in Whitley, 1928, vol. 2, p. 110.
5 *Sporting Magazine,* January 1794, p. 210, reprinted Taylor, 1971, p. 59.
6 Warner, 2004 (b), pp. 1–16.
7 The choice of Conduit Street may have been influenced by the fact that Stubbs's Lincolnshire patron Robert Vyner's town house was there. See Fountain, 1984, n. 29.
8 LB, p. 235.
9 LB, p. 54. It had been originally stated that each printed number would contain three plates but this was soon scaled down to one, as is shown by two copies of the letterpress in Keeneland, Va, one of each number, which are apparently unique survivals. These have just a single plate each. (I am grateful to the Keeneland library for this information.)
10 TN, 1809, p. 51.
11 Ibid.
12 LB, cat. nos 99–125.
13 For these arguments see JE, no. 95, and Taylor, 1971, p. 21.
14 LB, 1989, pp. 43–55.
15 OM, cat. nos 1113, 1119 and 1120.

CHAPTER 53

Comparative Anatomy

1 See for example Bacon's essay 'Of Deformity', and Descartes, *Passions de l'Ame* (1646).
2 Wordsworth, *The Prelude* (1850), VII, 628–9.
3 Physiognomical handbooks were still in print up to fifty years ago. See Rees, 1955, in which one can read that a snub nose signifies an immature nature, undeveloped intellect and mediocre mind, while thick lips denote gross sensuality, uncontrolled passion and appetite (p. 55 and figure 28).
4 From 'My First Acquaintance with the Lake Poets' in Hazlitt, 1930, pp. 46–7.
5 It is quoted by Leonardo's early biographer Giorgio Vasari.
6 Lavater, 1789, p. 12.
7 In his German text Lavater has two brief paragraphs on this animal, explaining 'I am but little acquainted with horses'. His translator, as we have seen, was better informed and Holcroft adds a further three and a half pages of his own on the subject. See Lavater, 1806, pp. 229–32.
8 As pointed out by Deuchar, 1988, who maintains that Stubbs was trying to answer criticism of his images as insufficiently demonstrative (pp. 148 ff.). I would argue that Stubbs began the 'lion and horse' series even before he suffered serious criticism of this kind, and that his interest in Le Brun, as in Burke's Sublime, formed part of the theoretical framework he applied to the representation of nature.
9 LB, nos 135–8.
10 Darwin, 1796, vol. 1, p. 397.
11 OH, p. 207, col. 2.
12 JF, vol. II, p. 597.
13 LB, p. 313.
14 Singer, 1962, p. 407.
15 Quoted Parris, 1974, p. 6 and n. 14.
16 Everard Home, biographical preface to Hunter, 1794. Quoted Parris, 1974, p. 15, n. 13.
17 OH, pp. 207–8.
18 My guess is that these extra animal studies were trials to determine the final trio of sub-

jects, rather than, as Nicholas Hall hints, an ambition to compare more than three species. But see Hall, 2000, pp. 162–3.

19 TN, 1809, p. 52.
20 LB, pp. 313–16.
21 The *Comparative Anatomy* drawings are in New Haven (YCFFBA).
22 OH, p. 208, col. 2.
23 The plates and drawings were acquired after Mary Spencer's death by Edward Orme, who republished the plates and a version of the text in a form quite different from anything Stubbs originally designed. But Orme made no attempt to have any of the remaining finished drawings engraved, and the bundle eventually reached America where it lay undisturbed for almost a century in the public library of Worcester, Massachusetts. Rediscovered in 1957, they were bought for the YCFBA by Paul Mellon in 1980. See Cormack, 1999, p. 94.
24 This argument is developed by Potts, 1990, pp. 29 ff.
25 Both these possibilities are aired by Fuller, 1993, pp. 90–1.

CHAPTER 54

Hambletonian

1 Quoted Longrigg, 1972, p. 73.
2 Whyte, 1840, p. 14.
3 On Fields, see Orton, 1844, p. 678.
4 Ibid., p. 56.
5 *The Sporting Magazine*, vol. 33, 1808, p. 131. This account of Hambletonian and the match with Diamond draws on reports published in the same magazine shortly after the event.
6 For a comprehensive account of the commission, see Egerton, 1985.
7 JE, p. 182.
8 JF, 9 April, 1800. It is very regrettable that no fuller account has ever been found of this trial, in which arguments about Stubbs's reputation and aesthetic were clearly aired at length.
9 As Judy Egerton surmises, the Ward version was perhaps commissioned by Vane-Tempest's widow or daughter and is now with *Rubbing Down* at Mount Stewart, Northern Ireland (National Trust). See Egerton, 1985, p. 268.
10 Orton, 1844, p. 56.

CHAPTER 55

Old Friends

1 The first was *Sweetwilliam* on 30 July followed at the beginning of September by *Marske*, against a background of Creswell Crags, and *Gimcrack* as a stallion at Oxcroft, Lord Grosvenor's stud. He also issued an undated print of *Eclipse*, from the painting of the great horse with his jockey and handler by the rubbing-down house on Newmarket Heath. LB, pp. 120–5.
2 LB, p. 375.
3 JF, volume I, pp. 154–8 (extracts).
4 Now in Liverpool (Walker AG).
5 London (RA collection). The profile was engraved by William Daniell and published in 1802 by Dance.
6 TN, May 1808, p. 57.
7 JF, vol. III, p. 694.
8 OH, p. 209.

9 JE, no. 137. The painting is in New Haven (YCFBA).
10 LB, no. 145.

CHAPTER 56

Last Days

1 Banks made a habit of weighing his visitors. He put Stubbs on the scales on 22 December 1782 at his house, 32 Soho Square, and duly recorded the result. See 'Stubbs and the Scientists' by Judy Egerton, n. 15, in Egerton, 1976.
2 JF, 8 July 1801.
3 Quoted LB, p. 376.
4 JF, 3 June 1807.
5 The enamels, with their catalogue numbers, were: *A Horse and Lion* (27), *Haymakers* (49), *A Harvest* (56), *Haymakers* (64), *Two Horses Fighting* (83), *The Fall of Phaeton* (84) and *The Farmer's Wife and the Raven* (86).
6 JF, 19 September 1806.
7 OH, p. 208, for this and the remaining quotations, all from a note in Mary Spencer's hand appended to the manuscript.
8 Stubbs's will and Ricketts's affidavit, reprinted in Gilbey, 1898, Appendix 1. Amendments to the will in Parker, 1971, p. 195. Ricketts was a ship's purser whose full name was Thomas Spencer Ricketts, but whose connection with Stubbs and Mary Spencer is unclear. See Fountain, 1984, p. 3.

CHAPTER 57

The Lost Legacy

1 By Fountain, 1984, p. 3 and n. 45.
2 Fredericksen, 1990, p. 29; DJF, 6 June 1807.
3 JF, 3 June 1807.
4 Dibdin, 1811, p. 613.
5 One of these studies is at YCFBA, another in Tate Britain. See JE, cat. nos 52 and 53.
6 One of the Hercules paintings is described in some detail in Gilbey, 1898. Taylor, 1971, p. 36, n. 29, quotes this 'in the hope that this may assist in its rediscovery'. This has yet to happen.
7 Orme traduced Stubbs's intentions by issuing the plates in two separate publications, *The Anatomy of the Human Body particularly adapted for the use of artists* and *A Comparative Anatomical Exposition of the Tiger and the Fowl*. LB, p. 316.
8 For details of these parish and other records, see Fountain, 1984. Mary Spencer's will is in the National Archives IR26722, fol. 52.

AFTERWORD

Of Wrath and Instruction

1 Taylor, 1971, p. 48.
2 This was pointed out in a brief but typically perceptive article by Peter Fuller in 1984. See Fuller, 1993, p. 91.
3 Sterne, 1997, p. 76. [vol 2, ch 5].
4 Loc. cit. p. 62. [vol 1, ch 24].
5 Quoted Nicholl, 2004.

Bibliography

Abbreviations used here and in the notes:

AG: Art Gallery.
BM: *The Burlington Magazine for Connoisseurs.*
CFL: Archaeological Survey of Merseyside, 1981.
CRS: The Catholic Record Society.
EC: Exhibition Catalogue.
GDNB: Tyrer, ed., 1968–72.
HW: Walpole, 1937–1974.
JE: Egerton, 1984.
JF: *The Diary of Joseph Farington.*
LPRS: Lancashire Parish Record Society.
MPPP: Walker Art Gallery, 1978.
OH: Transcript of Ozias Humphry's 'A Memoir Of George Stubbs' in Hall, ed., 2000.
PTRS: *Philosophical Transactions of the Royal Society.*
THSLC: *Transactions of the Historical Society of Lancashire and Cheshire.*
TN: T.N., 1808–09.
YCFBA: Yale Center for British Art, New Haven.
WS: *The Walpole Society Annual.*

Place of publication is London unless otherwise stated.

Ackroyd, Peter, *Blake*, 1995.
Allen, Brian, *Francis Hayman*, [EC], New Haven, 1987.
Angelo, Henry, *Reminiscences of Henry Angelo with Memoirs of his Late Father and Friends*, 1828.
Arch, N.J., '"To stop this dangerous mischief": York and the Jacobite Rebellion of 1745', *The York Historian*, 3, pp. 27–30, 1980.
Archaeological Survey of Merseyside, *The Changing Face of Liverpool 1207–1727*, Liverpool, 1981.
Archer, Mildred, *India & British Portraiture 1770–1825*, 1979.
Armytage, W.H.G., 'Charles Watson-Wentworth, 2nd Marquess of

Rockingham, F.R.S.: Some Aspects of His Scientific Interests,' *Notes & Records of the Royal Society*, 12, pp. 64–76, 1956.

Arts Council of Great Britain, *British Sporting Painting 1650–1850*, [EC], 1974.

Arts Council of Great Britain, *George Stubbs: Rediscovered Anatomical Drawings*, [EC], 1958.

Aspinall, A., ed., *Correspondence of George Prince of Wales 1770–1812* (2 vols.), vol. I 1963; vol.II 1964.

Atkinson, James, *A Medical Bibliography: A and B*, 1834.

Aveling, J.C.H., *Catholic Recusancy in the City of York 1588–1791* Catholic Record Society, 1970.

Aveling, J.C.H., *The Handle & the Axe: The Catholic Recusants from Reformation to Emancipation*, 1976.

Avery, Charles and Anthony Radcliffe, ed., *Giambologna, 1529–1608, Sculptor to the Medici : an exhibition organised by the Arts Council of Great Britain and the Kunsthistorisches Museum*, [EC], 1978.

Aylward, J.D., *The House of Angelo: A Dynasty of Swordsmen*, 1953.

Barker, T.C., 'Lancashire Coal, Cheshire Salt, and the Rise of Liverpool', THSLC vol 103, 1951.

Barker-Benfield, G.J., *The Culture of Sensibility: Sex & Society in 18th century England*, 1992.

Barnett, Gerald, *Richard and Maria Cosway: Regency Artists of Taste and Fashion*, Tiverton, 1995.

Barrell, John, *The Dark Side of the Landscape*, 1980.

Bazendale, David, *Lancashire's Historic Halls*, Preston, 1994.

Beamont, William, *Hale and Orford: An Account of Two Old Lancashire Houses, with Memorials to the Respective Owners to the Present Time*, Warrington 1886.

Beamont, William, *Memoir of Hamlet Winstanley, Formerly of Warrington, Artist*, 1883.

Bell, H. Wilberforce, 'The Vicissitudes of a Picture by George Stubbs', *Country Life*, pp. lii-liv, 26 September 1936.

Beresford, Maurice, *East End, West End: The Face of Leeds During Urbanisation*, Thorseby Society, Vol. LXI, Nos. 131–132, Leeds 1985–86.

Berg, Leila, *The Age of Manufactures 1700–1820*, 1985.

Bermingham, Ann, *Learning to Draw: Studies in the Cultural History of a Polite and Useful Art*, 2000.

Blackburne, Charlotte, *Hale Hall, with Notes on the family of Ireland-Blackburne*, 1881.

Blake, Robin, 'A Different Form of Art: Stubbs and Rockingham's Young Whigs in the 1760s', in Warner, op. cit., 2004 (1).

Blake, Robin, 'Field Work: Stubbs and the Humbler Sort', in Warner, 2004 (2).

Blake, Robin, 'Stubbs, the Macaroni and the Prince of Wales', in Warner, 2004 (3).

Blake, William, *Poetry and Prose*, ed. Geoffrey Keynes, 1927.

Bloy, Marjorie, *Rockingham and Yorkshire*, unpublished PhD thesis, University of Sheffield 1986.

Blyth, Henry, *The High Tide of Pleasure*, 1970.

Boswell, James, *Boswell's London Journal 1762–63*, ed. Frederick A. Pottle, 1950.

Boswell, James, *Boswell, the Great Biographer*, ed. Marlies K. Danziger & Frank Brady, 1989.

Boswell, James, *The Life of Johnson*, ed. John Wilson Croker, 5 vols. with added material from Hester Thrale and Edmund Malone, 1831.

Brewer, John, *The Pleasures of the Imagination: English Culture in the Eighteenth Century*, 1997.

British Sporting Art Trust, *Sporting Art in Britain*, Christie's [EC], 2002.

Brockwell, Maurice W., *Catalogue of the Pictures and Other Works of Art . . . at Nostell Priory*, 1915.

Bronowski, Jacob, *The Ascent of Man*, 1973.

Brown, E. Myra ed., *Made in Liverpool: Liverpool Pottery and Porcelain 1700–1850*.

Walker Art Gallery [EC], Liverpool, 1993.

Burke, Edmund, *A Philosophical Enquiry into the Origin of our Ideas of the Sublime and Beautiful*, ed. J.T. Boulton, 1958.

Burke, Edmund, *The Correspondence of*, ed. Thomas W. Copeland, Chicago, 1958.

Burman, Lionel, 'Wedgwood and Bentley in Liverpool and the North-West', HSLC, vol. 146, pp. 66–91, 1997.

Burton, Anthony, *Josiah Wedgwood: A Life*, 1976.

Burton, John, *British Liberty Endanger'd etc.*, 1749.

Burton, John, *An Essay Towards a Complete System of Midwifry, Theoretical and Practical, etc.*, 1751.

Burton, John, *A Letter to William Smellie, M.D., containing critical and practical remarks upon his treatise on the theory and practice of midwifery, etc.*, 1753.

Burton, John, *Monasticon Eboracense*, 1758.

Byng, John, *The Torrington Diaries: A Selection from the Tours 1781 and 1794*, ed. C. Bruyn Andrews, 1954.

Cash, Arthur H., 'The Birth of Tristram Shandy: Sterne and Dr Burton', *Studies in the Eighteenth Century*, ed. R.F. Brissenden, Canberra, 1968.

Cash, Arthur H., *Laurence Sterne: The Early and Middle Years*, 1975.

Clark, Sir George, *A History of the Royal College of Physicians of London*, Vol. 2, 1966.

Clayton, Tim, *The English Print 1688–1802*, 1997.

Clutton, Sir George, 'The Cheetah and the Stag', BM CXII, pp. 10–19, 1970.

Collins, G.E., *The History of the Brocklesby Hounds*, 1902.

Constantine, H.F., 'Lord Rockingham & Stubbs: some new documents', BM, XCV, p. 237, 1953.

Cook, T.A., *Eclipse and O'Kelly*, 1907.

Cormack, Malcolm, ed., *George Stubbs in the Collection of Paul Mellon: A Memorial Exhibition*, [EC] New Haven, 1999.

Croft-Murray, Edward, *Decorative Painting in England 1537–1837*, 2 vol., 1962.

Cross, Michael, ed., *Polite Society by Arthur Devis 1712–1787: Portraits of the English Country Gentleman and his Family*, Harris Museum [EC], Preston, 1983.

Currie, Sir Philip, 'A Memoir of Richard Cosway', in Daniell, 1890.

Dalrymple, William, *The White Mughals*, 2002.

Dane, E. Surrey, *Peter Stubs and the Lancashire Tool Industry*, Altrincham, 1973.

Daniel, William B., *Rural Sports*, 4 vols., 1813.

Daniell. Philip B., *A Catalogue Raisonnée of the Engraved Works of Richard Cosway, R.A.*, 1890.

Daniels, Stephen, *Humphrey Repton: Landscape Gardening and the Geography of Georgian England*, 1999.

Darcy, C.P., 'The Encouragement of Fine Arts in Lancashire 1760–1860', *Chetham Society* Vol. XXIV 3rd Series, Manchester, 1976.

Darwin, Charles, *The Origin of the Species*, 1859.

Darwin, Erasmus, *Zoonomia; or the Laws of organic life*, vol. 1 1794; vol. 2, 1796

Dawe, George, *The Life of George Morland*, 1807 and 1904.

Daynes, Gilbert W., 'Freemasonry and Social England in the Eighteenth Century', *Transactions of the Manchester Association for Masonic*

Research, 1929.

Defoe, Daniel, *A Tour Through the Whole Island of Great Britain*, 2 vols., ed. G.D.H. Cole, 1927.

Deuchar, Stephen, *Noble Exercise*, YCFBA, 1983.

Deuchar, Stephen, *Sporting Art in 18th Century England: A Social and Political History*, 1988.

Dibdin, E. Rimbault, 'Liverpool Artists in the Eighteenth-century.' WS, v.VI, 1918.

Dibdin, Thomas Frognal, *Bibliomania*, 1811.

Directors of the Incorporated Society of Artists of Great Britain, *The Conduct of the Royal Academicians, while Members of the Society of Artists of Great Britain, viz. from the Year 1760 to their Expulsion in the Year 1769. With some Parts of their Transactions Since*, 1771.

Doherty, Terence, *The Anatomical Works of George Stubbs*, 1974.

Dorment, Richard, *British Paintings in the Philadelphia Museum of Art, Philadelphia*, 1986.

Draper, Peter, *The House of Stanley*, Ormskirk, 1864.

Dryander, Jonas, *Catalogue of Drawings of Animals in the Library of Sir J Banks*, 5 vols. 1798–1800.

Duffy, Christopher, *The '45: Bonnie Prince Charlie and the Untold Story of the Jacobite Rising*, 2003.

Edwards, Edward, *Anecdotes of Painters who have Resided or been Born in England, with Remarks on their Productions . . . intended as a continuation to the anecdotes of Painting by Horace, Earl of Orford*, 1808.

Egerton, Judy, *George Stubbs, Anatomist & Animal Painter*, Tate Gallery [EC], 1976.

Egerton, Judy, 'The Painter and the Peer: Stubbs and the Patronage of the First Lord Grosvenor', *Country Life*, vol. 166. pp. 1892–3, 22 November 1979.

Egerton, Judy, George Stubbs 1724–1806, [Tate Gallery EC], 1984 (1).

Egerton, Judy, "George Stubbs and the landscape of Creswell Crags", BM 126, pp. 738–43, December, 1984 (2).

Egerton, Judy, 'A Painter, a Patron and a Horse,' *Apollo* 122, pp. 264–9, 1985.

Egerton, Judy, 'Four Shooting Paintings by George Stubbs' in *Essays in Honour of Paul Mellon*, ed. John Wilmerding, pp. 85–95, 1986.

Egerton, Judy, *The British School* (National Gallery Catalogue), 1998 (1).

Egerton, Judy, 'Lord Rockingham and Stubbs', Wentworth. The Property of The Olive, Countess Fitzwilliam Chattels Settlement and of other members of the family, auction catalogue, Christie's, (July 8) 1998 (2).

Farington, Joseph, *The Diary of Joseph Farington*, ed. Kenneth Garlick and Angus MacIntyre, in 17 vols, 1978–1998.

Fielding, Henry, *The Adventures of Tom Jones*, 1749 (Harmondsworth, 1966).

Fiennes, Celia, *The Journeys of Celia Fiennes*, ed. Christopher Morris, 1947.

Fordham, Douglas, 'Raising Standards: Art and Imperial Politics in London, 1745–1776', Ph.D. dissertation, Yale University, 2003.

Foreman, Amanda, *Georgiana, Duchess of Devonshire*, 1998.

Fothergill, Richard, *The Fothergills, a Second History*, Newcastle-upon-Tyne (privately printed), 2002.

Fountain, R. B., 'Some Speculations on the Private Life of George Stubbs', *British Sporting Art Trust Essay* no. 12, 1984.

Fountain, R.B., and Gates, Alfred, *Stubbs's Dogs*, 1984.

Fredericksen, Burton B., ed., *The Index of Paintings Sold in the British Isles during the Nineteenth Century*, Vol. 2: 1806–1810, Getty Art History Information Project, Oxford, 1990.

Fuller, Peter, *Modern Painters*, 1993.

Gilbey, Sir Walter, *The Life of George Stubbs R.A.*, 1898.

Gilbey, Sir Walter, *Animal Painters from the Year 1650*, 3 vols., 1900.

Gooch, Leo, 'The Religion for a Gentleman: the Northern Catholic Gentry in the Eighteenth Century', *Recusant History*, vol. 23, No 4, 1997.

Graves, Algernon, and William Vine Cronin, *A History of the Works of Sir Joshua Reynolds P.R.A.*, 4 vols., 1899–1901.

Gregson, Matthew, *A Portfolio of Fragments relative to the History and Antiquities of the County Palatine and Duchy of Lancaster*, 1869.

Hall, Nicholas H.J., ed., *Fearful Symmetry: George Stubbs, Painter of the English Enlightenment*, [EC], New York, 2000.

Harris, John, *The Artist & the Country House*, 1979.

Haskell, Francis and Penny, Nicholas, *Taste and the Antique : the Lure of Classical Sculpture 1500–1900*, 1981.

Hatton, Peter, *The History of Hale*, Hale, 1991.

Hazlitt, William, *Criticisms on Art: and Sketches of the Picture Galleries of England*, 2nd edition, 1856.

Hazlitt, William, *Selected Essays*, ed. Geoffrey Keynes, 1930.

Hoffman, Douglas, *The Marquis: A Study of Lord Rockingham, 1730–1782*, New York, 1973.

Hogarth, William, *The Analysis of Beauty*, ed. Ronald Paulson, 1997.

Holcroft, Thomas, and Hazlitt, William, *The Memoirs of Thomas Holcroft*, 1926.

Hughes, Edward, *Studies in Administration and Finance*, Manchester, 1934.

Hunt, David, *A History of Preston*, Preston, 1992.

Hunter, William, 'An Account of the Nylghau', PTRS LXI, p. xxi., 1771.

Ingamells, John, *A Dictionary of British & Irish travellers in Italy 1701–1800*, 1997.

Jarrett, Derek, *England in the Age of Hogarth*, 1976.

Jarrett, Derek, *The Ingenious Mr Hogarth*, 1976.

Jennings, Humphrey, *Pandaemonium*, 1985.

Johnson, Samuel, *Prose and Poetry*, ed. Mona Wilson, 1950.

Kemp, Martin, 'True to their Natures: Sir Joshua Reynolds and Dr William Hunter at the Royal Academy of Arts', *Notes and Records of the Royal Society of London*, vol. 46 (1), pp. 77–88, 1992.

Kenworthy-Brown, John, 'Matthew Brettingham's Rome Account Books 1747–1754'.

WS vol. 49, pp. 37–132, 1983.

Kitson, Sidney D., and Edmund D. Pawson, *Temple Newsam*, Leeds, (4th edition) 1930.

Laskey, J., *A General Account of the Hunterian Museum*, Glasgow, 1983.

Lavater, J.C., *Essays on Physiognomy for the Promotion of Knowledge and the Love of Mankind*, translated from the German by Thomas Holcroft, 1789. [Abridgement published 1806]

Lawrence, John, *A Philosophical & Practical Treatise on Horses and on the Moral Duties of Man Towards Brute Creation*, 2 vols., 1798.

Ledgard, A., 'Mr Stubbs's View of the Passions', *The Print Collector's Newsletter*, XVI pp. 1–4, 1985.

Lees-Milne, James, *Earls of Creation: Five Great Patrons of Eighteenth Century Art*, 1962.

Lennox-Boyd, C., Dixon C.R. & Clayton, T., *George Stubbs: The Complete Engraved Works*, 1989.

Leonardo da Vinci, *Leonardo on Painting*, ed. Martin Kemp, 1989.

Leonardo da Vinci, *Treatise on Painting*, 1721.

Lippincott, Louise, *Selling Art in Eighteenth Century London: The Rise of Arthur Pond*, 1983.

Lloyd, Stephen, *Richard and Maria Cosway, Regency Artists of Taste and Fashion*, Edinburgh, 1995.

Longrigg, Roger, *The History of Horse Racing*, 1972.

Longrigg, Roger, *The English Squire and His Sport*, 1977.

Loomes, Brian, *Lancashire Clocks and Clockmakers*, 1975.

Lovejoy, Norman O., *The Great Chain of Being*, 1936.

Mayer, Joseph, *Early Art in Liverpool with some Notes for a Memoir of George Stubbs*, privately published, 1876.

Mayer, Lance and Gay Myers, 'Painting in an Age of Innovation: Stubbs's Experiments in Enamel and Wax', pp. 123–140 in Warner, 2004.

McLachlan, H., *The Warrington Academy: Its History and Influence*, 1943.

McLynn, Frank, *Bonnie Prince Charlie: Charles Edward Stuart*, 1988.

Millar, Oliver, *Tudor, Stuart and Early Georgian Pictures in the Collection of Her Majesty The Queen*, 2 vols., 1963.

Millar, Oliver, *The Later Georgian Pictures in the Collection of Her Majesty The Queen*, 2 vols, 1969.

Milner, Frank, *George Stubbs: Paintings, Ceramics, Prints & Documents in Merseyside Collections*, Liverpool, 1987.

Mingay, G. E. *English Landed Society in the Eighteenth Century*, 1963.

Moncrieff, Elspeth, with Stephen and Iona Joseph, *Farm Animal Portraits*, Woodbridge, 1996.

Monkman, Kenneth, 'Sterne and the '45: 1743–1748', *The Shandean*, 2, pp. 45–136, 1990.

Morrison, Venetia, *The Art of George Stubbs*, 2nd edition, 1997.

Myrone, Martin, *George Stubbs*, 2002.

Namier, Sir Lewis, and John Brooke, *The History of Parliament: The House of Commons 1754–1790*, 1964.

Neal, Adam, *A Catalogue of the Plants in the Garden of John Blackburne Esq. at Orford*, Warrington, 1779.

Nicholl, Charles, 'Sneezing, Yawning, Falling: The Writings of Leonardo', *London Review of Books*, vol 26, no. 24, 16.xii.2004, pp. 19–22.

Noakes, Aubrey, *Sportsmen in a Landscape*, 1954.

O'Gorman, Frank, *The Rise of Party in England: Rockingham Whigs 1760–82*, 1975.

Oates, Jonathan, 'The Jacobites of Yorkshire', *Yorkshire Archaeological*

Journal, Vol. 74, pp. 205–217, 2002.

Ober, William B., 'George Stubbs: Mirror up to Nature', *New York State Journal of Medicine*, 70, No 8, 15 April, 1970.

Orton, John, *Turf Annals of York and Doncaster*, 1844.

Paine, Thomas, *The Rights of Man*, Part 2, 1792. Integrated Everyman edition, 1994.

Parker, Constance-Ann, *Mr Stubbs the Horse Painter*, 1971.

Parris, Leslie, *George Stubbs ARA 'Leopards at Play' and 'The Spanish Pointer'*, 1974.

Parris, Leslie, *Landscape in Britain c.1750–1850*, [Tate Gallery EC], 1973.

Parsons, Edward, *The Civil, Ecclesiastical, Literary, Commercial and Miscellaneous History of Leeds, Halifax, Huddersfield etc.* Leeds, 1834.

Pears, Iain, *The Discovery of Painting: the Growth of Interest in the Arts in England, 1680–1768*, 1988.

Pedretti, Carlo, *Leonardo da Vinci on Painting: A Lost Book Reassembled from the Codex Vaticanus Urbinas and from the Codex Leicester*, 1965.

Peet, H., 'Liverpool in the Reign of Queen Anne 1705 and 1708', THSLC 59, Appendix, 1908.

Peet, H., *Liverpool Vestry-books*, 2 vols., Liverpool, 1912.

Penny, Nicholas, (ed.) *Reynolds*, [Royal Academy of Arts EC], 1986.

Pepper, D. Stephen, *Guido Reni: a Complete Catalogue of his Works with an Introductory Text*, Oxford, 1984.

Petherbridge, Deanna, and Ludmilla Jordonova, *The Quick and the Dead: Artists and Anatomy*, [EC], 1997.

Picard, Liza, *Dr Johnson's London: Life in London 1740–1770*, 2000.

Picton, James A., *Liverpool Municipal Archives and Records*, Liverpool, 1883/6.

Piper, David, *The English Face* (revised and enlarged edition), 1992.

Plint, William, *A Treatise on the Breeding, Training & Management of Horses*, Hull, 1815.

Plumb, J.H., *England in the Eighteenth Century*, Harmonsworth, 1950.

Pope, Alexander, *Correspondence*, ed. G. Sherburn, 1956.

Porter, Roy, *English Social History in the Eighteenth Century*, Harmondsworth, 1982.

Porter, Roy, *Enlightenment: Britain & the Creation of the Modern World*, 2000.

Porter, Roy, *Bodies Politic: Disease, Death and Doctors in Britain, 1650–1900*, 2001.

Potts, Alex, 'Natural Order and the Call of the Wild: the Politics of Animal Picuring', *Oxford Art Journal*, 13:1 pp. 12–33, 1990.

Radcliffe, Walter, 'Dr John Burton and His Whimsical Contrivance', *The Medical Bookman and Historian*, vol. 2., 1948.

Randall, Joseph, *An Account of the Academy at Heath near Wakefield etc.*, Wakefield, 1750.

Randolph, The Rev. Herbert, *The Life of General Sir Robert Wilson*, 1862.

Rees, Grace A., *Character Reading from the Face*, 1955.

Reese, Max Meredith, *Goodwood's Oak: The Life and Times of the Third Duke of Richmond, Lennox and D'Aubigny*, 1987.

Rice, James, *The History of the British Turf*, 2 vols., 1879.

Richardson, Jonathan, Senior & Junior, *An Account of the Statues, Bas-Reliefs, Drawings, and Pictures in Italy, France etc. with Remarks.*, 1st edn. 1722; 2nd edn., 1754.

Rolfe, W.D. Ian, 'A Stubbs Drawing Recognised', BM, CXXV, pp. 738–41, 1983.

Rolfe, W.D. Ian, 'William Hunter on Irish elk and Stubbs' Moose', *Archives of Natural History* XI, 2, pp. 263–90, 1983.

Roscoe, Ingrid, 'Peter Scheemakers', WS vol. 61, 1999.

Rude, George, *The Crowd in History: A Study of Popular Disturbances in France and England, 1730–1840*, 1964.

Russel, James, *Letters from a Young Painter Abroad to his Friends in England*, 2 vol., 2nd edn., 1750.

Russell, Francis, 'Lord Torrington and Stubbs: a footnote', BM CXX, 11, 1980.

Russell, Francis, 'The Derby Collection', WS vol. 53 pp.143–180, 1987.

Savage, Nick et al., *The Beauties of the Horse: Drawings by George Stubbs and Related Materials for Artists of the Royal Academy*, exhibition leaflet, Royal Academy of Arts, 2002.

Scharf, George, *A Descriptive and Historical Catalogue of the Collection of Pictures at Knowsley Hall*, 1875.

Scott, Jonathan, *The Pleasures of Antiquity: British Collectors of Greece and Rome*, 2003.

Secord, William, *Dog Painting 1840–1940, a Social History of the Dog in Art*, 2001.

Sinclair, David, *The History of Wigan*, 1882.

Singer, Charles, *A Short History of Scientific Ideas to 1900*, 1959.

Shepherd, Robert, 'Stubbs: A Conservator's View', in JE, pp. 20–21, 1984.

Sisman, Adam, *Boswell's Presumptuous Task*, 2000.

Smith, Rodney, 'The Hunters and the Arts', *Annals of the Royal College of Surgeons of England*, 57, pp. 117–32, 1975.

Smith, The Rev. Sydney, *Selected Writings of Sydney Smith*, ed., with an introduction, by W. H. Auden, 1957.

Smith, W.J., 'Sir Ashton Lever of Alkrington and his Museum 1729–1788', *Transactions of the Lancashire and Cheshire Antiquarian Society*, vol. 72, pp. 61–92, 1962.

Smithers, Henry, *Liverpool, its Commerce, Statistics and Institutions etc.*, Liverpool, 1825.

Smythe, R.H., *Horses in Action: a Study of Conformation, Movement and the Causes of Spinal Stress*, 1963.

Sørensen, Bent, 'The Enduring Vitality of the Flayed Horse', *Apollo*, vol. 155, np. 481, March, pp. 30–39, 2002.

Stacpoole, Dom Alberic, O.S.B. (ed.), *The Noble City of York*, York, 1972.

Stainton, Leslie, 'Hayward's List: British Visitors to Rome 1753–75', WS, Vol. 29, pp. 3–36, 1983.

Stanhope, Philip Dormer, 4th Earl of Chesterfield, *Letters to his Son*, 1774.

Sterne, Laurence, *The Life and Opinions of Tristram Shandy, Gentleman*, 9 Vols., York and London, 1757–67. (Citations of vol. and chapter are good for any edition. Page references are to the Penguin Classic edition, ed. Melvyn New and Joan New, Harmondsworth, 1997.)

Stevenson, Lloyd G., 'The Siege of Warwick Lane together with a Brief History of the Society of Collegiate Physicians', *Journal of the History of Medicine and Allied Sciences*, Vol. VII, no. 2, pp. 105–121, 1952.

Stonor, Robert Julian, *Liverpool's Hidden Story: A Historical Sketch of the Catholic Church in Liverpool*, Billinge, 1957.

Strange, Robert, *An Inquiry into the Establishment of the Royal Academy of Arts*, 1775.

Stuart-Brown, R., *The Inhabitants of Liverpool from the 14th to the 18th Century*, Liverpool, 1930.

Stubbs, George, *The Anatomy of the Horse: Including A particular Description of the Bones, Cartilages, Muscles, Fascias, Ligaments,*

Nerves, Arteries, Veins, and Glands; In Eighteen Tables, all done from Nature, 1766.

Sunderland, John, 'Mortimer, Pine and some Political Aspects of English Historical Painting', BM, CXVI, pp. 317–326, 1974.

Swift, Jonathan, *Gulliver's Travels and Selected Writings*, ed. John Hayward, 1934.

T.N., 'Memoir of George Stubbs Esq. The Celebrated Painter of Horses', *The Sporting Magazine*, Vol. 32 pp.54–57 & 155–57 (May & July) 1808; Vol 35 pp. 49–52 (November) 1809.

Tattersall, Bruce, *Stubbs and Wedgwood*, 1974 [Tate EC; reprints J Wedgwood's letters referring to GS].

Taylor, Basil, *Animal Painting in England from Barlow to Landseer*, Harmondsworth, 1955.

Taylor, Basil, *George Stubbs, 1724–1806*, [Whitechapel Art Gallery EC], 1957.

Taylor, Basil, 'George Stubbs: 'The Lion and Horse Theme', BM, CVII, pp. 81–86, 1965.

Taylor, Basil, 'George Stubbs and Josiah Wedgwood', *Proceedings of the Wedgwood Society*, 4, 1961.

Taylor, Basil, 'George Stubbs's Painting of a Cheetah with Two Indians', *Art At Auction 1969–70* pp.10–19, 1970.

Taylor, Basil, 'Technical Aspects of Stubbs's Painting', in Tattersall, 1974.

Taylor, Basil, *Stubbs*, 2nd edition, 1975. (1st ed. 1971)

Taylor, Desmond, 'George Stubbs at Horkstow', *The Antique Collector*, pp. 66–67, August, 1987.

Tillyard, Stella, *Aristocrats: Caroline, Emily, Lousia and Sarah Lennox 1740–1832*, 1994.

Thomas, Keith, *Man and the Natural World: Changing Attitudes in England 1500–1800*, 1983.

Thompson, Laura, *Newmarket: From James I to the Present Day*, 2000.

Touzeau, James, *The Rise and Progress of Liverpool*, 1910.

Turner, William, *The Warrington Academy*, Warrington, 1957.

Tyrer, F.(ed.), *The Great Diurnal of Nicholas Blundell of Little Crosby, Lancashire 1702–28*, THSLC vols 110, 112, 114, 1968, 1970, 1972.

Uglow, Jenny, *The Lunar Men: the Friends Who Made the Future 1730–1810*, 2002.

Vincent-Kemp, Ruth, *George Stubbs & the Wedgwood Connection*, privately published, 1986.

Virgilius Maro, Publius, *Works in Latin and English*, trs C. Pitt and J. Warton, 4 vol., 3rd edition, 1778.

Walcot, Dr John, *The Works of Peter Pindar, Esq. . . . To which is Prefixed some Account of his Life*, 4 vol., 1816.

Walker Art Gallery, *Merseyside Painters, People & Places*, 2 vol [EC], Liverpool, 1978.

Walpole, Horace, *Correspondence*, edited by W.S. Lewis, multiple vols., New Haven, 1937–74.

Walpole, Horace, 'Notes on Exhibitions of the Society of Artists etc.', WS vol. XXVII, 1938–39.

Warner, Malcolm and Robin Blake, *Stubbs and the Horse*, Kimbell Art Museum EC, Forth Worth, 2004.

Waterhouse, E.K., *Painting in England 1530–1790*, revised edition, Harmondsworth, 1978.

Waterhouse, E.K., *Dictionary of British Eighteenth Century Painters in Oils and Crayons*, Antique Collector's Society, Woodbridge, 1981.

Watt, Alexander, *Leather Manufacture: A Practical Handbook,* 1906.

Weinreb, Ben and Hibbert, Christopher, *The London Encyclopaedia*, 1993.

Weiss, Leonard, *Watchmaking in England 1760–1820*, 1982.

Weston, Stephen, *Viaggiana, or, Detached Remarks on the Buildings, Pictures, Statues, Inscriptions, etc., of Ancient and Modern Rome*, 1776.

Whitaker, Thomas Dunham, *Loidis and Elmete: or, an attempt to illustrate the districts described in those words by Bede, and supposed to embrace the lower portions of Airedale and Wharfdale, together with the entire vale of Calder in the county of York*, Leeds, 1816.

Whitehead, Barbara, 'York and the Jacobite Rebels: some events and people in the York of 1745 to 1747.' *The York Historian*, 6, pp. 59–71, 1985.

Whitley, W.T., *Artists and their Friends in England 1700–1799*, 1928

Whyte, James Christie, *The History of the British Turf*, 1840.

Willey, Basil, *The Eighteenth Century Background*, 1940.

Williams, Raymond, *The Country and the City*, 1974.

Williamson, George C., *The Life and Works of Ozias Humphry*, 1918.

Wilson, Benjamin, *A Letter to the Marquess of Rockingham with Some Observations of the Effect of Lightning*, 1765.

Wilson, R.G., *Gentlemen Merchants: the Merchant Community in Leeds 1700–1830*, Manchester, 1971.

Winstanley, Hamlet, *Praenobili Iacobo Comti Derby* etc., Knowsley
Hall, 1728. [Etchings from the collection of pictures at Knowsley
Hall].

Young, Arthur, *A Six Months Tour through the North of England*, 2nd
edition, 4 vols., 1771.

Index